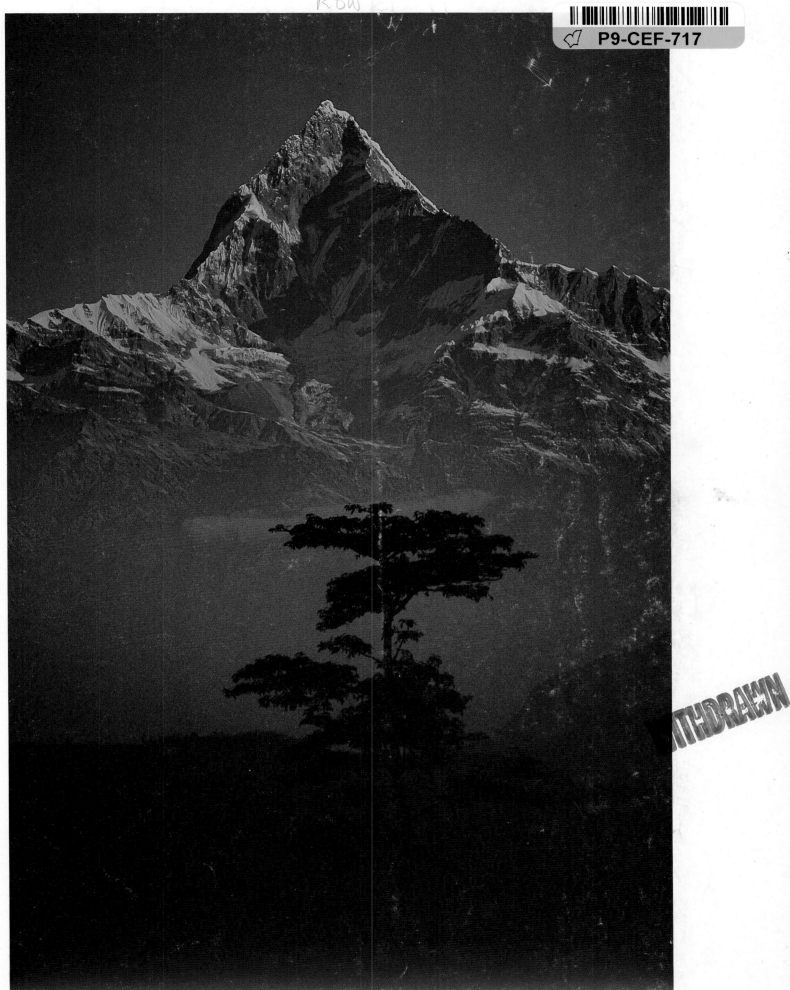

MACHAPUCHARE AT DAWN, NEPAL HIMALAYA

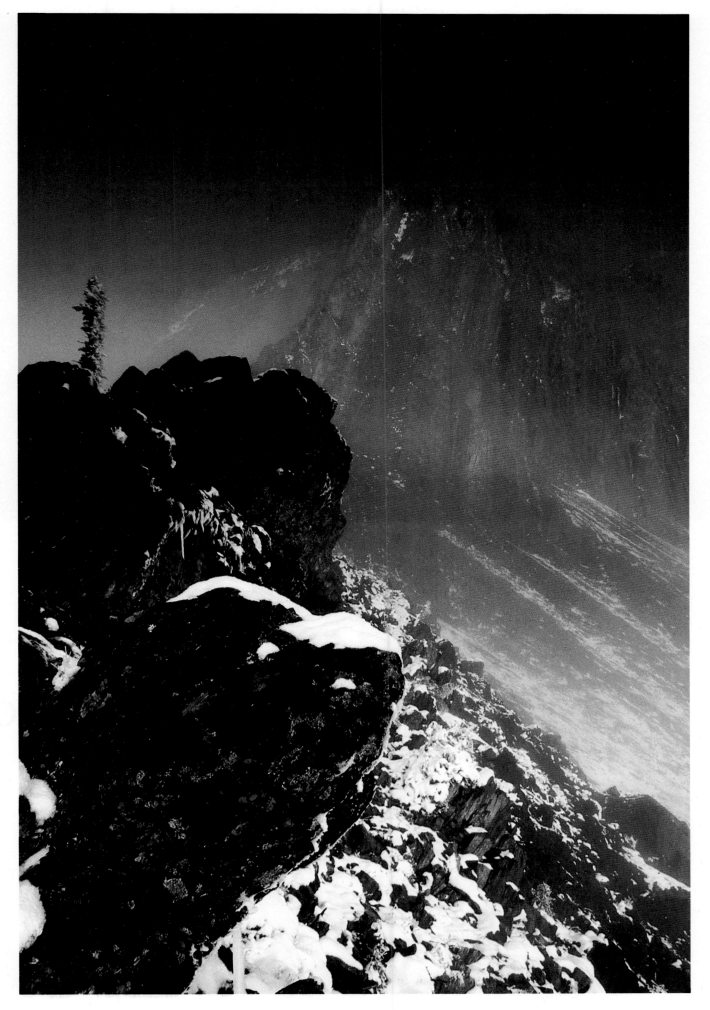

STORM ON MOUNT ANGELES, OLYMPIC PARK, WASHINGTON

GALEN ROWELL
In Search of the Dynamic

A YOLLA BOLLY PRESS BOOK

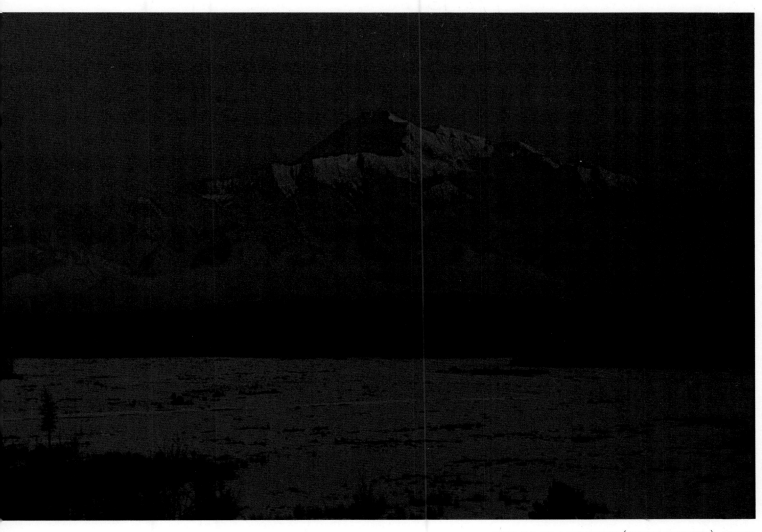

WINTER DAWN, DENALI PEAK (MOUNT MCKINLEY), ALASKA

MOUNTAIN LIGHT
Landscape

PUBLISHED BY SIERRA CLUB BOOKS SAN FRANCISCO

TO BARBARA, WHO CONTINUALLY EXPANDS BOTH MY HORIZONS AND HER OWN

A YOLLA BOLLY PRESS BOOK

Mountain Light was produced in association with the publisher at The Yolla Bolly Press, Covelo, California. Editorial and design staff: James Robertson, Carolyn Robertson, Barbara Young-blood, Diana Fairbanks, Tom Lawrence.

Composition by Mackenzie-Harris, San Francisco.

The Sierra Club, founded in 1892 by John Muir, has devoted itself to the study and protection of the earth's scenic and ecological resources—mountains, wetlands, woodlands, wild shores and rivers, deserts and plains. The publishing program of the Sierra Club offers books to the public as a non-profit educational service in the hope that they may enlarge the public's understanding of the Club's basic concerns. The point of view expressed in each book, however, does not necessarily represent that of the Club. The Sierra Club has some sixty chapters coast to coast, in Canada, Hawaii, and Alaska. For information about how you may participate in its programs to preserve wilderness and the quality of life, please address inquiries to Sierra Club, 730 Polk Street, San Francisco, CA 94109.

Preface to the Second Edition copyright
 © 1995 Galen Rowell
Second Edition: 1995

Published simultaneously in Canada

LIBRARY OF CONGRESS
CATALOGING-IN-PUBLICATION DATA

Rowell, Galen A.
Mountain Light.

"A Yolla Bolly Press book."
Includes index.
1. Photography—Landscapes. I. Title.
TR660.5.R69 1986 778.9'36'0924 86-1887
ISBN 0-87156-761-X
 0-87156-367-3 (pbk.)

Printed in Hong Kong
by South Sea International Press
10 9 8 7 6 5 4 3 2 1
10 9 8 7 6 5 4 3 2 1 (pbk.)

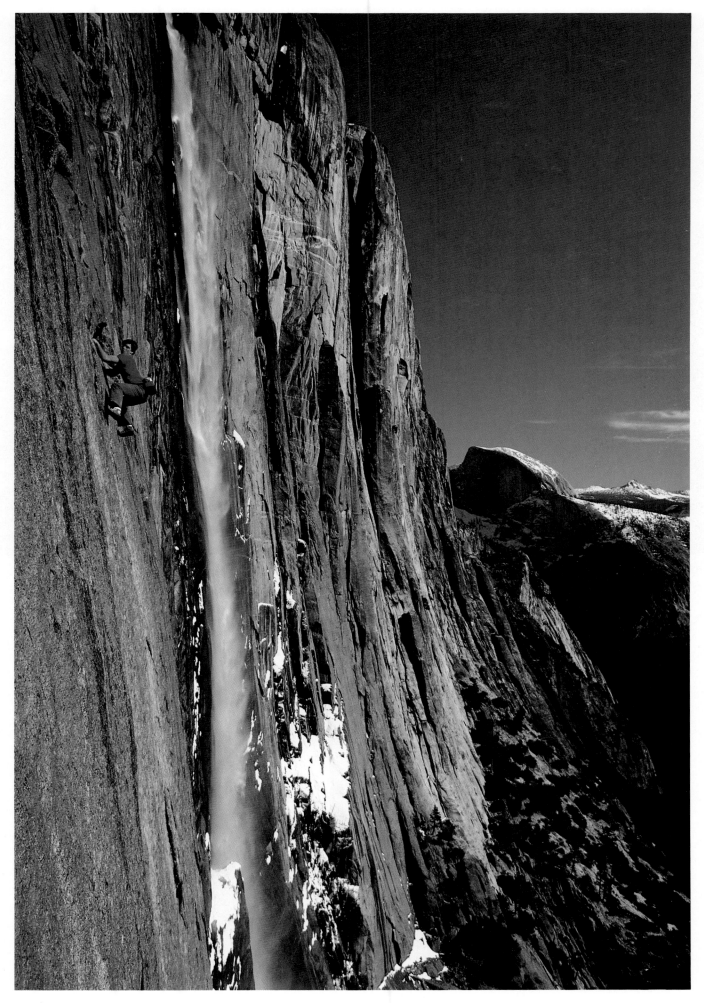

RON KAUK FREE-SOLOING BESIDE YOSEMITE FALLS, CALIFORNIA

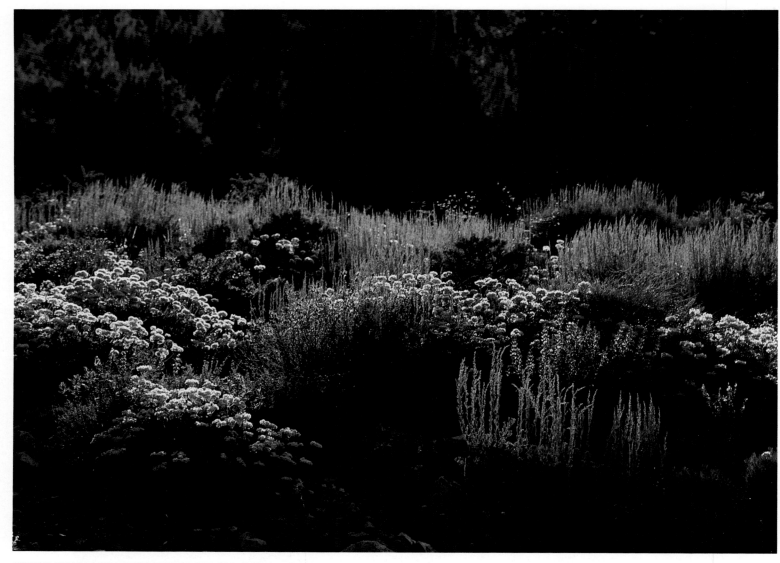

SUMMER FLOWERS IN SAGEBRUSH MEADOW, GRANT LAKE, CALIFORNIA

Contents

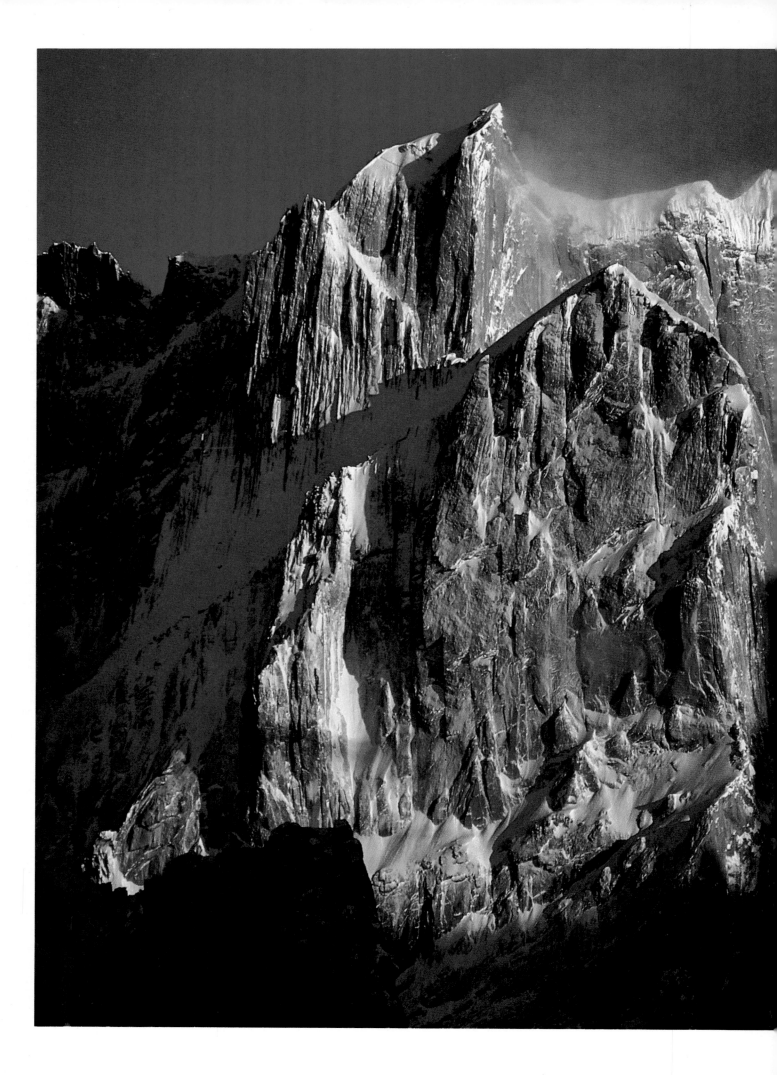

For fine landscapes that need the utmost in tonal separation and shadow detail, I prefer ISO 50 Fuji Velvia, but for action sports on sunny days or long evening exposures (where Velvia skies turn green due to reciprocity failure), I choose ISO 100 Kodak Lumiere. In low contrast light both this film and the equally sharp but less saturated ISO 100 Fuji Provia do well push processed to ISO 200, making them especially useful for dimly-lit wildlife and aerial scenes. Provia comes into its own for people and product photography on location, where color accuracy at close range is more important than saturation on more distant subjects. For the extensive general aerial photography I've been doing from my wife's Cessna T206 for a full decade now, I prefer Fuji Velvia pushed one stop to ISO 100 for a slight gain in contrast and warmth that helps cut through blue haze combined with a bit of extra speed and the film's predictably rich colors. The result looks better and more natural than what I get from standard ISO 100 films.

The greatest change in my outdoor photography over the past decade is the firm realization that I can control a tonal range two to four times beyond what color slide film would normally deliver. Just as Ansel Adams' Zone System allows photographers to expand the range of black-and-white prints through techniques of development and printing, my method expands the range of original color slides through combined use of new "smart flash" systems with four special graduated neutral-density filters that I designed with the Singh Ray company of Venice, Florida. They are available in densities of two and three stops in hard-edged and soft-edged versions. Without altering natural color balance, a properly used three-stop filter extends the range of brightness in which a person sees good detail in the best slide films from 8 to 1 up to 64 to 1. By adding a second three-stop filter, a normal-appearing horizon can be rendered against a sharply defined boundary of light and shadow in a scene that has a brightness range of 500 to 1 while holding well-exposed detail above and below. Add a new "smart flash" with creative methods of making its beam blend imperceptibly with natural light, and scenes can be rendered beyond the 2000-to-1 range of good detail seen by our eyes.

But that's another book for sometime in the future, when I muster up the courage to will myself indoors for yet another extended period of confinement while my soul urges me to be out there in the magic of mountain light.

GALEN ROWELL
Berkeley, California
April 1995

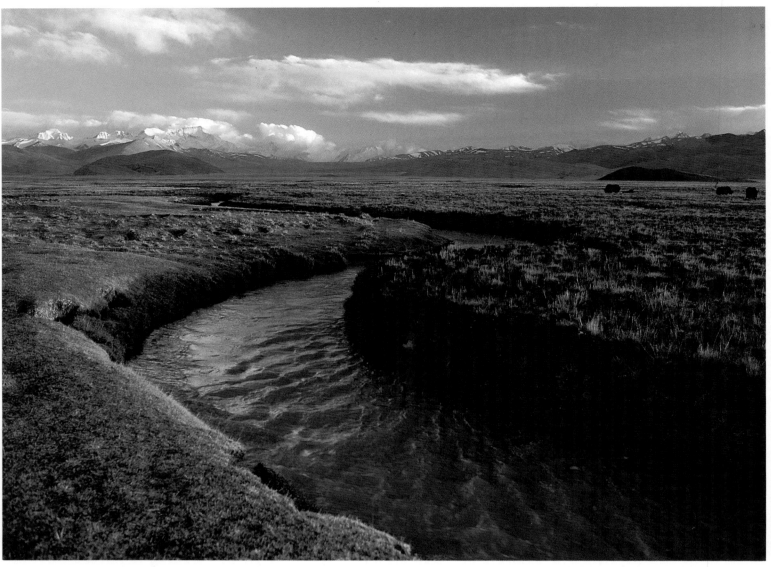

STREAM ON THE TINGRI PLAINS, TIBET

A CREDO FOR MOUNTAIN PHOTOGRAPHERS

The mountain photographer is interpreting the face of nature—that mysterious infinity, eternally a refuge, a reservoir, an amplifier of spirit; a mother of dreams; a positive though elusive voice in whose depth lies its subtlety. They will interpret best who are never so content as when under the influence of situations where silence is rich in the mute assurance and beauty of mountain surroundings. The quality of emotional knowing has a finer integration with our spirit than anything that comes from barren intellectual processes. This point of view only accumulates slowly, out of long experience and contact with wordless influences. Under the spell of solitude and of natural beauty the root system of this kind of awareness establishes itself. Great art is usually created under some such saturation of awareness. The work is then permeated with an inner perception of beauty and an inner personal philosophy. The hope for our photography is that it shall retain these high lights of more than beauty, that through it symbols shall be preserved of response to our mountains, keeping them to a flow, a golden thread, in our experience. CEDRIC WRIGHT, 1941

Preface

I began this book with a restless conscience. Beneath the desire to share my ideas about photography was a gnawing feeling that it had all been said before. What seemed reasonably unique, however, were some of my images.

At first I planned to avoid repeating known methodology by limiting myself to relating the stories behind a selection of my photographs, but friends insisted I include the more general development, philosophy, and methods of my work. With reluctance I took on this broader task, even though the idea of mixing my dreams and frustrations with nuts-and-bolts information did not inspire me. First drafts of early chapters lay unfinished for two years while my uneasiness worked itself out. I read books, attended seminars, and taught workshops in various parts of the country, presenting much of the material included here to working professionals and dedicated amateurs.

In the end the students decided the issue. I was greatly encouraged when they urged me to publish my workshop presentations in book form. Several professionals indicated that regardless of the number of individual parts of my methods they were previously acquainted with, the whole was unlike anything they had read or experienced before. As a result of their new awareness, they were able to predictably produce photos that they may have gotten earlier only by fortuitously doing the right thing at the right time.

Also, workshops taught me that the most powerful "instructors" are the photographs themselves, whether they are the selects of a professional's career or the telling rejects that most of us toss into the wastebasket with little more than a cursory glance. One of the biggest mistakes a photographer can make is to look at the real world and cling to the vain hope that next time his film will somehow bear a closer resemblance to it. By studying the images that didn't work, we can learn the language of a particular film and how to make it work in every possible way. If we limit our vision to the real world, we will forever be fighting on the minus side of things, working only to make our photographs equal to what we see out there, but no better.

Sometimes film and human imagination work together to produce truly remarkable images that are more powerful than reality. This is the plus side, and the resulting "additive" effects can be applied consistently only when a photographer understands how film sees the world. The clues are there to be seen in every one of the images, not in the abstract sense of how this particular type of film rendered that rock a certain way, but in the highly personal sense of how *his* photograph differs from what *his* eyes saw in a way he'll never forget.

This, then, is the major connection between the text in this book and the exhibits of photographs with their individual stories: together they explain how I create what I call "dynamic landscapes," photographs that combine a personal vision with splendid natural events. The results are images that depict landscapes not only as recognizable natural scenes, but also as what appear to be unrepeatable moments that evoke strong emotions. Creating such images involves methods that combine many kinds of thought and action that I describe in detail in the pages that follow.

Early in my career I might have given up photography entirely had it not been for an occasional image that far exceeded my expectations. Most of the time I had no idea what I had done right. Now I know that three separate elements must come together in the creation of such a photograph: technical proficiency, fine light, and an identifiable personal vision. The first can be learned. The second can be discovered with far more consistency than one might suppose. The third—the most elusive of all—is generally understood by everyone at an intuitive level, though it is not always easy to put into practice. Even a person who knows nothing about equipment or lighting has a definite feeling about whether a finished photograph is evocative or not.

The best photographs speak for themselves. Attempts to analyze their meanings invariably detract from the special quality that is beyond words in the first place. The photographs that move me the most propel me into an emotional realm where my experience is no longer verbal. I wince whenever I hear a photographer limit the effectiveness of his work by trying to express its meaning in words, and I cringe when I read photocriticism that authoritatively describes the vision that was in a particular photographer's mind at the moment the shutter was released on a day long forgotten in the nineteenth century. Therefore, in this book I tell how each photograph came about and I do not attempt to discuss what any given photograph means to me personally except as it relates to my discovery of the situation and my rendering of it on film. In retrospect I am especially thankful I do avoid such discussions, because even in the short time since I began the book I have seen my work change in ways I could not have anticipated.

When I first conceived the idea for this book I had not had a major gallery show. My

work had been limited mostly to editorial uses, advertising, and audiovisual presentations. Used in those ways, the photographs were tied to external purposes in order to illustrate a place, an adventure, a product, or a mood. These limitations vanished after I had three major shows in a single month in 1983. Images that I had formerly associated with particular places and times took on isolated, fanciful qualities on gallery walls. Visitors saw far beyond what had been previously reproduced on a printed page. Removed from the context of its original purpose, each photograph became more expressive of my intentions than of subject matter. Similarly, it will be seen in this presentation that the images are illustrations of the possibilities of photography rather than studies of place and mood.

For this book I have chosen eighty of my favorite images and have divided them into eight "exhibits" according to visual content rather than location or subject. In "Light Against Light," for example, there is the merging of different colors of light in landscapes of California, Canada, China, Tibet, Pakistan, and Nepal.

These exhibits of images and the explanations of their making alternate throughout the book with chapters on photographic technique. Thus, I combine my original idea of relating the stories behind the photographs with the larger task of describing how I have developed an organized approach to photographing wild places. I hope this combination of exhibits and explanation will enable my readers to come exploring with me and to discover, as I have, how to make the three-dimensional world come alive within the two dimensions of film.

GALEN ROWELL
Berkeley, California
August 1985

EXHIBIT I
Magic Hour

Twice each day the cool, blue light of night interacts with the warm tones of daylight. Luckily for color photographers, these events, though predictable, are not consistent. For a full hour at either end of the day colors of light mix together in endless combinations, as if someone in the sky were shaking a kaleidoscope. This effect takes place, not directly where the sun rises or sets, but where the sun's rays beam warm, direct light onto parts of the land and sky that are also lit by the cool, reflected light of evening.

The most interesting parts of the natural world are the edges, places where ocean meets land, meadow meets forest, timberline touches the heights. These geographical edges excite scientists in much the same way that edges of light fascinate me. Near the end of the day, transmitted light becomes ever warmer, reflected light ever colder. I look for this visual edge, especially where it is emphasized against clouds and other light backgrounds. In fact, my favorite way to photograph a geographical edge is to make it converge with a visual edge of light that will underscore the difference between the two zones.

Most amateur photographers think of landscapes simply as objects to be photographed. They tend to forget that they are never photographing an object, but rather light itself. Where there is no light, they will have no picture; where there is remarkable light, they *may* have a remarkable picture. When the magic hour arrives, my thoughts center on light rather than on the landscape. I search for perfect light, then hunt for something earthbound to match it with. The best images that result from this process look like visual riddles with unexpected answers; and like verbal riddles, visual riddles have been created by starting with the answers then working backward.

When the light is right and everything is working for me, I feel as tense as when making a difficult maneuver high on a mountain. A minute—and sometimes mere seconds —can make the difference between a superb image and a mundane one.

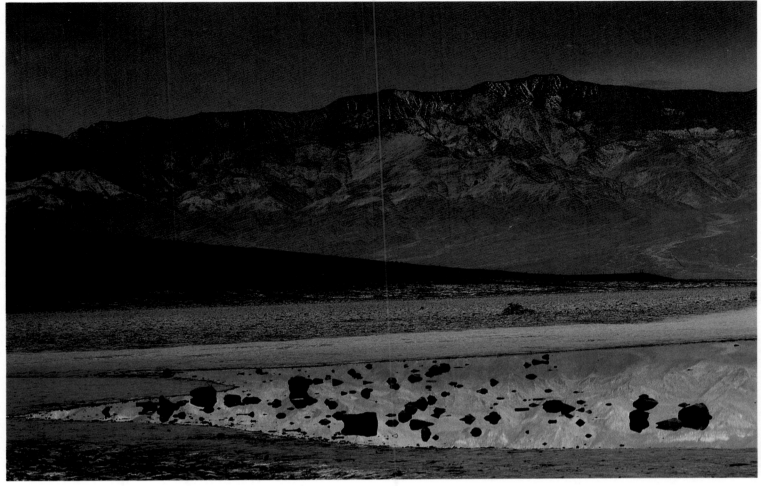

DAWN, DEATH VALLEY, CALIFORNIA

DAWN, DEATH VALLEY, CALIFORNIA; 1984

When I camped in Death Valley, en route to Nevada, I had a very different image in mind than this one. On a clear morning in Death Valley, every landform turns to fire at the sun's first light. I awoke and carried my cameras to Zabriskie Point in order to photograph what I expected to be a wildly colored panorama at dawn. It had rained during the night, however, and the fabled light never came. Clouds blocked the sun to the east, but to the west the clouds were breaking up.

I was bound for Las Vegas, but instead of continuing beyond Zabriskie Point, I turned around on a hunch and drove to the lowest point in the United States, Badwater. There, at 282 feet below sea level, an incongruous pool of water with a bluish cast reflected from the stormy sky lay on the desert floor surrounded by alkali. Just as I arrived, a band of soft pink light broke through the clouds onto Telescope Peak, the 11,049-foot-high point of the Panamint Range. One of the largest escarp-

ments in the United States, it is completely open and treeless, with its bones exposed to the sky. I love photographing arid country because vegetation doesn't hide the earth's contours.

At first the scene appeared very jumbled to me, and I walked to the water's edge to try to simplify it into a reflection of the Panamints in the pool. That didn't work because the light was too weak to give the image a strong impact. After shooting a few frames, I returned to my car. Before driving away, I looked again, got back out, and set my tripod up by the rear bumper. The zones that had at first seemed so jumbled now converged in strong diagonals that I was able to compose by moving my camera position back and forth. I worked to integrate three prominent zones: the water pointing left, the black ridge pointing right, and the bank of pink light on the peaks pointing left again.

The palette of colors was wonderfully delicate, but I discovered by using a telephoto on my Nikon F3 in the manner of a spot meter that the background was far too bright to allow the fine hues

in the foreground to come through. Because color films hold a much narrower range of brightness than that which the human eye can see, even a very experienced photographer may have trouble judging exposures in scenes that he has not photographed previously.

After I found that the range of tones was too broad to hold on Kodachrome, I put a two-stop split neutral-density filter over my lens to darken the upper part of the scene. The upper part of the filter is darkened and gradates into clear glass on the lower part. By placing the area of transition from dark to light across the most strongly shadowed part of the image, the transition was virtually unnoticeable. These filters leave obvious lines across continuous-tone areas such as snow or sky, but in situations like this one they appear invisible and can save the day.

TECHNICAL DATA *Nikon F3 with 55mm lens; Kodachrome 25; split neutral-density filter.*

WINTER SUNRISE ON A BRISTLECONE PINE, WHITE MOUNTAINS, CALIFORNIA; 1974

On the fifteenth day of a ski traverse along the crest of the White Mountains, we began descending almost imperceptibly toward timberline. Four of us had just weathered the most severe storm of the season during an attempt to make the first winter traverse of the range. We cruised over treeless highlands, then suddenly entered an open forest clothed in white.

There was the Patriarch Grove of bristlecone pines, then considered the world's oldest living things. (Scientists now claim that certain creosote bushes are older; they, however, survive by cloning rather than by the aging of single organisms.) We spent the afternoon in wonder, skiing through the trees and taking photographs. I carried a Nikkormat FTN with four lenses, and I used my ski poles, with straps interlocked, instead of a tripod to support my camera. Those afternoon images were fine; nevertheless, I envisioned something far better for the morning.

As leader of the group, I chose our final campsite of the trip, not so much for the slight protection it afforded from the relentless winds as for its proximity to a photo situation I had scouted.

Knowing that a nearly full moon would be hanging in the western sky at dawn, I wanted to find a photogenic tree, thereby enabling me to get the moon, alpenglow on the tree, and the High Sierra in the distance.

The only tree that filled the bill was at the edge of the grove directly on the crest of the range. All the limbs that reached above the horizon were dead and formed an exceptionally strong pattern, while the few live ones were low and out of the field of dawn light. I had been careful not to make ski tracks on the west side of the tree; then I suddenly realized that the telephone poles bringing power to a University of California high-altitude research lab were directly in my field of view. Although I almost gave up on the scene, in the end I convinced myself that it was enough better than any alternative to make me accept the poles. I hoped that I would be able to shoot the image before direct light struck them and made them quite obvious, but I also wanted light to creep down the trunk as far as possible, and its base was slightly in the shadow of the crest.

The morning dawned clear and still; the temperature was well below zero degrees Fahrenheit. While the others slept in, waiting for rays of the sun to warm the tent, I snuck out, put on my skis, and set out for the special tree. Well before the sun came up, I found a position where my shadow wouldn't intrude and waited, shivering from inactivity. I used a 35mm lens with slow ASA 25 film, which I knew would bring the shutter speed down dangerously low when I closed down the aperture to maintain enough depth of field to hold both the tree and the distant mountains in focus.

Then came the light. I cradled the camera in my makeshift bipod of crossed ski poles, then bracketed a number of images both to get the best exposure and to get the best overall sharpness through a compromise of shutter speed and depth of field. I was uncertain how slow to set the shutter speed and still count on holding the camera in the ski poles with cold hands, but I was reasonably certain that at 1/15 second with a 35mm lens I would have a sharp image. If I shot at 1/8 second, for example, I got better depth of field to hold sharpness in the distance but increased the odds of overall fuzziness because of camera movement.

TECHNICAL DATA *Nikkormat FTN with 35mm lens; Kodachrome II (ASA 25); small aperture for maximum depth of field.*

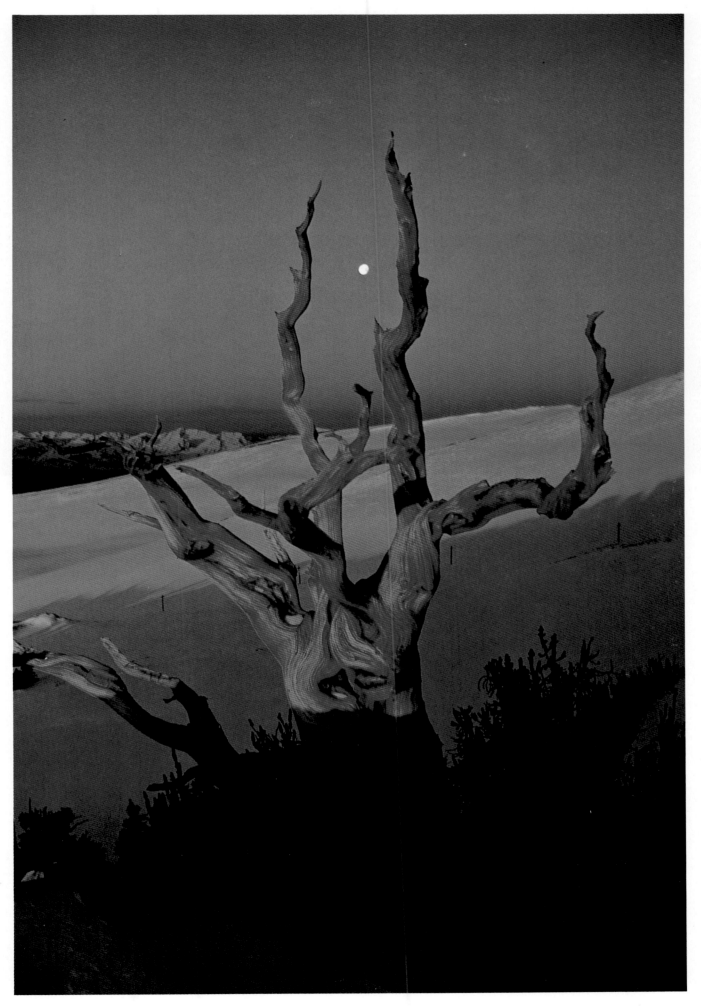

WINTER SUNRISE ON A BRISTLECONE PINE, WHITE MOUNTAINS, CALIFORNIA

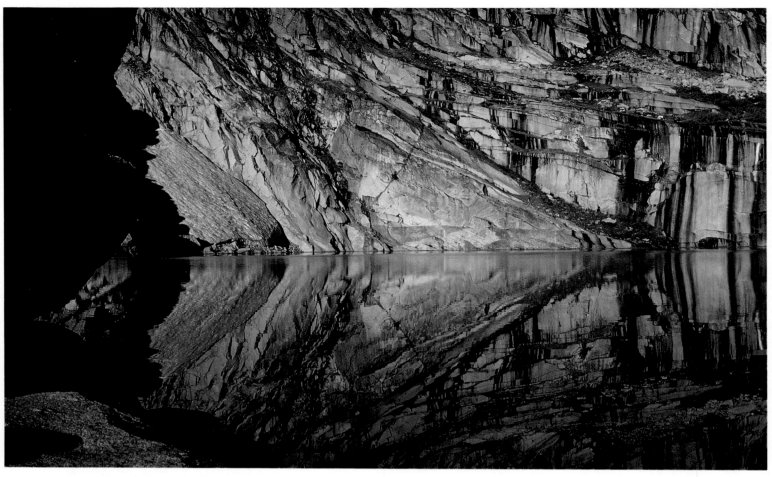

BIG BIRD LAKE, SEQUOIA NATIONAL PARK, CALIFORNIA

BIG BIRD LAKE, SEQUOIA NATIONAL PARK, CALIFORNIA; 1970

In the mid-sixties I learned the trade of first ascents from Fred Beckey, America's most ubiquitous climber. As he began to run out of climbing objectives that were pictured in books and journals, he switched to U.S.G.S. maps and became a master at locating virgin climbs in remote areas by the shape of their contour lines. In Beckey's tow I did new climbs in Utah, Wyoming, and Canada, as well as in the High Sierra in my home state of California. As photography took on a major role in my life, I began to favor explorations into new areas rather than repetitive trips to the fine climbs of Yosemite Valley.

In the late sixties I wallpapered a large basement room in my home with dozens of interlocking topo maps of the High Sierra. In the Beckey tradition I looked for coagulations of large numbers of contour lines that denote sheer cliffs, then set off to climb them. In late September of 1970, I enlisted Chris Jones and Greg Henzie to join me for a week's outing in a remote part of Sequoia National Park. On the map I had detected steep unclimbed faces on two obscure, unnamed mountains: Peak 11,598 and Peak 11,830. For a base camp I had chosen the only nearby feature with a name, Big Bird Lake.

We arrived one afternoon at an alpine lake of stunning beauty. Granite buttresses that exceeded my expectations rose out of the water like ships' prows. I made some standard images with the lake's ocean blue waters at the base of the mountain skyline, but they were lacking in creative zest. What struck me about the lake was the way cliffs dropped into it on the western side, while the eastern edge was flat, treeless, and perfectly open to morning light.

The next day we set off early and managed to complete both climbs. I had a chance to observe the sunrise from a distance and saw that it might be better from the edge of the lake. On the following morning I got up and waited for the sunrise, and for light to work its way down just to the lake's edge. I knew that if the light went a little bit

EXHIBIT I MAGIC HOUR 9

too far, it would erase the reflection, and if it didn't go far enough, it would interrupt the clean pattern I was after.

At this stage in my career, I had not yet done any preassigned photography. I still supported myself mainly by a small automotive business, and I rationed my film carefully. I allowed myself just one shot of the lake at dawn, handheld with a 105mm lens. Only after I saw the processed slide did I have any inkling that the idea for the photograph was not entirely my own.

My composition bears too much resemblance to Ansel Adams's "Frozen Lake and Cliffs, 1932" to be coincidence, especially since Adams's image has always been a great favorite of mine. Both photographs share an unusual telephoto view across a lake without a horizon, a patch of inclined snow on the left, and a strong overall pattern created by a cliff that rises directly out of the water. Adams's lake, although different, is in the remote back-country of the same national park.

I felt so uncomfortable with the notion that I had borrowed subject matter from Ansel Adams, that I did not include the image with submissions of my best work until 1982. During that year, I happened to read *Double Take*, a book by Richard Whelan that consists entirely of pairs of similar images by well-known photographers. It begins with the following observation:

"Anyone who knows Ansel Adams's great photograph of the ruined pueblos in the Canyon de Chelly in Arizona is likely to experience a dislocating sense of *déjà vu* when he first stumbles on Timothy O'Sullivan's [1873] photograph of the same ruins. . . . Was it an extraordinary coincidence that two great photographers happened to photograph the same ruins? After the initial surprise has worn off, the viewer will surely perceive how dissimilar the two photographs really are, despite the identity of the subject. . . . Each photograph will seem more integrally tied to the creative process than it did before the discovery of its double."

Adams himself wrote that O'Sullivan's work had "opened a wide new world" for him, and he singled out the image of Canyon de Chelly as "O'Sullivan's finest photograph . . . an image of great power and revelation." I have much the same response to Adams's image of a frozen lake at Kaweah Gap. It opened up a new way of seeing for me, and I had no intention of pursuing an exact replication. When I photographed Big Bird Lake with a fine reflective surface on the water,

I intuitively broke traditional rules of composition and split my image fifty-fifty to strengthen the patterns and emphasize the similarity between the two halves of my image.

TECHNICAL DATA *Nikkormat FTN with 105mm lens; Kodachrome II (ASA 25).*

VERMILION LAKES, CANADIAN ROCKIES; 1980

Expecting deep snows and subzero temperatures, I packed my skis and cameras when I traveled to Banff in January to give a lecture at a symposium. Knowing that my visit coincided with a full moon, I hoped to do some night photography. When I arrived, I was very disappointed to find cloudy skies, little snow, and lots of mud and slush, as if spring had arrived in January.

When I followed four coyotes to the edge of Vermilion Lakes near town, I noticed contrasting patterns on the lake's surface where open water, ice, and pools of water on top of the ice intersected. Even with a backdrop of distant peaks, the patterns did not seem worth photographing by themselves. The next morning before dawn I saw the full moon from my hotel window and rushed out to my car. Without much success I drove around trying to match the moon with the landscape. The sparse, grubby snow just didn't lend itself to such an image.

Then I remembered the lake and drove to its edge. As sunrise flushed both a cloudbank and the high peaks with pink, I took readings through my through-the-lens meter. I found a difference in exposure between the shadowy surface of the lake and the sunlit horizon that would wipe out virtually all foreground detail if I exposed for rich colors in the highlights. At first I thought about long telephotos of just the mountains, moon, and clouds, but I knew that what I really liked about the scene was the juxtaposition of those with the patterns on the lake.

Setting up my tripod, I tried several lenses and settled on a 55mm. Composing the image so as to use my split neutral-density filter to maximum effect (the upper part is darkened to hold back two stops of light, whereas the lower part gradates into clear glass), I bracketed several exposures and positions of the split between light and dark so that it would coincide with the horizon and not be visible in the finished image.

TECHNICAL DATA *Nikon FM with 55mm lens; Kodachrome 25; split neutral-density filter.*

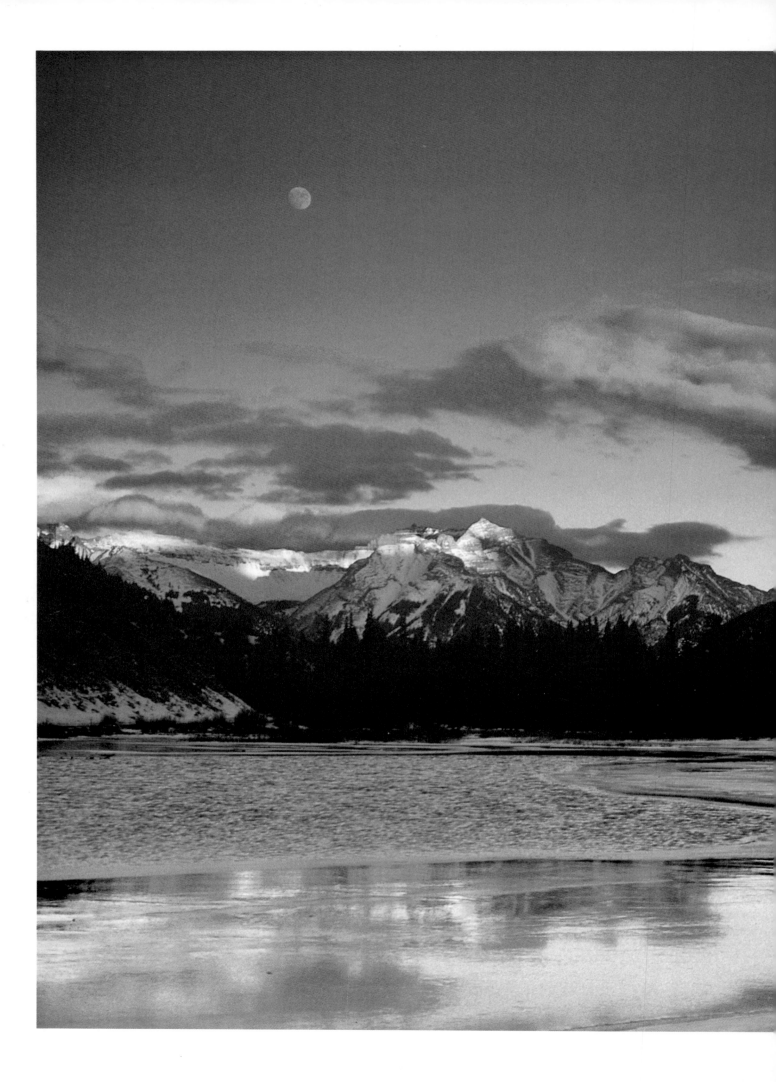

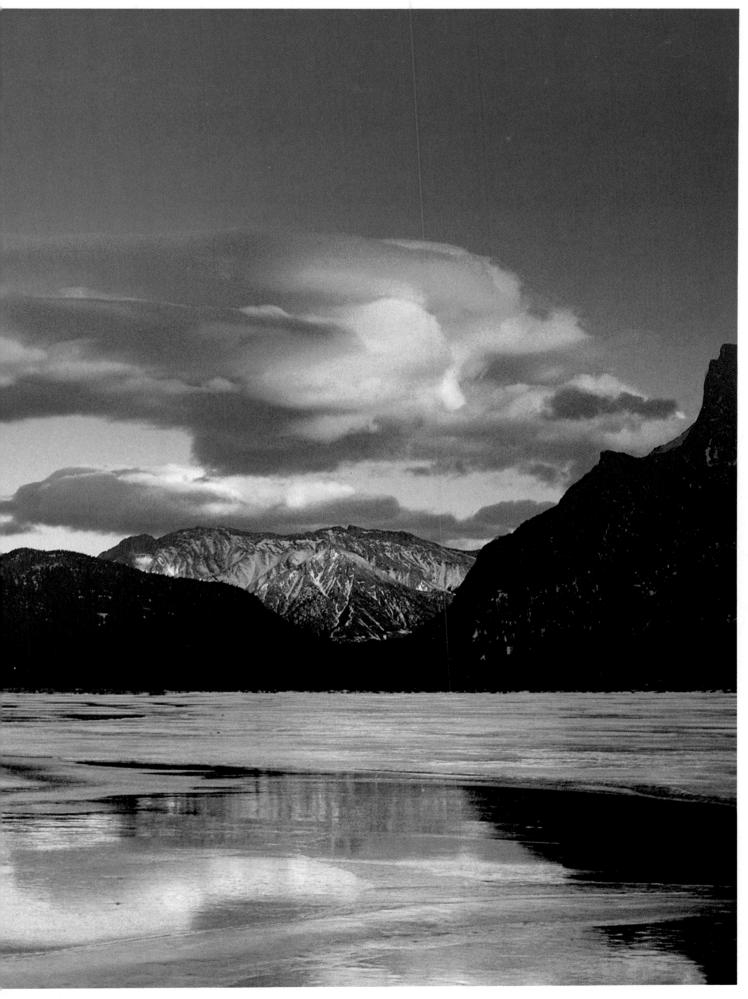

VERMILION LAKES, CANADIAN ROCKIES

WINTER IN THE PATRIARCH GROVE,
WHITE MOUNTAINS, CALIFORNIA; 1974

As mentioned earlier, in February 1974 I took part in the first winter traverse of the White Mountains. Four of us spent sixteen days skiing along the crest of that little-known range at an average of more than 12,000 feet. Although the White Mountains rise to 14,246 feet, the same order of magnitude as the High Sierra and the Rockies, they are not nearly as well known or as inundated with visitors. These arid mountains have no lakes, few fishing streams, and miles of treeless highlands.

A first-time visitor to the Whites is easily fooled into thinking that he has come to timberline at just 9,000 feet. There the typical Great Basin forest of pinyon pine and juniper ends. From many vantage points it is hard to see the isolated band of scattered trees far above, where bristlecone pines grow at elevations between 10,000 and 11,500 feet.

Bristlecone pines make such ideal photographic subjects that I have included several images of them in this book. In general I don't like photographs of forests because they so often seem to be contrived. The photographer's eye can give wonderfully random arrangements of trees an appearance of openness and order that just isn't there. The alternative—a cluttered, busy photograph—is even worse. My early attempts to show whole bristlecone forests fell into those two categories. My images of single trees came out fine because bristlecones are such isolated trees, but my attempts to capture the feel of the bristlecone forest were defeated by the very lack of consistent pattern that makes a visit to the bristlecones such a mystical experience.

I had in mind something unique and wanted to avoid the cliché of picturing a bunch of trees marching off into the distance in classic symmetry as if they were Greek ruins instead of wonderfully random living things. When I first spotted this tree, with its unusually heavy and twisted limb, my inclination was to circle it and find the best possible camera angle. I fought the urge because I knew I would put tracks in the snow directly in my field of view. I studied the situation and tried to reason out both my physical and photographic approach to it.

I knew I wanted to use a polarizer to purify the tones of the wood by cutting surface reflections and scattered blue light from the sky. A polarizer would also darken the sky so that the tree would stand out and my viewer's eye would be naturally drawn to the highlights in the twisted wood. Since a polarizer has its maximum effect on the sky at ninety degrees off axis with the sun, I had two possible angles of approach. In this case my choice was obvious because one side emphasized the big limb, while the other didn't.

Now I knew from which direction to approach the tree, and as I moved closer, the three-dimensional feel of the twisted limbs became ever greater. I put on my widest 24mm lens to emphasize the limb itself, then took a step back because I did not want to single out the limb against the sky. I needed the limb in context with the trunk, the ground, and the surrounding open forest. By placing the trunk at the extreme left, I emphasized the limb, but the composition didn't come together until I hit on the idea of using the curve of the limb to frame and emphasize trees in the distance. With my ski poles crossed and the straps interlocked to form a support for my camera, I made this image in early evening light just as the sunlight began to take on warm hues.

The next day was the last of our trip. We skied past the Methuselah Tree, forty-six hundred years old, en route to Westguard Pass, where the White and Inyo mountains merge together. I became so fascinated by the bristlecone pines that immediately after the trip I began research for an article on them that appeared in the September 1974 issue of *Sierra* magazine. My best source for information on the White Mountains was a friend, Doug Powell, who spent half the year teaching geography at the University of California in my hometown of Berkeley and the other half skiing mountain passes for state snow surveys. He had written a thesis on the Whites, and in addition he had precise memories of significant human events regarding the trees.

Doug told me of the time he sat around a campfire with a scientist named Edmund Schulman on a cool September evening in the 1950s. As the two men warmed their hands, Schulman pulled a branch from the fire and examined it closely: "1277 to 1283 A.D.," Doug heard him say. "This six-year ring pattern never repeats itself." Because of his intensive work with tree-ring dating, Schulman had spontaneously recognized the relative ring widths of annual growth rings that signified an ancient drought. When he finished studying the flame-blackened pattern, he tossed the wood back into the fire. It burned long and hot and even.

Not long after that Schulman became famous for his discovery that bristlecones are the oldest

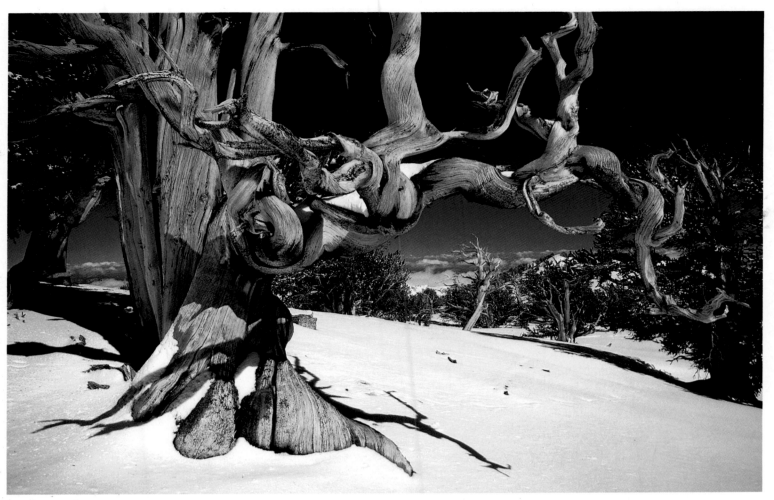

WINTER IN THE PATRIARCH GROVE, WHITE MOUNTAINS, CALIFORNIA

known living things in the world (it is now claimed that certain creosote bushes are older). He never enjoyed his fame, however; he died before the publication of his most important work. History remembers Schulman as a practical scientist who proved with numbers and graphs that some bristlecones of the White Mountains are more than four thousand years old. My friend remembers Schulman as a man who lived in the wilderness of logic, seeking patterns in what appeared to be randomness—a man whose thoughts often wandered along loosely structured, mystical pathways. Already ill with heart disease in his forties, Schulman could not have failed to note the contrast between the bristlecones and his own tenuous claim on life.

Even in his wildest dreams, however, Schulman never imagined the far-reaching effects of his discovery: that the twisted trees of the White Mountains would bring about a revolution in the study of Old World prehistory. Archaeologists used to date Neolithic European artifacts by the carbon-14 method, while dating Egyptian artifacts by "king's lists" found in tombs that mentioned precisely datable astronomical events.

Schulman's tree-ring dates of bristlecones disagreed with carbon-14 datings of the same wood by as much as a thousand years, and that little skirmish was not resolved during his lifetime. Later, however, scientists concluded that carbon-14 production in the atmosphere had not been constant. A bristlecone-corrected carbon-14 dating system came into being and proved that certain artifacts of European culture were actually older than their supposed Mediterranean progenitors. Thus, the theory of cultural diffusion, which held that European culture was derived from the "cradle of civilization" in Egypt and Mesopotamia, was no longer valid.

As we skied through the White Mountains two decades after Schulman, it seemed a sacrilege even to hang our sleeping bags to dry on these old trees.

TECHNICAL DATA *Nikkormat FTN with 24mm lens; polarizing filter.*

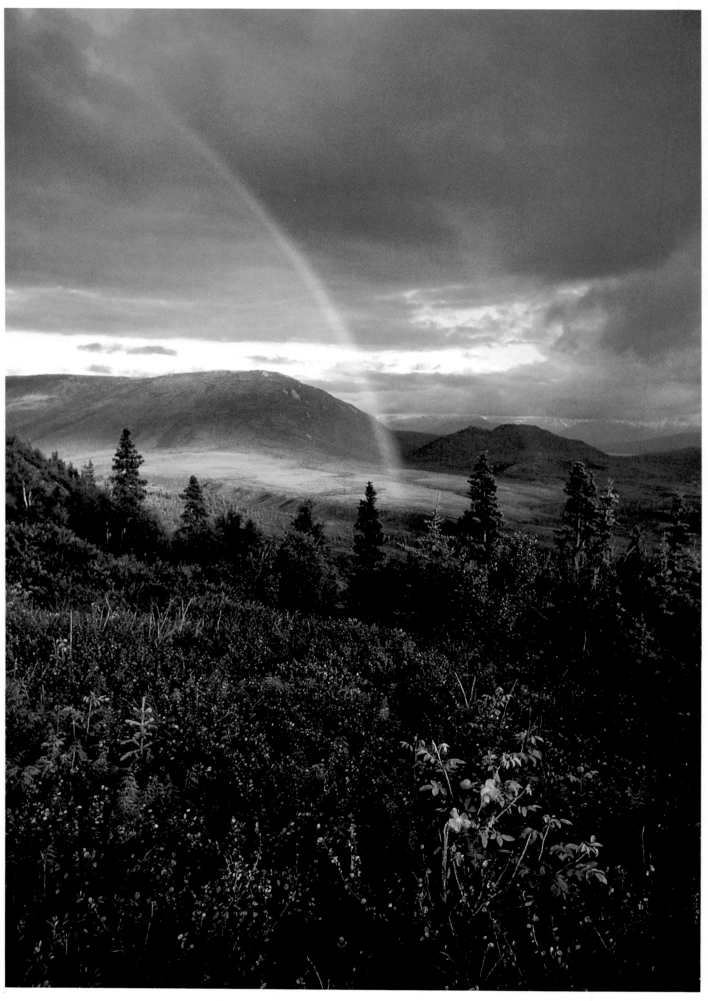

RAINBOW AND WILD ROSE, DENALI (MCKINLEY) NATIONAL PARK, ALASKA

EXHIBIT I MAGIC HOUR 15

RAINBOW AND WILD ROSE, DENALI
(MCKINLEY) NATIONAL PARK, ALASKA; 1979

Rainbows are most commonly seen during
magic hours because of their optical geometry.
They form a halo around the antisolar point,
the place directly opposite the sun. Because the
primary arc of a rainbow lies in a forty-two-degree
radius around this point, it is not visible above the
horizon unless the sun itself is low in the sky. A
full display of a rainbow commonly occurs min-
utes before sunset when the sun pops out under a
layer of clouds after a storm to illuminate falling
rain in the distance.

Unfortunately dinners also commonly occur
during the same part of magic hour. In this case the
Alaska Wildlife Safari tour group I was leading
was called to the Camp Denali dining room just as
the rainbow reached its maximum intensity. I had
already taken several photos of the rainbow, as
had other members of the group; but when dinner
and a downpour began almost simultaneously, I
found myself quite alone outside. I searched for a
subject to balance with the rainbow in order to
provide a sense of action in the foreground that
would lead a viewer's eye through the image. I
chose the wild rose partly because I could tilt my
wide-angle lens down and keep raindrops off its
surface. (For extensive wet-weather photography,
an umbrella, with a hook to attach it to a tripod,
is a most useful accessory.)

My principal problem was in making the rose
large enough in the frame to provide a counter-
point to the rainbow. Before composing the
image, I set my lens for its maximum hyperfocal
distance (a setting between the two extremes of
depth of field marked on a lens for any particular
aperture). In this case I had a 24mm lens, which I
set on its smallest aperture, f/16. The color-coded
markings for f/16 indicate a range of sharpness at
that aperture for an eight-by-ten-inch enlargement
viewed at a normal distance. I am not satisfied with
this minimal clarity, so I used the next set of mark-
ings (in this case for f/11). Setting infinity opposite
one color mark put the other mark at 2.9 feet.
At that point my lens was set at hyperfocal dis-
tance, and I knew that I could put the rose at 2.9
feet and still hold the rainbow in sharp focus.

All factors were then under control except
shutter speed. Everything I had done to maximize
depth of field had decreased my shutter speed. To
make things worse, I was using a polarizer to pull
more color saturation out of an already dark sub-
ject in evening light. As I recall, the meter read

about 1/2 second with ASA 64 film, and I brack-
eted two longer exposures to compensate for
slight loss of film speed caused by reciprocity ef-
fect (which is explained in Chapters 3 and 6).

My dinner was cold.

TECHNICAL DATA *Nikon FM with 24mm lens;
Kodachrome 64; hyperfocal distance at f/16 for
maximum depth of field.*

ALPENGLOW ON MOUNT WHITNEY,
CALIFORNIA; 1976

In the late sixties and early seventies I made
about seventy-five new climbs in the High Sierra.
Often a trip to do one virgin face in a very remote
area would result in a glimpse of five others to put
on my list. I was, of course, not the only one in-
volved in this "golden age" of technical climbing in
the Sierra high country, and by the mid-seventies
my list of objectives had dwindled considerably.

In 1975 I went on my first Himalayan expedi-
tion, and when I got home, I began to read the
writings of Eric Shipton as background for a book
I wanted to write. I found a quote that made me
rethink my emphasis on virgin walls:

"I welcome wholeheartedly the advance of
modern techniques because it has widened the
bounds of mountain adventure. There was a time,
long ago, when I was oppressed by the thought
that soon there would be no peaks to climb and no
new routes to explore. But the more I travelled in
the remoter ranges . . . the more I realized how
vast is the field of fresh endeavor. . . . With the
application of these new climbing and survival
techniques, the horizon is truly boundless."

The two sheerest walls on the High Sierra crest
had been climbed years before by parties led by
my friend Warren Harding, the first climber to do
the face of El Capitan. In 1959 and 1960 he had
approached those two Sierra climbs in a similar
fashion, using many days and many direct-climb-
ing aids to make the ascents. In 1972 I returned
with Harding to one of those routes, the eighteen-
hundred-foot East Face of Keeler Needle, a satellite
of Mount Whitney. Our first winter ascent was
only the second ascent of the face.

In 1976 I made a similar first winter climb of the
other face, the West Face of Mount Conness.
Afterwards, Chris Vandiver asked me if with mod-
ern techniques either of those walls could be

climbed without direct aid. I wasn't sure. Vandiver was one of the very best Yosemite free-climbers, and in June 1976 we managed to free-climb the Conness face by the skin of our teeth. (Free-climbing means upward progress unsupported by mechanical aids, but with a rope and hardware used for safety in much the same way acrobats use nets for safety—but not as direct supports. Free-solo-climbing implies no mechanical aids, no rope, alone.)

In August Vandiver and I tried Keeler Needle with Gordon Wiltsie, a climber-photographer from Bishop, California. We were stopped just a couple of hundred feet above the base by difficulties combined with an unusually chilly wind. That night we camped in a cave that was in the center of a cirque below the east faces of Keeler and Mount Whitney.

Dawn brought the most vivid alpenglow I had ever seen, and both Gordon and I scrambled for our cameras. I don't understand why alpenglow is often exceptionally bright when it comes between cloud layers in stormy weather. It is especially confusing since clouds normally cool the rays of sunlight rather than warm them the way smoke or dust in the air does (see Chapter 5). I do know that Mount Whitney is an exceptional location for alpenglow on any morning when there is direct sunlight from the east at dawn. Because of the curvature of the earth, light rays that first hit Whitney's eastern ramparts have almost kissed the horizon far away in Nevada. Miles and miles of Great Basin highlands provide so much disturbed atmosphere for the sun's rays that nearly all the blue rays are scattered before reaching Whitney, the highest peak in the contiguous states. As the sun rises in the sky, its rays no longer travel so close to the ground, and within minutes the vivid red of alpenglow gives way to the more normal yellow light of early morning.

To make this photograph, I simply stuck my camera with a 24mm lens and skylight filter out of the cave and braced it on a rock. Gordon made a quite similar one that has also been published. Moments later the sun went behind a cloud and snowflakes began to fall on us in August. We gave up the idea of climbing Keeler Needle that day, but we had to wait for enough of a break in the weather to recover the ropes and hardware we had left on the beginning of the climb.

As we lay in our sleeping bags, voices wafted out of the mist from the East Face route on Mount Whitney, a much easier pioneer rock climb that was first made in 1931. Two climbers we had seen on the trail were up there in the storm. We knew that they were heavily laden with enough gear to wait out a two-day storm if they had to. At noon, when the storm showed no sign of abating, Gordon and I headed up on the needle to retrieve our equipment. As we were doing so, Gordon mentioned that he had never done the Whitney face and would like to do it some day. I had climbed the face several times and felt a strong attraction to it right then after seeing it in wild light and after failing on Keeler Needle.

"How about now?" I asked, turning to Gordon.

"You're kidding! It's 2:30 in the afternoon, and it's snowing."

"No, I'm serious. If we climb unroped with no extra gear, we can stay warm and be up and down with lots of time to spare today."

Just then the voices came again. The other climbers were still on the route after eight hours, slowed by their own encumbrances. Gordon decided to go for it with me, but Chris declined because he had just done a harder route on the same face a few weeks earlier.

As we began the climb, Gordon had mixed emotions; he was enjoying the freedom of climbing unencumbered but missing the security of a rope. Since the route was well within our ability levels, we quickly adjusted to the lack of a rope by increasing our attention to potentially loose rock and by placing our fingers and toes with far more conscious care than when backed up by the "umbilical" rope. In many ways a safety rope is like a seat belt; it functions only after you've gotten yourself into trouble. While I find a rope absolutely necessary on climbs that are near my ability level, I believe that moving light and fast on easier terrain can be a safety factor in its own right.

Just below the top we caught up with the other two climbers, who were draped with gear like models in a mountaineering catalog. Seeing that we were unroped and wearing only sweaters, they asked if we had climbed to the top by the horse trail then scrambled over the edge for a look. When it came out that we had left the lake below the face just an hour and 45 minutes earlier, they expressed amazement. We, however, did not think our speed was so remarkable. The 1931 first-ascent party—four men wearing tennis shoes—had climbed the face in 3 hours and 15 minutes, unroped much of the way. Their leader was Robert L. M. Underhill, a famous figure in American climbing history who introduced the proper use of

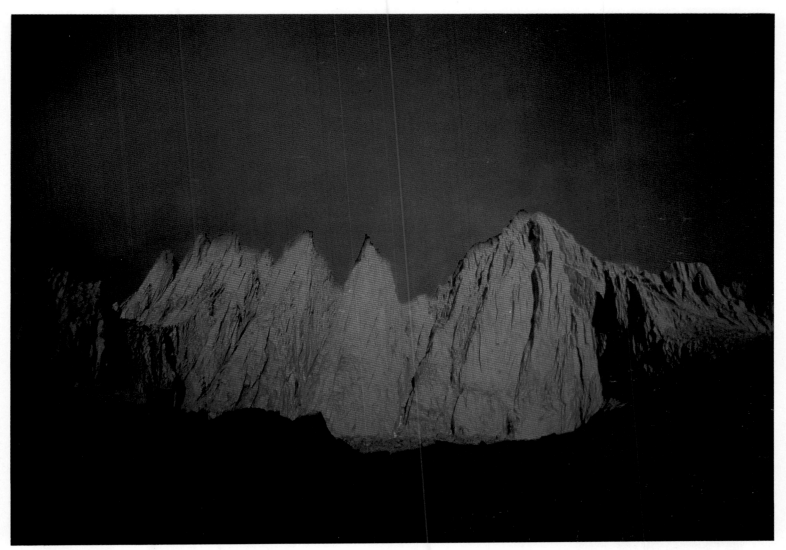

ALPENGLOW ON MOUNT WHITNEY, CALIFORNIA

ropes and pitons to both the Grand Tetons and the Sierra. In his account of that Whitney ascent, Underhill predicted, "I believe a good climbing party that knew the route could ascend in something like half the time we required." By his standard we were 7½ minutes slow.

Three weeks later we returned to Keeler Needle and succeeded in free-climbing it in calm, clear weather. Alpenglow flushed the East Face of Mount Whitney twice during our climb, but never with the deep crimson color we had seen on that stormy morning. On many repeat visits to Whitney I have not seen the equal of that intense phenomenon.

TECHNICAL DATA *Nikkormat FTN with 24mm lens; Kodachrome 25.*

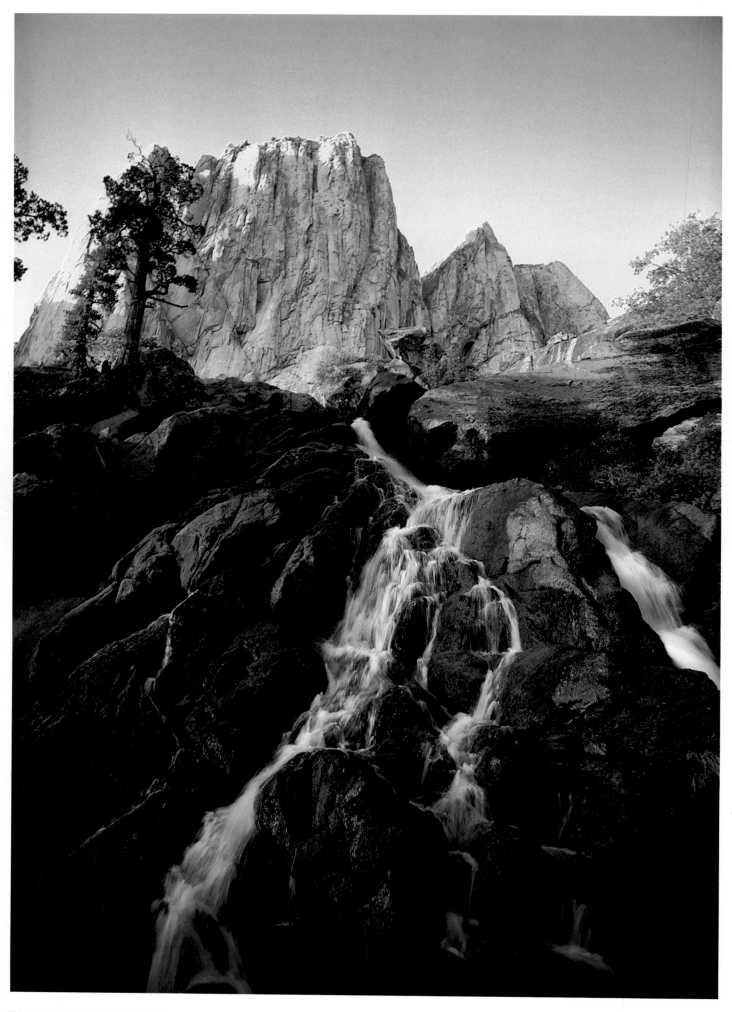

HAMILTON CREEK AND ANGEL WINGS, SEQUOIA NATIONAL PARK, CALIFORNIA

EXHIBIT I MAGIC HOUR 19

HAMILTON CREEK AND ANGEL WINGS,
SEQUOIA NATIONAL PARK, CALIFORNIA; 1978

The story of this photograph is a continuation
of the preceding Mount Whitney account. In 1978
Chris Vandiver and I hiked sixteen miles into
Sequoia National Park to a remote cliff called
Angel Wings, hoping to make the first free-climb
of its two-thousand-foot face. We expected to
bivouac somewhere in the middle, and our packs
were laden with food for five days, ropes, hard-
ware, and camera gear.

I had a Nikon FM with 24mm, 35mm, 105mm,
and 200mm lenses (now I prefer to take a light
75-150 f/3.5 Nikon zoom lens, which wasn't avail-
able then, instead of the two telephotos). At first
Chris walked at a very brisk pace, but he slowed
down and stopped frequently as we neared our
destination, complaining that something was
pulled in his leg. He wasn't sure if he could go on
the climb, but we decided to continue to the base,
camp there, and see how he felt in the morning.

On a previous trip I had made some photos of a
waterfall on Hamilton Creek with Angel Wings
in the background. Knowing that spot was directly
ahead on the trail, I hastened to it and waited for
the deep color of the last rays of the day to make
it come alive. Because I didn't have a tripod, I
would have to handhold an exposure slow enough
to make the water silky and provide depth of field
that would hold everything in focus. I knew that
1/15 second worked well for cascading water so
long as it wasn't too close to the lens, so I planned
to use that speed and bracket apertures around f/11.

In order to decide on a lens, I thought out the
scene in terms of a number of compromises. No
obvious composition struck me, but I knew that I
couldn't vary much from a level horizon without
tilting the trees in the upper right so much that
they looked disturbing. I wanted to have a pleas-
ing, random-looking order to the image, so first I
tried my 35mm f/1.4 lens, but found it unsatis-
factory because in order to get both the waterfall
and the distant cliffs in focus I would have to use
f/22, an aperture that the lens didn't have. Even if
I had been carrying a 35mm lens with such an
aperture, I couldn't have handheld a sharp image
at the slow speed it would have required.

With my 24mm lens I could shoot at 1/15 second
even though it was pushing the limits of handheld
sharpness. Since I had no place to brace in tall
brush, I held my breath and made more than one
image at each aperture to ensure that I would get
one perfect one.

My starting out with an f/1.4 lens in low light,
then shifting to a wider f/2.8 lens, underscores my
overall experience in trying to use fast, heavy
lenses for landscape photography. In theory it
sounds better to have, say, an f/1.4 lens instead of
an f/2.8 for low light, but in practice I rarely make
a decent landscape image at less than f/5.6 because
of the need for depth of field; therefore, I almost
never have the need for a fast lens unless I am
photographing action.

Chris and I camped not far from the site of this
photograph, and in the morning he was too sore
to attempt the very difficult climb. Although we've
talked about going back, we haven't done so, and
the longest face of Angel Wings has, as of this
writing, yet to be free-climbed.

TECHNICAL DATA *Nikon FM with 24mm lens;
Kodachrome 64; small aperture for depth of field; low
shutter speed to soften moving water.*

BRISTLECONE SNAG UNDER WHEELER PEAK, SNAKE RANGE, NEVADA; 1974

Because of my experiences with bristlecone pines in California's White Mountains, I became greatly enthused about photographing the trees in other locations as well. They occur only in and near the Great Basin of the American West, and my trail soon ventured from eastern California across Nevada, Utah, and Colorado. In the Snake Range of eastern Nevada, I combined a ski descent of Wheeler Peak, the highest mountain wholly in the state, with photography and pursuit of specific information for an article on bristlecones.

I was hot on the trail of what was then considered the oldest living thing ever discovered, a bristlecone pine that had died by the hand of man in 1964, sacrificed to the cause of research. The story of its death had been hushed up; only by reading between the lines in scientific journals did it become apparent that a 4,900-year-old tree with living branches had been felled, then sectioned with a chain saw. At dawn on a March morning, I found the tree's remains on a moraine at 10,750 feet, below the face of Wheeler Peak.

To locate the tree, I listed as many clues as I could glean from the journal, then combed the area like a treasure hunter. Much of the northern slope of the peak was blanketed with bristlecone forest, but certain facts narrowed my search: an altitude was given, and the tree was known to be near the crest of a lateral moraine. I searched for, but failed to locate, the tree on the evening we skied down from the summit, and the next morning I renewed my search before dawn, hoping to find magical light to render my subject on film.

As I searched the crest of the moraine on skis, I came across a fragile snag thrusting a blade of twisted wood into the sky. I figured out a camera angle that would include the mountain but didn't take a photograph because the dawn light hadn't arrived. Noting the location, I continued looking for the sawed stump, with plans to return to the blade the first moment light hit the forest if I hadn't found my elusive quarry.

Now I am glad that I did not locate the stump before first light, because I hurried back to the snag and was able to make this image. I focused very closely on the wood to enhance its bold form and used a polarizer to intensify the color of the wood and to darken the sky. With my camera cradled in crossed ski-pole straps, I shot at a small aperture to hold depth of field in the distance. I tried a 24mm lens, but it made the peak seem too small and far away, so I switched to a 35mm lens. Knowing that I would be pushing the limits of depth of field with my close approach to the snag with this lens, I did not use hyperfocal distance as my point of focus. Instead I focused to favor the snag, to make absolutely sure that it would be razor sharp even if the background came out slightly soft. Thus, the viewer's attention would be drawn to the outline of the snag.

The dead snag was the most attractive subject I found in the area that day. Shortly afterwards I discovered a stump partially protruding from the blanket of snow. Chunks of chain-sawed wood lay in the snow like arms and legs on a battlefield. The Forest Service had granted geographer Donald Currey permission to cut down a tree in order to date Little Ice Age events. Currey used a special Swiss increment borer to extract a pencil-size core from a tree that proved to be more than four thousand years old. He couldn't determine the exact age because his tool missed the center of the tree, so he tried again. The tool broke off. Rather than wait months for a replacement, he asked that the tree be sawed into sections so that he could count the rings.

In his scientific report Currey offers no apology for the destruction of the old bristlecone pine, which he fondly named WPN-114. After Currey's "discovery," the Forest Service invited a team of scientists to search for a still older tree. WPN-114 was an anomaly, however; no bristlecone pine in the Snake Range was discovered to be within twelve hundred years of its age. I have returned to Wheeler Peak many times, and I have taken many additional photographs, but I have yet to get one that equals the simple clarity of this first image, made before I located the old tree.

TECHNICAL DATA *Nikkormat FTN with 35mm lens; Kodachrome II (ASA 25); small aperture for maximum depth of field.*

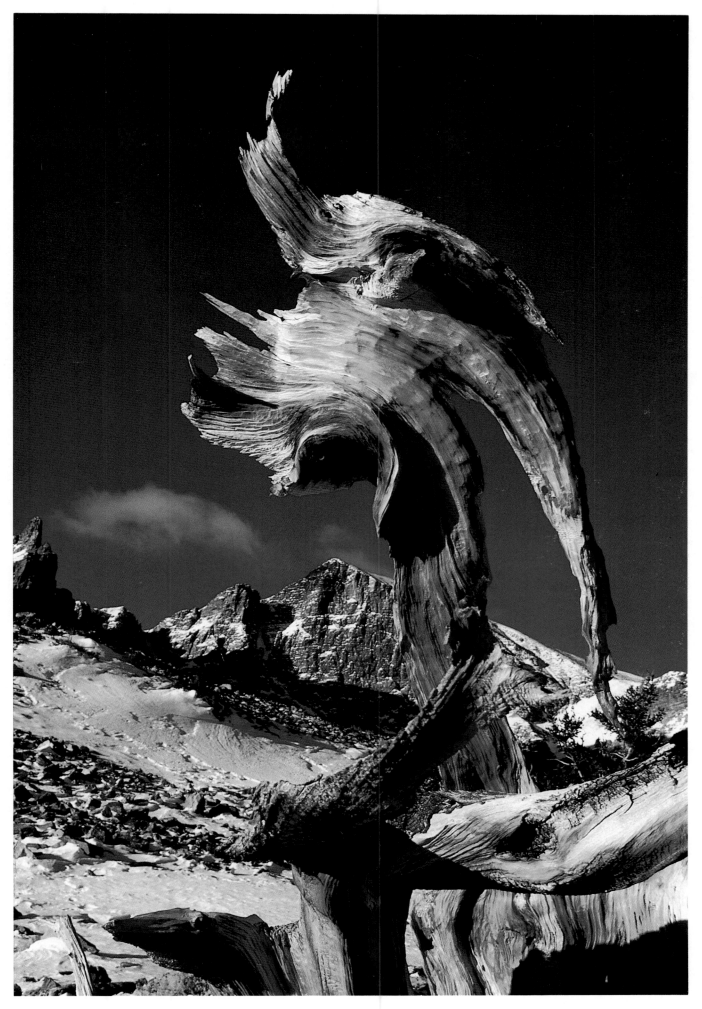

BRISTLECONE SNAG UNDER WHEELER PEAK, SNAKE RANGE, NEVADA

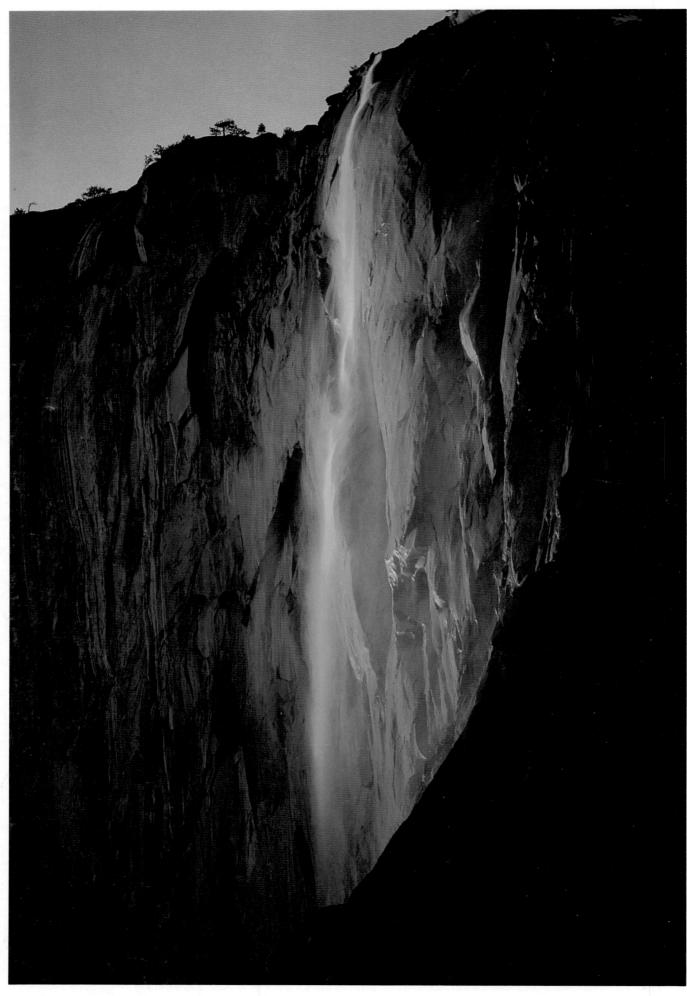

LAST LIGHT ON HORSETAIL FALL, YOSEMITE'S "NATURAL FIREFALL," CALIFORNIA

EXHIBIT I MAGIC HOUR 23

LAST LIGHT ON HORSETAIL FALL, YOSEMITE'S
"NATURAL FIREFALL," CALIFORNIA; 1973

This is not a photograph of the Yosemite Firefall, which was discontinued by the Park Service in 1968. Rather, it is a straight image of a natural phenomenon that occurs each February for a few days while the sun sets at just the right angle on the east side of El Capitan, striking the water of the fall while the cliff is in deep shadow.

One evening when Chris Vandiver and I were driving around Yosemite after a climb, we spotted this phenomenon, and I rushed across the valley to photograph it, arriving as the light was fading. I had not heard of it or seen it before, and I had no reason to expect I would ever see such light again, but on the following evening there it was. This time I was driving with Dick Riegelhuth, now chief ranger at Yosemite. We were discussing problems of resource management for an article I was writing when I saw the fall light up.

"Excuse me, Dick," I said, knowing exactly what I was going to have to do in the next three minutes to get my picture. "The light is wild on Horsetail Fall, and if you don't mind, I'm going to race over there and try to get a picture." I drove the valley loop at nearly double the speed limit, expecting my uniformed companion to lecture me at any moment. My next act broke even more regulations. Since there were no official turnouts with a clear view of the fall from the angle I needed, I drove to the concessioner's woodlot, where I grabbed a camera with a 300mm lens, hopped the chain-link fence, and looked for a place to brace my camera.

The framing was ideal because the red plume of the sunlit fall dropped below a dark sweep of shadowy buttress in the foreground before the color dissipated in the thinner veil of water lower down. Seen from the side, the way the fall lit the cliff was especially accentuated. My one problem was how to hold the lens high enough to miss the trees and steady enough to shoot at 1/60 second wide open in weak light.

Dick, who could have been writing one of the longest citations in park history, gazed at the incredible light, came up to the fence, and asked, "Is there anything else you need over there?"

"My tripod. It's in the backseat."

Dick passed it over, and I had just enough time to make several exposures before the light suddenly flickered out the way it had the night before.

TECHNICAL DATA *Nikon FTN with 300mm lens; Kodachrome II (ASA 25).*

ALPENGLOW ON CORNICED RIDGE,
DENALI PEAK, ALASKA; 1979

During a traverse of Denali (formerly Mount McKinley), the highest peak in North America, I camped above a cornice at 16,200 feet on the west buttress of the mountain. As evening arrived, I took several general views of my camp, one of which appeared in the *National Geographic* book *America's Magnificent Mountains*, for which I was shooting on assignment. I framed a section of the cornice in a 200mm lens but refrained from taking it until better light came. I wanted one side of the cornice lit with pink alpenglow and the other to reflect the blue of the sky and the shadows. Without any size reference, this section of ridge would take on a mystical quality.

The problem with waiting for sunset high on Denali in June is that the sun doesn't set at all at extreme elevations several days of the month. The top of the 20,320-foot mountain intercepts light beams aimed for the Arctic Circle, nearly two hundred miles to the north. Where I was that night, however, the sun set about eleven o'clock. When I ventured out of my tent to go to the promontory where I had previously set up the shot, the temperature was twenty-two degrees below zero Fahrenheit.

I supported the camera with a small tripod ball head attached to my ice ax, which enabled me to shoot at very low shutter speeds to maximize depth of field. I bracketed a wide range of exposures because my meter didn't read on account of the cold. Between shots I was very careful to advance the film slowly so as not to tear it or cause static marks on it as a result of electricity generated in the dry air. When I finished the roll, I rewound it slowly, but in almost every other way I used the same methods I would use in normal temperatures.

Most modern single-lens reflex cameras function in subzero temperatures without being winterized, except for their batteries. An automatic camera that depends on batteries to operate its shutter may require an external battery pack or, in the case of a Nikon F3, the addition of a motor-drive that has its larger batteries wired into the meter circuit. On light travels I find it easiest to use a camera with a mechanical shutter and either guess my exposures or hook up a Nikon external battery pack that fits in my jacket pocket.

TECHNICAL DATA *Nikon FM with 200mm lens; Kodachrome 25; small aperture for greater depth of field.*

ALPENGLOW ON CORNICED RIDGE, DENALI PEAK, ALASKA

CHAPTER ONE
Still Vision

SOME IDEAS BEHIND MY METHODS

On a winter morning in 1985, I was driving alone across the Nevada desert. Next to me on the seat were a bag of cameras and a small tape recorder. I often try to do more than one thing at a time, especially during long hours behind the wheel. For months I had been dictating ideas for this book into a tape recorder, and although I had notes on all the subjects I wanted to cover, I still hadn't figured out how to begin. Several ideas central to my work seemed deserving of space on page one, but I wasn't able to isolate them from my more general feelings about photography.

Even as I tried to describe the special feelings I have for my mountain subjects, I felt a simultaneous need to tell about the common ground I share with other photographers. In a very basic sense nothing I do is unique. Everyone who knows how to see with a camera went through an early stage of learning to recognize and trust his or her own perceptions. Thus, each allows a uniqueness to surface and develop into what we call a "personal style."

In photo workshops where I critique the results of dozens of students who have just been in the field at the same place at the same time, I invariably find that each person's work, even that of an absolute novice, bears a personal stamp. Any group of images by one person is as unique as a thumb print. The fact that occasional images by one student may appear similar to those of another no more disproves this uniqueness than finding single lines that look alike in two fingerprints disproves their uniqueness.

The roots of style are to be found in personal vision rather than in technique. The process of photography expressed in terms of technique alone is unintelligible to me, even though I have been practicing it for decades. Consider, for example, the familiar act of driving an automobile. If I had begun this chapter by trying to describe the mechanical adjustments necessary to operate my vehicle, I would have already lost my readers, including, probably, the automotive engineers. Describing a series of starts, stops, clutchings, shifts, and turns no more explains a journey than a description of camera brands, f-stops, shutter speeds, focal lengths, and films can explain my—or anybody else's—photographs.

At the heart of all photography is an urge to express our deepest personal feelings, to reveal our inner, hidden selves, to unlock the artist. Those of us who become photographers are never satisfied with just looking at someone else's expression of something that is dear to us. We must produce our own images, instead of buying postcards and photo books. We seek to make our own statements of individuality.

As I recorded these thoughts while driving across Nevada, I overtook a Yellow Cab going my way. It had California license plates, and we were the only two vehicles on a long stretch of open road. As if by reflex, I reached for my camera. Here was an opportunity for a photograph with a built-in kicker. The vivid hue of the cab set against the neutral tones of the desert magnified the incongruity of its location. Determining the technical aspects was second nature to me: experience with moving subjects, from bicycles to zebras, had taught me the fine points of photographing while driving. It would be easy to slip right of center on the seat and steer with one hand while opening the passenger's window with the other. Once alongside the cab, I could use my free hand to fire the motordriven Nikon with an ultra-wide lens. But I didn't.

I could not make that photograph because the result would have been somehow at odds with my personal philosophy. Before I press the shutter release, I think about the validity of my subject. Photographs can lie as surely as words, and just as with writing, making a photograph implies that the photographer understands what his photograph says. My rule of thumb is to hold back from making an exposure unless it directly involves me either intellectually or emotionally, or in both ways.

I have no idea why that cab was in the middle of nowhere. On other drives over that same desert, I've never seen anything like it. To have recorded that experience on film would have imparted to it a validity that I could not justify. Although the photo might have been catchy enough to sell to a magazine, it would not have been consistent with what I regard as the stylistic integrity of my work. I want my work to communicate, and I drew a blank on the cab. How could my photograph do anything to explain that cab's place in the desert if I didn't understand it myself?

A camera in the hands of a human being always reflects more than a mirror image of what is facing the film. The film, instead of being a simple mirror, is more like the one-way glass that store detectives peer through, where the illumination is greater on the other side. If the store lights were turned off, the detective would be clearly visible. So it is with photography. In the best photographs a kind of balance is achieved, and something of both sides is seen at the same time.

Henri Cartier-Bresson, one of photography's true masters, pursues this kind of balance to capture what he calls "the decisive moment." Even though he seeks only pure,

unmanipulated instants, he is consciously part of his own images. For him, "photography is the simultaneous recognition, in a fraction of a second, of the significance of an event as well as of a precise organization of forms which give that event its proper expression. [He believes that] through the act of living the discovery of oneself is made concurrently with the discovery of the world around us which can mold us, but which can also be affected by us. A balance must be established between these two worlds . . . both these worlds come to form a single one. And it is this world that we must communicate."

Cartier-Bresson's sense of balance in photography is not easy to attain. It is clear in all his best photographs, and I believe that it forms the most significant component of all aesthetic photography. We want not only to see an image, but also to have a sense of the special human vision behind it. If the vision overwhelms the substance, we say the work is self-conscious. If the substance overwhelms the vision, we call the result banal or un-imaginative.

The art that bears the most similarity to photography is music. Ordering a performance of light waves for the public eye is much like ordering a performance of sound waves for the public ear. Many photographers of the natural world, including such greats as Ansel Adams and Ernst Haas, emerged from strong musical backgrounds. The inventors of Kodachrome, Mannes and Godowsky, were prominent chamber musicians who performed their original experiments in the kitchens and bathrooms of their parents' New York apartments.

Regardless of the strong parallels between music and photography, society views the two fields very differently. Music is normally presented for intuitive enjoyment and taught as an art rather than as a science, whereas photography always has overtones of technology. Much of Webster's definition of music fits photography perfectly: "The art and science of combining . . . tones . . . to form structurally complete and emotionally expressive compositions." The reverse, however, is not true.

When I began photography, it was tightly defined as a science involving chemistry, radiant energy, and photosensitivity, without mention of any aesthetic goals. The error in this way of thinking is now apparent: any type of future music will fit music's nontechnical definition—combining tones expressively—but photography of the future, which is beginning to arrive in the form of video and other electronic imagery, is already surpassing the old narrow definition.

Because my mother was a concert cellist and teacher, I grew up hearing live music every day in my home. I never heard my mother or her musician friends define their music in scientific terms or say anything to make me doubt that music could be understood and appreciated by anyone who took the time to think and listen. By the time I began photog-

raphy that attitude was ingrained in me. I wanted my photos to be as comprehensible as her fine music, and with as many levels of appreciation as possible. I felt distinctly put off by any photograph that seemed to be outer directed toward displaying a technique rather than inner directed toward the vision in the scene itself.

A major part of my work involves an unusual marriage of events on both sides of my lens. I began photography, not as a journalistic observer of events, but as a direct participant. In my early twenties I found that my experiences in wild places were imprinting me with the most powerful memories of my life, memories that were difficult to share with people who hadn't been there. My original goal in photography was simply to create images that would facilitate my sharing.

Contrary to what some people may imagine, my photographic style does not depend on athletic ability. Most of my best images have come about precisely because of the non-athletic component in my mountain experiences. Even during the most ambitious adventures, I have free time to contemplate my surroundings, from camps, trails, and ledges. Many of the photographs in this book were made in locations readily accessible to people whose reasons for being in the wilderness are distinctly nonathletic.

It is not reasonable for a participant in a traditional, competitive sport such as baseball or tennis to try to photograph his or her own experiences while participating in the sport. I am able, however, to take photos while climbing mountains because even the most severe of my undertakings are essentially noncompetitive. Climbing is unusual among sports in that it has few spectators and no requirement for continuous physical performance. Even for a climber on Mount Everest, it makes little difference whether a given distance is covered in two hours or three hours, but the same discrepancy in time in a marathon run might mean the difference between first and one-thousandth place.

A more ideal situation than that of the climber to learn outdoor photography would be hard to imagine. Climbs and expeditions put me out in the open air at dawn and dusk, the magic hours for landscape photos. Balancing human subjects in action against their surroundings came naturally because I was a part of the experience. I easily lost my inherent reticence about taking close-up candids of people because I began working only with people I knew.

Most important of all, I happened upon a special relationship between myself, my career, and my subject material. I entered a world with no firm boundaries between working, playing, and living. Moments when I press the shutter are determined not just by what is out there framed in my viewfinder, but by the sum of my direct experience with the subject at hand. When I feel internal and external events coincide, I do my best work.

I was aware that my situation was fortuitous, but only after I met many other photog-

raphers did I fully understand that talent and drive are not nearly such good indicators of success as the simple act of doing work that matches and expresses one's own personality. Only then do subjects and personal vision coincide to make fine photographs.

By personal vision I mean something more than mere sense of sight. Photography is powered by the passion of individual photographers. At the most basic level all photographers are trying to do the same thing: make images that preserve their most deeply felt visual experiences. To deviate from this pursuit of personal truth, regardless of how much money or fame may be at stake, is to risk losing that all-important source of power forever.

One of the shocking realizations of adult life is that most of us are not fulfilling the most closely held dreams of our youth. Instead of pursuing dreams that were once integral parts of our personalities, we end up in one way or another fulfilling someone else's ideas about who and what we should be, usually at the expense of our creative urges. The universal yearning to be creative is eloquently expressed in these words by Antoine de Saint-Exupéry from *Wind, Sand and Stars*: "Nobody grasped you by the shoulder while there was still time. Now the clay of which you were shaped has dried and hardened, and naught in you will ever awaken the sleeping musician, the poet, the astronomer that possibly inhabited you in the beginning."

Vision is as much the work of the mind as it is of the eye. Scientists now believe that the major job of the visual system is to interpret a scene rather than to simply record it and thus prepare the brain for the proper response to each situation. And so, the best photographs visually excite us because they convey the excitement experienced by the photographer.

Another dimension to this idea of seeing came from an old Sherpa in Nepal who knew only a few words of English. For years he had watched foreigners flock to his homeland with cameras. Over a fire one evening he told an American friend, "Many people come, looking, looking, taking picture. . . . No good. . . . Some people come, see. Good!" I used his first five words as the title for a book on the effects of tourism in the Himalaya, but the quote has even more relevance to the internal qualities of place that link photographic images to personal vision. Fine photographers do not merely look, they see.

To see, instead of to look at, the desert through a photograph is to make its essential values come alive without resorting to gimmicks such as heavily filtered colors or yellow taxicabs. Unless a landscape is intended as an abstraction, it needs to be absolutely rooted in the integrity of the natural scene.

Photography has traditionally carried with it a cachet of fact, an illusion of captured reality. Today this quality is increasingly endangered by ever more sophisticated ways of manipulating images. Fifty years ago the great photographer Edward Weston was con-

sidered a naive purist for urging that all photographs exemplify "contemporary vision . . . based on an honest approach to all problems, be they morals or art."

Since then, what Weston feared has come to pass: today it is possible to create photographs of anything that can be imagined. By using traditional devices such as illusion, montage, multiple exposure, and contrived sets in combination with new methods of adding or subtracting from the image by computer, photography has become a medium without limits—unless they originate within the photographers themselves.

Kevin Kelly, coauthor with Stewart Brand of a 1985 magazine article "Digital Retouching: The End of Photography as Evidence of Anything," writes: "We have been spoiled by a hundred years of reliable photography as a place to put faith, but that century was an anomaly. Before then, and after now, we have to trust in other ways. What the magazines who routinely use these creative devices say is 'Trust us.' That's correct. You can't trust the medium; you can only trust the source." Thus, Kelly and Weston arrive at the same conclusion: the integrity of photography is not inherent; it is based almost solely on the moral and ethical decisions of individuals.

Media touched by the electronic age have not lost all credibility; we have learned to make distinctions. Words lie, for example, but we trust certain authors, even if they use word processors. And we don't base our judgments of the veracity of TV news broadcasts on the content of soap operas. And while photography could be taken to extremes so that it loses all credibility, that probably will not happen. Photography has at least equal odds of preserving its integrity because to a great degree the possibility for deception has been present all along. The only change is that the temptation to fool with photographs now is far greater than ever before because photographic images may be stored as digital information on computers before they are printed. In the long run the new technology could have a positive ethical benefit. It might force photographers to be more aware of the integrity of their work.

Because of the increased consciousness about altered images, I became acutely aware of my choices for this book. Over the years I have experimented with double exposures and montages and have rejected them out of hand for consideration here. In an overall sense I see the merging of computer technology with photography as firming my resolves rather than tempting me to contrive images. I've resisted other temptations in photography from the beginning, and I am now reminded more than ever of the need to preserve the personal ethic that has bound my life with my work for almost two decades.

Ever since the late sixties, when my photos began to be published, I've had occasional offers to shoot with movie cameras for more money than I was making shooting stills. Early on I made a commitment not to become involved with motion pictures. My major

consideration in making that decision was the close relationship I perceived between human memory and still photography.

I noticed that whenever I tried to recall something, the images that came to my mind were as still as photographs. Even if I attempted an "instant replay" of an experience, I found myself connecting a series of still flashes in my mind. A lawyer friend told me that he uses this known quirk of the brain to trip up eyewitnesses who unwittingly try to fill the gaps between remembered glimpses of reality.

Memory selects single important images, just as the camera does. In that manner both are able to isolate the highest moments of living. One of the most remarkable powers of the human mind is the ability to selectively forget things that are not important and to emphasize those that are; once again, just what the camera does in "memorable" images.

Because human memory will not hold a continuous record, we all experience lapses. A single remembered image may trigger vast amounts of forgotten material. For example, a person revisiting a distant city after many years' absence may have no conscious memory of how to get around. Nothing looks familiar until a single image, perhaps a building or an intersection, coincides with one buried deep in his mind. Suddenly he knows not only where he is, but also how to get where he wants to go.

I have watched movies on TV for as long as an hour before having the embarrassing realization that I have seen them before. Conversely, I have found still photographs, especially those originally matched to a powerful vision, virtually unforgettable. If I thumb through a photographic book, I know with some degree of certainty whether I have seen any particular photograph elsewhere.

Extensive reading on memory research convinced me that still photographs are better matched to the brain's long-term way of holding information than any other form of mass communication. The best photographs can capture a whole era in an image or two. Even the finest human mind never recalls everything from a previous experience. Memory is a sieve that keeps the nuggets and releases the rubble; I wanted my photography to do the same.

When I first began to document my climbs in Yosemite and the High Sierra, I set my sights on making my images coincide with the natural high points of my memory. I felt that by combining those images with my own texts, I could achieve a unity of expression that would be apparent to editors and readers alike. The fact that I often had to explain the significance of those early photos to my own friends didn't dampen my enthusiasm. With tireless energy I wrote unsolicited articles and sent them off to *Look*, *Life*, and *National Geographic*, accompanied by a handful of photos that I culled to match my words. Nothing sold.

My first work was in black and white, and I soon gave it up simply because of color's potential to transmit more information. I tried 2¼-inch-square, 35mm, and Instamatic formats and made the unlikely decision to use the Instamatic. Even though I would now love to have my early Instamatic images on full-size 35mm, the reasons for my choice are as sound today as they were then: the little camera was lighter and easier to use than the cumbersome 35mm cameras of the sixties. These advantages were important if I was to cover my rock and mountain climbs as an active participant. The special model I bought was equipped with a fine Schneider f/2.8 lens and built-in light meter. It produced tiny Kodachromes that proved sharp enough, even after conversion to black and white, to illustrate my first book, *The Vertical World of Yosemite*.

One of the best and brightest Yosemite climbers I have known wouldn't take on a partner who carried a camera. His reason was squarely in the path of my personal goal. This deeply introspective man, whose life revolved almost wholly around his mountain experiences, wasn't concerned with money or notoriety. He knew only too well that all he would ever have to show for his efforts were his memories. They gave him solace, especially when he felt a need to define his identity and his reason for living. When he seriously asked himself, "Who am I?" or "What do I really know about the world that doesn't rely on secondhand information?" he turned to the truths he had found in the mountains, to the high points of his experiences, which were committed to memory.

He rejected photography because of the gnawing discomfort he felt whenever he saw a slide of a climb that he had done. The moments when the photographer had clicked the shutter rarely, if ever, matched the moments in his memory. Because photographs are so easily remembered, he found the precious memories of his climbs being supplanted by the seemingly random moments recorded in someone else's photographs.

As I began to gauge the success of my work by how close it came to the high points in my own memory, my shooting style necessarily changed. Often I had no way of knowing whether a particular moment was at the peak of a high point until after the image was made. Some events break almost instantly; others escalate for minutes or even hours. I solved this dilemma by shooting in binges. When I didn't sense a high point coming on, I was very frugal with film and made only enough "record" shots to outline the story of where I was and what I was doing. When something really excited me, I often shot a full thirty-six-exposure roll or two of a single breaking scene. In situations with people, I shot even more, because a person's body attitude—the turn of a head, a gesture, the beginning of a step—is so crucial to the feel of a moment.

At home I edited down hundreds of slides into tight sequences that showed just enough of the mundane images to set the stage for the high points. Of course nothing re-

sembling those sequences ever appeared in the little magazines and Sunday supplements where I sold my first stories. They selected only a few images, usually more closely related to their design ideas than to my text.

Part-time journalism wasn't profitable for me. Even though I started to sell a number of text-photo packages to little magazines, I was embarrassed to tell even my best friends that I was hardly covering the considerable costs of my film and processing, let alone the long hours of writing. Nevertheless, at the age of thirty-two, I decided to make photography and writing my full-time career. I resigned myself to finding outlets where I could retain as much creative control over my work as possible, regardless of the money. By the end of that year (1972), I had a contract for *The Vertical World of Yosemite*, a coffee-table anthology of photos and writing on climbing that included many of my images. I also had a schedule of slide shows on mountain adventures for colleges and backpacking stores. Those gave me great satisfaction because I could sequence out my full story with my own complete choice of images.

In 1973 I agreed to help Dewitt Jones, a photographer friend, with coverage of a climb in Yosemite for *National Geographic*. We were to shoot any big climb of our choice, which would then be considered for inclusion in a major story on the national park. As the time neared, Dewitt was called off on another assignment. He generously suggested that I ask to do the whole coverage, and he set it up for me to submit my portfolio (which didn't exist) to Bob Gilka, *Geographic*'s legendary director of photography. Not knowing any better, I put my life's collection of best originals (neither insured nor registered) into the mail and sent it off.

A few days later Gilka called. I had the assignment—my first for a national publication —with a full expense account plus a fee. My joy was not shared by my fellow climbers. The thought of a feature article in *National Geographic* on their private sport created visions of such things as waiting lines for campsites in the climber's campground and popular climbs, what indeed happened in years to come.

I wondered if I could turn the tables on the effects of publicity. What if the article could have a positive effect on the sport? I discussed my assignment with Doug Robinson, a climber-writer known for his strong stands on mountain ethics. We decided that an article that showed climbers following the new but not fully established technique of climbing without pitons could set a major precedent. Instead of using pitons, climbers could use "chocks," little blocks of metal that could be slipped into cracks with wire or rope tethers to clip to a safety rope. The chocks could be placed and removed with no sign whatsoever of their use, and climbs could retain their wilderness character instead of ending up looking like worn granite pegboards in an outdoor gymnasium. On a steep wall

with thin cracks, however, the difficulty was considerably increased. Once the ethical basis for the new technique was sanctioned in ten million copies of *National Geographic*, climbers would think twice before damaging Yosemite's rock walls and compromising the climbs for others by hammering iron spikes in and out of the rock.

Doug and I, with Dennis Hennek, succeeded in climbing the Northwest Face of Half Dome without pitons. It was the first time a "Grade VI" climb had been done without them; we even bypassed all the pitons left in the rock by earlier parties. In three days of climbing I shot seventy rolls of ASA 25 Kodachrome film for a total of more than twenty-five hundred images. The exposed film went to Washington for processing and editing while I bit my nails in California, wondering if my cameras had functioned properly and if the film had survived the August heat.

Then, in what seemed a whirlwind, I was told my shoot was very successful, given an unexpected cash bonus and a new assignment to write text for what had then become a separate article on the climb, and asked to come to Washington, D.C. "Climbing Half Dome the Hard Way" was the cover story for the June 1974 issue, including sixteen pages of photos; for me it was much more.

When I went to Washington I found that nearly all of the decisions I had made about photography through trial and error were standard procedure at *Geographic*. Their photographers used 35mm almost exclusively, and they favored Nikon cameras. The illustrations editor was surprised that I had used seventy rolls of film. She couldn't remember when any photographer had gotten a complete story on so *few* rolls. The film supplied by *Geographic* was my favorite ASA 25 Kodachrome II, and with it was a note to use it at ASA 32 or higher in order to increase color saturation, something I had long been doing as a result of my own experiments.

The Half Dome story opened the door to a number of other national publications, but I soon confronted an identity crisis. It wasn't considered normal for a top-level photographer to do his own writing. And in order to do both, I turned down several photos-only assignments that did not seem to be in line with my goals. I also ended up publishing some text-only articles, including the first complete account in a national magazine of the Mono Lake crisis for *Audubon*. I submitted my best photographs, but because of a bizarre editorial decision, they ran the full text without a single illustration.

I came up with a stock answer to the predictable question of whether I consider myself a writer or a photographer: "I spend two-thirds of my time on writing and one-third on photography; two-thirds of my income is from photographs, one-third from writing."

By practicing both trades at once I was able to compare them and thereby gained a new understanding of the startling effects they have had on one another over the last cen-

tury. During the year the Half Dome story was published, my father turned ninety. To touch his hand was to go back in time to his birthplace in a log cabin in the Minnesota woods. In his youth he owned a camera, developed his own film, and filled scrapbooks with simple scenes of home and family. He never considered broader use of his camera because of the limits of the existing technology.

In 1923 my mother—sixteen years his junior—walked much of what is now the John Muir Trail. To this day one of her prize possessions is a scrapbook of photos of that adventure. The photos are glimpses only. On one page is a campsite and a mule train; on another are her companions and some views of mountains. Nowhere are there close-ups of wildlife, wide-angle views from up high, or the light of dusk upon a lake. Those kinds of photos were technically off limits to a black-and-white photographer traveling light in the wilderness in 1923. Now they are commonplace because of advances in camera technology, and without those advances I might not have taken up mountain photography.

In John Muir's time those who traveled through the mountains recorded their experiences in words or on sketch pads. Muir did both, but his words are better remembered. If he were alive today, I have little doubt that he would be a wilderness photographer.

Muir's writing style captures exactly what a 35mm camera does today: images of the land and moments of living at their highest. His style of wild flourishes of words has all but disappeared, replaced by the more precise form of expression we have come to expect from today's writers, and it is more than coincidence that ornate descriptiveness fell out of favor at the very time photography began to be widely published.

Today I see still photography in a position not unlike that of Muir's prose. There are more exciting and efficient ways to show images of the natural world to the public than by the laborious process of making a photo, processing film, printing it weeks, months, or years later, and delivering it in hard copy. Video cameras can now bring the wilderness live into our living rooms. Still photography will hold its present hallowed place in the world of art and communication only as long as it respects the natural integrity of the world it depicts and doesn't overtly try to compete with high-tech media.

Over the next decade or two today's finest landscape photographs could become as obsolete as those IBM cards produced by early computers. The laborious process of exposing and processing film will almost certainly be replaced by electronic imagery that can be stored and reproduced by computer. Video and disk cameras are only the forerunners of this trend. We now have the ability to store the information in a high-quality photograph on a computer before printing it, but we haven't even come close to working out the technology for a portable electronic camera that will make an original recording of such high quality.

This obsolescence of techniques and styles is not only typical of the history of photography, but also of the history of art and culture in general. Black-and-white photography survived the onset of color because of its reputation of integrity and its potential for artistic expression. One might expect color photography to be considered a natural artistic step up from black and white, but its acceptance in the fine-art world has been extremely slow. Black-and-white photography permits greater control of light and tone and also creates far less potential conflict with the established world of painting. As Beaumont Newhall says in his definitive book, *The History of Photography*, "The line between the photographer and the painter is no more clearly drawn than in color photography. Imitation is fatal. By the nature of his medium, the photographer's vision must be rooted in reality; if he attempts to create his own world of color . . . his results no longer have that unique quality we can only define as 'photographic.' On the other hand the painter cannot hope to rival the accuracy, detail, and above all the authenticity of the photograph."

I am unconvinced about the supposed creative limitations of color photography as compared to black and white. In black and white the eye and hand of one individual can work together to visualize, develop, and print each work of art in a manner similar to artisans of old. The color photographer, however, cannot develop and print Kodachrome, the preferred 35mm color transparency film for the last half century. Because dye couplers must be introduced into each of three film layers during an extremely complex development, photographers must send their Kodachrome to labs that have special machinery costing hundreds of thousands of dollars and a small army of technicians to operate it. Even *National Geographic* sends its Kodachrome to Kodak.

Does that make results on color slides less artistic than those on hand-developed emulsions? I think not. In fact, I can make an excellent case for the opposite point of view. The classic definition of the roles of art and science in photography was part of an 1890 report by Hurter and Driffield on a simplified method of exposure: "The production of a perfect picture by means of photography is an art; the production of a technically perfect negative is a science." By this reasoning a black-and-white photographer practices part art, part science. A color-slide photographer, however, is free to devote all effort to artistic intentions because the task is complete when the shutter is released. At that precise moment, science and technology take over the predictable production of the latent image. The result is a completed photograph rather than a negative that must then be made into a photographic print before it can be assessed by an audience.

Today's audiences see proportionately fewer photographic prints because of the profusion of color photography in the printed media. Fine prints are sought after by museums, galleries, and collectors, but they are unnecessary for the reproduction of an image. The

vast majority of published color photographs (including those in this book) are reproduced from transparencies, without the intermediate stage of a photographic print. Color transparencies may be viewed directly, projected, or separated for publication or electronic storage.

The use of color transparencies tends to favor the original integrity of the image itself over later darkroom manipulations. Thoughtful photographers have become aware that photographic styles which depend on quirks of present chemical technology instead of on consistent personal vision will become passé. Only those based on the qualities of light and form will remain equally valid in whatever new technologies evolve.

I am intent on preserving the integrity of still photography. I avoid lenses that curve horizons and filters that manipulate color away from what I perceive. Above all, I want my subject matter to be part of a genuine experience rather than a scene created for the camera or one found out of context, such as the taxi in the desert. I recognize that some of my photographs may seem unreal to people who have not experienced the many nuances of mountain light, but all are natural events. Those high moments of mountain experience, the ones that would burn themselves into my memory whether or not I have a camera, are what I want to put on film, or whatever media for recording still images may emerge in years to come.

EXHIBIT II
Backlight

When the sun is behind your subject, you can obtain some of the most exciting or some of the most disappointing results your camera will ever produce. The difference hangs on understanding what light does in backlit situations.

When I see tourists posing their families against a backlit outdoor scene in a national park, I know they will be disappointed by the unrecognizable silhouettes that will appear in their pictures. On the other hand, I have watched Hollywood films where the good guys were always backlit with a halo of light in their hair, while the bad guys had perfect frontlighting that showed up every flaw—thus implicitly maligning their character.

What Hollywood does that a family in the park doesn't do is furnish light in the shadows to provide extra detail when a subject is backlit. You can do that naturally by selecting places where the landscape acts as a giant reflector. Snow, granite, and sand work well in this regard, while forest floors reflect so little light that even a person dressed in white may look black against the sun. When I photograph close-ups of people and products in outdoor situations, I often bring along portable reflectors to bounce sunlight back on my subjects, and still get the added drama of backlighting.

At its best backlighting simplifies what might otherwise be busy or confusing situations by allowing unnecessary details to drop away in the shadows. Forests can look very complex and uninteresting until backlighting creates beams of light, called crepuscular rays, that have corresponding exaggerated shadows. These "god beams" are among the most beautiful of common optical phenomena.

As fully discussed in Chapter 5, perfect stars of light that appear around the sun when it is partly obscured by an object are caused by diffraction, a phenomenon in which some of the rays bend around the object. An equally vivid diffraction effect creates fringes when the sun is totally hidden behind the edge of an object and the camera is at a proper distance.

Sometimes photographers purposefully use backlighting to turn human forms into silhouettes. When a person stands profiled against a backlit scene without much reflected light, film will record a dark silhouette if the exposure is for the landscape. When producing human silhouettes, a photographer must previsualize only the outline of his subjects and forget the detail in faces and clothing that his eyes, but not his film, can see.

CLIMBER ON A PINNACLE NEAR MOUNT WHITNEY, CALIFORNIA

CLIMBER ON A PINNACLE NEAR MOUNT WHITNEY,
CALIFORNIA; 1973

In late spring one year I skied to the base of
Mount Hale with three companions. My goal was
a first ascent of the east face; my friends' goal
was to have fun. The sheer wall of Mount Hale
appeared to be too serious an undertaking, so we
opted for a traverse over a ridge toward the
Whitney-Russell col. When we gained the ridge,
I traversed to one side to investigate a spectacular
pinnacle that rose vertically on all sides. Not only
did it look climbable, but also it had the greatest
potential for a backlit summit shot I had ever seen.

The pinnacle was free-standing for about a hun-
dred feet, but it rose almost parallel with the wall
of the mountain so that its summit was only fifty
feet from the main cliff. When I scrambled up to
where I was in the summit's shadow, I could ac-
tually see light rays diffracting around both sides.
The air at thirteen thousand feet was so clear that
the sun was not brightening much of the sky
around it, as it would have on even slightly hazy
days.

With perfect diffraction, however, I would nor-
mally get a black silhouette fringed with unearthly
light. What made this situation so special was that
the main cliff of nearly white granite acted as a
giant umbrella, reflecting sunlight back onto the
spire. Thus, I could underexpose to emphasize the
diffraction and still get detail in the shadows.

I pointed out the situation to Jeff Campbell, and
since he wasn't up to climbing the pinnacle him-
self, I set up my camera for him and climbed the
pinnacle with his belay. I had set the exposure one
stop under the reading on the sky, and I counted
on making certain that no direct rays of sunlight
spoiled my reading by causing flare in my lens.
Once on the top I was able to direct Jeff's actions
by watching my shadow, making sure that he had
the lens right in the center of the shadow cast by
my head when he took the photograph.

TECHNICAL DATA *Nikkormat FTN with 35mm
lens; Kodachrome II (ASA 25).*

POOL BELOW ANYE MACHIN,
NORTHEASTERN TIBET; 1981

The February 1930 issue of *National Geographic*
reported the discovery of a Tibetan mountain at
least twenty-eight thousand feet high that rivaled
Mount Everest. During World War II, a crew
flying "The Hump" from Burma over the Hima-
laya into China stunned the world by reporting a
thirty-thousand-foot peak, which they had seen
when they were blown off course, in about the
same location.

After Mao took over China, the area became
off limits to foreigners. The mountain, Anye
Machin, was eventually surveyed by the Chinese
at a little more than 23,000 feet, and explorers lost
interest in it until the government reopened the
area in 1981. That year I was assistant leader of an
expedition that hoped to make the first ascent of
Anye Machin. Unknown to us the Chinese also
had sold permits for climbing the peak to the
Japanese and the West Germans. Also, the Chinese
had known for at least ten years that the peak was
only 20,610 feet high, but they failed to inform
permit holders until after they had committed to
the climb.

The evening after I reached the summit of the
mountain with Harold Knutson and Kim Schmitz,
I wrote in my diary that I had just climbed a Chi-
nese counterpart of Mount St. Helens, which also
has a history of sudden losses of elevation. Even
though we saw no sign on the summit of a prior
ascent, we later learned that a Japanese party had
indeed come up the other side a few weeks before
us.

The morning after the climb I set off from high
camp alone at 5:00 A.M. I was to meet a trekking
group and act as guide on a 120-mile pilgrimage
around Anye Machin, a holy mountain to the
Goloks, who live at its base. As I walked through
a section of snow-covered moraine at about six-
teen thousand feet, I came across a tiny pond no
more than ten feet across, a perfect horseshoe shape.
Nothing in the landscape indicated the pond's size,

POOL BELOW ANYE MACHIN, NORTHEASTERN TIBET

and I seized on the idea of making a visual hoax, like the mountain itself, that would make something appear larger than it is in real life. In this case I wanted the pond to look like a vast lake.

Since frontlighting would show intricate detail that might give away the size, I tried the most direct backlighting possible, aiming my camera into the sun. I set my lens at f/16 to turn the sun into a many-rayed star and chose a high angle of view with a cropped foreground so as not to show too much detail in the snow.

The shot would not have worked without bright subject matter in the foreground such as snow and water. Without it I couldn't have held detail in the direct sun and the landscape at the same time. Because I had plenty of light and a wide-angle lens, I was able to comfortably handhold the photograph at 1/125 second.

I was in a hurry on my descent when I made this image and probably spent less than thirty seconds. Months later I had forgotten all about it when I saw it among selects at *National Geographic*'s headquarters, where I had sent my exposed film. My story of the mountain and the Golok people who live on its flanks appeared in the February 1982 issue, and although the image was not used in that story, it was later published in my book *Mountains of the Middle Kingdom*.

TECHNICAL DATA *Nikon FM2 with 24mm lens; Kodachrome 25; f/16 for sunstar effect.*

AFTERNOON LIGHT IN THE BRALDU GORGE, KARAKORAM HIMALAYA, PAKISTAN

EXHIBIT II BACKLIGHT 43

AFTERNOON LIGHT IN THE BRALDU GORGE,
KARAKORAM HIMALAYA, PAKISTAN; 1977

On our return from an expedition to the Trango
Towers in Pakistan, we camped in the village of
Chongo. In the afternoon when the sun dropped
behind a series of rock spires in the distance, radiat-
ing crepuscular rays, or god beams, were defined
by the illuminated borders of the spires' shadows.

The light was interesting but hardly spectacular
at the time. Other members of the team didn't
even bother to photograph the scene. I knew that
my film's limited exposure latitude would turn
the shadows black if I exposed for the highlights.
Even so, the rays and spires by themselves didn't
seem to be enough to carry the image. I moved
my camera to a position where I created a diffrac-
tion star out of the sun by placing it partly behind
a ridge. I photographed the image with and with-
out the poplar tree in the foreground, deciding
after I studied my results that I much preferred
including the tree in the image to give a feeling of
life to the sterile landscape and a sense of mystery
to the small, but perfect, sunstar.

The god beams in this image appear to radiate,
but that is the result of an optical illusion. They are
actually parallel and seem to converge in the dis-
tance only because of the same kind of natural
perspective distortion that makes railroad tracks
seem to converge. These rays are commonly seen
when the sun is just behind clouds and when light
pours illuminated shafts into darkened buildings.
The hazier the air, the more pronounced the effect.

Even though I have returned to the same area
twice since I made this image, I didn't see the same
combination of light because the sun is in this par-
ticular position only in late June. God beams came,
but without the little catch light of a sunstar that
gives the image its needed extra touch. When the
International Center of Photography in New
York put together a 1983 gala exhibit of 270 im-
ages entitled "High Light: The Mountain in
Photography from 1839 to the Present," this pho-
tograph was chosen for the cover of the programs
and invitations. It illustrates a backlighting theme
the opposite of that on the preceding page: allow-
ing the foreground to go almost black with an
exposure directly into the sun, instead of searching
out very light subjects to render foreground detail.
I always look for one or the other: attempts at
something in between these two approaches in-
variably fail unless the optical effects themselves
are strong enough to carry the image—quite a
rare occurrence.

TECHNICAL DATA *Nikon FM with 105mm lens;
Kodachrome 25.*

BOULDERING NEAR BISHOP IN THE EASTERN SIERRA, CALIFORNIA; 1976

While Chris Vandiver and I were practicing climbing in the Buttermilk Rocks near Bishop, he attempted what seemed an impossible overhanging corner of a high boulder. I tried an easier route nearby and noticed that as his shadow passed me it was fringed by an exceptionally strong ring of diffraction, caused by light rays bending slightly around his body.

Diffraction of such intensity is a function of clarity of the atmosphere and the distance of the subject from the viewer. Even a small amount of haze in the air diffuses the sun's light and lessens considerably the purity of the effect. I have found that at distances of thirty to sixty feet the effect is at its maximum with a human figure against a sun in a clear sky.

My camera was in a bag nearby as we climbed, and after Chris fell off the difficult corner, I asked him if he would try it again. Since the climb was very short and the lee of the overhang very cramped, I put on a 20mm lens to increase the feeling of height while at the same time including the landscape at the bottom to verify the steepness of the rock. I lay on my back in the deepest recess of the overhang and handheld the camera with one side braced on the ground in a position I determined by the rock's shadow.

As Chris climbed past the sun once again, I took two shots at an exposure preset to be one stop darker than a reading for the sky without the sun in it. From experience I have learned that such a setting works well for silhouettes with fringed light. At that time my only camera did not have automatic exposure, and even though my new cameras do, I have continued to meter such situations manually. A small fringe of very bright diffracted light fools a meter into radical underexposure.

Chris fell off into soft sand a moment after I made this image, and to the best of my knowledge the route has yet to be climbed in its entirety. *Sports Illustrated* used this image to lead off an article on modern rock climbing, and later when it was included in a Sierra Club calendar, it provoked a customer to write a violent objection to the club, which was forwarded to me for response. An East Coast doctor threatened to quit the Sierra Club after expressing his opinion of how the publication of my faked photograph would ruin the club's image.

The doctor sent me an apology, conceding that if the situation were turned around, he would not be exactly happy to have an uninformed, harmful accusation sent to his hospital. In the end both the doctor and I learned something. The doctor learned about physical realities of mountain light that he may not have experienced personally, and I learned that my emphasis on the extremes of optical effects in the atmosphere can make even my straightest image suspect to those who have never seen such lighting with their own eyes.

TECHNICAL DATA *Nikkormat FTN with 20mm lens; Kodachrome 25.*

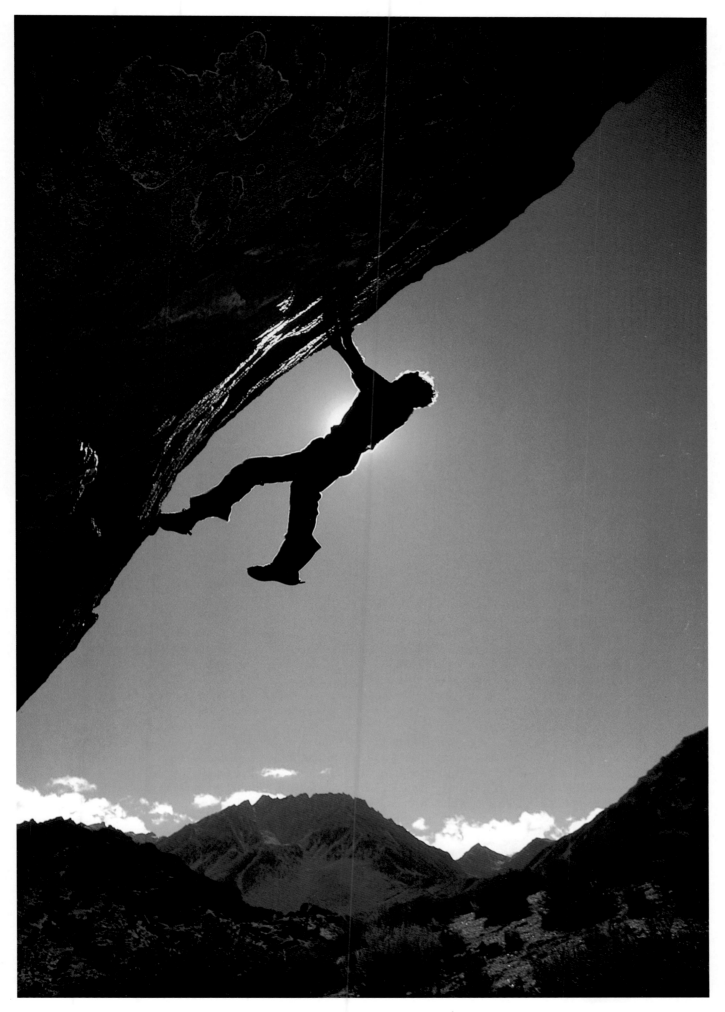

BOULDERING NEAR BISHOP IN THE EASTERN SIERRA, CALIFORNIA

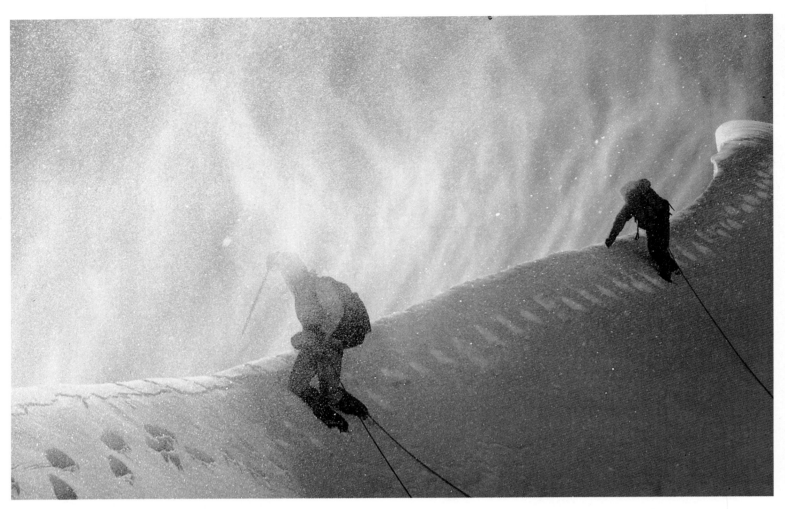

IN HIGH WINDS ON ANYE MACHIN, NORTHEASTERN TIBET

IN HIGH WINDS ON ANYE MACHIN,
NORTHEASTERN TIBET; 1981

One of the greatest problems I encounter when photographing mountain climbs is that my companions are invariably above or below me. Photos tend to show backsides and tops of heads, but few angles that really give the viewer a sense of a climber's world. The ideal vantage point would be out in space directly opposite climbers, and I always keep my eyes open for a situation that can provide that effect.

As Kim Schmitz, Harold Knutson, and I were making the first ascent of Anye Machin's northeast ridge, high winds buffeted us on a traverse of a corniced, knife-edge ridge. Snow crystals, backlit by the morning sun, blew into the air with each gust. When I saw a section of cornice that abruptly turned back on itself, I realized I could get into a perfect bird's-eye position to photograph my companions from the side as they came by on the crest of the cornice. Just as they came into view, a

gust of at least fifty miles per hour blew snow and ice high into the air.

My camera was ready for the peak moment of the gust, preset at an exposure for the back of my hand—so my meter wouldn't be fooled by the backlit snow. I handheld a couple of exposures with my 24mm lens, making a strong diagonal out of the cornice, but allowing it to taper off within the frame at the extreme right. Moments later I rejoined Kim and Harold and we continued on toward the summit.

Even though we found harder climbing above and more spectacular views across the range, we certainly didn't encounter another situation like this one. It underscores for me the importance of going with my gut reactions—in this case stopping when I saw a picture situation—rather than continuing on with hopes that things will get better. Time and again I've lost shots by being too lazy to stop and take out my camera.

TECHNICAL DATA *Nikon FM with 24mm lens; Kodachrome 25.*

EXHIBIT II BACKLIGHT 47

ICICLES ON THE BALTORO GLACIER,
KARAKORAM HIMALAYA, PAKISTAN; 1975

While on the way to K2 on my first Himalayan expedition, I wanted to make an image that expressed my feelings about the Baltoro Glacier. Broad scenics just didn't show the impact of being there. Close detail shots usually presented an uninteresting foreground because most of the glacier was strewn with superglacial moraine—rocks over the surface of the ice—which gave the thirty-six-mile-long glacier the look that God's own construction company had left a massive job unfinished.

I knew what I wanted was a tall order; nevertheless, I hoped to find it once we got above the permanent snow line. I wanted a powerful foreground that would lead the viewer's eye into a scene with ice, snow, a rugged horizon of peaks, and some sort of optical display in the sky. For two weeks no such scene presented itself. The possibilities began to look better, however, when we reached an area of large ice seracs, where numerous icicles were suspended from overhangs, creating grottoes of every size.

I left the trail and began to scout for a grotto that faced directly into the sun with a horizon of peaks. I wanted to get behind the icicles and photograph out. To make the icicles sparkle, I needed direct sunlight, which I could also use to create a sunstar in a clear sky by stopping down my lens. Also, I knew that my Nikon 24mm f/2.8 lens could produce an internal diffraction circle about the same size as the natural forty-six-degree halo that surrounds the sun when certain ice crystals are in the atmosphere. The halo occurs only when the sun is centered in the finder and the aperture is set at f/16 (a later model of this lens has an f/22 maximum aperture that also produces the halo).

I had already determined the need to set my lens at f/16 in order to have maximum depth of field. By setting my lens at hyperfocal distance (where infinity is placed at the depth-of-field mark for f/16, with the closest usable distance—in this case 2 feet—appearing opposite the other color-coded mark), I figured out my maximum range of focus. Since shooting right on the numbers is not good enough to maintain sharpness for big enlargements, I hedged the settings a bit—moved the infinity mark just inside the f/16 mark and moved my camera position 2½ feet from the icicles. Then I bracketed several exposures.

I thought I had controlled every variable imaginable, but I missed one. Many photographers tend to take it for granted that Kodachrome will always come out the same. Not so. The film is truly consistent only as long as the photographer makes a personal effort to keep it that way. In the case of the icicles, I was using one of the first emulsions of Kodachrome 64 ever released. It had been rushed to me by *National Geographic*, and it was a little too fresh from the factory. Fresh Kodachrome has a green bias, and as it ages, its color shifts toward magenta. The original of this image has a noticeable green cast in the snow and ice. This reproduction was made from an enlarged, color-corrected duplicate transparency that returned a normal balance of color to the scene.

Kodachrome slides can end up with a greenish cast from three different conditions or a cumulative combination of all of them. First, as I mentioned, film that is overly fresh is green. As it ages, it becomes neutral. With further aging it shifts toward magenta. Second, to a lesser degree, some properly aged films may also be slightly green because they happen to fall near the outside limit of manufacturing tolerances. Third, processing sometimes favors the green side of allowable tolerances. At this writing Kodak is working to further minimize the allowable green shift in processing of Kodachrome Professional films.

The best way a photographer can stack the odds in his favor is to use Professional film as Kodak recommends: pretest it and have it processed by the same lab that will process the eventual major lot. If the film is not neutral enough after two tests, the photographer has the option of trying another emulsion or filtering to neutralize the hue. Kodachrome Professional films are emulsions chemically similar to amateur Kodachrome that have been properly aged and kept in refrigerated storage so that they are released much closer to their intended color balance. Refrigeration by both dealer and customer is required to keep them at their color aim point (intended color balance). On the other hand, without refrigeration the Professional film will not shift color any more quickly than amateur Kodachrome, which is normally stored, sold, and used without refrigeration.

TECHNICAL DATA *Nikkormat FTN with 24mm lens; Kodachrome 64; hyperfocal distance; f/16 for depth of field and sunstar; sun centered in lens for diffraction halo.*

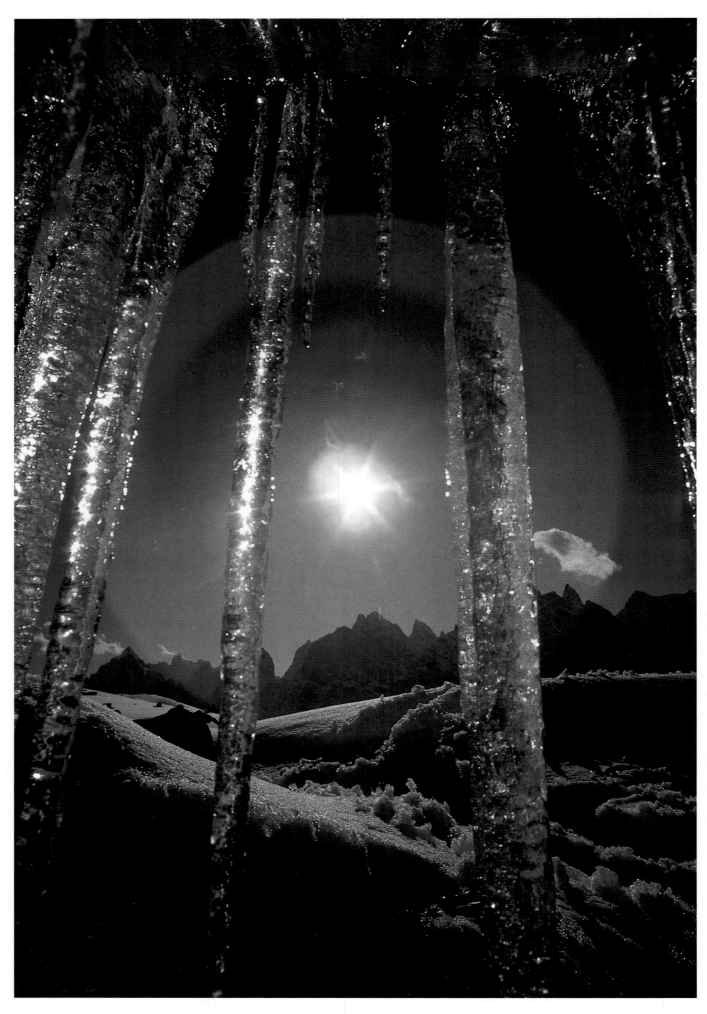

ICICLES ON THE BALTORO GLACIER, KARAKORAM HIMALAYA, PAKISTAN

CHAPTER TWO

Mountain Vision

HOW MOUNTAINS HAVE INFLUENCED MY WORK

My interest in photography did not begin with books or mentors, or with any burning desire to see the world through a camera. It evolved from an intense devotion to mountains and wilderness that eventually shaped all the parts of my life and brought them together. Photography was never simply a hobby or a profession for me. Once I began taking pictures, it became an integral part of my life.

At an early age I began expressing my love of mountains in a variety of ways. I began to climb and explore them. I was fascinated by their makeup, and I had ideas about becoming a geologist. Much later I started to feel the urge to communicate my feelings about mountains and wild places, but even then photography was not my medium. For years I wrote, lectured, and photographed on an amateur basis while supporting myself in a quite unrelated manner.

This book is a further expression of that urge to communicate the ways in which wild places have touched my life. Although its primary purpose is to describe my approach to photography, I do not wish to limit myself to facts and techniques. Not only could I never have learned wilderness photography from such a book, but also, by omitting mention of people who have influenced me it would leave the false impression that I figured out entirely on my own how to fuse intense wilderness activities and still photography into a single career. Though I have never had formal photographic instruction or a photographic mentor, I did indeed have models for the way I came to blend passion and profession, art and athletics into a coherent lifestyle with photography at its epicenter.

I began without defined career goals, but with considerable receptivity to people and ideas. Growing up in Berkeley in a university family meant constantly enduring intellectual gatherings in our home that lasted well into the night. My parents introduced me to scientists, socialists, writers, and musicians, always preceded by a glowing capsule biography of the guest's virtues (invariably embarrassing to both guest and child). A surprising number of Berkeleyites of that period were already environmental activists who spent

considerable time in the wilds. Without their ever knowing it, some of those people became models for me, even though I knew them only through casual meetings with my family.

As I grew up, those "phantom" mentors kept entering my life at unexpected times and places. I would read about them in the media, see them walking in the hills, or perhaps see them practicing mountain skills on nearby Indian Rock. Those who interested me the most had not restricted their lives to a single field of endeavor. They had strong feelings about wild places, and wonderful things seemed to happen as they bridged previously unrelated fields with their wilderness ethic. Their examples were crucial to the way I came to view the world.

My parents were mountain walkers, not climbers; environmental sympathizers, not activists. With hindsight I think that the reason I was able to visualize doing unusual things was not that I had been taught them or seen them done or been hired to do them, but that I had met some special people I greatly respected who I knew could and would do such things if they were in my shoes.

For the first time, at the age of eleven, I saw a large-format book on mountains that had been published by the Sierra Club. Photographs were sandwiched between chapters on the geology, glaciology, and botany of the Minarets region of the High Sierra along with Oriental-style paintings on rice paper.

The book was never sold to the public. A few hundred copies were bound for members of the 1951 Sierra Club Base Camp, a two-week summer wilderness outing. The writing, photography, and art were all the work of the campers. I was proud that the dedication, "Mountains and the Human Spirit," was written by my father, but secretly I was just as proud of the appearance of my own name on page 137 under "Campfire Reports."

Every evening a bonfire lit the heavens at dusk. A hundred-odd campers crowded around for the nightly program as the first stars came out. Most of the campers had at least one hidden talent. Music, drama, and short lectures were interspersed with reports of hikes, climbs, and fishing exploits. The big book reported that on the night of August 6, just after "Lost and Found" and my mother's rendition of "That Sure Feeling with Crampons on a Glacier," I was one of ten actors in a children's skit called "Buried Treasure."

I did indeed find buried treasure on that two-week journey. The camp leader, Oliver Kehrlein, was a spirited amateur geologist. He helped me collect and identify a colorful array of minerals from fresh discovery holes that prospectors in search of lead, zinc, and tungsten had made. Oliver told me that they had found enough ore to make a mining company consider building a jeep road right to our campsite on Lake Ediza.

The idea that civilization may come to the wildest place I had ever seen made a deep impression on me. What could the experience mean, this pure and simple life on foot by day and sleeping bags by night, if next year people were able to drive the miles we had walked in jeeps laden with the comforts of home?

I learned the basics of mountain climbing at that first camp, and later that year I began taking snapshots with a box camera I had won as a prize for selling newspaper subscriptions. Those skills, however, were incidental to a singular passion that began to consume all my spare time. I was fascinated by rocks and minerals and was quite certain that I would someday become a mineralogist. Within the next couple of years, two basement rooms overflowed with samples, and a bookshelf sagged under the weight of the books my father and I found in used bookstores.

I thrived in the role of hunter and explorer, asking questions, examining natural samples, and seeking my own answers. As I went back over my collection, I began to discover that Oliver had misidentified many of my original samples. This first experience of receiving incorrect scientific information from a well-meaning adult made a deep impression. I grew increasingly uncomfortable at school. Knowledge derived from systems that forced my conclusions by both asking and answering questions seemed to me inadequate at best. I distrusted being just a passive ingester of presented material, and I had no desire to pursue a career in any field based mainly on such information. I found myself continually misunderstood, labeled a smart-aleck kid who distrusted his teachers. In fact, I had learned already that knowledge in all fields is in a continual state of flux. My father retired in his seventieth year from his position as a professor of speech and philosophy at the University of California when I was just thirteen. In his new freedom he spent afternoons and evenings telling me how science, religion, and our perception of nearly every subject had changed since his birth in 1884.

Every summer when I returned to the mountains with my parents, my world turned right side up again. With the wilderness as classroom I could ask my own questions and seek my own answers without a middleman to judge my performance or force me in preconceived directions. I began to notice that what I learned through interaction with the environment seemed to lodge in my brain forever, while information gained only by reading lost its fine detail within a few days and continued to fade into a bare outline within a few weeks.

I remember my surprise when I realized that I couldn't recall very many names and dates from my spring classes, but I did remember the names and elevations of every nearby mountain, which I had learned during the previous year's outing, even though I had made no conscious effort to memorize the information. By looking at maps, scrambling up the

peaks, then looking at the maps again, the facts somehow coded themselves into my memory and stayed there.

By the same process I stored an enormous amount of information about mineralogy in my head. I would read a graduate textbook, for me barely intelligible, go into the field and see certain minerals in their native environment, then come back and reread the same text. I became adept at sight-identifying minerals without resorting to normal physical and chemical testing because of the combination of established facts and unstructured feelings I had stored in my memory.

I began to overhear adults talking about my "photographic memory," but I knew that it applied only to subjects that allowed me to carry out the threefold process of study, direct experience, and restudy. It didn't work for me with subjects such as history and English, but I found it was perfectly suited to learning high school physics. My fascination with direct experience of how physical principles worked so impressed my teacher that he found me a part-time job working for Atomic Laboratories, a company that manufactured classroom models to demonstrate physical phenomena. I thrived in physics, decided to make it my college major, won a scholarship to the University of California, and seemed well on my way toward a career, much to my family's relief.

However, new things were happening on the wilderness side of my life. When I was sixteen, I walked sixty miles, mostly without benefit of trails, from the 1957 Sierra Club camp near Devil's Postpile to Yosemite Valley. My eighteen-year-old companion, Mike Loughman, was the camp's rock-climbing guide.

Until then I had avoided serious rock climbing with ropes and pitons because I thought the Sierra Club's style of instruction emphasized equipment and safety over skill and enjoyment. Climbing sessions seemed more like engineering classes than sport. Although I did use some of the special techniques to descend into old mines to collect specimens, I had no desire to do roped climbing for its own sake until Mike introduced me to something very different that summer. Instead of spending the day fooling with ropes and gear, we started right off pushing the limits of what we could do with our own hands and feet.

My confidence grew by leaps and bounds. I learned to deal with my fear not just by using safety equipment, but by precisely discovering my personal limits while Mike belayed me from above. One day he coaxed me up a fifty-foot cliff that was far harder than anything I had done before. When my legs began to shake involuntarily with what climbers call "sewing-machine leg," I was certain I was going to fall, but I managed to detach my mind from my quivering legs and hold on all the way to the top.

Later I watched Jerry Gallwas, the camp cook, wander up and, unroped, climb the

same cliff with the flawless grace of a dancer. Over the next few days I noticed that this shy "older person" of about twenty-one studiously avoided climbing sessions with lots of ropes and pitons. He seemed to climb only when he could enjoy the freedom of movement of his own body on the rock. Then I learned that just a few weeks earlier he and two friends had climbed the face of Half Dome for the first time in history. I had simply assumed that walls like Half Dome and El Capitan were beyond human capabilities. They seemed ultimately foreboding.

Weeks later, when Mike and I arrived on foot at the rim of Yosemite Valley, I looked at the face of Half Dome and had new feelings about it. Knowing it had been climbed, knowing the person who had climbed it, and being something of a climber myself gave me a feeling of personal involvement with its destiny. Half Dome had long been an icon in my life. I had seen it before I could walk, chosen a boulder to represent it in a backyard model of Yosemite Valley for my fifth birthday party, and hiked along its base more times than I could remember. The way that first ascent of Half Dome changed the rock's character in my mind is similar to the way the Apollo missions changed my feelings about the moon a dozen years later.

Mike and I spent several days that summer climbing some of Yosemite's minor features. We weren't burdened with equipment, and as we embarked onto vertical oceans of granite with just a rope, a hammer, and a sling of pitons, I felt a total concentration of my senses beyond anything I had ever known. Time seemed to stand still as my feet, eyes, hands, and mind worked together with a sense of flowing that made me feel that there was nowhere else in the world I would rather be.

After I returned home, my friends asked if I had photographs of my adventure. Neither of us had taken a camera. It had not occurred to us to try to verify the truth of our experiences with photography. Even with hindsight I had few regrets, because I doubted that the altered state of mind that was so important to me could ever have come across on film. My accomplishments seemed strictly personal, and I had no desire to try to re-create them in other people's minds.

As I recount this part of my past, it seems improbable that I became a wilderness photojournalist. I would not have done so, were it not for the unexpected way in which people and events came together for me over the next year to make wild places the ultimate focus of my life. Climbing in Yosemite wove together many of the contacts and values of my childhood that had previously seemed unconnected.

During the winter after my Yosemite adventure, I began reading everything I could find about rock climbing. I learned that climbers had begun to use ropes and pitons in the mountains of California quite recently. Only twenty-six years earlier a Harvard climber

with experience in the Alps had introduced the proper use of the rope to members of the Sierra Club at the annual outing. The trip was described in the club's journal by a young man named Ansel Easton Adams, who cautioned that rock climbing "should be accepted with the greatest enthusiasm; yet I feel certain values should be preserved in our contact with the mountains . . . we should bear in mind that the mountains are more to us than a mere proving-ground of strength and alert skill."

I believed that overemphasis on equipment could threaten the aesthetic values of climbing, but I didn't agree with the inference that there was something wrong with pushing one's physical and mental potentials to the limit through climbing. I wished that Adams had been able to see rock climbing as done by people like Mike and Jerry, instead of the equipment-burdened style of practice climbing that had turned me off at first too. My mother pointed out that a neighbor who had once been my father's student was just the kind of climber I would like. Instead of practicing with ropes and pitons in the vicinity of the Sierra Club camp each summer, Dick Leonard, a middle-aged attorney, had made the hardest climb of his era in Yosemite in 1934 on Higher Cathedral Spire. Although I never climbed with Dick, he became one of my phantom mentors.

Leonard's firsts were not limited to mountains. Over the years he had synthesized his love of wilderness and his legal career into a law practice that extended ideas in the Bill of Rights to protect land and animals as well as people. As president of the Sierra Club in the mid-fifties, he was instrumental in its very first environmental stand on an issue outside the state of California. The club's decision to defend Dinosaur National Monument in Utah against a proposed dam was a turning point for me too.

At the age of thirteen, I had become a walking encyclopedia on the Dinosaur affair, not so much because of my interest in conservation as because I happened to apply to it the threefold process of sandwiching personal experience between periods of study that had given me a "photographic memory" of other subjects. My family visited the national monument that year more because of my interest in geology than because of controversy over the proposal to build a huge dam within national park boundaries.

I read several articles before the trip, searching through discussions of the dam for information on dinosaur fossils. Also, I asked my father about bringing my new Geiger counter, because Dinosaur was in an area where people were striking it rich with uranium. When I talked about getting lucky, my father pointed out the irony of what I was considering. What would I do if I discovered uranium on park land? Would I want a permit to extract it? The controversy over the dam centered on a similar issue, permission to extract water and power from a national preserve.

At school that fall I wrote a term paper on the Dinosaur issue. At my father's urging I

interviewed a neighbor, David Brower, who had just become the Sierra Club's first executive director. He had testified about the dam in Washington, D.C., and was beginning a national campaign to educate the public through newspapers, magazines, and personal appearances. I came away from the interview feeling that I had never before been in the presence of anyone so enthusiastic, informed, and articulate about what he was doing as Brower was. Brower and his job were one.

David Brower's name graced every other page of my Sierra climber's guidebook: he had made first ascents all over the range before settling down, like Leonard, to shape his love of wilderness into a unique career. As one of the world's first professional environmentalists, he had a wide range of choice about how to approach his job. Lobbying in Washington for Dinosaur was a necessary task, but he had something far more innovative up his sleeve. He was about to turn the Sierra Club from an occasional publisher of regional guidebooks into the nation's most outstanding publisher of photographic books on wild places, the quality of which far exceeded anything of the period. The Exhibit Format Series combined color wilderness imagery and conservation writings to create stunning books too large to be stored on most book shelves. Wherever they gained entry to a home or office (they were donated to senators), they functioned as Trojan horses of environmental concern, displayed for all to see on mantles and coffee tables.

Through Brower's efforts the Sierra Club's endeavor to prevent the building of a dam in an obscure national monument eventually changed the quiet outing club I knew so well into a worldwide force for conservation. I watched the controversy grow from a tiny seed into something that overwhelmed the club's other activities by the time I graduated from high school. During those years the mainstream of climbing in California moved away from Sierra Club outings into the hands of individuals who were usually nonmembers. I had mixed feelings about that, and I thought about it a great deal. To be witnessing the end of one era and the beginning of another in two fields at once had to be more than coincidence. I sensed a direct connection between mountain climbing and the environmental movement, but I wasn't sure exactly what it was.

When I thought about the way the Sierra Club was changing, I found strong parallels in the lives of my phantom mentors and some of their predecessors, beginning with John Muir, who had influenced the club right from its birth in 1892. In his case a youth of self-discovery through climbing and exploring had been followed by a middle age with an emphasis on writing about and saving the environment. Brower's case was similar except that he mixed publishing with his writing. Leonard's resembled Brower's except that he wrote legal briefs dealing with natural values instead of popular texts. Adams fit the pattern perfectly too, substituting photography for writing.

The Sierra Club itself was experiencing a similar evolution, yet there was an inconsistency. The time frames didn't coincide. What happened within individual lifetimes was happening over the course of a far longer period to the collective life of the institution. I could see no reason why the club's course and the courses of all those people I respected would have so many elements in common unless there was a hidden link between the youthful pursuit of climbing mountains and the actions of mature conservationists.

Of course I was intrigued by the notion that I might fit the general pattern. Thinking about this, I stumbled onto the idea that none of the key figures of the Sierra Club's conservation movement had entered careers through a normal course of study. Their writings and photographs had not come as a result of pursuing a college degree or any other project conceived for an external reward, but rather as expressions of deeply held beliefs. Muir, Adams, Leonard, and Brower took their power from situations where they had to actively adapt themselves to their natural surroundings. They did not follow the conventional approach of changing their environment to suit their needs. Through climbing mountains, where the very essence of the experience is based on the natural character of the terrain, they discovered a new way of viewing the world that profoundly changed each of their lives. Applied on a larger scale, the environmental movement was born.

I did not follow directly in their footsteps. The realizations I had gained set my life on a new course, but it did not lead immediately to wilderness photojournalism. In college, despite my interest in physics and geology, I failed to find an area of study that gave me the hands-on feedback I so intensely craved. Unable to imagine myself in a career based on my studies, I switched majors several times, from physics to geology to the humanities. After several years of mixing school, climbing, and repairing cars for spending money, I quit college and opened up a small automotive service business with a couple of friends as employees.

What was intended to be a temporary interruption in my education consumed the next decade of my life. My little business gave me much of the personal freedom I desired, and unwittingly I started to fall into the course of my phantom mentors. What I did in the wilderness had no purpose other than sheer enjoyment and personal satisfaction. On weekends and short vacations I climbed mountains and began exploring ever more remote corners of the California Sierra.

Often when I walked alone in the mountains, I tried to make sense out of the two halves of my life. What went on in the city during the week seemed chaotic and unrelated to the events in my mountain world. As I walked up a mountain to timberline, I felt a renewed sense of simplicity and understanding. Here was life reduced to bare essentials, a place with fewer species, fewer interactions, and so little vegetation that the bones of the

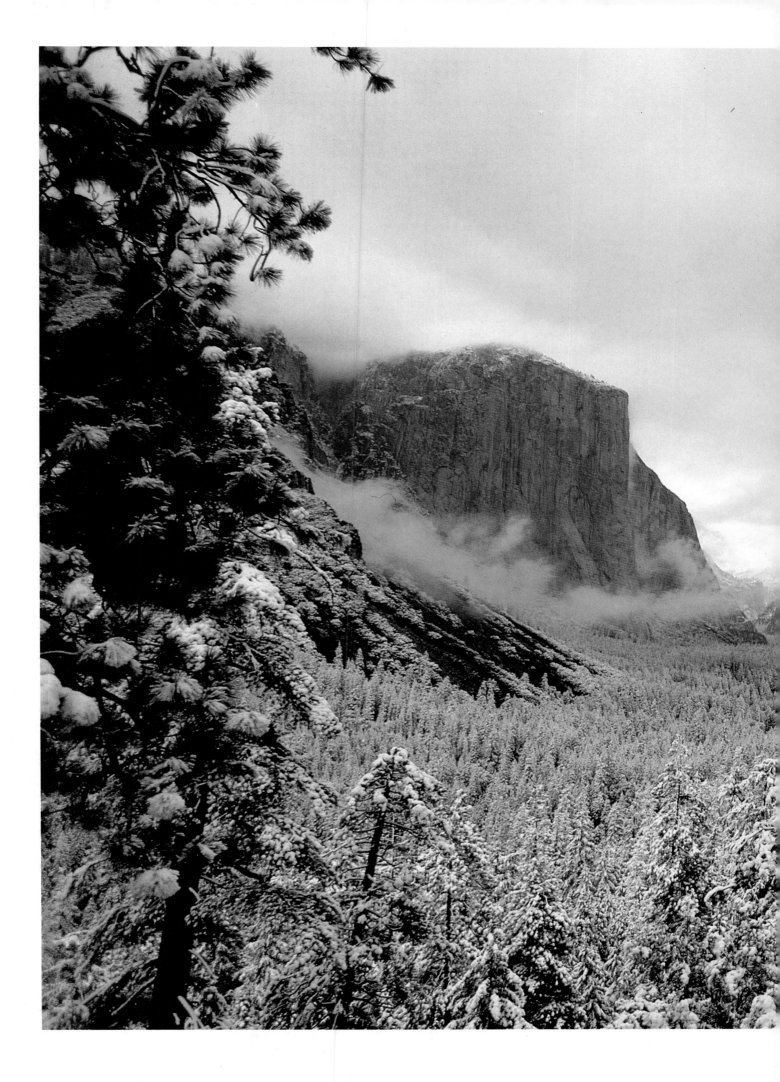

EXHIBIT III SOFT LIGHT 63

grasses that became a cover of *Garden* magazine, a national journal for botanical societies.

What I wanted for myself, however, was an image that conveyed a sense of the elegance of this little island of wildness so close to the road. It had to show detail, be intimate, have character, and include the aspen forest. Somehow the showy flowers didn't help me. They made the scene look gaudy rather than intimate, as if I were indeed photographing in some sort of garden, however natural it happened to be.

I chose the aspen tree in this image because of the atypical curving bulge at the top of the frame and the way it balanced with the wild rose below. I found it most difficult to make a satisfactory image, however. It took a frustrating half hour to translate the vision in my mind into one I could see through my viewfinder. I liked the perspective I got with my 55mm macro lens, but the image looked too contrived with just the tree, the rose, and the clearing. I solved the lone-tree problem by setting my camera angle low enough to include a hint of forest in the distance. The single rose gave me similar problems, so I included another rose on the opposite side at a greater distance, but the symmetry didn't look right until I hit on the idea of making the two roses part of a diagonal line that went through the dark knot on the aspen trunk.

During all the time I took to work out the composition, the weather cooperated by keeping an even cloud cover overhead. I metered this image at one-half second with the aperture closed down to f/32 for maximum depth of field. I then compensated for the reciprocity failure of the film at this slow speed by giving it an extra stop of shutter speed—a one-second exposure. I used no filters, knowing that reciprocity failure would slightly warm up tones under the cool, stormy sky.

In later years I made it a point to stop at my "secret glade" as often as possible. The perfect soft light did not occur again, although I made many more images that continue to give me pleasure. One year I drove right by the glade and had to turn around to look for it. I finally found it: it will never be the same during my lifetime. Where I took this picture, aspen stumps now jut from trampled ground; and the water course has been disturbed. The trees may have barbecued burgers in the nearby campground or warmed the air of a cabin in a nearby Forest Service tract: for me, however, they live on in this image.

TECHNICAL DATA *Nikon FTN with 24mm lens; Kodachrome 25; f/32 for depth of field.*

FALL STORM OVER YOSEMITE VALLEY, CALIFORNIA; 1971

The first storm of the season sometimes gives the trees and cliffs of Yosemite Valley the fine texture of an etching. Half an hour of sun can erase that quality; an extra hour of snowfall may bury it. In the case of this photograph, I had been stuck all night on the Tioga Pass road by a surprise September snowstorm. Just before dawn the road was plowed and I drove into the valley as the clouds were lifting. Noticing that snow clung to trees and grasses but not cliffsides and rock slopes, I realized that a broad view of the valley might look especially fine.

I drove to the traditional viewpoint at the Wawona Tunnel and took photographs on a tripod with several lenses of normal and short telephoto focal lengths. I was especially taken by the way the snow-covered forest defined the cliffs, and I decided to emphasize that effect by trying my 24mm lens. At first I had trouble figuring out a pleasing composition in which one of the two dark trees on either side of my camera didn't intrude on the image. Since Bridalveil Fall was not flowing at all, I compromised by inching my tripod so as to let a snowy branch obscure part of the fall's empty black apron and yet preserve the line of ridge crest from there to the edge of the frame. Once this complicated part of my composition fell into place, I leveled my camera and bracketed several exposures.

When I first projected this image for some photographer friends, one of them said it looked like a negative for Ansel Adams's famous "Clearing Winter Storm," taken in 1940 from the same location. I got out an old Hills Brothers coffee can I had saved that displayed that image as a full-size wraparound. The comparison amazed us, because the values were indeed reversed. Adams had photographed a clearing *winter* storm after most of the snow had melted from the trees. His trees were black; mine were white. His talus slope in front of El Capitan was white; mine was black. His sky was ominous and dark, rendered through a yellow filter; mine was nearly white, because the clouds were lighter than my exposure for the ground. Both images gave roughly the same feeling of openness even though Adams did not use such an extreme wide-angle view. Thirty-one years earlier, the trees were much smaller.

TECHNICAL DATA *Nikon FTN with 24mm lens; Kodachrome II (ASA 25).*

ASPEN AND WILD ROSE, LITTLE LAKES VALLEY, HIGH SIERRA, CALIFORNIA

JEFFREY PINE AND JUNIPER ON OLMSTED POINT, YOSEMITE, CALIFORNIA

At Olmsted Point I ran up the hill to the pair of dwarfed trees. There they were, commanding full visual attention for the first time in my experience. I set up a tripod and used a 24mm lens to spread the trees and rocks over the curve of the dome. I used a Nikon A2 (81A) filter to cut the bluish cast of the storm and a slow exposure to streak the snowflakes and to obtain a wide range of depth of field.

TECHNICAL DATA *Nikon FTN with 24mm lens; Kodachrome II (ASA 25); 81A filter; slow exposure.*

ASPEN AND WILD ROSE, LITTLE LAKES VALLEY, UPPER ROCK CREEK, HIGH SIERRA, CALIFORNIA; 1976

One of my favorite mountain areas is Little Lakes Valley at the head of Rock Creek. A profusion of wild granite peaks, glacial lakes, and green meadows lies just beyond the end of the highest paved roadhead in the Sierra Nevada range.

For many years I have escaped the heat of the Owens Valley in summer by driving to 10,400 feet and hiking into the John Muir Wilderness. In winter I've ridden by snow cat, operated for the public by Rock Creek Lodge, into what legendary Sierra mountain man Norman Clyde called the best ski valley in the whole range. In gaining easy access to such a high and beautiful place, however, I passed time and again, without ever stopping, within a stone's throw of the site of this photograph.

Then one afternoon a thundershower chased me down from a day hike. I dawdled along the road, stopping to check out trees and streams that I had given only sidelong glances in the past. In one spot I stepped into a wet bog but decided to continue anyway. Only thirty feet from the road I was surrounded by aspens and flowers in a glade watered by a natural spring. At least twenty species of alpine flowers were near the height of their bloom. Within minutes I had made an image of the spring water snaking through columbines and

CIRQUE OF THE UNCLIMBABLES, LOGAN MOUNTAINS, NORTHWEST TERRITORIES; 1973

All the qualities of this remote wilderness came together in this scene, where water snakes through an alpine meadow toward lichen-draped boulders, sheer granite walls, snow, and a typically gray sky. The classic curve of the stream and the soft light filtering through the clouds added a gentler nature to the scene in spite of the sheer walls in the distance.

In 1972 I camped within a stone's throw of this spot for two weeks with my friend Jim McCarthy, who had taken me to his favorite place on earth—the Cirque of the Unclimbables. It lies in the Canadian North in a completely roadless area larger than California. At the time Jim assured me that fewer than twenty-five people had ever set foot in the cirque, which I found astounding because it was more beautiful than anything I had seen in the national parks in the United States. I took many photographs that year, including several of this same peak from this same meadow, but the composition didn't really work because I never got a good feeling of balance between the peaks and the meadow below.

When I returned the next year, I knew exactly what I wanted. I knew that the magic of the place just wouldn't come out in high-contrast photographs made in bright sunlight. When the sky was cloudy-bright and the carpet of grass was evenly lit without shadows, I set out with my camera to find a balanced view of the classic granite peak—Mount Harrison Smith—and the bouldered meadow that looked like something around Stonehenge.

I chose a 24mm lens to emphasize the S curve of the stream in the foreground and worked carefully so that the reflection of the peak was not cut off by either bank. Since the light was darker and more bluish than I would have liked, I used a Nikon A2 (81A) filter to neutralize the cast. The camera was on a tripod with a small aperture to hold a large field of focus.

TECHNICAL DATA *Nikkormat FTN with 24mm lens; Kodachrome 25; 81A filter.*

JEFFREY PINE AND JUNIPER ON OLMSTED POINT, YOSEMITE, CALIFORNIA; 1973

Olmsted Point along the Tioga Pass highway is a favorite stopping place for photographers. There the views are more spectacular and varied than anywhere else on the west side of the pass. Looking to the southwest, one sees, from an unusual perspective, Half Dome rearing its great head above Yosemite Valley. Eastward is a splendid high-country panorama made famous by an Ansel Adams image that shows Lake Tenaya sandwiched between Tuolumne domes with Mount Conness in the distance.

When I drove over the pass on my way to Sierra peaks in the early sixties, I sometimes saw photography classes wandering through an unusually large grove of western junipers at Olmsted Point. Stately trees with wonderfully curved limbs and trunks rise forty feet and more above the white arc of the dome. Their roots take hold in barren cracks that allow them to occupy auspicious locations that command views in all directions.

The appearance of junipers in the High Sierra has fascinated me ever since the age of ten when a naturalist taught me to identify the trees around my family's camp by counting the needles and examining the cones. I quickly learned to tell one pine from another, but I was stumped when I came across this "foreign race" with berries and no needles at all. Western junipers occur in special arid situations where temperature and moisture conditions favor their growth; in those same conditions a few Jeffrey pines also manage to grow, stunted and twisted into remarkable forms. (Perhaps the most famous Jeffrey pine in the world is the lone tree atop Yosemite's Sentinel Dome.)

Less than fifty feet from the Olmsted Point parking lot at the edge of the grove of junipers is a spot where a young juniper and a dwarfed Jeffrey grow side by side near two erratic boulders, left behind by the last retreat of the ice. This meeting place on top of a small dome seemed very powerful to me, but it didn't come across as such in my photographs when I tried to use it as a foreground for High Sierra landscapes.

Then one day I was driving back across the pass in a fall snowstorm. Distant vistas were obscured, but objects close by took on the appearance of old etchings, defined only by highlights of white snow and dark ground. (This quality lasts only until the snow sticks enough to cover the ground; sometimes just minutes, a few hours at best.)

CIRQUE OF THE UNCLIMBABLES, LOGAN MOUNTAINS, NORTHWEST TERRITORIES, CANADA

EXHIBIT III
Soft Light

When the sun goes behind a cloud, many landscape photographers put away their cameras. Contrasts necessary to give distant features a sense of power and form tend to disappear in soft light. So do specular highlights—the reflected bright spots on the surface of things that create texture, pattern, and sparkle. Yet at the same time, color film reaches its zenith; more aspects of the landscape can be photographed successfully in soft light than at any other time.

As soon as I see that the shadows are gone in an outdoor situation, I know that I have soft light and a contrast ratio well within the limits of my film. I can photograph faces without fear of having them go partially black; I can shoot forest detail that would otherwise be splotched with light and dark spots, beyond hope of rendering as a color image.

The best kind of soft light comes under a cloudy-bright sky. Then the whole canopy of the atmosphere acts as a giant white umbrella that throws even white light everywhere. Studio photographers imitate this light by using large light banks or "soft boxes" so close to a model's face that no hint of shadows or specular highlights occurs, thus making skin look soft and perfectly even.

The clean, even colors that come in nature under a cloudy-bright sky are not found in shadows on clear days or under dark storm clouds. They happen only when nature's umbrella is white, a situation that can be caused by clouds, fog, light rain, or snow. If I am on assignment and these conditions present themselves, I shift gears to take advantage of the light and consequently make some of my most important outdoor images of people. If I am in the mountains, I look for the colors of flowers and meadows to come alive. When the air is clear beneath the clouds, there is the potential for making a classic landscape, with mountains in the background and a softly lit foreground scene that doesn't overpower the whole.

land stood out for all to see. The higher I went, the more simplified things became. Beauty and purpose began to shine through. A lone whitebark pine, twisted and stripped of bark by the elements, evoked far more emotion from me than a whole forest of perfect trees far below. Budding flowers that barely reached my ankle touched me in a way that waist-high blooms in a lush meadow never had. Mountain skylines formed by natural forces working through time seemed to have more architectural continuity than any cityscape I had ever seen. Here were things that touched my soul, images that I wanted to share, but I didn't know how.

FALL STORM OVER YOSEMITE VALLEY, CALIFORNIA

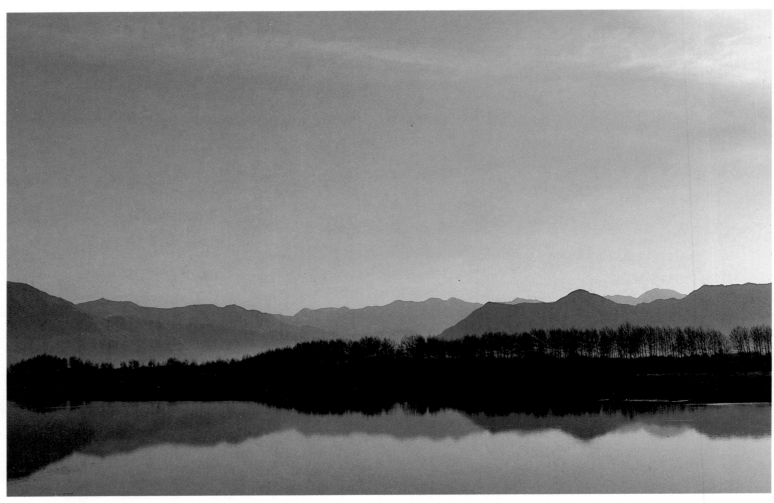

VALLEY OF THE TSANGPO RIVER, TIBET

VALLEY OF THE TSANGPO RIVER, TIBET; 1981

When I first visited Tibet in 1981, only an estimated twelve hundred non-Asian foreigners had ever seen the holy city of Lhasa. Six hundred twenty-three of them were members of the British 1904 Younghusband Expedition, which forced the Tibetans into diplomatic relations with the Crown, thus bringing the isolated kingdom into a political arena that hastened its downfall at the hands of the Chinese, who wanted Tibet either totally independent or under their direct control. As early as 1910, the Chinese entered Lhasa with an army that scorched and plundered, demanding allegiance to Peking.

I came to Tibet via Peking as the leader of the first American trekking group allowed into the Tibetan backcountry. The People's Republic of China had given our group of fifteen a permit to visit the base of Mount Everest, and our first stop in Tibet was Lhasa. After a flight over a forbidden sector of the Tibetan Himalaya in an ancient Russian prop plane, we landed at an airport more than a hundred kilometers from the fabled city.

As we followed a dirt road through the valley of the Tsangpo River, I remembered a glowing description of the first sight of Lhasa written by Heinrich Harrer, the German mountaineer who escaped from a British prison camp in India during World War II, and who then crossed the Himalaya on foot to sneak into the holy city. Like we did, Harrer followed a tributary of the Tsangpo, the Kyichu River, into Lhasa. He wrote that suddenly he "turned a corner and saw, gleaming in the distance, the golden roofs of the Potala, the winter residence of the Dalai Lama and the most famous landmark of Lhasa. . . . We felt inclined to go down on our knees like pilgrims."

I expected the same vision, forgetting that Harrer arrived in the clear air of midwinter and that we were coming in spring. We rounded a corner, looked toward Lhasa, and saw only haze. Our van stopped beside a fifty-foot-high Buddha carved in

EXHIBIT III SOFT LIGHT 67

the mountain wall, but I spent most of my time looking in the opposite direction for a glint of gold through the haze. The sun was high in the sky, and there were no defined shadows in the direction of Lhasa. My first inclination was not to take a photograph at all because I knew empirically that midday light under a clear sky is too harsh for satisfactory landscapes. Still, something was different here.

Had I posed a human subject in front of the scene, the light would have been as awful and harsh as I had expected. Black shadows would have fallen across the person, and the photograph would not have been satisfactory without reflectors or strong fill light to even out the scene. But in the distance—the great distance of Tibet that was always so much farther than it seemed to my eye—the hazy atmosphere evened out the light. There were no harsh blacks or whites in the landscape, no shadows to turn black. The landscape itself was bathed in soft light at high noon because of the scattering effect of the atmosphere.

The scene had a celestial appearance because the features of the landscape were indeed hanging in a blue sky that enveloped the ground as well as the heavens. The same scattering that causes an all-pervasive blue overhead was affecting the features before me, which were reflected in the waters of the Kyichu River. Only the line of trees on the far bank was close enough not to be muted by the blueness. In valleys, peaks, and sky alike the distance and dust in the air had softened the light as surely as fog or mist in closer quarters.

I used Kodachrome 25 film to hold maximum sharpness and exposure latitude as well as to minimize ultraviolet response. Kodachrome 25 is much less responsive to this invisible energy than its faster counterpart, Kodachrome 64, which records ultraviolet as a bluish cast. Lhasa is at nearly twelve thousand feet, where ultraviolet radiation is much stronger than at sea level; and since my image was dependent on the subtle separations of blue tones,

I couldn't afford to risk an overall cast that would pollute those gradations.

The line of trees was important to give a feeling of sharpness in the soft light, so I was careful to render it as clearly as possible by using an aperture of f/8 on my 24mm lens with my camera on a tripod. I selected a portion of the river that showed no surface ripples indicating its direction of flow in order to convey the sense of stillness I felt. A horn blared three times as I bracketed exposures. Our Chinese driver was in a hurry to get us to Lhasa. Once there, we waited for five more hours, five miles from town, while our $150-a-day-per-person accommodations were readied (six to a room with no hot water), although they had been booked a year in advance.

Two years later, as climbing leader of an Everest expedition, I revisited Lhasa and had to stay at the same guest house for foreigners. One morning I snuck out before dawn in my running clothes and joined thousands of pilgrims circling the Potala Palace in the rising sun, passing dozens of little sacred fires by the side of the trail. Buddhism was regaining some of its old strength, and open worship was once again being allowed. I was welcomed into the procession, where not a Chinese face was to be seen. For a few minutes I experienced the Lhasa of Heinrich Harrer's day; on foot, at one with a happy independent people.

After three circumambulations of the Potala, I broke into a run again and followed the banks of the river through Lhasa, seeing water that would eventually cross the Himalaya and spill into the Indian Ocean. When I came back through town on the way back to the guest house, the pilgrims had ceased circling the Potala. Their fires were dying embers, and they sat in small groups by the side of the road, ready to begin a modern day in Lhasa.

TECHNICAL DATA *Nikon F3 with 24mm lens; Kodachrome 25.*

YELLOW POPPY BELOW ANYE MACHIN,
NORTHEASTERN TIBET; 1981

My first visit to Tibet included two back-to-back expeditions, one of which was to the Mount Everest region, where I was quite disappointed in the general appearance of the countryside. The land looked like a freeze-dried Nevada. Indeed, much of the terrain is like the most barren parts of that state, but far colder.

Nevada is arid because Sierra peaks reaching 14,500 feet put it in the rain shadow of prevailing moisture patterns from the Pacific Ocean. The Tibetan side of Everest is even more arid than Nevada because Himalayan peaks twice the height of the Sierra put it in the rain shadow of monsoons from the Indian Ocean. When I went to the North Col of Everest, I didn't have to change from running shoes to mountain boots until I finally reached snow line at 20,500 feet.

This image was made just a few weeks later in northeastern Tibet—now Chinghai Province of China—where moisture from the South Asian monsoon penetrates from Southeast Asia. There I found lush beauty similar to that of Alaska: ice and green grass in close juxtaposition. Even many of the flowers were familiar, because during the Pleistocene ice ages a circumpolar zone of cold-weather vegetation ringed the earth at temperate latitudes north of the equator. Thus, I found buttercups, gentians, monkshood, and cinquefoil that reminded me of my home mountains in North America.

However, the flashiest plant in the Anye Machin Range was totally unfamiliar to me. Hundreds of large yellow poppies dotted wet meadows up to sixteen thousand feet. They were so prominent in the landscape that throughout history visitors have taken notice of them. Tibetan lamas gathered them for dyes used for the yellow hats of the Geluk-pa sect. Joseph Rock, who wrote about the area for the *National Geographic* in 1930, identified them as *Meconopsis integrifolia* and collected specimens for Harvard's Arnold Arboretum. (Rock was a botanist by profession but not by education. His biographer later traced his beginnings to the U.S. Forest Service headquarters in Washington, D.C., where the young Rock "informed the startled officer in charge that the division needed a herbarium," then "identified himself as a botanist and proposed that he be the man to collect for the division. Arrogance, charm, and the fact that no one checked his credentials carried the day for him.")

Our expedition climbed Anye Machin, a 20,610-foot peak that Rock had reported to the world as a rival of Mount Everest. His manuscript for the *Geographic* claimed the mountain was 30,000 feet high, but the editors decided to be more conservative. The final text reported: "Twenty-eight thousand feet, or almost as high as Everest, its tallest peak lifts its snow-white head, majestic as the Matterhorn."

Our base camp at fourteen thousand feet was dominated by visions of Anye Machin and of the yellow poppies sprinkled over green meadows. I searched for a place to bring these two most important aspects of the landscape together in one photograph, but I had difficulty getting a composition to work because of the broad foreground necessary to include a number of the widely scattered poppies. Lighting was also a problem. In shade the poppies seemed flat; in bright sun the leaves of the plant cast distracting shadows. In both cases an exposure for the flowers would have washed out the snowy peaks.

One morning I awoke to diffuse light breaking through clouds. The poppies seemed to glow in the light, and their leaves stood out from the landscape as never before. After some searching, I found a flower positioned perfectly in front of Anye Machin II, a peak 50 feet lower than the highest summit we climbed. (Somehow the Chinese mistook it to be the highest peak in the range, surveyed it to be 23,491 feet in 1960, and climbed it a few days later, continuing Joseph Rock's bad habit of reckless exaggeration.)

I wanted an image that emphasized the poppy more than the mountain, so I moved in close with a 55mm macro lens and selectively focused on the foreground. I worked to set the sunlit leaves of the plant entirely against a dark foreground hill, both to make them stand out properly and to keep them from clashing with the fine curve where dark hill joined snowy mountain. Then I closed down the aperture to about f/16 in order to bring the mountain partly into focus. The brightness of the mountain overwhelmed the flower, so I put on a split neutral-density filter that darkened the upper part of the image by two stops, thereby making the flower itself the brightest object. My large tripod, brought in by yak train, wouldn't go low enough. In order to use a small aperture and slow shutter speed, I resorted to the tiny Minox tripod, weighing four ounces, that I carry in my camera bag.

TECHNICAL DATA *Nikon F3 with 55mm lens; Kodachrome 25; f/16 for depth of field; split neutral-density filter to hold back exposure in the mountain.*

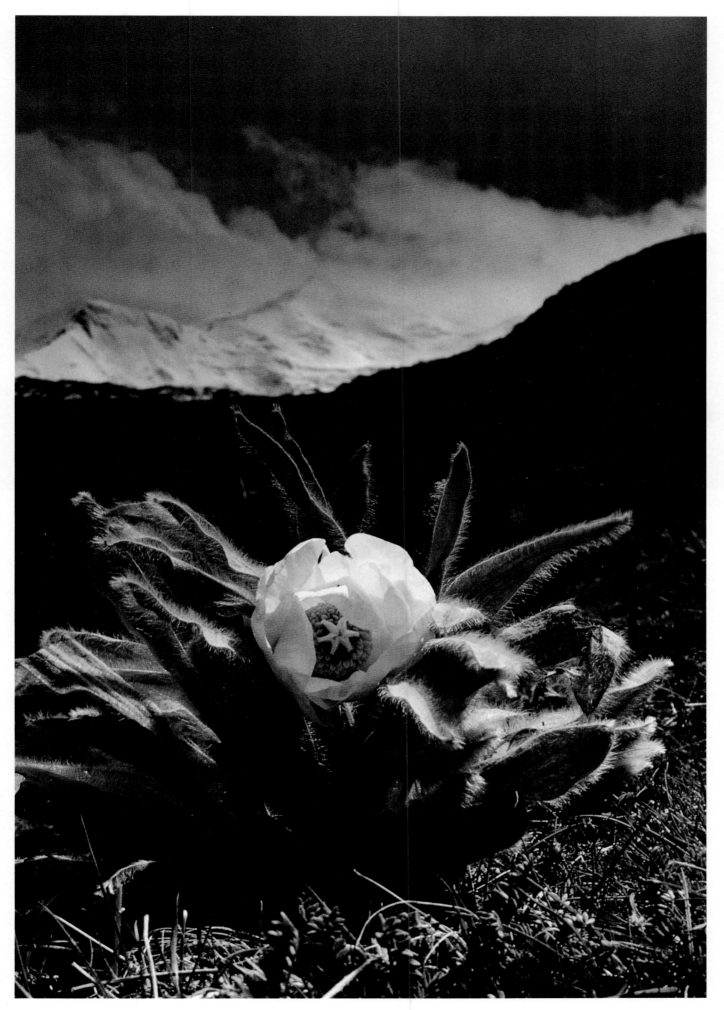

YELLOW POPPY BELOW ANYE MACHIN, NORTHEASTERN TIBET

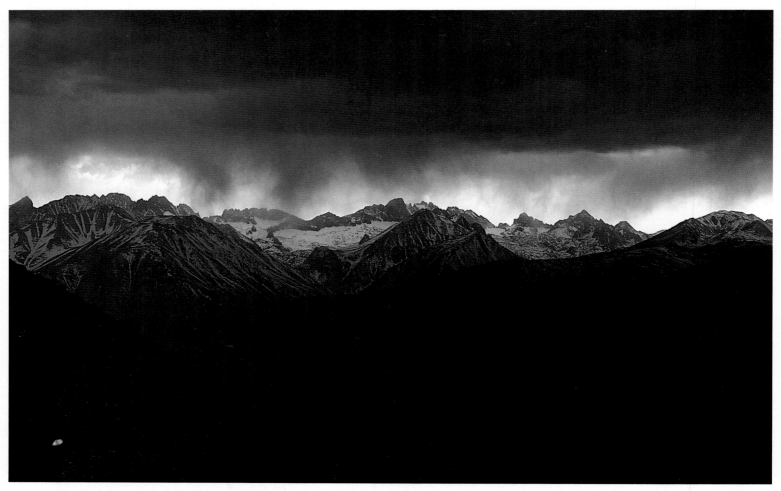

STORM OVER THE PALISADE RANGE, HIGH SIERRA, CALIFORNIA

STORM OVER THE PALISADE RANGE, HIGH SIERRA, CALIFORNIA; 1976

My favorite highway is U.S. Route 395 just east of the High Sierra. On a clear day hundreds of miles of peaks on the crest are visible, with one major exception. The most glaciated of all, the Palisades, lie almost hidden beyond a front range. For an unobstructed photograph a detour is necessary up the Westguard Pass road. Near Tollhouse Spring a cleft in the White Mountains in the foreground perfectly frames the Palisades, but at such a distance the air quality is a major photographic problem.

I once shot several rolls of telephoto on a clear winter morning after a storm. To my surprise only the shorter telephoto images were of publishable quality. Anything over 200mm had a flat and fuzzy look. The sheer quantity of air, regardless of how clean and clear it was, degraded the images made with long lenses in color, contrast, and sharpness. I returned to this viewpoint in the summer and found the air so hazy that no photog-

raphy of the distant peaks was worthwhile. Several years later I drove the same road and camped in the White Mountains to photograph bristlecone pines. The next afternoon a heavy thunderstorm hit. Lightning struck nearby, and I decided not to test fate on the crest of the range. As I drove back toward the Owens Valley, I dropped underneath the brooding clouds and saw the Palisades as clearly as on a winter morning. The storm had washed away the haze.

I remembered from my winter images that long telephotos hadn't been sharp and shorter lenses had produced undramatic scenes. Even the best compromises taken with short telephotos didn't produce top results because the subject had little emphasis. The peaks looked like a narrow strip of corrugated snow sandwiched between lots of blue sky and foothills.

Now, however, the storm clouds added a new dimension. They were at just the right level for my vantage point at Tollhouse Spring. When I got there, I drove up and down the road to open

EXHIBIT III SOFT LIGHT 71

and close the bright gap between the peaks and the clouds until it was just right. When I was too high, the gap was wide; when too low, the clouds merged with the peaks. After finding the right vertical distance, I got out of my car and moved sideways to find just the place where the sagging bursts of rain would line up with the highs and lows of the Sierra crest. Once I found what I wanted, I set up my tripod and used a 105mm lens with a Nikon A2 (81A) filter to cut the bluish cast. Because I was unsure of exactly how the film would render the radically different values of the bright sky, white snow, shadowy mountains, and thick clouds, I bracketed exposures above and below my meter reading. Only the darker image held enough detail in the highlights and enough blackness in the storm to give the scene the feeling I experienced when I was there.

TECHNICAL DATA *Nikon FTN with 105mm lens; Kodachrome 25; 81A filter.*

VALLEY OF THE TEN PEAKS, BANFF PARK, CANADIAN ROCKIES; 1973

Carl Sharsmith, a legendary Yosemite botanist and an old friend of my family, was asked by a tourist what he would do if he had only one day to spend in the park. He replied, "I'd cry."

I was faced with a similar dilemma in Banff Park in the Canadian Rockies. I had one day to spare between flying down the Alaska Highway in a small plane and driving home to California with my family. Had that day been in Yosemite, the odds are good that it would have been warm and sunny. I could have climbed a peak, hiked a trail, or gone swimming in a mountain lake. In Banff, however, things were different. It rained steadily as I drove a carload of tired travelers through the park, searching for something to hold their interest.

From Lake Louise we took a side road to Moraine Lake in the Valley of the Ten Peaks. As we came out of a forest into our first open view of the mountains, I saw wildflowers in profusion on the hillsides. The rain had slowed to a light drizzle, and the wet flowers seemed to glow with an intensity far greater than normal. In the distance I could see a downpour in the valley itself, right where we were heading. Had I not seen the heavy rain ahead and felt somewhat responsible for the happiness of my passengers, I probably wouldn't

have stopped where I did. I chose a field of flowers that climbed a hillside toward the distant peaks, hiding the lake and highway in between.

My son and daughter, aged five and nine, respectively, began to frolic through the flowers as soon as the car door opened. I kept them from trampling the scene I planned to photograph, which was about fifty feet from the car.

I set my camera on a tripod and wrestled with the need to make compromises in order to get a decent image. A flower photographer's hell is a place of tremendous beauty where every species in the world stays in bloom in continuously perfect light and where a gentle breeze blows eternally, making sharp photographs impossible. Here the breeze was light but sufficient nevertheless to move the tall fireweed in the foreground.

I had wanted to get a bold image by moving in close with my 55mm macro lens and holding the background slightly out of focus. Technically I couldn't do it with ASA 25 Kodachrome because the flowers were moving too much. I began to analyze the scene by putting on the 200mm telephoto to turn the camera into a makeshift spot meter. I wanted to compare the light values of the peaks in the rain with the flowers under a brightening sky. Luckily they were almost the same. Now I knew I was safe in making the mountains a major part of my image so long as I cropped out as much of the distractingly bright sky as possible. When I tried that with my 24mm lens, however, new problems arose. The peaks seemed too far away, and the trees tipped sideways with parallax distortion when aimed the lens downward.

By now the children were covered with mud and getting impatient. I posed a couple of hasty shots of them in the flowers, but I felt pressure to make them quickly and to get the car moving again. I finally settled on a 35mm lens set at f/11, which gave me good enough depth of field, while retaining a shutter speed high enough to hold a fairly sharp image when the breeze ebbed to its lowest. The slight blur in some of the foreground flowers is due to *their* motion, not the camera's.

Because my family and friends wanted to get going, I worked quickly. I knew my camera, and I knew the light was dead even, so I didn't bracket any exposure or try any filters. I made only two landscape images, each with slightly different compositions, then spent the rest of the afternoon driving in the rain, ready to cry inside.

TECHNICAL DATA *Nikkormat FTN with 35mm lens; Kodachrome II (ASA 25); f/11 for depth of field.*

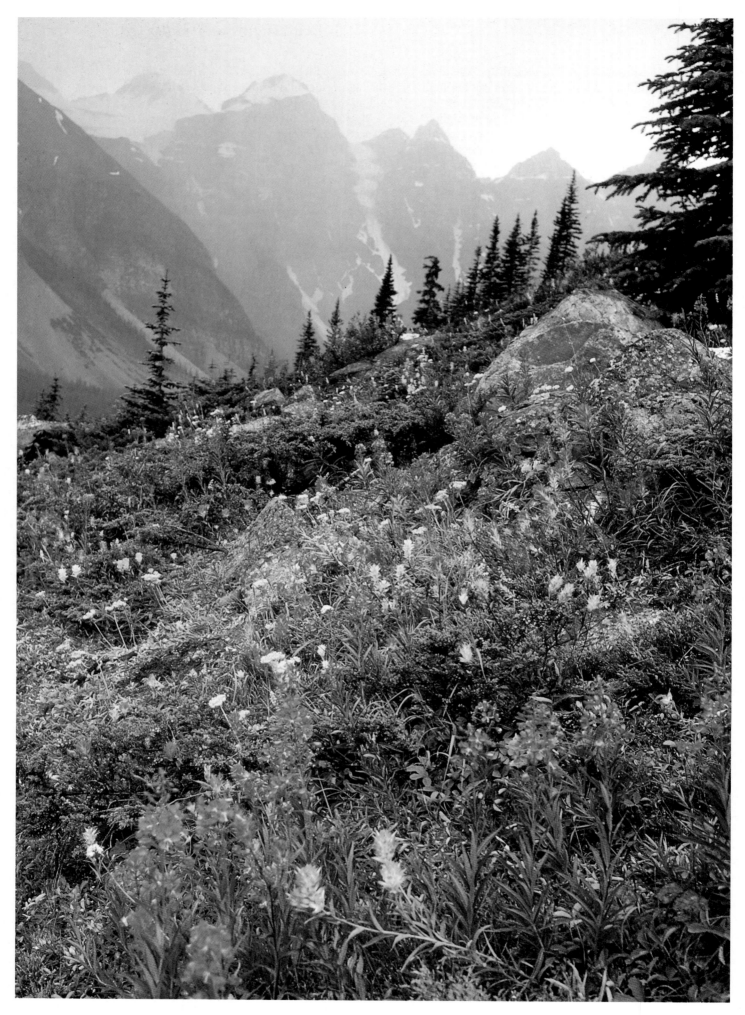

VALLEY OF THE TEN PEAKS, BANFF PARK, CANADIAN ROCKIES

CHAPTER THREE
Integrated Vision
MERGING A CAMERA'S WAY OF SEEING WITH MY OWN

My first single-lens reflex camera didn't do what it was advertised to do. What I saw through the viewfinder was not what I got on film. Everything seemed different. Every color, every tone, every shadow deviated from what my eyes had perceived. The problem I was having is universal among beginning photographers. Trying to duplicate a scene that pleases your eye without knowing how your camera will render it is as futile as trying to duplicate a meal that once pleased your palate without the benefit of a recipe.

Instead of seeing through my camera, I was letting it see for me. Looking at my results made me feel as if my camera were speaking some kind of visual foreign language; only by accident did our ways of seeing coincide. Occasionally a single image would have a wonderful sparkle and a deep saturation of color beyond what I thought I had seen.

I accepted those rare gifts from my camera as my own achievements. I perceived an elegance in these simple solutions to complex visual problems that reminded me of descriptions given by research scientists who had made discoveries after long experimentation. Like those scientists, I had hundreds upon hundreds of failures; unlike them, I could not consistently repeat my successes because I did not fully understand my medium.

About that time I came across a statement in a book on human behavior that pegged me perfectly: "Human beings tend to attribute their own successes to personal intelligence, knowledge, and artistry, but they explain away their failures as the results of situations beyond their control." When I read those words, I knew in my heart that most of my photographic work was really failure, and I began searching for a system that would not only give me predictable results, but would also preserve the spontaneity of my vision.

The consequences of my failures were not great enough to cause me to abandon my free-shooting style. Most professional photographers have a very high failure ratio. If a

mechanic fixed only one out of ten cars and a banker made errors in nine out of ten accounts, they would soon be out on the street; but a photographer who gets only one good shot in fifty may be a great success because this tremendous margin is not considered error so long as it results in an occasional accomplishment.

In the mid-sixties Kodachrome film with processing cost only eight cents per slide by mail order. I shot thousands of images, threw away most, and used the best for slide presentations, which I found to be the most forgiving way to exhibit photography. An idea executed too poorly for book or magazine use worked fine on a screen in front of a captive audience, where a speaker could fill in the gaps between images that could not stand alone. Subjects that wouldn't deserve more than one image in a published photo essay could be circled like prey with several flawed slides until the point was finally made.

My biggest disappointment came after I retired my trusty Instamatic for a top-of-the-line Nikon. My results declined. The Nikon gave me overexposed pictures when I set the meter according to the speed marked on the film box. I had never had to worry about setting the Instamatic because it adjusted its own speed (by a tab on the film cassette). I was perplexed, especially after a trip to a camera repair shop, where I was told that the metering system on the Nikon was within manufacturer's tolerances.

Not long after that I met a professional black-and-white photographer who gave me a suggestion that further confused me: he said I should not consider the ASA number printed on the film box as a holy unchangeable figure, but rather as a starting point. So far so good. Then he suggested that I buy a special piece of gray board with an 18 percent reflectance, take a picture of it, have the slide analyzed with a densitometer, plug the result along with the film speed into a mathematical formula, and set my camera for the corrected number.

I decided not to follow his suggestion after I thought about a few pictures I liked very much that I had taken with the Nikon. I wanted to duplicate those results, not get overly involved in pursuing some technical analysis that might not give me what I really wanted. I could see that I was dealing with two distinctly different kinds of variables. The first were the physical ones of the camera and the film's response to light. These would indeed respond to my friend's scientific test. The second were my own aesthetic preferences. Some photographers like bright images with open shadows, and they choose their subject matter accordingly. Others, myself included, prefer darker scenes with more intense colors and inky black shadows.

Applying the same threefold process of sandwiching direct experience between periods of study that had worked so well for me in other fields, I devised my own simple system to obtain a corrected film-speed number that would bring my vision directly into

sync with my equipment. Because even top-of-the-line camera meters vary at least a third of a stop in each direction, my personal number would hold true only for the particular camera and meter I tested.

Taking a single thirty-six-exposure roll of ASA 64 Kodachrome, I chose six different scenes and made six exposures of each, keeping track of them in a notebook. Each of the six exposures was at a different ASA speed. Beginning at ASA 40, I used each of the six click-stops up to ASA 120. With the camera on a tripod and the shutter speed constant, I centered the meter needle by adjusting between apertures for each image. I chose scenes on the street outside my home that would show up differences in lighting and film responses. One had blue sky and clouds; another was wholly in shadow; yet another had flesh tones in open sun.

When I received the processed slides, I chose my favorite of each scene and checked off its ASA number in my notebook. In four out of six cases I preferred ASA 80. In one I liked ASA 50, and in the last, ASA 100. It was now clear that to obtain results that pleased me with this particular camera and film type, I needed to set my meter at ASA 80 for Kodachrome 64 film. It was also clear what kind of situations would give me problems at ASA 80 and in which direction I must compensate for them. (This test is even easier with modern automatic cameras that set themselves in between full stops of aperture or shutter speed each time the ASA setting is switched.)

There were other lessons to be learned from this single test roll. To have filed it away without further study would have been a big mistake. It gave me a precise indicator of how Kodachrome shifted colors and tones at 1/3-stop increments, as well as a feeling for the acceptable margin of error in each of the lighting situations. In the high-contrast light that one normally finds in direct sun, I saw distinct differences in the 1/3-stop increments. With indirect light I saw little. Thus, I learned that I had to bracket different exposures of people in action in high-contrast light to make sure I got what I wanted; in even shadows, however, I could go with one exposure with full confidence.

I knew I could learn to deal with the technical limitations I had discovered, but at first I didn't understand why colors that appeared static to my eye shifted with slight changes in exposure. When I began to see the overall picture of what was happening, it changed my entire perception of photography. I had been making an assumption that had been disproved in the seventeenth century by a young genius named Isaac Newton: I had mistakenly thought grass was green.

Before Newton's simple experiment, the world took it for granted that colors were fixed properties of objects. Colors that came out of a prism were considered equally intrinsic. He decided to see what would happen if he aimed the colors coming out of one

prism into another. They came out white, proving once and for all that light, rather than any object itself, is the source of color.

All objects are colorless—black, that is—until they reflect or transmit light. This simple realization, which I should have recalled from my physics classes, completely turned around my photographic approach. Instead of looking at the natural world for objects to photograph in color, I began to look for light. When I found magical light at the beginning or end of a day or during the clearing of a storm, I dashed about to find something earthbound to match it with. Eventually my eyes became finely tuned to natural light and its nuances in much the same way that people engaged in other outdoor pursuits develop heightened senses because of their direct experiences.

Where a tourist sees just snow, an experienced skier perceives the difference between powder, crust, and corn. Similarly a surfer reads water and a glider pilot reads air currents. In each case—snow, water, air—a man-made device allows human beings to enter into a special relationship with the natural world. So it is with light and the camera, which may allow a photographer to see light as it would not be seen otherwise.

When the light is right, my camera is out long before I know what I want to photograph. Several friends have told me they don't take photographs because they have a deeper appreciation for things when they don't put a camera between themselves and their experiences, but for me it is often just the opposite. Many of the great natural scenes I've photographed have come to my awareness precisely because I was at that moment pursuing light with my camera. By using an instrument finely attuned to light, I'm constantly being drawn into scenes that I may not have noticed otherwise.

When I began to do assignment photography, however, I saw considerable truth on both sides of the question. Whenever I photographed a spectator event, such as the 1980 Winter Olympics, my overall perceptions of the drama and the results were definitely impaired by use of my camera. If, however, I photographed a mountain climb in which I was a participant, my perceptions were enhanced by having a camera.

This distinction of experience repeated itself again and again, and the pattern soon became clear. Events in which my own actions had little or no effect upon the outcome invariably clashed with my efforts to photograph them. Even when I made a fine image, I did so as an outsider. Events in which I was a participant were just the opposite for me. My pursuit of a subject in which I was an integral part fed on its own energy, whether the subject was a landscape that became ever more intense as I used my own motion to play foreground off background or whether it was an adventure where my appreciation of the surroundings was enhanced as I sought out moments when my companions appeared to be in wondrous balance with the natural forces *we* were confronting.

Recognizing the significance of being a participant rather than an outsider, I needed to find a method that would help me produce photographic records of important personal experiences even in unlikely circumstances. If I could master this, even some of the time, I felt I would succeed in creating the kinds of images I was seeking. Subjects that spark internal responses, as do Beethoven symphonies, never become obsolete. Yosemite can be played by photographers in at least as many ways as musicians find to play a symphony, and one performance does not negate the other.

Ansel Adams clearly understood the need for photographers to translate external events into images that touch inner visions. He saw the average photographer as almost wholly caught up "in the world of time and space surrounding him." He believed that great images happen only when "the realities of the external event pass through the eye-mind-spirit of the photographer" and are "transformed into interpretation and expression." When he became a photographer early in the century, color-slide film did not exist. In order to realize his inner vision, he needed to follow each image through every stage—from his mind's eye through "management of the camera-optical image, exposure and development of the negative and the controls of photographic printing."

Much of Adams's greatness can be attributed to his unique ability to simultaneously master the technical and aesthetic sides of photography and hold them in fine balance. To do that he invented his "zone system" to control exposure, developing, and printing of black-and-white images. Although the zone system is incompatible with the mutually dependent emulsion layers of color transparencies, its basic principle of previsualizing how film will "see" light still applies. Previsualization means just what it says: seeing before, seeing things before an image is made the way film sees them.

To literally previsualize, I would not only have to crawl inside a camera, but also be able to see light the way film does. Then I would have the direct answers as to why my first single-lens reflex camera didn't record what I thought I saw through the viewfinder. Since I obviously couldn't get inside the camera, I did the next best thing: I imagined that film could tell me how it saw the world. Based on that, I wrote a first-person narrative, which, although somewhat odd, has proven to be an effective method for teaching beginning photographers to think in terms of light on film. Reading it in a workshop is far more productive than giving hours of lecture instruction. By putting the message in the first person, I found that students could readily identify with and internalize a visual language foreign to their own.

"I am a frame of Kodachrome film waiting for you to open the shutter. If I get overexposed to the light, I'll get ugly and burned out like an old billboard that has been in the sun too long. I can be burned out in a much shorter time, however. If I am properly ex-

posed at 1/500 second, I pale at 1/250, begin to bleach out at 1/125, and I'm all but gone at 1/60. At 1/1,000 I'm richly colored but a little dark. At a 1/2,000 I blend with the darkest shadows.

"You can see detail in me only within this narrow range, but your remarkable human eye is capable of seeing an illumination range of more than two thousand to one. No wonder you are always asking for more than I can give! Where your eyes see something clearly highlighted in intense light, I white out completely. Where your eyes see detail in dark shadows, I, like a blind person, see only blackness.

"Remember there is only one of me. You have two eyes. Don't expect me to see in three dimensions. If you want to show relative distance, you can suggest it only by the way you position objects within my frame.

"Don't expect my single sheet to see motion. At a shutter speed that is too high I will freeze some living things and make them look dead, and at a shutter speed that is too low your unsteady hands will blur all of me. If you want to picture motion, you can only suggest it by selectively blurring part of me. You must blur either your subject or your background, but not both.

"Don't believe that you are seeing all of what I see. You see through screens and mirrors, not from my vantage point behind the shutter. With good cameras you see about 85 to 95 percent of what I see. Only a few top-of-the-line models have perfectly sized parts so that what appears in the viewfinder approximates my exact field of view. This is why you are forever getting your hand in the images when shading the lens from bright light, and why the power wires you so cautiously crop out of sight are in clear view at the top of my frame. Don't be fooled into thinking that 85 to 95 percent is 'almost all' of my image area. When you take a portrait from the waist up, the face occupies only about 10 percent of the total image area, yet you tend to ignore an equivalent area along the edges of the frame, the area you don't see through the viewfinder.

"We do not see color alike. The light-sensitive chemicals that trigger dyes during my development do not produce exactly the colors you see. Of far more importance to you, however, is the fact that unless I fade over the years, my tones are rigidly fixed by the lighting in which you take the photo. Colors change for you whenever you walk from one kind of lighting to another, but few of you are aware of it, because your brains are forever making adjustments. If your companion is wearing a blue-and-red shirt, you think the shirt is the same color outside as it is indoors under artificial lighting. I know that isn't so. I record the same shirt in radically different colors in each situation unless you use a special filter or a specially balanced film.

"The vision through your eyes is filtered through your brain, which interprets colors

for you before you 'see' them. Humans must have had an evolutionary need to see colors in relation to one another no matter what the lighting source. Now you have a visual 'appendix' left over from a time when your ancestors needed to recognize the tawny coat of a Pleistocene lion on the African savannah by moonlight, at dawn, or by the light of the noonday sun. When you subject me to that variation in light, I give you colors you don't recognize as really having been there.

"The constancy of color falls off when I make slow exposures of a full second or more. Colors shift because not all my emulsion layers respond at the same rate to the low light. You seem to be disturbed by this phenomenon, and you have given it a fancy name that almost every professional photographer knows: reciprocity departure effect. Few people seem to know about the Purkinje effect, however, which makes your color vision vary even more in low light than mine does.

"Leonardo da Vinci noticed that relative perceptions of color seemed to change according to the brightness of the light: 'Green and blue are invariably accentuated in half shadows, yellow and red and white in the light parts.' This happens because in dim light your visual perception shifts from the yellow-sensitive cones of the retina to the blue-sensitive rods. Low light is more than just dim for you: your color contrasts change markedly. A red flower that appears far more brilliant than the greenery around it in daylight looks dull in low light to you because you are actually perceiving proportionately less red light. In these same conditions I produce an overall magenta cast.

"I can help you see the world only if you understand how I respond to light and if you use me for what I do best. Without your guidance I cannot produce an image that will be meaningful to you. But remember this paradox: if you choose to follow rules, precise rules, about everything you do with me—about focusing, exposure, lighting, firm camera supports, composing with diagonals and patterns and S curves—you may make many good pictures with me, but few, if any, great ones.

"I was designed and manufactured by scientists, who seem to have much in common with photographers. Indeed, many are both. People in these fields tend to follow rigid rules and do well by their professions, but nothing truly great comes out of them unless they make an intuitive leap, the way Isaac Newton did when he put colored light back through a second prism and found that color is a property of light itself. Yousuf Karsh, the great portrait photographer who has dedicated his life to catching expressions on people's faces that reveal their entire character in a single image, made just such a leap when he decided on the spur of the moment to photograph the cellist, Pablo Casals, from behind, without his face visible at all, thus showing at once the man's aura and the way he made music through his entire body.

"Although I may be a product of state-of-the-art chemistry that is beyond your understanding, the magic in me must come from you. There is magic only in your own vision. If you have any doubts about this, if you still believe some of the magic is intrinsically mine, just remember all those uninspired slides you threw out after using me on a day when your inspiration or commitment was at a low ebb."

By trying to see the world from the film's point of view, the photographer's purpose —to unite vision through the camera with vision through the eyes—is obvious. The next step is more difficult and less often attempted, although it can be accomplished in a number of ways. To facilitate those all-important leaps of intuition and to ensure that free expression is not restricted, it is necessary to be flexible in the way you use a camera.

The need for flexibility became quite apparent to me in my second year of serious photography. As I learned about the technical aspects of photography and began to understand how film sees the world, the technical quality of my images improved at the expense of my inspiration. The images that had thrilled me in the beginning were no longer forthcoming.

In the beginning I had freely experimented, aiming my camera at subject matter that I soon came to reject for technical reasons. Perhaps the contrast was too high or the light too low, but I tried my best. Most of those images were disappointing, but every once in a while I produced a photograph that not only pleased me, but also gave me creative insight, although it was often unpublishable for technical reasons. However technically poor those images were, something about the way the light and forms came together gave me a personal thrill.

My challenge, then, was to understand how those rarely produced images came about and to learn to repeat them well enough, at least, to coincide with the high moments of my experience. I knew there was an extremely fragile balance between maintaining enough technical awareness to ensure competence and keeping an open mind to make the intuitive leap as often as possible, avoiding the fatal attraction of repeating only what had worked successfully before.

The methods that worked for Ansel Adams or Yousuf Karsh wouldn't work for me, although I could use them as starting places. Karsh works with cooperative models in controlled situations. He sets up his camera in advance with all the precision of a pilot doing a preflight check. His special images come from the visual attitudes he evokes from his subjects after most of his technical work is done.

I could not use the equivalent of a pilot's preflight check in dealing with fleeting moments in nature. Following a list of items to be checked off in order would cause me to lose my most valuable images. When a full moon rises suddenly from behind a ridge or a wild

animal is momentarily profiled in the sunrise, I need to move quickly, yet leave my mind free to think creatively.

To shoot many different subjects in natural light, each with different technical requirements, I devised something I call the "limiting-factor" method. Professional sports photographers gravitate naturally toward this way of shooting, but most scenic photographers focus on static subjects so often that they are rarely forced to organize their approach to technical problems—that is, how and in what order they adjust the camera's settings. The sequence they use is more the result of habit than of planning. When a fast-breaking situation presents itself, they waste a lot of time fooling with their equipment because they have a random order of action rigidly wired, through repetition, into their nervous systems.

The limiting-factor method instantly streamlines and reorders my mental checklist for each photo situation. I simply think of every photo as having one problem to be solved, a limiting factor, and I begin with that. If there is more than one, I pick the most crucial. If I can't think of one, I know I'm in one of those rare right-place/right-time situations where I can't miss.

Take, for example, the case of a moon rising over a distant ridge, which I want to capture with a long telephoto lens. Focus is not much of a problem because both objects are at infinity. Neither is aperture; the image will look the same at any aperture. Shutter speed is the most critical factor. I begin with the idea of maximizing shutter speed, and almost instantly my other settings fall into place.

As the moon pops over a hazy horizon, the aperture is set wide open, and the through-the-lens meter reads f/5.6 at 1/125 second with ASA 64 Kodachrome, telling me that I cannot handhold a 400mm lens at this highest-possible speed. (The rule of thumb is that a lens can be handheld only down to the shutter speed closest to the reciprocal of its focal length; in other words, 1/500 second for a 400mm lens.) My next priority is to find a secure place to brace the camera or to set up a tripod. Seconds after the moon appears, I'm ready to go with my checklist complete.

Another example requires an entirely different sequence. Suppose I were walking along a trail in strong afternoon light through a field of flowers behind which there are mountains just as a group of hikers approaches an S curve in the trail. It would seem to be a perfect opportunity to capture the hikers in relation to their environment; however, this kind of shot can be tricky to execute. Since there is plenty of light, shutter speed is not an initial problem, especially if the subjects are walking toward me: their motion can be stopped at about 1/125 second.

Focusing on the hikers is not a problem either, but if I wish to make a calendar-quality

image, where both the hikers and the background are sharp, then depth of field is the limiting factor. To maximize depth of field, my mental checklist is as follows: (1) choose the widest-angle lens that will work with the subject matter, (2) set the speed at 1/125, (3) use the meter to determine which aperture I can work with, (4) check the color-coded depth-of-field marks on the lens barrel that correspond with that aperture to determine the range of distance I can hold in sharp focus, and (5) move the camera position back or up if the subjects will fall outside that range.

The limiting-factor method takes me still further. By using a different checklist for each image, the emphasis is on change rather than on repetition, and my mind is free to make those crucial intuitive leaps. I can say to myself, Hey, wait a second! If I focus only on the first row of flowers with the lens wide open at f/2, the hikers and mountains could blur into wonderful symbolic forms in the background. Or I could focus on the hikers and make the flowers a pleasing blur of color in the foreground. Or I could give up the idea of literally picturing the entire landscape with the hikers, switch to a medium telephoto, and prefocus on a spot where the hikers will walk through. With the hikers big in the frame, it will be visually acceptable to let the background blur, where it wouldn't be with a wide-angle lens.

I could make even greater leaps by not taking literally anything in front of my eyes. I don't have to be fixed on the hikers even if human presence seems important to this image. I can wait until they pass, scuff the dirt around on the trail, and make my own fresh set of footprints through the S curve. Using a wide-angle lens near ground level to shoot the footprints snaking through the meadow, I will get something of the same feeling of human presence without any of the limitations of trying to stop action. Working with a tripod at leisure, I could select a far more creative image that retained much of the initial feeling that caused me to first stop and think there was a picture in the hikers walking toward me.

Actually it is quite rare for me to be in just the right place at the right time, see a pretty landscape, photograph it, and have it become a favorite image. Almost all my favorites are photographed when a little stroke of intuition enables me to "step outside" my normal way of seeing. Thus, I create images that I wouldn't necessarily have noticed if I had been simply walking through the place.

When I first thought about making the image that resulted in "Machapuchare at Dawn" (page i), I had no conception of a single tree in the haze slightly offset below the peak. I studied the scene for a while and decided the mountain and the tree were the two elements with which I wanted to work. Each was in different light, but because of the camera's two dimensionality, I knew I could create an illusion by merging them into one

plane with a telephoto lens. The other people with me that morning hadn't seen that scene until they saw it on film after the trip.

For "Rainbow over the Potala Palace" (page 211), I had a similar approach. I didn't see the rainbow coming out of the palace at first; I saw a rainbow in a field and a palace next to it. I was led to it in pursuit of a photographic intuition.

My limiting-factor method enables me to quickly deal with technical problems and move on to the intuitive part of making images. The method is not unique; other photographers develop their own special techniques for leaving the external world momentarily in order to produce images that express their deepest convictions.

Each time I pick up a camera I'm trying to say something. I'm trying to communicate my view of the world and to share those high moments when what I see and what I feel are a single experience. Mechanical competence with a camera is just half of the equation. The best images come from a blend of technical discipline and creative thought, a meld of left-brain/right-brain action. Only then can a photographer merge, for an instant, his camera's way of seeing the world with his own.

EXHIBIT IV

Sundown to Sunrise

Many of my favorite images were made after sunset or before sunrise. To work only in direct light is to miss a feast of subtle twilight colors that often become far more vivid on film than they appear to the eye, plus the chance to simulate night photography with some daylight still present.

Most "night" photographs are actually made during the first hour after sunset, when the color of light has turned bluish. Underexposure makes them appear to be made at night. Early in the evening enough soft daylight is available to buffer the harshness of moonlight, which has a point source. Of equal importance at this time of day is that a photographer can see what he is doing.

Urban photographers love to match cool evening light with warm artificial lights. Getting a balanced image of an interior scene with what appears to be moonlight is a matter of following a simple procedure. Take a meter reading of the interior, put your camera on a tripod, compose, and wait for the outside light to equal or be slightly less than your reading.

Automatic meter readings work surprisingly well for evening images because the reciprocity failure of color film at speeds around one second tends to naturally underexpose the scene just enough to make it look like night. A perfectly exposed night photograph is really not a pretty thing. It has bright daylight values mixed with a strong bluish cast, as if something went wrong with the film.

Since for evening photography I must use a long exposure anyway, I don't try to use fast films. My experience is that they look muddy and washed out compared to images made on slower daylight films. I like to use Kodachrome 25, which, like the human eye, has very poor response to reds and greens in low light. It also shifts slightly magenta on long exposures, thus canceling some of the excessive blueness that other films render in neutral tones. For color accuracy in low light, Fujichrome Professional 50 is my choice. With that film I made an unfiltered image of Yosemite by full moon that appears to be in daylight except for the streaking of stars in the sky because of the long exposure.

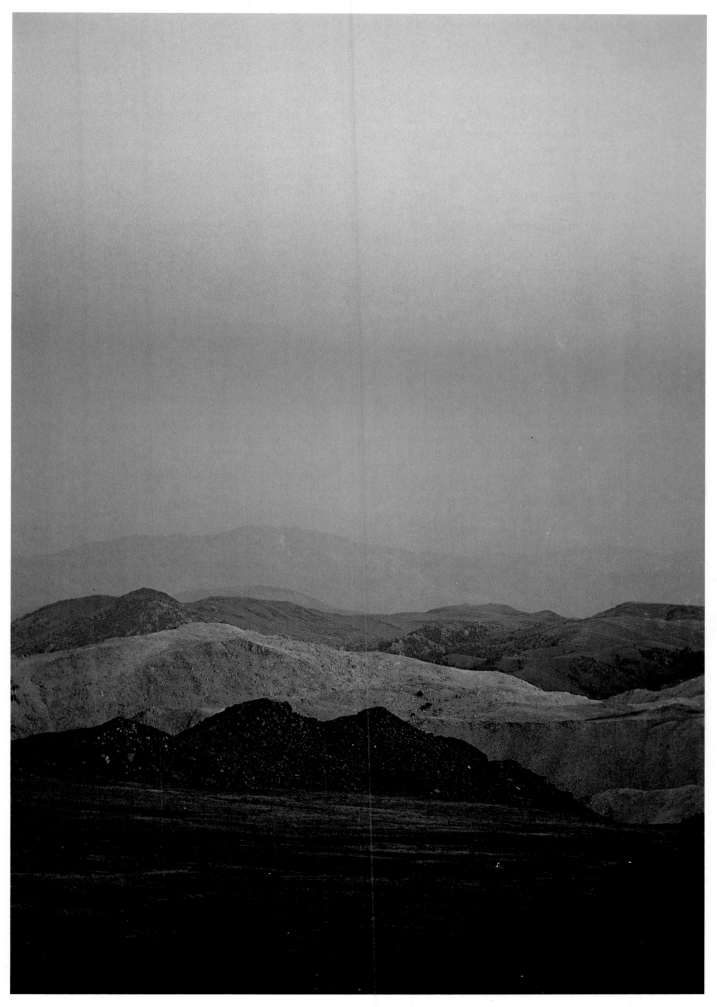

TWILIGHT IN THE WHITE MOUNTAINS, CALIFORNIA

TWILIGHT IN THE WHITE MOUNTAINS,
CALIFORNIA; 1977

At 14,246 feet White Mountain Peak is the highest desert mountain in North America. On a fall afternoon in 1977, I walked to the summit with a friend, never seeing a single patch of snow. Even when sunset came, I didn't take any landscape photographs because the tones of the land were too gentle, distant, and muted to make visual sense to me.

As we walked down the trail in the gathering dusk, colors in the sky and the landscape began to shift quickly. My camera was ready, but I waited to find a scene that would integrate the effects in the sky with those in the landscape. Rounding a corner, I saw seven distinct zones of color in nearly parallel bands. I worked the scene by moving back and forth until none of the crests overlapped each other, then braced my camera on a rock and shot with a 105mm lens.

My technique was absolutely straightforward, but the image itself has a surreal appearance, especially for those who have not observed optical phenomena in the evening at high altitudes. Each color layer has a clear explanation. What is unusual is the subtle integration of bands of light with bands of landscape.

The uppermost band is called the twilight wedge. It is colored red as direct sunlight hits the upper atmosphere. Just below it is the blue earth shadow, rising up as the sun dips below the horizon. In the lowlands the boundary between these zones is not very distinct because a person is looking upward at an angle to the direction of the light. Since the layers are translucent, one tends to blur into the other like beams of colored stage lights viewed from the side. At high altitude, however, the viewer is raised into a position almost in line with light aimed from below the horizon toward the twilight wedge. Figuratively, the viewer is in a box seat with nature's stage lights behind him. The boundaries of the projected colors are quite distinct from this angle of view.

The next band is a distant ridge of mountains, colored blue by the scattering of light. There is enough blue sky between the camera and the land to act as a strong filter, but the next zone of color is far darker because the ridge itself is so much closer; thus, the blue shift is greatly reduced.

Then comes a zone that wonderfully confuses colors of the sky and the topography. This lucky band of very light rock reflects some of the bright, warm light from the sky. It happened to be in just the right place to separate two dark bands in the landscape.

In front of the light band is a talus pile of dark rock only a couple hundred feet from the camera. It remains naturally dark in the image for two reasons. First, it is so near that its color is virtually unaffected by scattering, and, second, it is so dark that it doesn't reflect much sky color.

The final band is a field of arctic tundra, light green in normal light but muted by reflection from the evening sky into a pastel earth tone.

TECHNICAL DATA *Nikon FM with 105mm lens; Kodachrome 25.*

THE GREAT ICE PLATEAU, NUN KUN, INDIA; 1977

When I led an expedition to 23,410-foot Nun in 1977, I knew very little about the mountain. I had read a book about the first ascent from the opposite side, but I had no idea what the terrain would be like on our chosen route along the northwest ridge. The only expedition to climb it had been a group of Czechoslovakians who spent weeks placing five thousand feet of fixed rope high on the mountain.

We encountered steep climbing and avalanche danger at 16,000 feet, but at 17,500 feet we were surprised to step onto level ground. A huge plateau of glacial ice flowed from Nun and its satellite peaks into a basin large enough to hold a city of a hundred thousand people. There we camped for a week, bringing up loads from below, acclimatizing, and waiting for the right weather to go for the summit. During that time I took many photos but none that captured the sense of vast emptiness I saw with my eyes.

Even more incongruous than the ice plateau itself was the camp of a French expedition just a hundred yards from us. Sylvain Saudan, a famous extreme skier (extreme skiing begins where if you fall you die), had come from Chamonix to ski from the summit. He had failed to climb the mountain with a small team the previous year, so this time he came far more fully equipped and made himself at home. I was invited to his tent, where a chef in a white hat served me wine, cheese, and caviar on a table covered with white linen. Saudan owned a restaurant called L'Impossible in Chamonix. Not being an aficionado of Indian food, he had invited his chef to join the expedition.

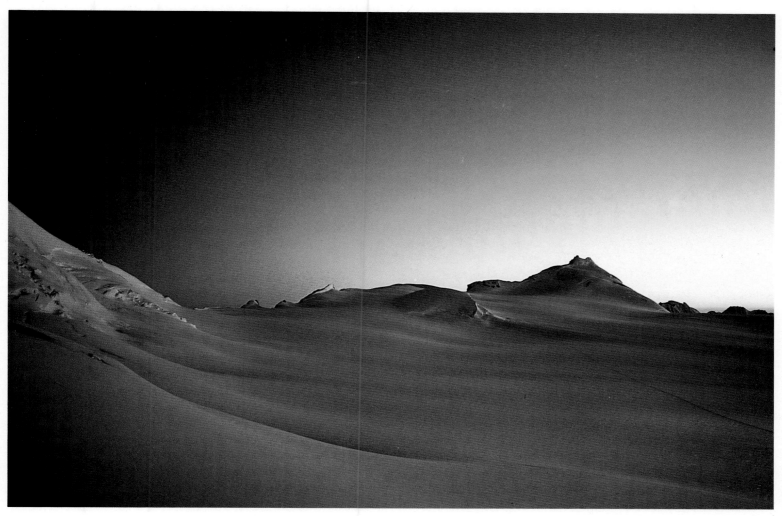

THE GREAT ICE PLATEAU, NUN KUN, INDIA

All the activity on the glacier had a negative effect on my photography. The snow around our camp became hopelessly tracked with footprints, and the feeling of untouched isolation was destroyed.

I spent three days taking a party to the summit and back, alpine style, and on our way down we decided not to camp in the same place. In order to facilitate putting a second party on top, we moved our advanced base camp across the basin onto a rocky spur directly under the route. Fortunately the horizon there was trackless except for a single, distant path in the snow.

I stayed up the first evening with my camera set on a tripod outside my tent. The moon rose before sunset and bathed the white basin in even blue light. For a long time after sunset, the horizon was much too bright for a satisfactory photograph. I waited until the last twilight glow on the horizon was weak enough to balance the light on the plateau, then used a 24mm lens to take in the flank of Nun and the subtle patterns that stretched all the way across the scene. My emphasis was on vastness and simplicity, and I knew the image wouldn't work without a line of twilight color separating the very similar tones of sky and snow.

TECHNICAL DATA *Nikon FM with 24mm lens; Kodachrome 25.*

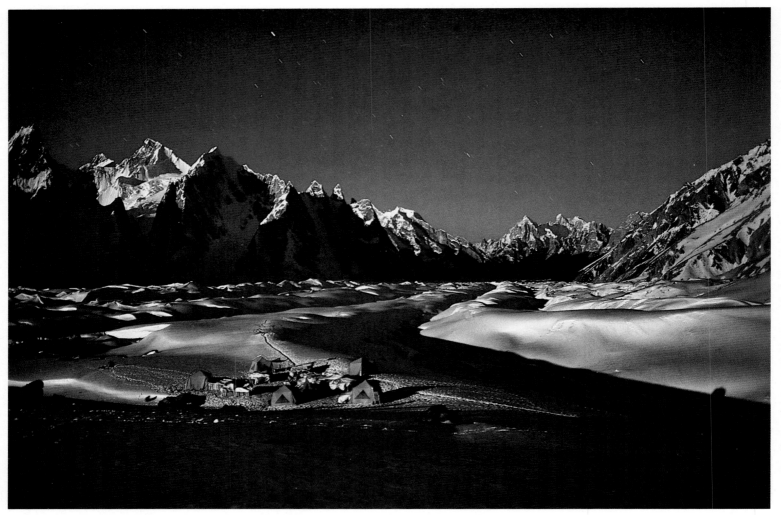

MOONLIGHT AT CONCORDIA, KARAKORAM HIMALAYA, PAKISTAN

MOONLIGHT AT CONCORDIA, KARAKORAM HIMALAYA, PAKISTAN; 1975

Concordia, directly below six of the seventeen highest peaks in the world, is a great meeting place of glaciers. I had especially looked forward to photographing Concordia because images made there by other photographers lacked, I thought, some of the dramatic impact that I believed was inherent in the scene. When I saw it for myself, however, I realized why. Both evening and morning light were blocked by the great peaks, and at any given time of day the contrasts were extreme.

My arrival happened to coincide with a full moon, but moonlight suffered a fate similar to that of morning and evening light. Most of the members of my K2 expedition tucked themselves into their sleeping bags well before the moon appeared. Although we could see moonlight on distant peaks, before it could reach us the moon would have to climb over a near ridge of twenty-six-thousand-foot peaks.

In temperatures of around ten degrees Fahrenheit I set up my camera on a tripod with a fast 35mm f/1.4 lens and waited for the moonlight to creep up the glacier. I wanted to capture the glow of the firelit porters' camp against the blueness of moonlit ice and star tracks in an indigo sky, but long before the moon came into view, many of the porters had left their fires and "sardined" themselves into their tents, where they were even warmer although they had no sleeping bags. Twenty-five Baltis crammed into each one of the four-man umbrella tents, forming a human pile with their homespun woolens laid in a mat over the top.

With only minutes to spare before the fires went out, moonlight finally reached us, bringing strong definition to the long fluid arcs of snow-covered moraines that swung through our camp like lanes of an outsize race track. Under our feet the Baltoro and Godwin-Austen glaciers merged. Countless other glaciers descended from every surrounding

EXHIBIT IV SUNDOWN TO SUNRISE 89

side valley, linking once, twice, even three times before joining the great Baltoro ice stream as it flowed for thirty-six miles toward the lowlands.

I used a locking cable release on my Nikon FTN to bracket time exposures of forty-five seconds, a minute and a half, and three minutes on Kodachrome 25 film with my lens wide open at f/1.4. Only the three-minute exposure turned out to be light enough to print. The length of the star streaks is a factor of both the time of the exposure and the focal length of the lens. Extreme wide angles, around 20mm, render shorter streaks, thus preserving the feeling of a point of starlight in exposures over a minute, whereas a 500mm telephoto begins to streak starlight in a few seconds. In this case I knew I was going to get streaks because I had waited so long after dusk for the moonlight. I chose the 35mm because of both its fast aperture and the way it rendered the composition.

With today's equipment I would not have to guess the exposure. I could take an off-the-shelf Nikon F3, set it on automatic on a tripod or a pile of rocks, actuate the self-timer, and wait seconds or minutes until I heard the shutter close. Because of reciprocity failure, I would need to turn my exposure compensation dial to plus one and a half for exposures over a minute, but regardless of manufacturer's cautions to the contrary, the camera will make fine auto exposures up to at least fifteen minutes.

I much prefer this image over my daytime photographs of the same spot for a reason other than its mystical quality as a well-exposed night image. The reason is more connected to the mountains themselves. Daylight images of mountains are sometimes used to represent the immutable, unchanging aspects of life—perfect backgrounds for advertisements of financial institutions. My photos of Concordia in daylight indeed have that air of permanence to them. They look like moments caught out of time that could represent any moment in the past million years.

That is not what I felt at Concordia. Loud creaks and groans announced that the ice underneath us was moving. Avalanches scoured surrounding slopes every few minutes, sending puffy white clouds roaring down side valleys. Clouds laden with snowflakes moved overhead, messengers from the Indian Ocean.

Ice ruled my existence at Concordia. I walked on it, slept on it, melted it for water, and was preparing to follow it all the way to the summit of K2. I felt as if I were a part of the Pleistocene ice ages, watching geological time pass. The long exposure captures something of that for me by blurring away any particular moment in favor of a flowing mood that was part of the feeling of being there in person.

By the time I first saw this image—months later, after it had been processed and edited by *National Geographic*—another event had cemented Concordia in my mind forever. On my way back from K2, a Balti mail runner brought us letters at Concordia. One of them was a fat manila envelope from my mother. It contained the ashes of my ninety-year-old father, who had died while I was on the mountain. Rather than deal with formal red tape, my mother had simply sent the ashes by air with a letter telling me to set them to the winds in the most beautiful place I could find below K2.

A full season had passed since this image was made in spring on my way to the mountain: the snow was gone, and rock moraines of various color and composition flowed into this focal point of beauty from peaks of varied geology all around us. On a perfect morning I walked east from our camp, which was set on a drab moraine of grayish gneiss. I wandered over yellow sandstones, reddish conglomerates, black hornfels and slates. When I came to a moraine of nearly pure blocks of white marble, I knew I had found the place. I released the ashes into a gentle breeze and watched them settle into nooks between the boulders where wild primroses blossomed out of the glacial silt.

TECHNICAL DATA *Nikon FTN with 35mm lens; Kodachrome 25; three-minute time exposure.*

LENTICULAR CLOUDS, EASTERN SIERRA, CALIFORNIA; 1980

I don't believe in UFOs. The classic image of a flying saucer that suddenly appears out of no-where is all too familiar to me. I round the corner of a side valley on the eastern slope of the High Sierra and there in front of me, readily photo-graphable, is a white, saucer-shaped object in the sky. Sometimes I even see "major invasions" of these objects, stacked one on top of another or in formation, obviously at extreme altitudes.

If you substitute the words "lenticular cloud" for UFO, many of the most spectacular sightings in history make perfect sense. In the Eastern Sierra these "lens clouds" often appear in a clear sky when conditions are right for what is called the Sierra Wave, which occurs when winds high in the atmosphere that can exceed two hundred miles per hour are forced upward by the land mass of the Sierra range. In proper climatic conditions, first one, then whole rows of spectacular clouds appear in the sky well east of the mountains. Only when they fill in to become a continuous bank can it be seen that their leading edge mimics the shape of the mountains on the horizon.

Because lenticulars form so often in a clear sky, they are particularly apt to catch the rays of the rising or setting sun. In the Eastern Sierra the winds come predictably from the west, the clouds occur predictably out over the Owens Valley, and the evening light catches them and turns them predictable colors.

In 1980 I drove from Colorado to California by way of the Southwest. I crossed Death Valley and began to head home along the eastern slope of the Sierra on U.S. Route 395. In the afternoon I no-ticed one lenticular cloud hanging in a side valley near the town of Bishop. I decided to wait around to see what was going to happen at sunset. By an hour before sunset, a row of spectacular clouds had formed over the valley, and I drove around to search for a good location from which to shoot. I had already photographed lenticulars many times, but I wanted to do something special to emphasize their already otherworldly appearance.

First, I needed a vantage point with an open vista in line with the clouds. Second, I wanted to get a reflection. Third, I wanted to polarize the sky in order to darken the blue and emphasize the color in the clouds, which required an angle close to ninety degrees off axis with the sun.

Water is scarce in the Owens Valley, but I knew of a pond with a lone tree below Sherwin Grade on an old section of highway. I drove to it, checked out the situation, framed an image with my 24mm lens, then took off to look for other vantage points. None compared with the pond, so I returned and shot a roll of images at sunset. The light was red and remarkable, but it looked like many other fiery sunsets I had photographed. After the glow disappeared from the lower clouds, it moved up to the higher ones, setting off the layers with different colors of light. There were red clouds, gray clouds, and blue shadowed areas in the gray clouds, all set off against a cobalt sky. Underneath the events taking place in the sky was a typical Great Basin landscape in spring: snowy peaks fronted by sage and a lone cottonwood tree. The pond mirrored some of the sky, giving necessary light to the dark foreground of the image.

I decided that the subject matter was so unusual in form and lighting that it could stand a very straightforward composition. I centered the major cloud and its reflection, used my 24mm lens with a polarizer, and took several slow exposures of about 1/2 second on a tripod.

"Image maturity" is a concept I often consider before deciding on a final composition of my sub-ject. If something has been seen many times before in photographs, I call it a *mature* subject. Deer, for example, have been photographed often and ob-served at close range by most of the potential audience for my photographs. Snow leopards, on the other hand, are *immature* subjects. The differ-ence for the photographer is in his interpretation of them on film. A deer rendered full frame in even light is a boring subject, but just two ears sticking out of grass in a meadow could be a delightful one. People know deer, so the idea of a deer is com-municated clearly by the ears sticking out of the grass. On the other hand, an image of a snow leopard's ears and eyes peering out of the grass somewhere in the steppes of high Asia would make the viewer think, Too bad you didn't get a picture of the whole animal.

The lenticular cloud in blue, gray, and red light was an immature subject. Rather than trying to create a subtle composition of something not fa-miliar to many people, I made an image of the whole, showing the clouds in direct relationship to their surroundings.

TECHNICAL DATA *Nikon F3 with 24mm lens; Kodachrome 25; polarizer to darken blue sky.*

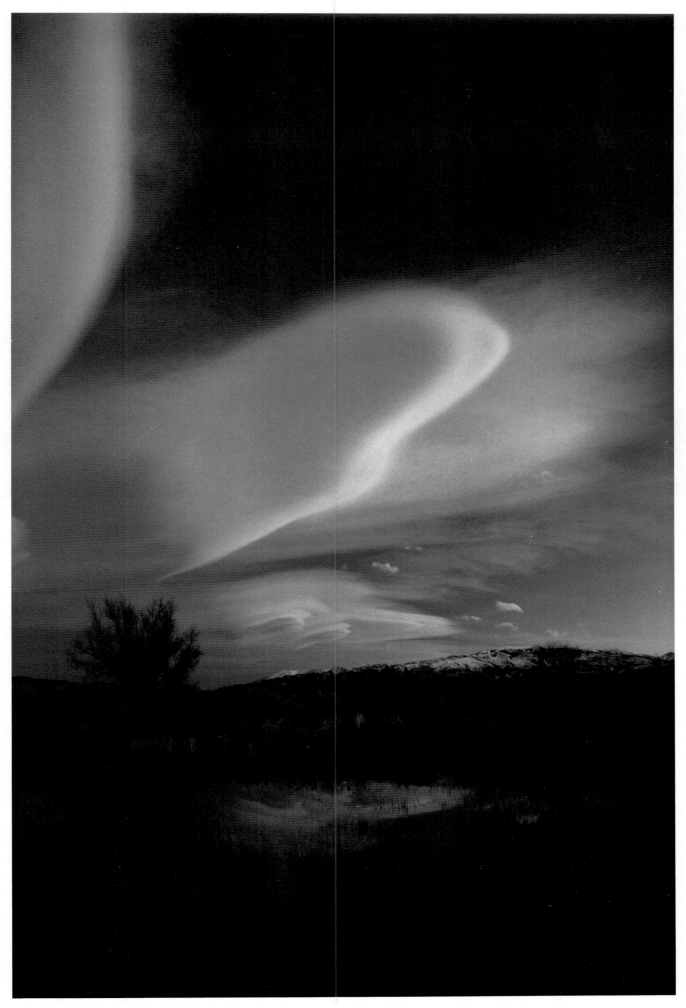

LENTICULAR CLOUDS, EASTERN SIERRA, CALIFORNIA

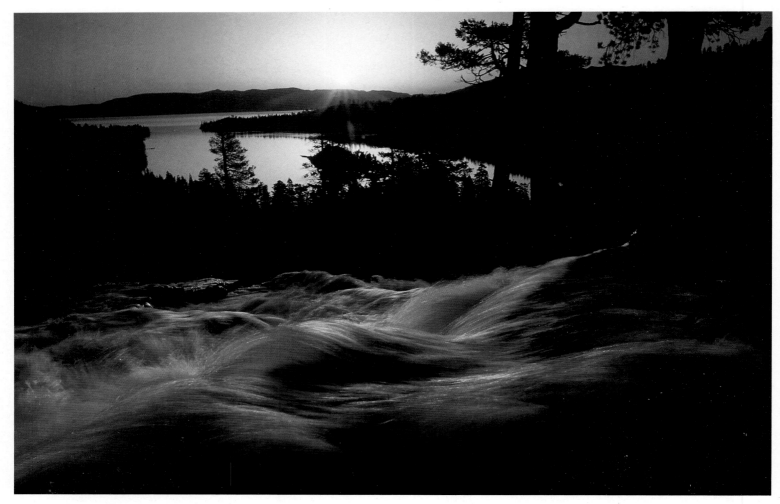

SUNRISE AT EMERALD BAY, LAKE TAHOE, CALIFORNIA

EXHIBIT IV SUNDOWN TO SUNRISE 93

SUNRISE AT EMERALD BAY, LAKE TAHOE,
CALIFORNIA; 1985

I could describe this image in terms of its content without ever divulging the far more interesting story about how I came to be at Eagle Falls above Emerald Bay with my camera at five in the morning on April 24, 1985. Once I was there, I set up a camera on a tripod well before sunrise. I composed an image with the water rushing toward the top of the falls in the foreground and waited for the sun to appear. I was on the second day of a three-week assignment to do a story on the entire Lake Tahoe Basin for the *National Geographic Traveler* magazine.

When the sun came, I shot images first with one camera then with another. One was loaded with Kodachrome 25, the other with Fujichrome Professional 50, a brand-new film on the market. I wanted to test the two films to see how they responded to the great diversity at Eagle Falls. Not only were there sunrise colors, deep shadows, and green trees, but also running water. After shooting exactly the same image in the dim light with both cameras, I walked around and discovered a perilous perch on the brink of the falls where I could get my camera right next to the water in line with the sunrise. I couldn't set up my tripod, but I was able to use one leg of it as a monopod to steady the camera for exposures at f/5.6 at 1/8 second in order to get the necessary depth of field and just the right silky feeling in the water. In this case the Fujichrome pulled much more green out of the water, with additional texture in the highlights.

Now back to how I happened to be at Eagle Falls on the second morning of my assignment. I've observed that photographers on assignment have two divergent ways of approaching outdoor subject matter. One group checks every available reference on what has been done before—magazine stories, coffee-table books, sometimes even advertisements that depict the subject area. In that way these photographers hope to learn about the best vantage points and the way the landscape looks on film.

Another group consciously avoids studying previous photography of a region in order to maintain a fresh creative approach. These photographers are aware that landscape images are so dependent on nuances of light and season as to be generally unrepeatable. Any photographer who has returned to a place with hopes of repeating his own favorite image knows this truth.

While teaching a workshop in the Sierra shortly before the Tahoe assignment, I was introduced to an interesting mix of these two approaches. Although he was a student for that week, Doug Peck was actually a teacher at Brooks Institute of Photography. He told me that when he had been a student at Brooks he had done a project called "Plotting a Sunrise," based on the location of the rising sun at Eagle Falls at various times of the year. Hearing that I was going to Tahoe, he offered to send me a copy.

A very interesting package arrived, complete with a map of Tahoe numbered with his favorite shooting locations. A diagram indicated a position above Eagle Falls overlooking Emerald Bay with very much the same composition as this image except for the closeness of the rapids in the foreground. The sun's position for each month of the year was marked in the sky, spanning nearly all the horizon. In six months the position of sunrise moves sixty-two degrees, nearly from one edge to the other on a 24mm wide-angle image. During June the position of sunrise moves only a couple of degrees, but in April it undergoes great motion, changing a full fifteen degrees.

Peck emphasized the ideal nature of June 21, when the sun rises directly above the mouth of the bay from Eagle Falls. My first inclination was to mark off June 21 on my calendar and to be there, but I began to consider other factors. In the image he presented trees blocked the view of Emerald Bay on either side. Although June 21 put the sun over the mouth of the bay, it also placed it near the extreme left of the image. Knowing that 1985 was an extremely low snow year and that Eagle Falls wouldn't have much water in June, I opted for late April and knew just where the sun would rise when I went to sleep near the falls the previous night.

Thus, Doug helped to combine the two approaches to outdoor scenes. His plotting of the sunrise gave me a precise idea of the lighting I would have on any given clear morning, yet my final composition turned out to be very dependent on my own imagination. As Doug concluded, "It is usually taken for granted where the sun rises and sets, but this added knowledge can be put to use by the artistic photographer to create a fantastic photograph." Thanks, Doug.

TECHNICAL DATA *Nikon F3 with 24mm lens; Fujichrome Professional 50; 1/8 second for silky water.*

MOONRISE, SHERWIN PLATEAU,
EASTERN SIERRA, CALIFORNIA; 1984

The evolution of this photograph began with a similar twilight composition of the same rocks in more ordinary light. In 1983 I selected the old 1970 image for a gallery show called "California Views." Something about the natural architecture of the rocks and the few isolated pine trees appealed to me, but I thought the image could be considerably improved in different light. I often drove near this site as I crossed the Sherwin Plateau between Mammoth Lakes and Bishop, but the lighting was never satisfactory. Since the rocks are in a valley between thirteen- and fourteen-thousand-foot summits, they get neither sunrise nor sunset glow.

The unusual form of the rocks cried out for some sort of excitement in the sky. On a couple of occasions, I had seen spectacular wave clouds glow red at sunset, and I rushed out the dirt road. I got fine shots of clouds, but the foreground rocks were far too dark to be rendered properly.

After I prepared for the exhibit, the image was even more strongly in my mind. My next trip to Mammoth coincided with the night of the full moon, and I set out before sunset to photograph moonrise over the White Mountains. Near the top of Sherwin Grade on U.S. Route 395, I put my camera on a tripod with a 400mm lens and waited for the moon to peek over the shoulder of the peak. I made some nice photographs, then the moon suddenly disappeared into foreground clouds.

Why at that moment I thought about this site is not clear to me. I had decided against it for moonrise because the moon wouldn't show until well after the evening light was gone from the rocks. It suddenly dawned on me that I didn't need to make a big telephoto landscape and that just a normal moon next to the desert rock pile would be perfect in the right light. The contrast would be low, and even after sunset, snow would texture the foreground, and the sky would be filled with colorful twilight phenomena, clouds, and the moon.

I got into my truck and rushed to the little dirt road just beyond the top of the grade that led to the rocks. It was completedly snowed in. I parked my car, grabbed a tripod, a 35mm f/1.4, and an 85mm f/2 lens, and prepared to take off. Although I had cross-country skis, I thought I would waste too much time changing shoes and digging out poles, so I just took off, "postholing" through the snow in my running shoes. I arrived just as the moon was about to rise from behind the rocks. I had time to set up a tripod and get my feet good and cold waiting. I almost left then because when the moon did pop up from the horizon, a cloud was in the way and it didn't appear to be moving.

What kept me pacing in my tracks, however, was the fabulous light. The blue of the twilight wedge was rising in the eastern sky as the pink glow in the west lit the clouds, and to a lesser degree the rocks and snow. My exposures with the 85mm closed to 5.6 to get some depth of field were around one second at the time the moon finally showed itself. I knew I would have a magenta color shift because of reciprocity failure in the Kodachrome 25, so I did not use any additional filtration.

The cloud didn't move but began to dissipate in the night air, and the moon suddenly showed through a hole. I started shooting immediately, hoping to preserve a wisp of cloud over part of the moon to make its overexposed disk more believable. (If the moon appears simply as a pure white orb in a clear sky, it can look as if someone just took a paper punch to the transparency.) Since the light from the moon is of daylight intensity, it is impossible to expose for both detail in a twilight landscape and the moon at the same time. As previously mentioned, any color photograph that shows a perfectly exposed moon in a situation without direct sunlight is either a double exposure or a composite.

To get this image, I followed nearly all the basic methods I describe in this book. I scouted my location beforehand, chased the light to a place where I matched it with a suitable landform, composed and shot on a tripod, and captured fine outdoor optical phenomena in the sky. I'm still not content, however. Next time the light feels right and the rocks have a carpet of snow, I'll be there again. It will always look different.

TECHNICAL DATA *Nikon F3 with 85mm lens; Kodachrome 25.*

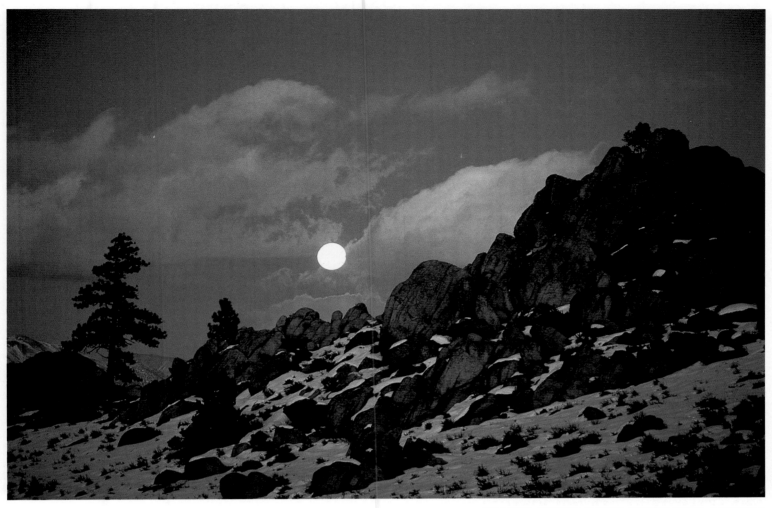

MOONRISE, SHERWIN PLATEAU, EASTERN SIERRA, CALIFORNIA

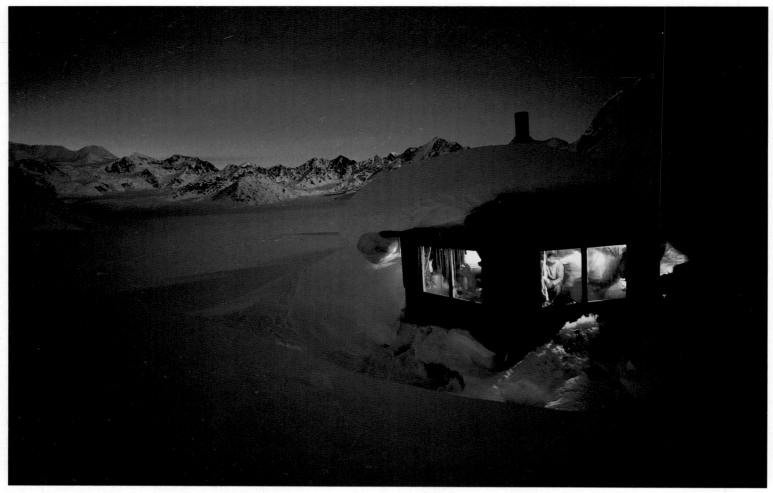

CABIN IN THE DON SHELDON AMPHITHEATER, ALASKA RANGE

CABIN IN THE DON SHELDON AMPHITHEATER, ALASKA RANGE; 1978

I first visited this cabin in 1974 with the legend-ary Alaskan bush pilot, Don Sheldon. He flew three of us up the Ruth Gorge in his turbocharged Cessna 180, buzzed the virgin five-thousand-foot face of Mount Dickey, which we hoped to climb, then landed us next to a rock promontory with a cabin on top. Inside were bunks, with a circular fireplace in the middle. Outside was a double-size replica of Yosemite Valley in the Pleistocene. Granite walls rose out of the ice into the sky, all unclimbed and mostly unnamed. In the distance was Denali Peak, the highest in North America.

Sheldon had built the cabin for two reasons. First, it made a great place to bring clients, both mountaineers bound for routes on Denali's satel-lite peaks and people who wanted simply to spend an exotic evening fifty air miles from the last out-post of civilization. Second, by formally establish-ing his presence with a federal permit for the cabin, Sheldon was guaranteeing that he would

have a legal landing place if the proposed exten-sion to the national park took in the southern slope of the mountain and banned landings within the park.

The little cabin sits on the edge of what was then called Ruth Amphitheater, a wide, level part of the Ruth Glacier, which flows from the slopes of De-nali through the Yosemite-like gorge below. Ruth was the name of the daughter of Frederick Cook, a turn-of-the-century explorer who faked the first ascent of Denali.

When I took this picture four years later, many things had changed. Sheldon had died of cancer, and the amphitheater had been renamed in his honor. I arrived with three companions, not in an airplane, but on cross-country skis with eighty-pound packs. Near the cabin was a food cache flown in for us by another pilot. We were two-thirds of the way through the first circumnaviga-tion of Denali on skis. Five glaciers formed a nat-ural ring of ice ninety miles in circumference that we had been following for two weeks.

EXHIBIT IV SUNDOWN TO SUNRISE 97

As I began to tear into the food boxes, Alan Bard asked me to hold up. I stopped, sensing that something was in the boxes he didn't want us to see. After a big dinner and a blissful night's sleep, we took a rest day. I had almost forgotten about the box incident when Alan strongly urged me to take a late afternoon ski tour with Ned Gillette, a tour that would keep Ned out for at least an hour. When he returned, the cabin didn't look the same. It was decorated for Ned's surprise birthday party with balloons, streamers, and party favors that Alan and Doug Weins had hidden in the cache box when they had packed it in Ned's own basement.

That evening Ned opened his presents. Among them were a toy telephone, a plastic gun that spun tops into the air, a tall bottle of brandy, and a birthday cake with candles. We all wore pointed hats and were blowing obnoxious whistles when a group of young climbers on their first expedition happened on the scene. They couldn't have looked more disoriented had they been invited into a spaceship.

Later that evening (and it was a long Alaskan evening), I happened to walk away from the cabin and look back at it with the fire and candles inside. I had photographed the cabin in all sorts of daylight lighting, but that night scene was by far the most striking. Because the trail to the cabin was so tracked up, I chose to shoot from an angle off to the side, which made the cabin look especially incongruous, fully lit in virgin snow.

I didn't have a regular tripod, but I did have my tiny Minox. By stacking some firewood in the snow, I was able to make a platform for the tripod and bracket several exposures with a 24mm wide-angle lens. Because I didn't have an automatic camera (and the temperatures were too cold to use one without auxiliary batteries), I had to guess exposures and use a locking cable release. This exposure was approximately four minutes.

The next metamorphosis of the cabin came when an agency looking for an image to advertise brandy called me. The theme was to be "Christian Brothers warms the night." To the agency's delight, an image taken inside the cabin showed Ned whooping it up with a bottle of Christian Brothers brandy. Nevertheless, the advertisement that finally appeared in national magazines and on billboards was a vertical frame of this image with one manipulation: a couple drinking brandy, a studio setup, was superimposed in the window.

TECHNICAL DATA *Nikon FM with 24mm lens; Kodachrome 64; four-minute exposure.*

SUNRISE AT MONUMENT VALLEY, UTAH; 1984

Monument Valley is one of the most-photographed spots in America. An image of a sandstone tower colored red by the low sun against a deep blue sky was once a thing of rare beauty. It is now a cliché. This process affects all photographic subjects to some extent. Once a landscape has been seen a certain way too often, it needs to be reinterpreted.

Having been to Monument Valley many times, I thought about what I wanted to get before we arrived for just one night. I conceived an image in my mind with a foreground that had bold scarlet light on sandstone, a middle ground in deep shadow, and a distant horizon of rock monoliths with the rising sun coming in between. We camped on the rim, and before dawn I began looking for the foreground I wanted. I had to have a rock that would capture first light without harsh shadows, and I kept coming back to this one, even though most of it was ruined for photography because tourists had carved their initials in it.

Just before the sun arrived, I struck on the idea of using a part of the rock that had no carvings, strongly weighted in the lower left of my frame with the sun in the upper right to balance the composition. A 20mm lens tipped downward on a tripod solved the compositional problems, but it was obvious to me that the sun coming directly into my lens would overpower the foreground. I put a split neutral-density filter over the lens and turned its horizon at an angle so that it would darken by two stops all of the shadow area and the horizon with the sunrise.

Now the foreground rock would come into its own with plenty of exposure against a shadowy background. I needed all the depth of field I could muster to hold both the rock, just twenty inches from my camera, and the horizon at infinity in focus at the same time. I set the aperture at f/22, focused for the hyperfocal distance exactly between the extremes, and bracketed exposures around one second.

TECHNICAL DATA *Nikon F3 with 20mm lens; Kodachrome 25; split neutral-density filter; f/22 for depth of field.*

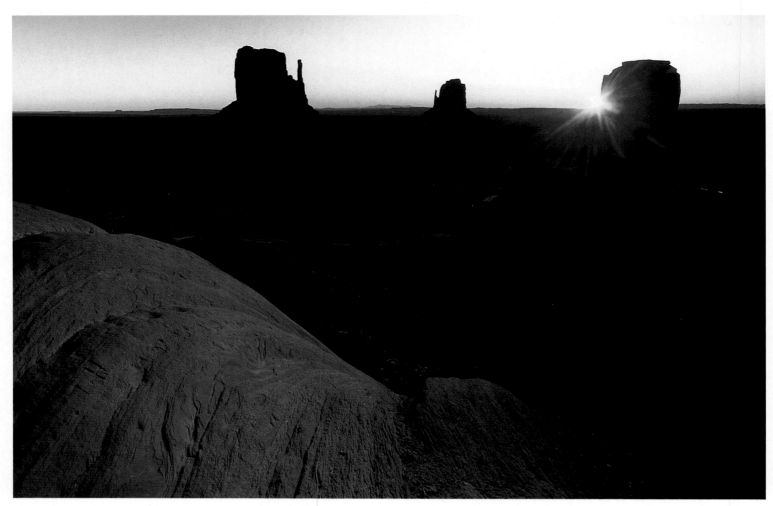

SUNRISE AT MONUMENT VALLEY, UTAH

quality large prints of photos that looked okay as slides or smaller prints. Their enlarged circles of confusion often become obvious, and their photographs look unsharp, even though they followed the instructions in the manual to the letter.

I found out the hard way that when I set the infinity mark on a lens precisely at the colored depth-of-field mark for my chosen aperture, the results weren't sharp enough to satisfy me. They may have been sharp enough for a small print, but not for publication. Knowing how depth of field operates, I don't have to be satisfied with just having my subject inside an arbitrary range of soft focus. Our eyes are drawn to the sharpest point of a photograph, and if that point doesn't correspond with the subject, the image is in big trouble. When I need a wide range of focus for a landscape image with close foreground and deep background, I always give myself a considerable margin by using the depth-of-field markings for the next numerically smaller aperture than the one my camera is set for.

Choice of shutter speed when handholding a camera is a compromise similar to depth-of-field determination. One shutter speed is not magically sharp, and another fuzzy. One simply produces smaller circles of confusion than the other, and when a big enough enlargement is made, the difference between landscape photos handheld at 1/125 and 1/500 second, respectively, becomes readily apparent if both were taken in the same manner.

This does not mean that a tripod is always a necessity for 35mm landscape work. When I need to make those little fuzzy circles smaller, I use a number of different methods if I don't have a tripod or the time to set one up. (As previously mentioned, the rule of thumb for handheld exposures is to choose a shutter speed at least as high as the reciprocal of the focal length of your lens. That means that a 50mm lens should be handheld at a shutter speed no slower than 1/60 second.) When I find I don't have enough light to handhold an image with the lens on my camera, one possible solution is to consider changing to a wide-angle to hedge an extra stop of shutter speed. I often take along a 35mm f/1.4 lens, because it can be handheld down to 1/30 if necessary.

Whenever possible, even in strong light, I brace my camera against a tree or rock, adding at least two extra stops to handheld steadiness and making those circles correspondingly smaller at normal shutter speeds. I can gain even another stop or two by pressing my camera with steady downward pressure into a folded jacket or sleeping bag set on something firm. Thus, I normally get sharp images at ¼ second with my 24mm lens. Best of all—even more stable than a tripod because of the lack of vibrations—is propping the camera with pebbles and using a self-timer so as not to shake it during exposure. This usually works only for telephotos in open areas, but when the situation is right, it can be amazingly effective. I've even been able to take deadsharp 1-second exposures of wildlife

in the Himalaya using an 800mm lens with the camera braced on piles of pebbles at either end.

A more common situation, one that confronts every 35mm photographer, is to come across a scene that looks as if it would be splendid using a large-format camera, but only so-so on a 35mm slide. This is exactly the kind of situation where differences in approach between large- and small-format photographers matter more than their equipment. A large-format photographer would stop at such a scene, consider it for a while, then spend long minutes setting up his camera until the scene was framed exactly the way he wanted it. A typical amateur with a 35mm would stop, turn toward the scene, make a handheld exposure or two within the first minute, and leave. The reason the 35mm image doesn't look like the 4-by-5 image is more a result of method than of equipment.

When I come across a still landscape that moves me, I pretend my Nikon is a bigger camera. I heft it onto a tripod, fool with composition for long minutes, shoot at f/16 to maximize depth of field, and get a result that resembles in every respect what I would have gotten with a bigger camera, except the size of the film grain in an enlargement. Images made in this manner regularly stand up to poster-size enlargements and are often mistaken for large-format work.

I make a nearly opposite adjustment when I have to deal with motion in low-light situations. For a few years I carried an extra camera loaded with Ektachrome 400 on major assignments for such situations, but I always hated the harsh, grainy results. While experimenting with slide duplication, I found out that I could make very acceptable duplicates of underexposed Kodachromes as long as the slides had been taken in low-contrast light, which was almost always the case when the light level was very low. This discovery led to my further discovery of what I call my "secret ASA 400 Kodachrome."

Here's how it works. Suppose I'm carrying a camera loaded with Kodachrome 64 at dusk in an Asian bazaar. I see a wonderful face in a doorway, but even with my fast 35mm lens my meter indicates a 1/8-second shutter speed. With no place to brace my camera, the image will obviously be blurred at this speed. I move the speed two stops higher to 1/30, take the picture, and finish off the roll the next day with normal exposures. The image of the bazaar was effectively made at ASA 400, two stops underexposed from the ASA 100 at which my camera was set (as per the ASA test described in Chapter 3 and my penchant for slight underexposure to increase color saturation).

Back at home I copy the dark result onto Ektachrome 5071 duplicating film and increase the exposure two stops. The resulting copy of a Kodachrome is sharper and less grainy than an original image on ASA 400 film, and I obtained it without carrying any extra equipment or film in the field.

CHAPTER FOUR
Selective Vision
ON COMPROMISE AND COMPOSITION

Khumbu, my golden retriever, shows no interest in photography. He is oblivious to the charms of a lake, a stream, or a wild animal in a large exhibition print, yet those same subjects turn him into a bundle of wild excitement when he sees them in reality. I used to think that Khumbu's lack of appreciation for my life's work was due only to the canine balance of his senses. I assumed that his positive reactions to real landscapes were based on symphonies of sound and smell beyond my perception. Then Khumbu went for his first ride in a small plane.

Up in the sky, where all sounds and smells were of the plane itself, Khumbu announced his recognition of muddy ponds and farm animals with vigorous tail wags. He obviously had the ability to use sight alone to identify details in a landscape. Why, then, was he unable to see the content of a photograph, regardless of its size or sharpness?

In a primary way photographs fail to represent reality for Khumbu. His mind does not comprehend their symbolism, and their visual language is lost on him. He may indeed react to a very obvious symbol, such as a dye-transfer print of a dog biscuit, but we haven't tried that expensive experiment yet. It is significant that to some degree Khumbu's sensory failure is shared by human beings as well. Although we have the brainpower to recognize the subject matter in most photographs, our appreciation has little to do with how faithfully an image reproduces nature. In fact, we rarely have any more enthusiasm than Khumbu does for completely literal attempts to translate wild places onto film. Our eyes

wander around looking for a purpose or a point of interest, and those rarely occur in an image simply by chance.

Another example of how this sense of unreality affects our appreciation of photographs is evident in unfiltered images made by artificial light on daylight film. If I use the proper blue filter over the lens, the photographs have the correct color balance and I see a full range of color. Without filtration the photographs take on a yellow cast that makes other colors unrecognizable. So far so good. The discrepancy comes when I compare these yellow "failures" to what I saw through unfiltered eyes at the scene. There I saw an almost full range of color because my brain compensated for the radically different color of artificial light; yet no matter how hard I look at that yellowish photograph, I cannot convince my brain to compensate because it doesn't perceive photographs as the real world. Trying to view such an image in artificial light merely compounds the problem.

I conclude that we appreciate photographs not so much for the ways they precisely render reality as for the ways in which they transcend it. We respond to images that show us a clear expression of something other than a replication of the world. In other words, when we are deeply moved by a photograph of a landscape, we are usually reacting to what I call the "selective vision" of the photographer rather than to the fidelity of the scene itself.

Photography succeeds not when the original vision is created photographically, but when the photograph is able to evoke or re-create a similar vision in the mind of each viewer. If the re-creation is not understood or not relevant or not powerful enough, the image fails. But if the special unity of composition found by the photographer triggers strong emotions, the image has a chance of success.

The source of these selective visions has absolutely nothing to do with precision. If photography depended on precision, modern inventions such as automatic exposure, automatic focus, and computer-designed optics would already be delivering predictably perfect pictures. They don't, however, because the aptitude for selective vision defies automation. What is important is a nearly opposite virtue: a finely tuned sense of compromise. The history of photography is usually written with an emphasis on either technological developments or fine-art imagery. Let's take another look at it as it relates to compromise and selective vision.

L. J. M. Daguerre, inventor of the daguerreotype, was a professional painter by trade. When he offered his process to the public in 1838, he made no mention of a camera's artistic potential. His was a "process that gives Nature the ability to reproduce herself . . . anyone can take the most detailed views in a few minutes." The creative role of the photographer was virtually nonexistent.

For the next decade even a smile couldn't be photographed because exposure times were measured in minutes rather than in fractions of a second. Cameras were primarily used to make rigid-appearing portraits and images of still scenes. Most photographers who rated a place in the early history of the medium were interested in the evolving technology, rather than in what we would now call photographic artistry. Art photography appeared very early in the game, but instead of seeking out truths in nature, practitioners favored using models and image manipulations such as soft focus and double exposure to produce scenes that emulated paintings.

Technology for its own sake had its heyday in the 1870s. In 1877 Eadweard Muybridge succeeded in photographing a galloping horse at 1/2,000 second. The pursuit of sharpness also reached an extreme rarely matched even today when a photographer named Merlin used a 10-foot camera with a 100-inch lens mounted on a 74-foot tower to make a 5-by-3½-foot negative of Sydney, Australia.

By the turn of the century, exquisitely sharp images were commonplace, and a funny thing began to happen. Compromises in absolute quality became acceptable. As the momentum of documentary photography increased, negative size and sharpness were allowed to decrease. Selective vision became more important as new films and simpler cameras allowed photos to be made almost anywhere at any time.

After 35mm cameras came on the scene in the late twenties, many of the significant images of the era began to show evidence of compromise of technical precision. For example, Robert Capa's famous "Death of a Loyalist Soldier, 1936" is somewhat blurred and far from ideally composed, yet Capa was a skilled technician capable of making technically excellent images. Henri Cartier-Bresson's handheld 35mm images also show technical compromises. The work of both these men is so revealing of the human condition and of the future possibilities of the art of photography that it ultimately has become more significant than most of the large-format imagery of the times.

Without a good sense of compromise a photographer tends to miss the most decisive moments. As a beginner I noticed that whenever I tried to be very precise with my subject, I often lost the image completely. Animals disappeared as I set up my tripod, breezes blew wildflowers I had just spent long minutes framing to perfection, and fine light fizzled in front of my eyes while I cleaned my lens before shooting a landscape.

My decisions about what equipment to use, film, exposure, depth-of-field setting, and bracing rely far more on my ability to compromise technical precision than on my ability to create a perfect picture from a perfect situation.

Composition is one of the few acts of picture taking that has completely defied automation, and it always will. Even though rules of composition are taught in photography

and art classes, there are no absolutes. Composition results from a long series of choices and compromises. Once I have chosen a subject, where do I place it in the scene? Do I shoot from eye level, or above, or below? How do I deal with translating three-dimensional elements to two? Do I frame the image vertically or horizontally? Will my subject look best in dark, moody surroundings with poor shadow detail, or should I expose to open up the shadows and thereby risk losing the mood? Where do I place the brightest or lightest colors? Do I frame in a foreground or shoot my subject mainly in one plane? In my opinion composition boils down to nothing more than pleasing the eye. A good intuitive sense goes a lot further than a headful of rules.

With landscapes I first try to single out a meaningful area from the panorama before me. Sometimes this choice is strikingly obvious; at other times it requires a great deal of awareness and sensitivity and experience. When nothing looks quite right, a photographer must make critical decisions about how to compromise his ideal vision. I want my selected area to hold something of the character of the whole, yet at the same time emphasize the importance of certain features. Time and again I fail to realize that the special character I sense outside the field of my selected vision will not be in the photograph unless I consciously work to put it there. To succeed I have to block out the world around me and be extremely sensitive only to the material in my viewfinder.

Because I want the eye to be led through a photograph and pleased by it, I try to eliminate all elements that do not work toward that goal. Our brains are geared to see order in randomness; therefore anything that suggests order if the order suggested isn't in fact there is displeasing to the eye. An image that splits the horizon in half implies a relationship between its halves. If one isn't apparent, the image is compromised. But when photographing a subject and its mirror reflection, a fifty–fifty split may work well to emphasize the sameness of the halves.

I call this leading and pleasing the eye the "principle of visual harmonics," and understanding it, I believe, is the key to composing by feel and balance rather than by set concepts such as the traditional "rule of thirds" (placing subjects at points one-third of the way from the sides of the frame). Visual harmonics are a result of the geometrical relationships created within a picture by its composition. When they coincide with the subject matter, they greatly strengthen it. When they clash with the subject matter, they may weaken an image to the point of invalidation. For example, take the photograph that immediately precedes this chapter, on page 98. It has three rock towers and three zones of distinctly different subject matter, but it was not composed by thinking in terms of thirds. I was concerned with balancing foreground matter with the background landscape in such a way that nothing jarred my eye.

Visual harmonics must coincide in a bold and obvious way when the overall emphasis of an image is a pattern, yet they need to be absent in situations where simple subjects are balanced against their environment so that isolated points of interest appear random and natural rather than obviously contrived. The last photograph in this book (page 218) has just such a calculated randomness. Imagine the difference if the moon were exactly centered in the photograph.

A photo editor once complimented me on my compositions and at the same time criticized the work of a well-known photographer whose work I continue to admire. His explanation was fascinating. After looking at photographs intently over a period of years, he saw contrived order in compositions using the conventional rule of thirds to avoid the appearance of contrived order. His experienced eye homed in on the thirds in the same way that most people's eyes home in on more obvious fifty-fifty splits at the horizon.

This conversation reinforced for me the importance of compromising and balancing the elements in each photograph according to its special needs. Over the years I have developed a method to avoid thinking in terms of halves, thirds, quarters, or the golden mean as I compose a landscape: I always begin by spontaneously balancing the features I have chosen by intuition. I look for the most important convergence of light or form and try to decide where to place it in my picture. If a certain framing feels right, I go with it. Only when it doesn't, or when I have too many other factors to consider, do I use a rigid procedure to achieve a balanced composition that does not appear contrived.

My Nikon cameras have a 12mm circle in the viewfinder representing an area favored by the exposure meter. This circle occupies roughly the center third of the 24mm-by-35mm frame. I place my subject on the edge of the circle and move it around until it feels best. The Nikon viewfinder circle works well for this selection process because of the very randomness of all the points on its perimeter. Located on a circle inside a rectangle, these points give me instant access to what I think of as the visual equivalent of prime numbers. None of them touches a grid intersection of halves or thirds, and they neatly solve the problem of making a harmonious composition.

Another concept I use is called "visual sea level," which means simply including a visual point of reference in any photo that may be difficult for the viewer to interpret. An isolated photo of a mountain climber can be very hard to orient unless part of the horizon or a profile of the steepness of the mountain is included. In wildlife photography an animal does not have to be totally sharp so long as its eyes are rendered sharp.

When I made the image "Rainbow over the Potala Palace" (see page 211), I was struck first by the obvious splendor of the rainbow converging with the palace. I polarized the sky to cut the specular highlights off the raindrops and to uniformly darken the back-

ground. Then I focused on what seemed to be the most powerful image: rainbow and palace floating in the sky without a foreground. Later, when I looked at my exposures of the composition far from the context of the scene, it was obvious that they lacked credibility. Luckily I had kept the principle of visual sea level in my mind and had also made images that included a strip of mundane foreground with green trees, small buildings, and telephone poles. That foreground made the image successful.

The most common use of visual sea level is also the most difficult to manage. Putting a human figure into a landscape compensates for the sense of scale lost in two dimensions, but when the person is rendered too large or too recognizable, the image ceases to function as a landscape. If the person is too small, the scale may not be readily apparent. Eventually, a photographer gains an intuitive sense of what looks right in different situations. Against an even background of snow, sand, or sky, a tiny figure can look striking, but in a forest scene a very small figure further confuses an already complex scene.

Another general rule of composition that I follow faithfully is to include nothing at the edges of my images that will interrupt my viewer's eye, unless I want such an element there to lead the eye toward a subject (as with a strong diagonal or an S curve). When the main events are in the interior of a photo, the viewer's eye should be able to run around the periphery without finding anything distracting. Continuous tones without bright highlights or unobtrusive patterns make ideal borders.

Even the most beautiful elements in nature—sunsets, waterfalls, clouds, and rainbows—don't look their best in photographs when singled out. They are invariably more interesting when juxtaposed against their surroundings; they need something else to locate them in the universe. This balance of something splendid against something ordinary is contrary to a photographer's natural inclination. We tend to either single something out or include too many ordinary things.

In photo workshops I have found that at least 90 percent of the students make a basic compositional mistake. Their best pictures are invariably improved by cropping the foreground. Why? Because when we look at a scene with our eyes, our three-dimensional vision takes into account the fact that things close to us appear larger because of natural perspective distortion (the same phenomenon that makes railroad tracks appear to converge in the distance). When we make a photograph, however, we are translating a three-dimensional vision into two, and the foreground will always look overemphasized unless we take that factor into account beforehand.

It takes only one workshop critique session, when I project students' freshly processed slides in front of the whole group, for the ubiquitousness of this problem and its simple solution to be obvious. Image after image, including most of the best ones, become more

powerful as I hold cardboard in front of the projector to crop the lower edge of the image area.

I have yet to find a student who solved this problem by looking at other people's images or by reading books. It becomes clear only after the threefold process of shooting one's own images, studying them, then shooting again. I cannot overemphasize the importance of paying close attention to poor photos as well as to good ones, for it is in the rejects that our own conceptual errors are the most apparent. Too many of us get back our slides, pull out the good ones, then banish the rest.

Projection makes slides appear almost too good to be true. This is related to yet another compositional factor that is often overlooked: the range of brightness of a photograph. Remember that your eyes see a range of 2,000 to 1 while a color slide holds a range of less than 8 to 1 for publication purposes. When a slide is projected, it attains a brilliance and a range of tones that are far closer to reality than in printed form. That is the case because the slide is viewed in a darkened place with an extremely bright light passing through it just once. Prints look dull because they are normally viewed by the same light that must also go through the layers of the photographic emulsion, bounce off the paper, and come back again before reaching the eye. The images in this book, for example, will regain some of their original brilliance and tonal range when viewed in a darkened room under a bright light, but that is not the way we normally read a book.

The loss of tonal range in a printed photograph is impossible to precisely estimate beforehand, except by long experience and intuition. Many photographers on commercial assignments produce Polaroid prints to give an art director a rough idea of the lighting and composition before obtaining final approval for a shoot. In the fast-breaking kind of outdoor situations that I photograph, however, I can't afford to make a Polaroid because I rarely have a second chance at my subject. Many of my subjects are in extremely high-contrast light. As I watch a climber move along a ridge in shadow with a panorama of snowy mountains behind, I may know that he and the entire foreground will photograph as a black silhouette. Still, I used to have a hard time visualizing that final result because my eyes saw plenty of detail and color. Usually I misjudged the amount of darkness in my composition and ended up with black areas so large that they overwhelmed the rest of the composition. For years I had trouble composing such scenes until I happened upon a special technique that helps me previsualize dark areas.

Most single-lens reflex cameras have depth-of-field preview buttons, which rank near the top of the list of seldomly used camera functions. Their intended use is to close down the automatic diaphragm of a lens to actual picture-taking aperture so the photographer can preview the range of focus of a scene. When the button is pushed, the view-

finder darkens as the automatic lens diaphragm closes down to the aperture at which the photo will be taken. (Automatic diaphragms were invented to counter this darkening by staying open for bright viewing regardless of the aperture setting. They close down only during the instant a photo is being made.)

The depth-of-field preview button allows you to momentarily see the amount of sharpness at the actual picture-taking aperture, even though the image is considerably darkened. The amount of darkening has no relation to that in the final image, and thus no manufacturer has ever suggested that it be used for previsualizing lightness or darkness. For example, if you set your camera at f/16 in dim light after sunset and push down the preview button, you will probably see nothing but blackness; yet by adjusting shutter speeds you could bracket a complete range of exposures of this scene.

Whenever I need an aid for composing a high-contrast scene where I know that shadow areas will go black (by metering and finding a difference of more than three stops between highlights and shadows), I depress my preview button and close down the aperture until the low values go dark and lose their detail. Although this does not give me an accurate range of tones, it provides the visual information I need to compose my picture: a rough idea of the exaggerated darkness of shadows I will get when I expose for the highlights. By using my preview button, I pit areas that will be dark in the final image against brighter zones that will show normal colors. I find it especially useful when working with silhouettes or when making shots directly into the sun.

Depth of field itself is a classic case of compromising precision in photography. The depth-of-field marks on a lens imply a discrete range of focus within which images will be uniformly sharp, but that is not the case in practice. Instead of a magical zone of clarity, depth of field is merely a way of thinking about achieving acceptable image quality by compromise.

Depth of field is based on the idea that a point of light is never rendered as a point on film. It always widens into a blur. The optical name for this blur around a point is "circle of confusion." The zone of proper focus of a lens is defined by the smallest circle of confusion. In either direction the circles become larger (although because of the physics of optics they become larger twice as fast in front of an object as they do behind it). When the circle of confusion is large enough, we perceive it as a blur instead of as a point.

The depth-of-field marks on a lens barrel are designed to show a photographer the range within which the circles of confusion will be acceptably small enough to make an 8-by-10 print that looks uniformly sharp. Photographers who don't understand the compromise inherent here and think of depth of field in terms of precision are liable to get themselves into trouble when they try to sell their images to magazines or make exhibit-

All of the techniques, compromises, and intuitive decisions I have discussed in this chapter have a single purpose: they enable me to photograph in wild places with a minimum of baggage–both physical and mental. Because I want to record the full range of my experiences–landscapes, interplays of light, wild animals, plant life, and people out there doing things–my methods have to be second nature, thereby providing the freedom my mind needs to explore the selective visions that make an image far more interesting than a simple attempt to duplicate reality.

EXHIBIT V

Artist's Light

When I began photography, I was wary of artist's light. As a child I had been dragged through art galleries, and early on it became clear to all who knew me that I was far more interested in the potential of the natural world to engage my senses than I was in some visionary world created by an artist. I took it for granted that all painters modified light in order to create their own worlds of fantasy.

I understood exactly why artists wanted to alter light, because I myself couldn't bear to photograph a landscape in ordinary light. Although I had to compromise my ideals to make certain pictures of human activities, I searched out special light to enhance the land-forms and the mood of all my landscapes. Within a few years I produced some images that gave me a sense of *déjà vu*. To my surprise I discovered that I had put onto film moods of light and form that bore an uncanny resemblance to the work of certain artists.

At first I thought I must have unconsciously looked for the same kind of light I had seen in paintings. However, such stylistic continuity was not possible with the sporadic glimpses of painterly light and form I was discovering in nature–light such as that in paintings by Turner, Rousseau, Church, Bierstadt, and Dali. I searched for a reason why my work sometimes had the look of those artists, but not of others.

Only at another level did the connection become apparent. With one exception, all of those artists lived long after the Renaissance but before the advent of color photography. Dali is rare among modern painters in that he likens his process to photography. He describes his work as "instantaneous and hand-done color photography of the superfine, extravagant, hyperaesthetic, virtual images of concrete irrationality."

Aside from Dali the connection among these artists' efforts is a reverence for the natural world; they conveyed in their paintings the type of thinking that Emerson, Thoreau, and Muir were putting into words during the same era. And so a style of painting that reflected similar direct appreciation of wild places blossomed for a brief moment in civilization. Nineteenth-century landscapes presupposed color photography, which eventually diminished critical acclaim for literal paintings of landscapes, ushering in an era of modern art that no longer seeks to replicate the light of natural moments.

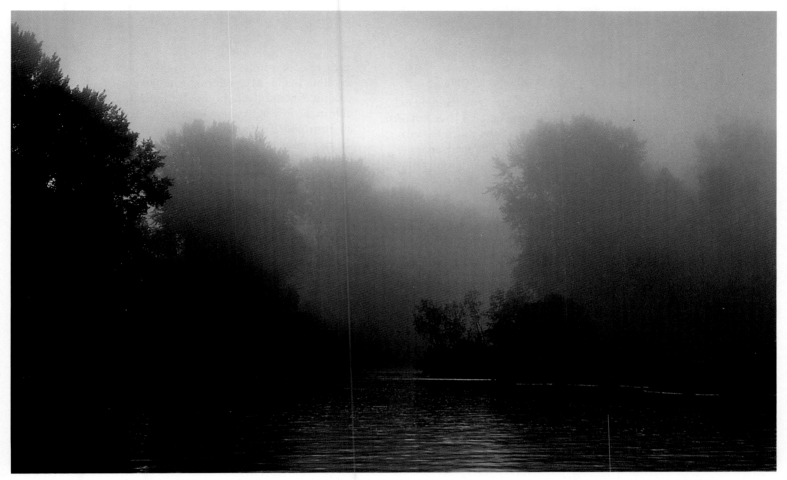

SUNRISE OVER THE SKEENA RIVER, BRITISH COLUMBIA, CANADA

SUNRISE OVER THE SKEENA RIVER, BRITISH COLUMBIA, CANADA; 1974

After driving all night down the dirt Stewart-Cassiar Highway from Alaska, I stopped by a river's edge as first light poured through rising fog. Rather than photograph objects, such as the forests or the river, I chose to work with just the light and the mist. There in nature I found the tones that I had dismissed as embellishment in the nineteenth-century landscapes of J. M. W. Turner.

Turner is known for his atmospheric landscapes in misty morning light. His paintings depart from the convention of using foliage or people for framing. He deemphasized topography to gain effects of light and tone. One of his most famous images is titled *Sun Rising Through Vapour*, and the accuracy of his perceptions led the famous critic John Ruskin to write, "Turner is the greatest landscape painter who ever lived. If truth were all that we required from art, all other painters might cast aside their brushes in despair."

Ruskin was so captivated by Turner that he spent several years promoting Turner's art through his writings. At the same time, Ruskin gained an obscure niche in history for himself by making, in the 1840s, what may well be the very first daguerreotypes of the Alps. As a boy he had systematically traveled Europe in search of beauty in nature, and he recognized that Turner's near-abstractions were based on similar study. "Turner thinks and feels in colour," he wrote. "He cannot help doing so. Nature has given him a peculiar eye, and a wildly beautiful imagination, and he must obey its dictates."

Both Turner and Ruskin were entranced by visions of mountains. Turner spent time in the Swiss Alps, painting rainbows and sketching avalanches as well as working with a more usual veil of colors. After Turner's death, Ruskin and his father sought to increase their already-large collection of Turner paintings and sketches. "The chief thing is to get mountains," Ruskin wrote in a letter of advice to his father. "A mountain drawing is always, to me, worth just three times one of any other subject."

TECHNICAL DATA *Nikon FTN with 105mm lens; Kodachrome II (ASA 25).*

LYNX IN ALPINE FLOWERS,
TEKLANIKA RIVER, ALASKA RANGE; 1974

In the decade since I saw this lynx standing tall and unselfconscious at close range, I have not seen another of his species in daylight, much less in a bed of wildflowers. A series of unusual circumstances came together to make this photograph possible, but of equal importance was the fact that I was prepared for just such a situation to confront me. On two previous visits to Denali National Park, I had frequently missed fast-moving wildlife situations because I fiddled too long with my equipment.

The rare nature of this photograph is clear from the following quote from a current issue of the *Guilfoyle Report*, a newsletter for nature photographers: "Photographing a wild lynx is very difficult and getting acceptable pictures of one is a real accomplishment. In fact, I doubt if anyone has actually done it. Pictures of a tame lynx are easier to get and would certainly be closer up and of better quality; inevitably they would tend to invalidate wild lynx shots, which are natural and real."

In fact, I have found precisely the opposite to be true. For the past decade wildlife magazines have consistently rejected this very real image because it looks more like a Rousseau painting than a photograph of a rarely seen animal. The French artist Henri Rousseau loved to paint fanciful images of wild animals in direct forest situations. His *Jungle with a Lion* has remarkably similar subject matter, while *Exotic Landscape with Tigers and Hunters* even includes tall yellow and red wildflowers with a profile of a big cat in heavy green foliage. Although admired by Picasso, Rousseau's paintings were denigrated during his lifetime by critics who found his style ingenuous and simplistically naive. Is it coincidence that the equally close and symplistic vision in my photograph from the wild provokes similar criticisms of unreality?

Over the years I have been told with certainty that the lynx in this photo must be either stuffed, tame, or sickly. To the contrary, it was one of the brightest and most alert wild creatures I have ever observed. I encountered it while I was driving with my family on a dirt road through Denali Park. At the time I had two Nikons next to me on the car seat, each with the exposure preset for the dim existing light. It was one of those overcast mornings when the valleys we encountered alternated between fog, rain, and drizzle. I was growing so frustrated by the lack of clear vistas that I was ready to compromise just to get a sharp picture of anything living. My preferred combination of a 500mm lens and Kodachrome II film wasn't possible in the low light unless I got out of the car and used a tripod. To do so would scare away most of the rare animals, so I put High Speed Ektachrome (a grainy film I no longer use) in the camera and equipped the second one with Kodachrome II and a 200mm lens that needed less light. (Kodachrome 64 film was introduced a year later, and Fujichrome Professional 100, my present choice for wildlife work, didn't appear for another decade.)

Near park headquarters, Nicole, my daughter, who was ten, saw a large cat without a tail dart into the bushes. Her description didn't fit any other Alaskan animal; it had to have been a lynx. Even before we saw the second lynx, I was speculating on why we had seen such a rare nocturnal creature in broad daylight. On my visits the previous two summers I had seen quite a few snowshoe rabbits, yet on this journey I was seeing none. Snowshoe rabbits, like lemmings, have cyclical population explosions followed by sudden die-offs. The lynx responds to this repeated pattern, which peaks every ten or eleven years. In the eloquent words of the naturalist Ernest Thompson Seton, the lynx "lives on Rabbits, thinks Rabbits, tastes Rabbits, increases with them, and on their failure dies of starvation in the unrabbited woods."

The rabbit population had just crashed; hungry lynxes were forced to hunt by daylight. Although I wasn't consciously looking for another lynx, I was definitely contemplating Nicole's rare sighting when I rounded a corner and spotted movement in the underbrush. Cutting the engine and coasting to a stop, I grabbed the camera with the 200mm lens and braced it on the window opening. Forty feet away, half hidden in the foliage, was a very skinny lynx.

The photo situation seemed poor because the animal was in a glade that was much darker than the surrounding terrain. With lens wide open my meter indicated two stops less light than I could safely handhold, which put me into a momentary quandary. If I set the shutter speed at 1/250—the required speed with a handheld 200mm lens—I would be underexposing by two stops. On the other hand, if I used the setting indicated by the exposure needle, I would be shooting at 1/60, an ironclad guarantee for blur. I considered and rejected the idea of switching the lens to the camera with faster but murkier Ektachrome.

I opted for a compromise and set the camera at

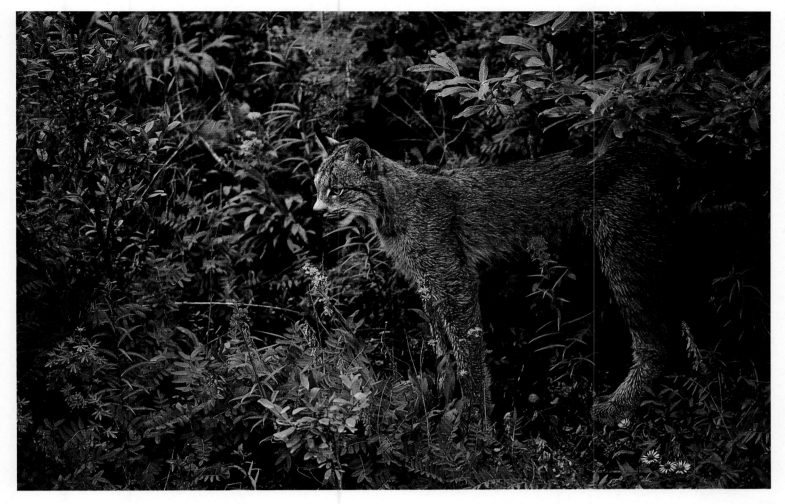

LYNX IN ALPINE FLOWERS, TEKLANIKA RIVER, ALASKA RANGE

1/125, one stop underexposed. I knew that color printing could compensate for that much under-exposure and that bracing the camera on a parka against the window opening could compensate for the one stop of lost shutter speed. At best I expected one quick record shot before the animal darted off, but after I took a mediocre profile deep in the brush, I was surprised to see the lynx move toward me, fully aware that I was there. I felt my heart pounding and thought about the need to press the shutter between beats. The sighting was absolutely wonderful, but at first nothing seemed to come together photographically. My shutter speed was far too slow to capture the animal in motion, and I was at a loss about what to do next.

I couldn't imagine why an animal legendary for its shyness was so bold, let alone predict its next movements.

Suddenly the lynx stood erect and very still. I barely had time to make two exposures before it shot itself like a rubber band into a bush and disappeared out the back with a rabbit in its mouth. Unseen by me, the rabbit had been concentrating on my presence; the lynx had used me as a decoy to make its bold daylight stalk, and I, in turn, had captured the moment when it was most intent on its prey.

TECHNICAL DATA *Nikon FTN with 200mm lens; Kodachrome II; one stop underexposed.*

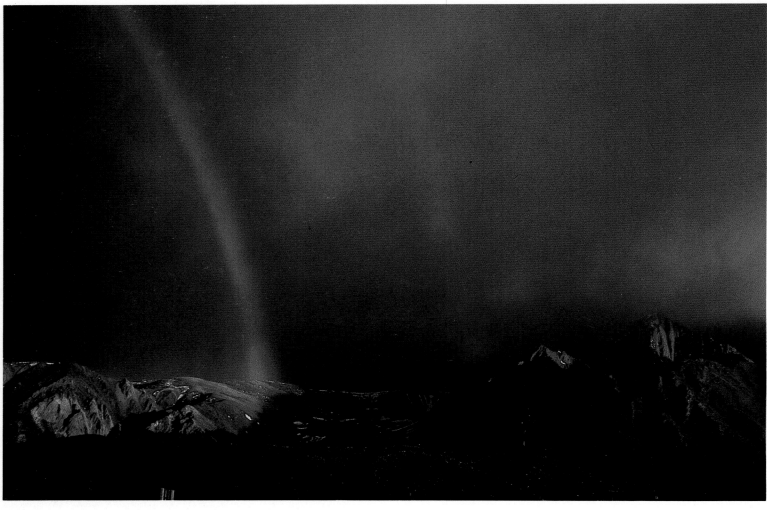

THUNDERSTORM OVER MOUNT MORRISON, SIERRA NEVADA, CALIFORNIA

THUNDERSTORM OVER MOUNT MORRISON, SIERRA NEVADA, CALIFORNIA; 1972

After a climb on the east side of the Sierra, I barely made it down the trail to my car before a thunderstorm hit. I drove through heavy rain that I expected to continue into the night. After about an hour of driving, however, I suddenly emerged into sunlight and was surrounded by peaks, veils of mist, and a rainbow. At the time I was not aware of the painterly quality of the light, and I stopped to make a 200mm telephoto of a portion of the bow next to Mount Morrison, which was bathed in a veil of raindrops colored gold by the setting sun. Then I continued on, feeling very satisfied with an image that pulled a strong center of interest out of the scene.

As I moved away in my vehicle, the rainbow appeared ever farther from Mount Morrison, but the sky quickly opened up with an even broader range of hues. The section of the sky above the peaks displayed the gold of evening light on the mist, the black of thunder clouds in shadow, glimpses of blue in the background, and parts of both the primary and secondary arcs of the rainbow. I stopped again, braced my camera on the car roof, and composed a much broader scene than before with a 55mm lens. Rather than focus on any particular area, I tried to integrate all the sky phenomena into one image, with enough of the horizon to give it relevance. I exposed directly on my meter (which, as usual, was set at ASA 40 to saturate colors with slight underexposure).

The first telephoto was chosen for a double-page spread in *National Geographic*, tied to a story on Owens Valley's water problems with a caption that began, "Rainbow's end holds a treasure of moisture. . . ." However, the image reproduced here has until now remained unpublished. It lacks the kind of obvious information of place that attracts book and magazine editors, plus it has a

EXHIBIT V ARTIST'S LIGHT 115

curiously unphotographic grandeur more reminiscent of a nineteenth-century painting than of a modern Kodachrome.

Frederick Church, the leading American landscape painter of the mid-nineteenth century, was captivated by recreating optical effects he witnessed in the air and sky. He approached his subjects with the eye of an artist-naturalist rather than with the eye of a romantic painter. Several of his images have a quality of light extremely similar to that in this photograph, with rainbows, mist, and wilderness brought together into a single frame. Among his subjects were waterfalls, icebergs, alpenglow, and high peaks of the Alps and the Andes.

Church's faithful renditions of the optical effects of mountain light were part of the reason his paintings sold for up to $20,000 during his lifetime. He had a following in Europe, and the mountain-loving critic John Ruskin wrote that a Church rainbow looked so real that he at first thought it was a reflection from his window. Ruskin also saw that Church was depicting subtle effects of light on water that were not only real in appearance but also new to painting.

Although considered an artist of the Hudson River school, Church loved mountain subjects, and he traveled around the world in a quest for nature's most dramatic landscapes. He was influenced by Alexander von Humboldt and Sir Thomas Hooker, who explored the earth's wild places during the same era, looking for natural phenomena instead of pursuing geographical "firsts."

Church was the only formal pupil of the well-known landscapist Thomas Cole, who almost singlehandedly founded the school of native American landscape art. Cole confronted longstanding artistic dichotomies by foregoing romanticism for a touch of reality. He went a step further than his contemporaries by depicting landscapes with a sense of the ebb and flow of history, transitional scenes, rather than focusing on a single period or event. Church carried this sense to its logical extreme: the history of the landscape itself, the raw geology of the earth.

Alexander Eliot, art editor of *Time* magazine in the fifties, was not particularly fond of Church. In a history of American painting he left Church out of the Hudson River school and put him into a category he called "The People's Choice," artists who were beholden to public whim with "one common denominator: a safe and sober mediocrity that could be admired without effort." Eliot conceded that "Church's skill served to stretch the admiration of his admirers; he brought far places into their minds accurately and convincingly. Today the movie travelogue and the travel lecturer's slide fulfill much the same function."

Eliot's widely held view that immediately dramatic phenomena somehow overpower artistic intentions carries over into photography as well. John Szarkowski, director of photography for the Museum of Modern Art, has stated that "a skillful photographer can photograph anything well" and that "talent is more important than good ideas." Believing that a photographer's style may be seen the most clearly in the absence of dramatic subject matter, Szarkowski brought a one-man show of Irving Penn's closeups of cigarette butts to the museum in 1975. Thus, the attitude against depicting vivid natural phenomena in art that Church fought a century ago continues unabated today.

Even though the art of photographic seeing may be easier for a critic to dissect when applied to banal subject matter, I see no reason to emphasize this sort of imagery over dramatic landscapes that render the photographic process less obvious but thereby give the viewer the inspirational and unselfconscious feeling of being within the scene.

TECHNICAL DATA *Nikkormat FTN with 55mm lens; Kodachrome II (ASA 25).*

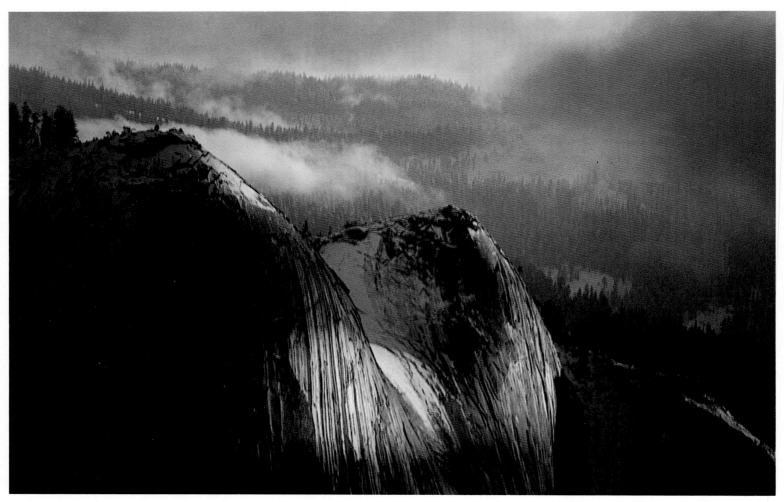

WATER STREAKS ON QUARTER DOMES, YOSEMITE, CALIFORNIA

WATER STREAKS ON QUARTER DOMES, YOSEMITE, CALIFORNIA; 1972

For years I did not consider this image among my true dynamic landscape images because it came too easily. I simply stopped the car by the Tioga Pass, set up the tripod, and made several straight images with a telephoto lens. By luck I was able to shortcut all the procedures that normally lead me to fine light and form except in the final seconds of composing what was before me. I was therefore quite surprised when the International Center of Photography chose it as the single color image to be used in its annual report to represent its major 1983 exhibit, "High Light: The Mountain in Photography from 1840 to the Present."

I find myself inexorably drawn to this same image when I think about the theatrical light painted by Albert Bierstadt, the artist whose work has most often conjured up memories of real natural displays. Yet Bierstadt remains an enigma to me. He was capable of great accuracy and tremendous exaggeration, sometimes even in the same

work. His *Yosemite Valley; 1866* is a photographically faithful rendition in normal midafternoon light with threatening clouds overhead. His *Lake Tahoe; 1868* appears as if Angel Falls, Half Dome, and Nanga Parbat have been grafted onto the cliffs above Emerald Bay, with a sky to herald the second coming of Christ.

Photography had a definite influence on Bierstadt's work, although color photography did not yet exist. Both his brothers were photographers, and they frequently accompanied him on his East Coast excursions, taking images of scenes he set up so that he could later paint them in his studio. Bierstadt settled in New York City in 1859, and historians have speculated that he must have seen Carleton Watkins's 1862 exhibit of Yosemite photographs there before setting out on his own Yosemite venture the following year. In 1863, five years before the arrival of John Muir, Bierstadt spent seven weeks in Yosemite. Thus began his best-known work. His hallmark was a clear sense of perfection in wilderness scenery, and Yosemite

EXHIBIT V ARTIST'S LIGHT 117

was perfectly suited to his style. In 1872 he returned, this time in the company of the photographer Eadweard Muybridge.

Bierstadt had a special sense of how to recreate, in spectacular scenery, wildly dramatic lighting that he probably observed elsewhere. His sense of light was not nearly as accurate as Church's. Still, Bierstadt's overall moods closely match the extremes I have seen in many of his own locations. Bierstadt traveled more than any other American artist of his day, visiting the Canadian Rockies, the Alaska Range, and the Alps as well as the major ranges of the American West.

At the time of Bierstadt's visits to Yosemite, he was the most critically acclaimed artist in American history. His paintings sold for as much as $35,000 each. In the 1880s his work fell rapidly out of favor as photography satisfied the public's desire to see images of natural landscapes in great detail. Today it has regained much of its former glory, and some of his small canvases, painted to show direct observation of the beauty of the West instead of to create the sense of grandiosity that carried his large panoramas, have become especially cherished.

TECHNICAL DATA *Nikon FTN with 200mm lens; Kodachrome II (ASA 25).*

EDGE OF THE PATRIARCH GROVE, WHITE MOUNTAINS, CALIFORNIA; 1976

In the winter of a drought year, I visited the Patriarch Grove of bristlecone pines. Two years earlier I had traveled through the grove on skis and made some very satisfying images of individual trees (see pages 7 and 13). This time, however, the dirt road was passable all the way to eleven thousand feet and the trees were bare of snow. I was unable to make an image that pleased me at close range because the trees lacked the wintery character I had previously photographed.

My next hope was for a fine silhouette at sunset, but at that hour most of the trees were in shadow on the lee side of the crest. To complicate things even further, the air was so clear and cold that the area of color around the setting sun was very small. After the sun went down, I climbed a hill at the edge of the grove where I had made a photograph in morning light two years earlier. I thought that in the soft light of dusk I might be able to use the same tree for a very different sort of image.

The idea didn't work, but when I turned around I faced a most unusual landscape, which looked like a surreal painting by Salvador Dali. Near the edge of a sloping plain of burnished earth were a few dead trees that took on the appearance of figures frozen in time and space. The land had very normal hues, but the sky overhead appeared in otherworldly tones of mauve and cobalt, caused by the earth's shadow pushing upward into the still-sunlit atmosphere. It was a scene totally lacking the airy feeling painted by romantic artists. Just as in Dali's paintings, there was extreme detail with a wildly distorted sense of scale. The subfreezing clarity of the air combined with bare ground was creating a rare situation with no atmospheric haze whatsoever to impart a feeling of form and distance to the contours of the land.

I decided to compose an image that emphasized the irrational elements of the scene by placing the dead trees all the way to one side of the image and the interesting arc of snow-filled gully all the way toward the other. The sense of nothingness in the center of the image mirrors the feeling of "wide-open Homeric spaces" that Dali searched out to emphasize the surreal nature of many of his best paintings. This scene is contrary to conventional images of bristlecone pines in many of the same ways that Dali's self-portrait *Dali, at the age of six when he believed himself to be a young girl, lifting the skin of the water to observe a dog sleeping in the shadow of the sea* is contrary to conventional self-portraits.

When I made this image, I had a strong sense of working the scene to enhance its already surreal appearance. I even thought about adding a crazy human element as Dali might have done, but as I considered the zaniest pose I could personally strike, or how my old Chevy station wagon would look just coming over the horizon, I realized that I would be going too far. What I had found, a surrealistic feeling in a straight rendition of a landscape, was far more valid confirmation of the realism inherent in Dali's nightmarish visions than any manipulated image could provide.

TECHNICAL DATA *Nikkormat FTN with 24mm lens; Kodachrome 25.*

EDGE OF THE PATRIARCH GROVE, WHITE MOUNTAINS, CALIFORNIA

CHAPTER FIVE

Extraordinary Vision

OUTDOOR OPTICAL PHENOMENA AND THE
CONTROL OF NATURAL LIGHT

In Europe during the Middle Ages, mountains were thought to be spiritual realms. Alpine villagers frowned on those who roamed too high because of the wrath they might trigger from the heavens. And from the valleys where the villages reposed it was obvious to all who observed the heights that mountain light was very different from light in the lowlands. Days began and ended with unworldly colors, and as if that weren't enough evidence of spiritual influence, occasional shepherds and crystal hunters who ventured too high brought back spine-chilling tales of halos, glories, and human figures in the clouds.

Imagine, for example, what it must have been like to witness the "specter of the Brocken" in those times. You have just climbed to a high ridge that was off limits for people of your village. A giant's shadow appears in the clouds, surrounded by a halo of delicate colors. You begin to run. The giant runs too. As suddenly as the vision came, it vanishes into an ephemeral wisp of cloud. When you return home, you either don't tell anyone what you have seen, or you relate the event as divinely inspired.

The specter of the Brocken was named for a German mountain where it is often observed. Significantly, the specter is visible only from high places, never from the flatlands. It appears when one is looking directly opposite the sun, toward the antisolar point, into certain kinds of mist. By definition the antisolar point is below the horizon when the sun is visible at ground level. (In other words, your shadow is *normally* on the ground, not in the sky.) The phenomenon held its mystique until nineteenth-century scientists began to climb mountains and systematically study atmospheric effects. They identified the shadow in the clouds as that of the observer, and the fact that it often appeared to be very large was

attributed to an error in perception: the observer has no point of reference for the hazy shadow's size. The colored glory around the shadow is the product of reflection and subsequent diffraction by small water droplets.

Today the specter is most frequently seen, not from mountaintops, but from aircraft flying above clouds. When the angle of the sun is right, a glory appears in the mist, and as the plane draws ever closer to the glory, its shadow suddenly pops into the center of the ring.

When Edward Whymper made the first ascent of the Matterhorn in 1865, four of his six companions died in a fall near the summit. Whymper vividly described the phantasm he saw later during his descent: "A mighty arch appeared. . . . Perfectly sharp and defined except where it was lost in the clouds, this unearthly apparition seemed like a vision from another world, and almost appalled we watched with amazement the gradual development of two crosses, one on either side. If the Taugwalders had not been the first to perceive it, I should have doubted my senses. They thought it had some connection with the accident, and I, after a while, that it might bear some relation to ourselves."

Whymper not only made it down alive to tell his story, but also had the presence of mind to look for a rational explanation for his vision. He found what he wanted in a book on an 1821 polar expedition by Sir William Parry, which described halos, arcs, and pillars of light that sometimes intersect to form crosses. In certain atmospheric conditions the possibilities are so complex that some modern physicists have begun to program computers to practice "sky archaeology," the fine art of attempting to re-create historic displays of bows, halos, and arcs that occurred before the advent of photography.

The connection between Parry's polar sightings and Whymper's mountain vision is a key one. With the exception of rainbows, most of the spectacular colored halos and arcs that appear in the sky are caused by refractions from suspended ice crystals. Because they depend on freezing air, these phenomena are most often observed in high mountains and cold climates. Much of our scientific literature on outdoor optical events comes from people who have spent long periods of time in high or cold places and who were intrigued by what they saw. One of the best early works on sky colors and twilight phenomena was published in 1912 by Arnold Heim, a famous Swiss geologist who made extensive studies in the Himalaya. A comprehensive 1980 work, *Rainbows, Halos, and Glories*, was my source for much of the scientific information in this chapter. The author, physicist Robert Greenler, made many of his observations in Antarctica.

My own strong interest in outdoor optical phenomena was sparked by both mountaineering and photography. After spending long periods of time in high places, I began to see that all colors in nature are relative and that their explanation was far more simple than

I had imagined. Two factors—the warming of direct light as it is transmitted through the atmosphere and the cooling of indirect light as it is scattered and reflected—account for nearly all the variations in natural light everywhere on earth.

It is not the rare, exceptional phenomena caused by mountain light that are the most significant to photographers, but rather the everyday occurrences of normal light as seen from high altitudes. Both the vantage point and the clarity of the air help create an understanding of the nature of light that is much more difficult to attain in the flatlands. As early as the turn of the century, M. Minnaert, a Dutch scientist who studied the behavior of light and color in nature, noted: "The original beauty of the hues in the landscape, more and more spoiled in our parts by the effects of industrial development, can still be enjoyed in full splendor in the mountains."

The most familiar mountain color shifts are described in legend and song. The words of an anthem, "of purple mountains' majesty," ring true on clear days in the high country when successive ranges of mountains appear ever more bluish purple in the distance. The reason for the color shift explains half of the normal sky phenomena: those that favor the blue end of the spectrum. The shortest wavelengths of visible light are blue and purple. In passing through the atmosphere, they have a slightly greater tendency to scatter than the longer waves at the red end of the spectrum. Given enough space for considerable sorting to occur, the air itself turns the color of the shorter wavelengths (as does water, which becomes increasingly blue with increasing depth). The objects themselves do not change color, but the light that reaches our eyes and film takes on a distinct cast. Rather than seeing purple mountains, we are seeing the atmosphere as a variable colored filter in front of normal mountains that do not look purple to people observing them at close range.

At sunrise and sunset the opposite phenomenon takes place. The longer red waves of light pass more easily through the atmosphere. The closer the sun is to the horizon, the more vivid the reddish color because the atmosphere closest to the ground has the most interference. The particles that cause the interference must have a size relationship to the wavelength of light. The moisture in clouds does not, and, thus, the sun seen through clouds at midday remains white, whereas the sun seen through smoke at any time of day is often cherry red.

The intense scarlet color we see on mountains at sunrise and sunset is called "alpenglow." It comes about because of the double journey light must take through atmospheric haze. Light rays pass once from the sun to ground level; then they must continue through additional haze back up from the horizon to reach a mountaintop or cloud after sunset. This double journey doubles the light's redness. To explain it differently, consider the curvature of the earth and the fact that mountains and clouds rise well above that curve.

The last light rays they receive skim the horizon quite some distance away. From that point they continue back up through the atmospheric filter a second time, scattering so much of their blue and purple wavelengths that they appear wholly red by the time they reach their subject. Indeed, a look in the shadows at this time shows a deep bluish purple color, because shadows are lit only by scattered light.

After the sun sets, a variation of this phenomenon continues. The deep blue of the twilight wedge, also called "the earth shadow," rises into red sky still lit directly by the sun. This meeting place of colored light looks far more splendid at high altitudes because of simple geometry. When the phenomenon is at its best, a few minutes after sunset, the juncture of blue shadow against reddish atmosphere is much closer to the line of vision from a high mountain. The light from the distant sun cuts an angle from below the distant horizon that is not much different from the line of sight at high altitude. From a vantage point at sea level, however, the twilight wedge appears far more diffused because our upward angle of view does not match the inclination of the colored planes of light; being translucent, they diffuse into one another.

The literal definition of the word *photography* is "to write with light," and in the mountains I take that as a dictum. I especially search out images that show the borders of transmitted and scattered light, which, at the right time in the right place, can turn a bland landscape into an intersection of ruby and sapphire hues. Much of the time I'm in the mountains, however, I'm not able to wait for light and form to work together, especially when I want to photograph human events as opposed to landscapes. By understanding how the balance of warm and cool light works, even in the middle of a clear day, when such difference is not readily apparent, I'm often able to elevate my photos above the commonplace in quite ordinary light.

Consider the following situation. At three in the afternoon on a winter day, I crest a hill on touring skis and see a colorful camp with tents and people in the snow. The sun is shining out of a clear blue sky, and the situation is such that I can choose any direction or angle of view. If I choose the most obvious position, with even frontlighting so that no shadows fall on faces or equipment, I maximize the warm light from the sun, but I also pollute the tones of the image with a tremendous amount of scattered blue light from the sky. The intensity of most colors is weakened by the blue cast, especially on film. The effect is much like holding a large blue umbrella over a strobe in a studio situation.

Another choice would be to use backlight for drama, but if I do that I would end up with a lighting contrast beyond the capability of my film. My subjects would be lit only by the scattered bluish light in the shadows, while the light behind them on the landscape would be the far more intense direct light of the sun. I could make a moody silhouette of

forms in that situation, but not a documentary image on color film with detail in faces, clothing, and the landscape at the same time.

The two reasons for changing the light are (1) to eliminate as much scattered blue light as possible in order to saturate the colors, and (2) to lesson the highlights so as not to exceed the film's latitude. My polarizer cuts most of the scattered blue light and allows the warm light from the sun to prevail only if I choose an angle close to 90 degrees off the axis of the sun. Fixing my camera position on one side or the other from the line of the sun helps dull the highlights on the snow, and by shooting near ground level I can reduce them even further. I try to make the snow reflect the darker sky instead of the sunlight or other sunlit snow.

The finished image bears almost no resemblance to what I would have gotten from a standing, frontlit position. Because harsh contrasts have been reduced and warm tones enhanced, the photo looks as if it were shot at a different time of day on a different type of film.

Some photographers attempt to shortcut working with transmitted and reflected light sources by using a strong warming filter for their landscapes. However, the filter is always readily apparent because filtration affects both types of light. If red or orange appears in the shadows too, the photograph looks phony even to the untrained eye. On the other hand, using just enough filtration to cut the excessive blueness of the shadows gives good results. A skylight filter is designed for this purpose, but in practice a stronger 81A filter is required when shooting flesh tones under a blue sky in shadow.

I use the relative blueness of the sky as an indicator of lighting contrast. When the sky is white and completely cloudy, the contrast is obviously very low. The soft, even light is perfect for portraits but deadly for distant landscapes. The opposite extreme happens high in the Himalaya, where the air is so thin that little scattering occurs. There the sky turns bluish black; therefore, little light is present to fill in the shadows. The contrast becomes so great that a face half in shadow is rendered half black.

What is not so obvious as these extremes is that the blueness of the sky varies with time of day, angle from the axis of the sun, air quality, barometric pressure, and humidity. In general a dark sky indicates favorable conditions for photographing broad landscapes, while a light sky is better for scenes with people. The physics of this may seem confusing unless one keeps in mind that there is less blueness in what appears to be a rich blue sky than in a paler, brighter sky that actually has more blue scattering. The sky is rich blue at sunrise and sunset, for example, when relatively little blue light is being reflected to earth. Dust and vapor lighten, rather than darken, a sky. When air is moist before a storm, it is very pale, but afterwards, when the air is clean and dry, its color shifts to dark blue.

The blue-sky effect has profound implications for aerial photography. When a photographer shoots images down through blue sky, it is not easy to visualize how much bluer distant objects become. From commercial jet territory at thirty-five thousand feet, the entire world is muted with a bluish cast. Colors and contrast are all but gone. Colors become vivid again closer to the ground, especially when a polarizer is used to screen out the large amount of scattered blue light.

A hidden coincidental benefit of using a polarizer for aerials is that by seeking an angle off axis from the sun, where the light is polarized, a photographer is forced to shoot landscapes where sidelighting creates shadows. Aerials that lack strong shadows appear flat and soft regardless of the technical quality of the image. A zebra's camouflage works because there is an alternation of light and shadow in most ground-level scenes, but from the air a zebra stands out in much the same way it does in a zoo. Even light, without shadows, is as deadly to aerial photographs as to a zebra standing still in a clearing waiting for hungry lions to pass.

Dividing light into its two main components—transmitted warm rays and reflected cool rays—is an ideal method for dealing with the physical properties of light, but sometimes I encounter situations where my eyes fail me. In those cases, colors shift by mechanisms unrelated to the physical world. The following experiences demonstrate how one of those processes affected the results of my first trip to the Himalaya.

On my way out of the mountains, I saw the most intense color I had ever seen. A blanket of green shocked my eyes more than the brightest sunset or the bluest sky. Hanging meadows next to the glacier upon which I was walking emanated the verdant color of life with incredible brilliance. My companions went on ahead while I got out my camera and shot half a roll of various exposures and compositions. I felt tremendous exhilaration as I integrated patches of vivid color with patterns in the ice below, certain that one of these images would be among the best of my entire three-month journey.

Back in the States, I was disappointed that the color in my slides bore no resemblance to what I had seen with my own eyes. The meadows in my pictures were quite drab, and the images even had an overall blue-gray pallor caused by the veil of rain.

I was deeply embarrassed to admit that the vivid green had been only in my mind. The physics of light couldn't explain what I saw. For months I had lived without seeing green. My world had been almost entirely blue and white: snow, ice, and sky at very high elevations. To my green-deprived brain the first sight of meadows muted by rain had brought forth verdant images of emeralds, oceans, fresh vegetables, and home.

At the time I had absolutely no inkling that my perception was faulty. Since then I've learned that that type of illusion is normal. We generally see what we are prepared to see.

When our perceptual systems jump to unfounded conclusions, we see illusions. In an article in a recent issue of *Smithsonian* magazine, Roger Shepard, a psychologist at Stanford University, said, "We can be told about visual illusions until we consciously understand, but it does not affect our experience of them. We can't undo them. Perception depends on highly efficient machinery over which we have no control."

A photographer may not have control over his individual perceptions, but he does indeed have control over what he chooses to photograph. Reading illusions is just as much a part of reading natural light as reading real physical phenomena. I will probably never repeat my mistake with the green meadow because I studied my results, went back in the field, and learned to predict when and how such faulty perceptions occur. I now know how to make certain illusions work for me, and how to obtain by natural methods, without manipulation, that illusory shade of green I once only imagined.

Early in my career I made a photograph of a Canadian meadow that had an electric green quality. It was made before I began to use film generously to bracket exposures and to experiment with compositions, so the image was one of a kind. Although the photograph looked stunning to me, the only unusual element was the intense green color in one area.

Years later I saw that none of my more recent slides duplicated that fabulous green. I tried to repeat the rich tone in photos of High Sierra meadows, using the same polarizing filter as before with half-stop exposures bracketed on either side of my meter reading. I produced a range of gradations from light green to dark brown, but none came close to the vivid color of the Canadian image. This photo demonstrated the opposite of my experience with the dull meadow in the Himalaya. Instead of seeing vividness I couldn't produce on film, I had a fine result on film that I couldn't repeat.

For more than a year I played games with greens whenever I had a chance. I knew that when working with a polarizer in direct light, most colors gain their maximum intensity if the camera is aimed ninety degrees off axis from the sun. That is true, however, only with reflected sky light. The color of grass depends in part on translucence, which is at its highest when directly backlit by the sun. This translucence also increases when the angle of light is low, but at sunset the reddish light tends to weaken the tones of green. By experimenting I found that I got the best green about an hour before sunset at an angle of forty-five instead of ninety degrees off the sun's axis. At that point my polarizer cut much of the reflected light from the sky and some of the surface reflections off the grass, while enough of the rich transmitted light showed through the stalks.

Even with this added technical knowledge my best Sierra green lacked the electric quality of the Canadian meadow. I speculated that Canadian grass might react to light

differently, or that I might have used a batch of Kodachrome biased toward green. Then I happened to put a powerful viewer on the brightest sections of the Sierra and Canadian transparencies. To my astonishment, the greens appeared equally vivid. Had I gone off the deep end? Had there been no difference all along? When I pulled back and looked with my naked eye, the Canadian scene regained its special measure of richness.

This final part of the riddle is explained by a psychological illusion we all experience. The same color placed against dark and light backgrounds appears to the eye as two entirely different shades. The darker the surroundings, the richer and more saturated the adjoining color seems. The Canadian meadow was surrounded by black lichen-covered cliffs, while the Sierra meadow was framed in white granite and puffy clouds.

The lesson to be learned from this is not just that colors in nature are relative, but that they can be consistently photographed only by understanding their sources. In natural light all visual events fit into one of four categories: (1) real phenomena that appear on film much as they do to the eye, (2) real phenomena that appear differently on film than to the eye, (3) psychological illusions that cannot be photographed, and (4) psychological illusions that can be photographed.

The best color landscape images invariably cross the boundaries of these categories to become more striking than the scenes that met the photographer's eye (although in his mind's eye he may know exactly how his results will appear). Images that hold the greatest mystique combine category one with category two or four. Thus, they provide a reality check–straight imagery of recognizable phenomena in company with enhancements of other phenomena.

The greater the photographer's restraint, that is, not trying to overwhelm his viewers with the unusual aspect in each image, the more elegant the results tend to be. A good example of such restraint is evident in Ansel Adams's most popular image, "Moonrise over Hernandez, New Mexico, 1941." In the upper part of the image, a small full moon floats in a very black sky above a band of white lenticular clouds. That part of the image is considerably more dramatic than the way the eye sees the moon in an evening sky before sunset, yet when matched against a very straightforward rendition of a little town in the lower part of the image, the surreal quality of the sky does not overwhelm the elegance of the natural scene. Had Adams used an extreme telephoto to make the moon very large, or had he cropped out the town to include only the phenomena in the sky, the image would not have had the wonderful sense of balance that makes it so successful.

To better understand how optical phenomena need to be psychologically integrated into a photograph, let's look at a common example of each of the four categories and examine the characteristics of each in detail. It may come as a surprise that rainbows are

solid examples of category one, even though they appear mystical and without firm definition in space. They make superb photographs because they usually occur in low-contrast lighting situations well within the latitude of color films. When and where they will appear are not mysteries. Rainbows occur only where water droplets of the proper size refract sunlight, which usually happens during the clearing of an afternoon rainstorm when sunlight hits a wet cloud in the distance.

To look for a rainbow in a wet cloud, turn toward the antisolar point, directly away from the sun. The primary arc of a rainbow always forms at a radius of forty-two degrees around this point. Thus, no rainbow can be seen across level ground unless the sun is lower than forty-two degrees above the horizon; and that is why afternoon sightings are most common. Once, while attending an outdoor wedding, I witnessed a "rainbow-rise" over the eastern horizon just as the sun dipped below forty-two degrees in the west. Another time I searched for a rainbow in rising mist after a storm and saw a bow appear in just the area of the sky where I expected it. Something was missing, however: the rainbow had no color. The rare white rainbow occurs when the water droplets are too small to cause the proper refraction.

True to legend, a rainbow appears to recede as the viewer approaches. This happens because a moving person is actually witnessing multiple rainbows. With each step one rainbow disappears and another takes its place in a new set of droplets. Two people standing next to each other would actually see two different rainbows, reflecting off different water droplets.

Although rainbows defy normal measurements of size, their angular size is always the same. It takes a 20mm lens to barely encompass a full single rainbow, and a 15mm lens to handle a double rainbow, which displays an additional, weaker arc at a wider, fifty-one-degree angular radius. Many of the most vivid rainbow photographs are of sections of the primary arc and are made with a telephoto lens. At certain angles a polarizer used at a partial setting cuts specular reflections from the droplets and thereby darkens the background while letting the colored bow refract from inside the droplets at full intensity.

Crepuscular rays, or god beams, as they are often called, are good examples of category two. These shafts of light that commonly radiate to earth from behind clouds, aim heavenward from the horizon around sunset, or pour into darkened buildings through windows or skylights are real phenomena that appear significantly different on film than to the eye. On film they take on a solid, surreal appearance that seems far more auspicious than the original vision.

The reason for this heightened appearance is simple. Light rays are theoretically invisible from the side. They become visible only when they illuminate dust and vapor in the

air. This same phenomenon is responsible for making air at sunset painfully visible for drivers headed west in direct illumination. As soon as a driver rounds a corner into shadow, the air becomes transparent again. God beams occur where similar sharp junctions of sun and shadow happen in the sky. When a mountain ridge or clouds block only part of the sun, shafts of sunlit air with sharply defined boundaries of shadow form beams. Because the contrast between shadowed air and sunlit air is usually great enough to exceed the latitude of color film, an exposure for the highlights will make the shadowed sky go almost black while the god beams are rendered pearly white.

I've already described one example of category three, the muted green meadow in the Himalaya. Another illusion that does not photograph as it appears is the relative size of the sun and moon at the horizon. Not only celestial objects, but also people and buildings, change their apparent size when seen directly in front of our eyes instead of from above or below. Photographers are often tempted to capture the "big moon" hanging low in the sky, but it does not photograph any differently from a "little" moon higher in the sky unless a telephoto lens is used to reinforce the illusion.

Research has shown that people judge objects on the horizon to be 2.5 to 3.5 times larger than the same objects seen higher in the sky. This exceptionally strong illusion is related to the way our eyes upturn. If we look at a "little moon" high in the sky by reclining and keeping our head and eyes in a straight-ahead position (the way we were looking at the horizon), the illusion of increased size returns. The important thing for a photographer to keep in mind is that something on the horizon that seems imposing to the eye may not look that way on film with a "normal" 50mm lens, and perhaps not even with a short telephoto.

While the illusion of bigness at the horizon fails to carry over into finished photographs, other illusions actually do appear on film. True perspective distortions and many psychological color shifts fit into category four. We accept seeing parallel railroad tracks converge in the distance both in reality and on film, but similar convergence of the parallel sides of a building can be profoundly disturbing in a photograph that makes any pretense of representing a level view. Architectural photographers fight this effect in two ways: they go to great pains to aim their cameras absolutely level with the horizon, or they use special equipment that allows them to straighten converging lines by tilting and/or swinging the film plane away from its normal position. I sometimes carry a special "perspective-control" 28mm lens that swings eleven degrees off axis.

We aren't nearly as aware of psychological shifts of colors, but they also offer the photographer a similar choice of including the illusion or deleting it. As previously explained, color perception changes with the hue of surrounding colors, a fact that has been

known at least since Renaissance times. If we recognize a color illusion we like, we have only to preserve the adjacent tones to have the illusion appear in the final image. If we want to cancel an effect, we crop out those adjacent tones.

Sunstars in a photograph are not illusory phenomena, but rather a product of normal diffraction of a number of kinds. A sunstar is created when light rays touch the edge of an object or pass through a very small gap. Some of the rays are deflected by diffraction to bend slightly around corners and thus form stars from points of light.

A naturally occurring sunstar can be seen when the sun is partially blocked by an object actually in the photograph. Trees and buildings are commonly photographed with a perfect little star of light just touching their edges. To produce such a star, it is best to bracket two or three frames with a very small edge of sun visible. The star effect cannot always be seen through the viewfinder for the same reason that the clean round outline of the sun isn't seen during the day in a clear sky: the sun's light is too bright for observation. Through a darkened glass of the sort used to view eclipses, these diffraction stars are clearly visible at the time they are being photographed.

A different form of diffraction star, somewhat mechanical in nature, actually generates from inside the camera when direct sunlight is forced through a small-lens diaphragm opening. When you see a photograph that includes a sunstar that does not touch some object, it is usually the result of camera-caused diffraction, best rendered at f/16 or f/22 with normal or wide-angle lenses. If you are to see a clear sunstar, the image must be underexposed, so it does not burn out the sky at the edge of the sun. All but the brightest subjects go dark in the presence of this kind of star, which works best in snow or desert scenes with strong silhouettes present.

Photographers have a great degree of control over the appearance of these diaphragm-generated sunstars. The length of the rays increases with apertures of smaller size. The shape and clarity of the pattern are functions of the lens design. One manufacturer's 28mm may produce a much more distinct star than another's. In general, "slow" lenses that have a relatively small maximum aperture, such as f/3.5, are much more likely to give clean sunstars than fast lenses, which have a great deal of extra glass that invariably increases flare around direct light sources.

A sunstar can be produced mechanically with a star filter, which is simply clear glass with purposeful parallel surface flaws. There are several different types, producing made-to-order two-, four-, six-, or eight-point stars wherever a direct light source hits them. There are no free lunches in this world, and the drawback of star filters is that they uniformly degrade the image. Instead of creating a star by an isolated bit of natural diffraction, they put a disturbed surface over the entire lens. All light is affected by diffraction as it

passes through one of these filters, although only direct sources make stars. Normal light is flattened and softened as if Vaseline had been smeared over the lens. I've seen some exciting photographs made in urban situations with these filters, but the poor contrast is deadly for landscapes. Who wants a great sunstar leaping out of a curiously flat natural scene that lacks clarity?

Another form of diffraction creates a natural optical effect so strong that it suggests the supernatural. When the sun is barely hidden behind an object, diffraction bends some rays of light slightly around the corner. In the right situation a fringe of unworldly bright light outlines whole subjects with an eerie glow. Because of relationships between the relative size of the sun and the small angle of deflection caused by diffraction, the most vivid fringes are seen around subjects the size of a person, or smaller, placed thirty to sixty feet away from the camera in a position where they entirely block the direct sun.

Determining the right camera position to photograph the diffraction fringe is a simple matter of finding your subject's shadow and placing your camera barely inside it at the proper distance. After performing the procedure many times, I began to notice that I could see the effect of the diffraction fringing in both directions from inside the shadow. When I looked toward the sun I saw the bright fringe itself, while away from the sun was a shadow surrounded by a hot edge of light that was brighter than the surrounding sunlight.

Once, while climbing in the High Sierra, I looked back at my partner and saw very close to me an unusually clear diffraction shadow ringed with hot light. It was cast by the top of a 100-foot rock pinnacle directly in line with both my head and the sun. (I didn't see the fringed shadow of myself in this situation because my shadow was too close to allow much diffraction.) The natural geometry of the situation was perfect, with just the right distance between the pinnacle and a parallel wall behind it from where a photograph could be made. I wanted a person on top of the spire, but my partner was not a high-level climber. After setting up my camera for him to use, I climbed to the top and directed the photograph by watching the position of my fringed shadow. The resulting image, with its very vivid diffraction fringes, appears on page 39.

When I photograph I am constantly on the lookout for either diffraction fringes or their shadow counterparts. I commonly see hot fringes around my own shadow when it is cast far enough away at dawn or dusk, and around the shadow of airplanes in which I am flying. The effect is greatly enhanced when combined with dew drops or other similar-size droplets of moisture. Because of their optical geometry, these droplets can reflect light directly back toward the source in much the same way that the eyes of an animal at night glow back at a strong light. This is called the "heiligenschein effect," and it explains what the sixteenth-century sculptor Benvenuto Cellini saw when he wrote "a halo can be ob-

served above my shadow in the morning from the rising of the sun for about two hours, and far better when the grass is drenched with dew." Cellini, however, took the significance of not seeing halos around his companions' heads a bit beyond the horizons of science: "The divinity of God and of His secrets . . . deigned to grant me that great favor, for ever since the time of my strange vision until now an aureole of glory (marvellous to relate) has rested on my head."

In one way my own experience is a close parallel to Cellini's personal discovery of his private optical phenomenon. Once seen, his halo seemed to be always with him. So it is with me for all outdoor optical phenomena. I look for what I have seen before, and I follow hints of magical light the way I would follow clues on a treasure map. As Louis Pasteur once said, "Chance favors the prepared mind," and I almost never arrive at the right place at the right time to make a photograph by chance. I am there because my photography has led me there through an understanding of the nuances of mountain light.

EXHIBIT VI

Figures in a Landscape

The basic idea of photographing people or animals in a landscape is as old as photography itself, yet most modern guides to outdoor photography say nothing about how to take such an image and make it come to life. Such guides break down imagery into landscapes, wildlife, and people, ignoring that special brand of photograph that portrays a living person or creature in a special relationship with its environment. To capture that certain moment when something living is in fine balance with natural forces is one of the most satisfying aspects of photography. Such a photograph can be made in two distinctly different ways. Commercial photographers often stage models in a natural scene to create a poetic mood in order to sell a product. Although I have indeed done such commercial work, the images I personally value record spontaneous events.

The photographs in this exhibit have captured moments when living became visual poetry. Written poetry expresses facts and emotions in a style more concentrated, imaginative, and powerful than that of ordinary speech. And as with written poetry, there is no formula for creating poetry on film. To make a visual poem, a photographer must balance his sense of order, so important in other styles of work, with an equally developed sense of disorder. Some photographers have an intuitive feel for this, while others lack it completely. What Stanley Kunitz, a poetry consultant to the Library of Congress, once said about writers applies to photographers as well, "Order is teachable; but in my bones I know that only the troubled spirits among them, those who recognize the disorder without and within, have a chance to become poets, for only they are capable of producing a language galvanic with the contradictions of the actual."

The most powerful images present viewers not only with beauty, but also with a challenge to visual assumptions. To accomplish that, a photographer's mind must go beyond the known and the accepted. When we think of genius in other fields, we do not consider as highly those who invented strictly practical things as we do those who changed the way we mentally order our world. Darwin took the static order out of nature. Marx took many preconceived assumptions out of politics. Einstein destroyed our simplistic assumptions about time and space, while Freud erased equally important simplistic notions about the ordered innocence of the human mind. The best images of figures in a landscape accomplish a lesser but similar task. They take an expected piece of information, a landscape, and give it an entirely new meaning.

CLIMBER ON MOUNT DICKEY, ALASKA RANGE

CLIMBER ON MOUNT DICKEY,
ALASKA RANGE; 1974

Until the summer of 1974, not one of the massive faces in Alaska's Ruth Gorge had been climbed. That summer I was a member of a three-man party that made the first ascent of the highest granite wall in America, the five-thousand-foot southeast face of Mount Dickey. Our strategy was to go as light and fast as possible, and that meant carrying a minimum of camera equipment. Since Nikon's lightweight FM cameras and E Series lenses had not been introduced, I took my trusty Nikkormat FTN with a 24mm f/2.8 lens and a tiny 45mm f/2.8 GN lens. Even that small amount of gear was a major addition to the lightest load I had ever carried on a big climb. Intending to rely on snow, we took little water. I had sweaters and a rain parka, but no down jacket. Between the three of us we had one ice ax, one pair of crampons, one bivouac sack, and one small tarp—token gestures if conditions turned extreme.

Halfway up the wall we watched a storm creep up from the south and engulf us. We awoke from a bivouac to see shafts of orange sunrise light coming through holes in thick clouds. From our high perch we could see that valleys to the south of us were locked in clouds, while below us streamers of white mist were creeping up the Ruth Glacier, already lapping the base of our cliff. In the gloom of the four-o'clock dawn, we discussed whether to abandon the climb. Caught midway up the face, we decided that we might as well go up as down.

The landscape had a totally different look that day than it had the day before, when glaciers and peaks stood out everywhere like waves and troughs of a wild sea. Today that sense of openness was replaced by one of dank confinement. The sky was fathomless gray, as was the air below our feet. Clouds soon closed in to make even the rope below me disappear.

When it was my turn to lead, I would climb as far as I could, try to find a ledge, tie off the rope to pitons, and wait while my partners came up the rope on mechanical ascenders. About midmorning, before the storm was fully upon us, I reached the largest ledge on the route. A window opened up in the clouds, allowing a glimpse of Moose's Tooth on the opposite side of the gorge. I took several scenic photographs and saw an opportunity for a different kind of image if the cloud window stayed open long enough for Ed Ward to appear on the rope in the foreground.

I unroped and walked across the ledge, positioning myself where Ed would become a strong silhouette against the clouds. I used a 24mm wide-angle lens to get the proper feeling of a small figure balanced against the powerful forces of nature he was confronting. A normal lens could not have made even a marginally acceptable image in this situation.

The next morning we awoke in a blizzard. The climb looked like a vision of the Eigerwand in storm, and we had only one tool to keep us on the route that we had so carefully picked out earlier: a razor-sharp black-and-white photograph of the face made by Bradford Washburn on a large-format camera. With this in hand, we continued to the summit, bivouacked there, then descended the back side of the mountain to Don Sheldon's cabin (page 96), where we slept and ate for several days until the storm ended and Sheldon could fly us out to civilization.

TECHNICAL DATA *Nikkormat FTN with 24mm lens; Kodachrome II (ASA 25).*

LOOKING TOWARD THE NANGPA LA
FROM THE TIBETAN PLATEAU; 1981

Tibet was not what I expected. On my first trip I drove across hundreds of miles of cold, high desert that had little aesthetic appeal. High mountains were rarely visible, the wildlife was gone, and the Chinese presence had erased nearly all evidence of Buddhism. As I said previously, being in Tibet is often like being in a colder, drier Nevada.

To have left Tibet immediately after that overland journey to Mount Everest would have left me forever jaded about the country. On the return, however, we made a three-day side trip to Tingri, a trading center near the Nepalese border, where Sherpas used to bring rice, grain, raw iron, and livestock to trade for Tibetan salt, wool, and other commodities. Unfortunately, trade virtually ceased after the 1959 rebellion in Tibet because the Sherpas found the Chinese authorities in Tingri unpredictable and often unfair in their dealings.

For us the plain of Tingri was the Tibet of our dreams: a broad grassy plateau stretching right to the foot of icy peaks. I made this photograph from a camp by a stream that snaked through a green meadow that seemed to sprawl all the way to the Himalayan crest, thirty miles distant in exceptionally clear air.

A tremendous gap led into Nepal between the twenty-six-thousand-foot massif of Cho Oyu and

LOOKING TOWARD THE NANGPA LA FROM THE TIBETAN PLATEAU

the Rolwaling Himalaya to the west. This pass, the Nangpa La, appeared to cut so deeply between the massifs that even I, who had seen the glaciers and rubble from the Nepal side, imagined that the carpet of grassland parted the snows. The pass was actually more than nineteen thousand feet.

Photographing the scene was problematic. I wondered how I could ever make a two-dimensional image capture the feeling of vastness I felt being there. Framing the two mountains and the gap between them in a photograph seemed to give little sense of distance. I climbed a hill behind camp and took some broad scenics, but our modern tents served only to detract from the power of the landscape.

Late one morning I saw a Tibetan rider heading out across the plain. I set up a tripod with a 400mm lens, but quickly saw that I couldn't get a good image. The donkey's hind end was toward me, and the extreme telephoto only magnified the haze and made the mountains look blurry. I switched to a 75-150 zoom lens and composed for the landscape rather than for the rider. Thus, the rider appeared as an incidental element in the scene, just as he really was at the time. I made a number of images, bracketing exposures and focal lengths, but only this one worked. The rider momentarily veered sideways to show his profile, and the open exposure emphasized the bright, shadowless aspect of the plains at midday.

TECHNICAL DATA *Nikon F3 with 75-150mm zoom lens; Kodachrome 64.*

MOUNTAIN GOAT CLIMBING SHEER WALL, LOGAN MOUNTAINS, NORTHWEST TERRITORIES, CANADA

EXHIBIT VI FIGURES IN A LANDSCAPE 137

MOUNTAIN GOAT CLIMBING SHEER WALL,
LOGAN MOUNTAINS, NORTHWEST TERRITORIES,
CANADA; 1973

In 1973 I revisited the Cirque of the Unclimb-
ables and attempted to climb the virgin northeast
buttress of Mount Harrison Smith, which appears
in the photograph on page 59. My partners in
failure were a Weyerhaeuser logging supervisor
and a botanist. The unforeseen difficulties of the
climb brought out facets of personalities that re-
minded me of John McPhee's real and wonderfully
mythical tale of an environmentalist and a dam
builder running the Colorado in the same raft.

The rock rose vertically above the meadows,
and the meadows continued upward too. Cracks
in the granite were filled with soil, grass, and
flowers. We had to climb these cracks and place
pitons in them. When it was the logger's turn to
lead, he resolutely gardened sections of the cracks
to place pitons, using the pick of his alpine ham-
mer. He worked silently except when he called
out the Latin name of yet another flower he had
discovered in the process. When it was the bot-
anist's turn to lead, he became so frustrated by
having to clean away the hanging ecosystems to
get to the piton cracks that he referred to the same
flowers as "filthy grunge." After two days of
climbing, sometimes in the rain, we were so weak
and wet that we gave up and rappelled back down
the route.

The next morning the botanist woke me at
dawn. A lone mountain goat was wandering by
the base of our climb. Before venturing out of the
tent into plain view, I thought about what I knew
about this animal. We had seen goats before, and
they were extremely wary of humans, which sur-
prised me at first. Then I realized, however, that
probably less than twenty-five people in history
had visited the cirque, and the goats hadn't yet
figured out whether we were dangerous or not.
Goats that have been around nonhunting humans
tend to become very tame. Also, I thought I knew
something about goat psychology: when fright-
ened they climb cliffs to avoid predators, certainly
not for adventure and idealism the way we hu-
mans do.

Considering everything I thought I knew about
goats, I devised a quick plan. Grabbing a tripod, a
500mm lens, and a camera loaded with High Speed
Ektachrome, I ventured out into the meadow in
my underwear, not wanting to take the time to
dress. I thought I would have my photo in a min-
ute or so, then crawl back in the sack. I first pre-
tended to be unconcerned about the area where
the goat was and played out a "lost wallet routine"
to set the animal at ease. As soon as I figured I was
nearing the goat's flight range, I made a sudden
charge at a dead run from an angle that cut off
access to the route he was following. The goat did
exactly what I had hoped he would: he climbed
the first ledges up our route and ended up at a
cul-de-sac where we had roped up for a vertical
5.8 pitch.

Bursting with pride at my cleverness, I carefully
framed a fine image of the goat on the cliff,
squeezed off a first casual shot, and tried to advance
the film. The lever stuck midway; I was out of
film! In my haste I had broken a cardinal rule of
wildlife photography: never stalk an animal with-
out at least one extra roll of film in your pocket.

For several long minutes the goat and I were at a
standoff. He pawed the ledge threateningly, and I
stared at him, remembering stories of wolves,
mountain lions, and hunters who had been gored
by angry goats. I tried to prevent his escape with-
out triggering his aggression while I considered
what to do next.

I retreated to a nearby rock and set up my tripod
behind it, crouching so that only my torso was
visible. I was wearing a red undershirt, and when
the goat finally looked away for a few moments,
I slipped out of it and hung it on the tripod, putting
a stick inside the shirt to stretch it out like a scare-
crow. I was a good two hundred feet from the
goat, and I wasn't sure that my gimmick would
work, so I added an extra touch. Crawling behind
the rocks out of sight, I casually stood up, walked
up to the tripod and began talking to it, hoping
that the goat would think that there were now two
of us. I changed the pitch in my voice and carried
on a two-way conversation with my tripod for
several minutes before walking back to my tent
to get more film and a second camera.

When I returned, the goat was still intent on
watching my friend the tripod. The plan had
worked! For the next hour I photographed the
goat in close-ups with Ektachrome and in more
distant 200mm images on Kodachrome II film. As
I approached more closely, the goat bounded
straight up the rock, exactly on the route we had
just failed to climb. He performed flawlessly,
leaping to stances, mantling on small holds, and
displaying musculature that led (much later) to
the nickname "Arnold Schwartzengoat."

At one point the goat climbed a 5.8 crack in
much the same manner we had done, and I shot

a frame that I knew would be my best if it proved to be sharp. (I ended up being unhappy with the close-ups, which emphasized the animal alone rather than the dynamic tension between animal and rugged environment that is so evident in this image.)

The show was not over. The goat tried every conceivable way of getting down, and instead of stopping at a point where he began to feel uneasy, he pushed himself, as a true climber would when trying something harder than his standard. I nervously watched him pivot on hopelessly narrow stances and attempt a traverse that blanked out and forced him to make a tentative backward retreat.

I moved so I was no longer blocking the goat's descent path, but he stayed on the wall, continuing his antics like a climber playing on boulders. While wandering around the base, I discovered the mummified body of another goat that had evidently fallen from that very cliff. I began to question my assumptions about goats and retreated to my tent to let the animal descend in peace.

Quite some time later the goat hopped down the section of cliff shown in this photograph in a few bounds. Once at ground level he looked our way, apparently to see if we were watching him; and, as it turns out, not to flee if we were. We stepped out of the tent to watch the animal continue along the base of the mountain in the direction he had originally been headed. At the first crack system, however, he headed up again, this time a flashy three-hundred-foot romp. At the top he pivoted full circle like a fashion model, then bounded down. He repeated lesser antics in other spots, seeming always to make sure that we were watching.

The goat's behavior appeared to have no survival value, and I had to reconsider my supposition that goats climbed only for rational reasons. My first response was that the animal was nothing more than an alpine show-off; then I realized that my attitude reflected that of many people who do not understand the motivation of mountaineers and who are all too ready to condemn as frivolous any activity whose purpose cannot be explained with reason and logic.

Even if I couldn't express them clearly in words, the results of the goat's frolics were obvious to me. Here was an animal that takes chances, as do hu-

man climbers. His beauty, like that of a timberline pine, was shaped by pushing the limits of his existence.

TECHNICAL DATA *Nikkormat FTN with 200mm lens; Kodachrome II (ASA 25).*

PRATT'S CRACK, PINE CREEK, EASTERN SIERRA, CALIFORNIA; 1973

Climbers on the east side of the Sierra often recount the legend of the discovery and first ascent of this climb by Chuck Pratt, a superbly talented crack climber who made many first ascents in Yosemite. Sometime in the sixties he was riding with a friend along the dead-end road in Pine Creek Canyon when he saw these perfect monoliths joined together to form a long jam crack. They were virtually alongside the road, so he asked his companion to stop. They got out of the car, looked, gathered their ropes and hardware out of the trunk, and climbed the route on sight.

Many pictures were made over the next few years, but all of them were from the base, which made the walls converge into the distance like images of tall trees from underneath. I thought that the most unique feature of the climb was the absolutely parallel nature of the cracks and corners for hundreds of feet, and I scouted a camera position to capture that and to determine the right time of day to avoid high-contrast light. During the winter of 1973, Dick Dorworth and I set out to make the climb, for alpine practice and to get the best possible photograph. I asked Dick to wear a red sweater so his tiny form would stand out on the rock from my vantage point high on the opposite wall, where I would be dead parallel with the middle of the climb, thus ensuring an undistorted image. With my camera braced on a rock, I made several exposures with a 55mm lens.

Since it was late in the day, the climb was lit entirely by clean white light reflected from a snowy hillside, and the textures and colors were maximized in that even light. The image matched my greatest expectations. Although I have returned many times to the climb in years since, I've never seen it like this again.

TECHNICAL DATA *Nikkormat FTN with 55mm lens; Kodachrome II (ASA 25).*

PRATT'S CRACK, PINE CREEK, EASTERN SIERRA, CALIFORNIA

RIDER AT HOLY SHRINE, ANYE MACHIN, NORTHEASTERN TIBET

RIDER AT HOLY SHRINE, ANYE MACHIN,
NORTHEASTERN TIBET; 1981

This is one of the most spontaneous images I have ever made—shot when I was a participant in a most unusual situation. I was able to break stride and get this photograph only because I was carrying a camera in a small chest pack I use for running and skiing. Anticipating that I might want to shoot human figures under the brooding clouds, I had put a split neutral-density filter on my lens minutes earlier.

At the time, I was the leader of a group of Americans making a circumnavigation of Anye Machin, a holy mountain of Tibet. With me were some of America's outstanding natural scientists. Our failure to find profuse Tibetan wildlife, as promised by the Chinese government, is described on page 188. At the moment I made this image, however, I was much more concerned with another informational failure of the Chinese. We were to be accompanied by helpful local guides, who would carry our equipment on yaks. Instead, we were

met by Golok Tibetans carrying AK-47 automatic rifles. They laughed at the Chinese, flaunted authority, and refused, through our Chinese interpreter, to tell us anything of their personal or political history.

Before the Communist liberation of 1949, the explorer Joseph Rock had found the Goloks to be extremely arrogant and rude: "Such hostile and unfriendly people I have never met anywhere else in the world." The Goloks retained their independence through the war of liberation, and not until 1956 did Chairman Mao finally send troops into their area to make them adhere to the Communist doctrine. Thousands of troops went in; the two hundred survivors who returned had had their noses cut off flush with their faces as a warning.

In 1981 the Goloks were only partially subjects of the Chinese government. They received education and health care, but they lived and acted in their traditional manner. Families lived year-round in black tents made of yak hair, owned their own horses, shot wildlife with abandon, and

EXHIBIT VI FIGURES IN A LANDSCAPE 141

herded yaks and sheep that only on paper were owned by the government. The communes around Anye Machin had no Chinese members.

When I made this photograph, I was alone with Chong Hun, one of our yak drivers, because I had stayed back to search for a minirecorder that had fallen out of my pack. After looking for an hour, I gave up and tried to catch my group. Around the first bend I found Chong Hun waiting with his horse. He motioned for me to give him my back-back containing thirty pounds of cameras so I could walk faster while he rode. Gradually, I was able to break into a run next to the trotting horse. When we caught up with the others, Chong Hun kept on going. Not about to let my cameras out of sight, I ran after him. We continued side by side until we were alone on the grasslands under Anye Machin.

The following description of what happened next is from my book *Mountains of the Middle Kingdom*:

"I am running uphill with a Golok rider close at my heels. Half a mile above me is a hilltop shrine, a cluser of rock piles, poles, and cloth flags. A low sound that seems born of the earth itself grows ever louder as I draw near. At first I do not realize that it is coming from behind me. It speeds up when I speed up, slows down when I slow down. The Golok rider is chanting in rhythm with my footsteps.

"My lungs feel ready to burst with each stride. I can only run here at 15,500 feet because I am acclimatized from climbing to the North Col of Everest last month and to the top of Anye Machin last week.

"Now my goal is just to reach the hilltop, lie down, and rest. I feel the euphoria of oxygen debt as I push hard up the final grade. The Golok doesn't stop at the top as I expect; he moves ahead of me, dismounts from his horse, and leads it briskly along a well-worn path. I follow him on three complete circles of the shrine with its two-hundred-foot wall of intricately carved mani stones [making this photograph on the move].

"Just when I think things are going well, the Golok turns serious. I stand very still as he draws a long knife and holds it to my face. He cuts a locket of my hair; then one of his own; finally one from his horse. He ties them to a rope on one of the poles as an offering to the gods.

"Neither of us speaks the other's language. We are alone in the shadow of a mountain. Explorers from the West created the legend of its height, but here in the East there is an equally lofty belief about Anye Machin.

"Each circumambulation of the shrine sends a prayer to the deities of the earth, sky, moon, and stars that are represented by heaps of mani stones a little apart from the main wall. The Golok patron saint, Machin Bomra, owner of the earth, lord of the mountains, has the highest stone heap of all: Anye Machin itself. Chong Hun is a yak driver for my trekking party; we are on day five of a circumambulation of this greatest shrine of all.

"Before the communist "Liberation" up to 10,000 Goloks a year circumambulated the holy peak by the same 120-mile trail. Never in my wildest dreams did I imagine myself in this situation: running alone with a Golok horseman. . . .

"Now as Chong Hun and I circle the shrine for the last time, he stops to pray. I recognize a series of Tibetan characters on a flag, point, and say, "Om mani padme hum," a universal prayer that transcends the separate dialects of the Goloks and the Lhasa Tibetans. Chong Hun's face lights up. When I mention the holy places I have been to in Tibet—Drepung, Jokhang, Tashilhunpo, Gyantse, Rongbuk—he proudly gestures that he has visited those places also. I doubt that any Han Chinese has ever shared such interest and respect for his religion, and it is clear that he is deeply moved.

"I sit alone with Chong Hun for half an hour before the arrival of the others. They photograph the unusual scene of a Golok reclining in the grass with a hand on a foreigner's shoulder instead of his neck. When cameras begin to click, even though I encourage it, I feel something of the sense of intrusion that a native must experience when foreign guests arrive."

For the rest of our journey, our Golok hosts treated us very differently. We were companions in camp, guests in their family tents, and in every way part of their world. By connecting with one man on a level that showed we shared many of their same values and respected their Buddhist shrines, we overcame the natural distrust they had for anyone who arrived under the auspices of the Chinese.

TECHNICAL DATA: *Nikon F3 with 24mm lens; Kodachrome 64; split neutral-density filter.*

THREE CLIMBERS ON MOUNT EVEREST'S WEST RIDGE AT 24,500 FEET, TIBET

EXHIBIT VI FIGURES IN A LANDSCAPE 143

THREE CLIMBERS ON MOUNT EVEREST'S WEST RIDGE
AT 24,500 FEET, TIBET; 1983

I was the climbing leader of an unsuccessful first ascent of Everest's West Ridge without oxygen. Ours was a completely self-contained effort. Without native porters or motors of any kind, we had hoped to climb the virgin Tibetan side of the ridge to twenty-four thousand feet, then follow one of two routes previously done from the Nepal side along the border to the top.

Also, I was assigned by *Sports Illustrated* to photograph and write a story (which appeared November 14, 1983). Each day when I carried a load of supplies between camps to support my lead climbers above, I also carried a camera and at least three lenses.

Part of my group's choice of style was determined by natural evolution: the more that is known about Everest, the less is needed to climb it. Part was sportsmanship: a voluntary limitation of tools to deal with nature. We believed that breathing the thinnest air on the earth's surface was part and parcel of Everest's challenge. A close friend and world expert on the effects of high altitude, Dr. Charles Houston, has written that no other mountain is "so dangerously close to the limit of life," yet a moderately experienced climber "could climb Everest as easily as a low Alpine peak by breathing oxygen every minute all the way from bottom to top and back. But why do it?"

Although oxygen use has been compared to blood doping, it does have undeniable health and safety benefits. Without it climbers at great heights become as sick men walking in a dream. When Everest was first climbed in 1953 with oxygen, team physiologists dismissed the ethics of oxygen as a futile controversy, both because the mountain had finally been conquered by its use and because "oxygen undoubtedly reduces the mountaineering hazards and greatly increases the subjective appreciation of the surroundings, which, after all, is one of the chief reasons for climbing."

While I was on the mountain, I had the eerie feeling that we were lopping the last fifty years off of Everest's history. Here we were, without oxygen or communication with the outside world, struggling our way up the Tibetan side of the peak in a manner reminiscent of the classic British attempts on Everest in the twenties and thirties.

In 1924 George Leigh Mallory and Andrew Irvine headed for the summit of Everest without oxygen. The afternoon before, Mallory had sent down a message with a Sherpa: "Perfect weather for the job. . . . It won't be too early to start looking for us either crossing the rock band or going up the skyline at 8:00 A.M."

At 12:50 P.M. Noel Odell looked up from twenty-six thousand feet to see the clouds part over the final peak of Everest. "I noticed far away on a snow slope leading up to what seemed to me to be the last step but one from the base of the final pyramid, a tiny object moving. . . . A second object followed, and then the first climbed to the top of the step. As I stood intently watching this dramatic appearance, the scene became enveloped in cloud once more." Mallory and Irvine were never seen again. They disappeared into thin air, the cold thin air of the worst spring season in thirty years.

Throughout our expedition I had Odell's description of their disappearance in my mind. I had just finished writing about it for my book *Mountains of the Middle Kingdom*, and now I was thrust into the same environment. Even though we were on a different route than Mallory's, I wanted to make a photograph that conveyed something of the same feeling of tiny men, totally on their own, marching upward into the clouds toward the summit of Mount Everest.

One morning as I was carrying a load from twenty-two to twenty-four thousand feet, the upper ramparts of Everest were moving in and out of the clouds. I watched three climbers leave Camp Four and move along the West Ridge; they were in view only part of the time. Gauging their progress and my own, I tried to place myself in position to capture them as they passed a particular spot where the route dropped off the crest of the ridge onto an exposed traverse.

With mechanical ascenders I was climbing up mixed ice and snow. When I came to the top of a rock promontory, I took off my pack and used it to brace my camera with a 70–210 zoom lens. At first I tried composing a shot using a 2x Nikon teleconverter to make the lens a 420mm. Without the summit of the mountain, however, the image lost its meaning and sense of scale. I opted for the 210mm image, even though the three climbers would be barely more than dots on the landscape.

Clouds closed in as the climbers started across the traverse. I waited and waited, but the clouds remained. Finally I started climbing again. Less than a minute later the clouds parted and I saw the three climbers moving very slowly, still on the traverse. I stopped, removed my pack and clipped it to one of my ascenders, and kneeled down with my crampons in the hard snow, my camera braced

on the pack. With only seconds to spare, I was able to make the image I had hoped for before the clouds closed in a final time. The nearly black sky is a result of exposure for detail on the snowy peak combined with the extreme darkening of normal blueness that takes place at high altitudes because of the thin atmosphere.

Unlike Mallory and Irvine, those climbers were indeed seen again. We, too, experienced an unusually harsh spring with deep snows and high winds. We gave up the attempt after two and a half months, when premonsoon storms put our route out of condition; our bodies were thoroughly exhausted by load carrying and too many days with too little oxygen.

TECHNICAL DATA *Nikon F3 with 70–210mm zoom lens; Kodachrome 25.*

CELEBRATING THE RETURN TO GREEN GRASS
AT URDUKAS, KARAKORAM HIMALAYA,
PAKISTAN; 1975

During an expedition to K2, the world's second highest mountain, I spent three months living on glaciers in a frigid, sterile world. On the long walk out I finally stepped from ice to Urdukas Camp, a traditional stopping place among giant boulders set in rolling meadows filled with wildflowers. We had left Urdukas in May when it was under several feet of snow. When we returned, we found a paradise beyond our wildest hopes.

Our gear was wet from a storm, and as we spread it out to dry on firm ground with no ice underneath, I noticed that Leif Patterson's face wore a glow of joy. I wanted to make a photograph that would capture his look, but I wasn't sure how to go about it. I took out my 105mm lens, which I used for portraits, and began watching Leif intently. He was not comfortable posing, so it had to be a candid shot. Nothing seemed to work for me. Gradually I moved farther back until Leif became part of the landscape of green grass and snowy horizon.

Leif and I had been tentmates for much of the expedition, and I felt a wonderful sense of rapport with him. He was a man of great outward modesty and even greater personal integrity. He, too, was documenting the Karakoram, but only for himself, with a Hasselblad and a diary. Once when the clouds cleared around Mustagh Tower after a

storm, I ran into my tent, scooped up my camera gear, and said, "Grab your camera, Leif. Mustagh Tower's coming out!"

Leif replied, "No, thank you. I have no interest in photographing that mountain."

"Why not?"

"Because this is a false view. The mountain is not what it seems from here."

"But many mountains are like that."

"This one is different. The famous Vittorio Sella photograph has misrepresented it to the world, and I do not want to be part of that falsehood."

Leif spoke without malice, never suggesting that I refrain from photographing the mountain because of his personal decision. I went ahead and made that image of Mustagh Tower because I disagreed with Leif. Photos and other forms of art are bound to exaggerate things we cherish in much the same way that a good anecdote distills a meaningful fragment from the complex horizon of life. When I came back to the tent to put away my cameras, Leif asked me if I had gotten a good shot. When I told him yes, he said, "I'm glad. You wanted that photograph pretty badly."

I wanted a photograph of Leif at Urdukas that would express both our expedition's relief and his personal joy over our return to the living world. I thought about it awhile and realized that if anything would work on Leif it would have to be a direct, forthright approach. I composed an image on a tripod with a polarizer to bring out the clouds and greenery, then said, "Leif, show me how it feels to be here among the flowers."

Leif turned toward me and spontaneously opened his arms with a look of peaceful ecstasy. I took this photograph, and the instant passed.

I had been shooting the expedition for the *National Geographic*, and all my exposed film was sent to them in Washington, D.C. Months later I saw the top few hundred selects for the first time, and I wondered why this image was not among them. I had gone to great pains to set up the camera beforehand so that everything in the scene would be rendered just as I wanted it. Going back to the yellow boxes of my outtakes, I found this slide. The editor had rejected it because at first glance it had looked too posed.

Because the expedition failed to climb K2, the magazine decided not to run the story. All the images were returned to me, and this one came to be published more often than any other photo from the trip. It graced an early cover of *Mariah* magazine (later to become *Outside*), advertise-

CELEBRATING THE RETURN TO GREEN GRASS AT URDUKAS, KARAKORAM HIMALAYA, PAKISTAN

ments and catalogs for adventure travel, articles on Himalayan trekking, and a page in my book on the expedition.

Leif never saw the published versions of this photograph of him. He and his eleven-year-old son were caught in an avalanche near their mountain home in British Columbia. The dedication page of my book *In the Throne Room of the Mountain Gods* reads, "In memory of Leif-Norman Patterson, the best of us, who died in an avalanche in his home mountains just as this book was going to press."

TECHNICAL DATA *Nikkormat FTN with 105mm lens; Kodachrome 25.*

CALIFORNIA GULLS, MONO LAKE, CALIFORNIA

CALIFORNIA GULLS, MONO LAKE, CALIFORNIA; 1974

On Negit Island in the middle of Mono Lake, I was surrounded by thousands of sea gulls, circling in a frenzy. A thunderstorm had just passed, and sunset light poured in from underneath, turning the birds golden against a blue-black sky. After trying a number of unsatisfactory camera angles and lens choices, I lay on my back with a 24mm wide-angle lens, waited for the birds to slow down and fly close, then fired off a number of frames.

How I came to be on tiny Negit Island is a story worth relating in some detail. While covering the Owens Valley region of eastern California for the *National Geographic* in 1973 and 1974, I did extensive photography around Mono Lake. The national environmental controversy over what

appears to be a lunar crater filled with water had yet to begin. At that time the lake possessed the largest single nesting colony of the California gull, a bird that leads a dual life.

Tourists who watch these gulls scavenge tidbits at San Francisco's Fisherman's Wharf are usually unaware that they live inland for much of the year. During Pleistocene times, California gulls populated inland seas that filled much of the Great Basin. Their descendants continue to return to the last remnants of their ancestral birthplace to nest. Because land predators can easily decimate breeding colonies, the gulls narrow their requirements for nesting even further. They seek out islands in old inland seas that have viable food sources nearby.

By this selection process little Negit Island in

EXHIBIT VI FIGURES IN A LANDSCAPE 147

Mono Lake became the world's largest nesting colony for California gulls. There the birds were able to live by eating tiny brine shrimp and brine flies. When I arrived, scientists, but not yet the general public, were deeply concerned about the lake's future.

I would have made only the usual cursory photographs of the lake from its shoreline were it not for the advice of a fiery old woman, Enid Larson, who had just stopped the building of a proposed local freeway by pointing out to the highway department that her data on an uncommon forest chipmunk showed that the maximum amount of open ground it would cross exceeded the width of the existing two-lane road but was less than the proposed four-lane freeway.

"You can do it," Enid told me. "Why, when they see your photographs and hear how Los Angeles is siphoning off water bound for Mono Lake, you can stop them. The first thing you need to do is to go out to the islands during nesting season and see for yourself. There's no other place like it over there. The island teems with life. Here's a name for you to call at Fish and Game. He'll get a boat to take you out there."

The lake's level has been measured annually since 1913. Between 1913 and 1940, the era that includes the Dust Bowl drought years, the lake dropped 2.5 inches per year. After Los Angeles began to export water in 1941, the lake dropped an average of 11.5 inches a year until 1970, when a second aqueduct barrel was opened. Over the next four years, until my visit, the lake averaged a 20-inch drop per year. Negit Island was within a couple of years of having a land bridge connect it to the mainland, thus almost certainly destroying

the nesting colony (both of which indeed happened in 1979).

The *National Geographic* story barely touched on Mono Lake and did not use this or a similar photo. My Mono Lake photos were returned after the Owens Valley story appeared in early 1976. I immediately proposed an in-depth story on the lake to *Geographic* and was told that it was too soon after my story on the adjoining region. *Natural History*, *Sierra*, and other magazines also turned me down.

I found a home for my story at *Audubon*. They gave me an assignment to research a full investigative article, and they held this and my other Mono Lake photos for nearly two years before running the text in March 1978. Unfortunately, they didn't have the space that month for photos, so my story appeared without illustrations, thereby robbing it of much of its clout. Nevertheless, it was the first complete story of the crisis in any national magazine. But it was too late. By that time Negit was no longer an island. Attempts to dig a trench to separate the island from the mainland were futile. The land bridge was formed by the receding water, and predators destroyed the nesting colony. No other image of mine has taken on such a powerful historical meaning so quickly.

At the time of this writing, Mono Lake has risen because of two of the biggest snow years in history. The gulls are starting to return to Negit in small numbers. Invariably the lake will start to fall again at 20.5 inches per year unless the courts find a firm loophole in the City of Los Angeles's legal acquisition of Mono Basin water rights.

TECHNICAL DATA *Nikon FTN with 24mm lens; Kodachrome II (ASA 25).*

PORTERS IN THE BRALDU GORGE, KARAKORAM HIMALAYA, PAKISTAN

PORTERS IN THE BRALDU GORGE, KARAKORAM HIMALAYA, PAKISTAN; 1975

On the way to K2 in 1975, we enlisted 650 Balti porters to carry loads to Base Camp so that nine American climbers could spend three months attempting to climb the second highest mountain in the world. The idea of uprooting a major group of local villagers from their fields to spend weeks working for us as laborers did not appeal to me personally. We had enormous impact on the local culture, and the locals, in turn, altered our experience so much that we were unable to record their ancient culture in its normal state. We all moved along as part of a modern caravan and observed the scenes created by our presence.

Many funny photographs were made of Balti porters. One fellow, resting with a pair of new K2 skis over his shoulder, begged the caption, "Is this the way to Chair 7?" It would have been easy to pose a cross-cultural image that would bring laughter to a lecture audience. A porter smoking

K2-brand cigarettes; the expression on the face of a small boy wearing headphones listening to Bob Dylan. I didn't want those photographs. I wanted to show the Baltis in tune with their landscape in as many ways as possible. They were people of the goat: they herded goats, ate goat flesh, wove undyed woolens from goat hair, braided ropes from goat tails, and made shoes from goat skin. Theirs was a world of subdued colors of the earth, and I noticed how invisible they became against the natural tones of their surroundings.

I wanted to make an image that would capture the feeling of this integration of the Balti with his natural world. My chance came in the Braldu Gorge, where the route went in and out of deep *nullahs* (side canyons) along trails cut out of the vertical walls of rock and mud. There the route into a *nullah* would often be parallel to the route coming out the other side, and one morning I turned a corner just in time to see the right situation evolving.

EXHIBIT VI FIGURES IN A LANDSCAPE 149

On the opposite wall of the *nullah*, an arc of trail cut the canyon wall, fully in even shadow light except for a kiss of sun in one corner. The soft light would help blend the figures, who were wearing earth colors, into the land. To get the proper perspective, I chose a 105mm lens and put on an A2 filter to cut the blue tones inherent in shadows. Then I set my camera on a tripod, focused, and waited.

Group after group walked by, each with some sort of anomaly that distracted from the pattern I was after. Perhaps it would be a porter with a brightly colored jacket bought in the Skardu bazaar, or it might be a group clustered together for no apparent reason that drew the eye from the whole scene. Finally, one band of men walked in unison, separated by that random distance that comes naturally to men who live much of their lives on the trail. I set my lens at f/4 to hold barely enough depth of field so that my 1/250-second shutter speed could stop the action and made this image.

TECHNICAL DATA *Nikkormat FTN with 105mm lens; Kodachrome II (ASA 25); A2 filter.*

PORTERS AT CONCORDIA,
KARAKORAM HIMALAYA, PAKISTAN; 1975

In a way the photograph on the following two pages could be called a matched image to the one opposite. Here are the porters again, but this time they are out of their element, standing out in bold relief against the snows of Concordia. I made the photo in a similar way, by first finding the landscape I wanted, then positioning myself away from the group in a good location. Because of the roughness of the terrain and the size and closeness of the peaks, I could not get a good image with a telephoto. I chose a rolling clearing between moraine hills, stood back, and used a 20mm lens to hold in focus the longest string of porters possible along with Gasherbrum IV at the left, Chogolisa in the middle distance, and Mitre Peak at right. A polarizer accented the clouds and increased definition of color and shadow on the porters.

I had far less time to make this image than the one in the gorge. By the time we reached Concordia, more than 500 of our 650 porters had gone on strike and left us. The Balti people of the Karakoram are full-time farmers and herders, unlike the Sherpas of Nepal, who work well in the high mountains, for it is part of their cultural heritage as traders to leave their villages during much of the year to carry goods for profit over high passes.

An earlier Karakoram explorer said of the Baltis, "Their fear of authority is only matched by their irresistible urge to outwit it." The Baltis quickly figured out that because there were nineteen expeditions arriving at different times in the spring of 1975 and because the government had decreed that expeditions must pay porters in full on their last day of employment, it made sense to quit on the slightest pretext once an expedition reached the discomfort of snow line. Then they could go back to the warm valleys and hire on with another expedition.

Some expeditions were left stranded in the snows with tons of equipment. They didn't even reach their base camps. Just before Concordia we broke such a strike by using a very direct method. We were at the end of our tether, and as Fred Dunham put it, "The milk of human kindness has just run out." Our most gentle teammate, Leif Patterson, even proposed that the quitters be stripped naked and marched home in shame. "They'll get out alive," he said with a prosecutor's glint, "but they'll have a lesson. I don't want to kill them outright."

It was Lou Whittaker who dreamed up a counterstrike when our expedition was on the verge of immediate collapse. We assembled the porters before us, where we had a big sack of rupee notes on the table and told them that if they failed to carry for us, we would be failures too. We would burn all our equipment and money on the spot, walk out empty handed without paying them, and complain to the Pakistan government. To underscore the threat, Lou's twin brother, Jim, pulled out a ten-rupee note and casually set it afire. As it burned on the negotiating table in front of the 130 wide-eyed Baltis, our climbing team left without a word.

The remaining porters agreed to carry to Concordia, the grandest meeting place of glaciers on earth, where I made a photograph that gives the feeling of great numbers of human beings working together toward a common goal.

TECHNICAL DATA *Nikon FTN with 20mm lens; Kodachrome 25; polarizer.*

PORTERS AT CONCORDIA, KARAKORAM HIMALAYA, PAKISTAN

BALTI IN A DUSTSTORM, KARAKORAM HIMALAYA,
PAKISTAN; 1975

This is one of those rare images that flashed before my eyes. Only instinct and camera handling wired into my nervous system allowed me to get a picture at all. I was in a jeep of indeterminate age filled with K2 climbers and duffels of equipment. We were finally on our way to the roadhead after a week's delay. The moment we left the town of Skardu an imaginary starter's flag must have dropped somewhere in our driver's brain. As we roared away against unseen competition, we all thought about the twenty-three people who had been killed in jeep accidents around Skardu that year. We felt more like participants in the Baja 1000 than climbers in the Himalaya as our vehicle hurtled through lost villages at full throttle. The jeep created such a wake of dust that the onset of a natural duststorm caught us unaware.

Behind us, soon miles behind us, was another jeep load of climbers with a more reasonable driver. Leif Patterson wrote in his journal about sights we never saw:

"I would love to just stroll leisurely among the neatly kept fields. Everything bears witness to the lack of machinery. No wires, no bulldozer scars, no waste of any sort. Every stick, every branch, every bit of bark of a felled tree is carefully used. It is such a delightful experience to see what neatness and pleasure the unassisted human hand alone can produce. Life could be good and stable here, yet I know that the hard work and toil would look less romantic after a while. It is never possible to judge life from a car window."

On the outskirts of Shigar, we drove into blowing sand and dust. Veiled women silhouetted in the fields braced themselves against the wind.

Herdsmen and flocks of goats dotted the land like boulders, taking on the color of the land with a coating of tawny dust. At ground level was a roiling Sahara, but far above this layer of dust was ice and snow, barely visible, like some apparition of heaven.

I kept my camera ready with a 105mm lens and a manual exposure setting taken from the surface of the ground so that the brightness of the blowing dust wouldn't underexpose a human subject. With the lens wide open at f/2.5, I could shoot at 1/1,000 second with ASA 64 film. I unsnapped a section of the canvas top by the door in order to stick my camera out the side, and when we slowed down for a rough section of road, I saw that we were about to pass a barefoot Balti wrapped in a homespun robe of goat's wool. The man turned to avoid our dust, and as we went by, I composed a photograph with him on the right side, so that he would appear to be walking into the scene. Because there were bushes in the way, I wasn't sure that I had made a worthwhile photograph until I saw the processed slide many months later.

My failure rate for photos made from moving vehicles is higher than for any other kind of travel photography I do, yet I continue to make them. Every once in a while I make an image like this one, with a sense of movement and spontaneity that makes up for all my past failures. In three months of traveling on foot with Balti people, and during three more subsequent visits to their land, I made no other photograph that better captures this ethereal feeling of a native in balance with the turmoil of his land.

TECHNICAL DATA *Nikkormat FTN with 105mm lens; Kodachrome 64; 1/1000 second to stop motion.*

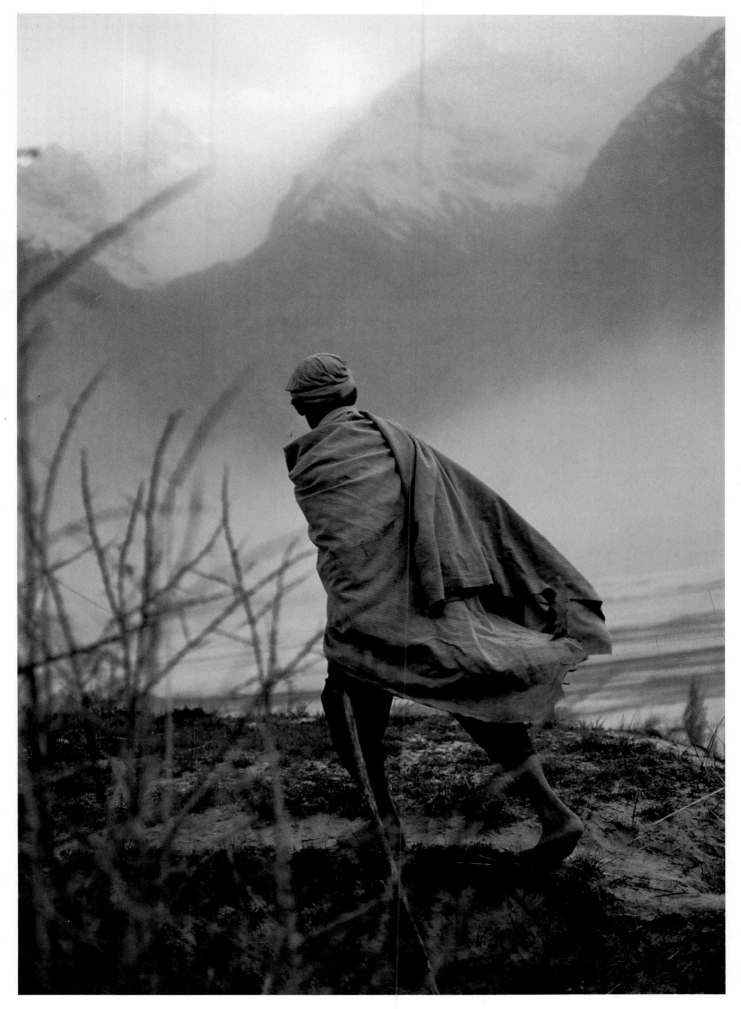

BALTI IN A DUSTSTORM, KARAKORAM HIMALAYA, PAKISTAN

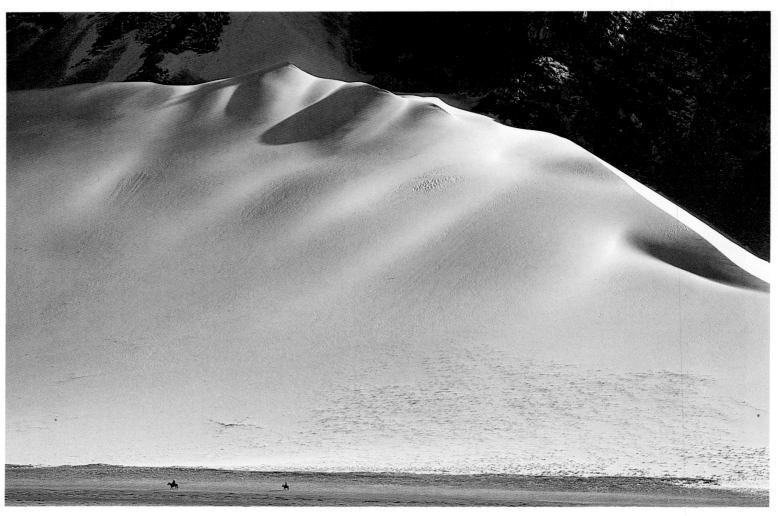

RIDERS BENEATH GIANT SAND DUNE, PAMIR RANGE, CHINA

RIDERS BENEATH GIANT SAND DUNE,
PAMIR RANGE, CHINA; 1980

Many viewers mistake this photograph for a snow scene; it is actually white sand deposited by winds at the end of a mountain valley. The dune, larger than any I have seen anywhere else in the world, rises above the ancient Silk Road followed by Marco Polo. Its base is at thirteen thousand feet in the High Pamirs of western China, a place still populated, as in Polo's day, by seminomadic Kirghiz who herd goats and sheep on the broad, well-watered steppes below the giant peaks.

I made this photograph on my last morning in the Pamirs. Before dawn we had ridden in a rented bus from a camp in a high meadow to the headquarters of the nearest commune, where we had been invited to a victory breakfast to celebrate our climb. A few days earlier three of us had skied to the summit of 24,757-foot Mustagh Ata and back down to the snow line at 17,000 feet. It was not only the highest complete ski ascent and descent

in history, but also the first climb by Americans in mainland China since Mao founded the People's Republic in 1949. In celebration of this event, we were to join officials of Bulunkol Commune for a dawn meal on our way back to Kashgar.

The commune was situated on a bluff directly opposite this giant dune, and as my hosts steamed stale rice and cooked vegetables in a greenish fluid I can liken only to used transmission oil, I sat on top of a wall and watched the patterns of sunlight on the sand. Two tiny dots moved along a strip of spring-fed meadow near the dune, and at closer range I saw two women carrying pails of water toward the commune from the same meadow.

With my 600mm lens I identified the dots as Kirghiz riders. I watched them stop at a well, and I hoped that they would continue on underneath the dune, where their presence would create the sense of scale I needed for a meaningful landscape image. Just then breakfast was called. I dutifully sat down at the banquet but soon broke protocol

EXHIBIT VI FIGURES IN A LANDSCAPE 155

and excused myself. Thinking back on it, I'm not sure I would have done so had it not been for our assignment from the *National Geographic*. I felt an allegiance to something other than pleasing my hosts as I rushed outside, checked the riders' progress, and thought about how best to compose an image.

With my 600mm lens I could make only an informational shot of the riders, which would totally lose the impact of their surroundings. With a normal lens or short telephoto I could make a landscape that would include the sky and the mountains as well as the dune and meadow; that, however, lacked a clear point of interest. After analyzing the scene, I concluded that it had three essential elements: steep, rippling sand; a level strip of grass; and the startling sense of scale imparted by the two figures.

By using my 180mm f/2.8 lens, which also happens to be one of my sharpest, I was able to crop out all extraneous matter from the landscape and home in on the three essential elements. Because I didn't have my tripod with me, I built a pile of rocks to support the lens on top of the com-

mune wall. I was very aware that this sort of subject matter might lend itself to oversize prints, so I tried to muster every bit of sharpness my Kodachrome 25 film could record. I waited until the riders were in just the right position to balance the flowing patterns of light across the sand, then made several exposures at f/8, an aperture that would give me the best edge-to-edge resolution.

My expectations for great enlargement of this image proved correct. The *National Geographic* ran a frame similar to this one across two pages in February 1981. Several clients ordered thirty-by-forty-inch prints to decorate office walls, and even that large size was exceeded when the curator for my traveling exhibition "Mountain Light" chose the image to print six feet by four feet for use in the entry hall. In that giant size the print not only holds much of the impact of the original scene, but also extends many people's conceptions about the capability of evenly exposed 35mm Kodachrome to hold up to extreme enlargement.

TECHNICAL DATA *Nikon F3 with 180mm lens; Kodachrome 25.*

ASTROMAN, EAST FACE OF WASHINGTON COLUMN,
YOSEMITE, CALIFORNIA; 1985

In this image, Ron Kauk, whom I consider to be
the best all-around rock climber in America,
reaches into a crack high on a route called "Astro-
man." What separates this from other climbing
photography I have done over the past two dec-
ades is that I am neither a direct participant tied to
my teammate nor a remote observer apart from
my subject's experience. A rope leading up to my
position is conspicuously absent from the photo-
graph. Together, Kauk and I planned this photog-
graph. We were members of separate climbing
teams on the same face on the same day. The
dizzying orientation of the photo represents the
way Ron appeared to me as I faced into the over-
hanging fifteen-hundred-foot wall and looked
down past my own feet, spread apart enough to
make this photo. Thus, the image represents the
same perspective a lead climber has when he looks
down.

Ron was seventeen years old in 1975 when he
stunned the climbing world by making the first
free-climb of a classic route up the East Face of
Washington Column. (Free-climbing means using
ropes and pitons for safety, but relying only on the
rock itself for upward progress; free-solo-climbing
is doing the same thing without a safety rope.)
With John Bachar and John Long, Ron finished
the climb in a few hours instead of in the normal
two days that parties carrying much gadgetry for
direct-aid climbing usually take. Even though the
path of their route had been taken by hundreds of
other climbers, Kauk's party decided to give the
climb the new name "Astroman" because as a
free-climb it was a unique experience.

In 1984 Ron asked if I might be interested in
working with him to make some outstanding
photographs that depicted the present state of the
art of rock climbing. He expressed a strong distaste
for the photography of free-soloing that had re-
cently been published in *Life, People, Newsweek,*
and even *American Photographer.* Ron was con-
cerned because those magazines distorted the truth
by their emphasis, implying that unroped climb-
ing has become the ultimate direction of his sport.
He pointed out that any climber can always do
harder climbs with a safety rope than without.
Therefore, the real leading edge of the sport must
always involve roped climbing. Both he and I
agreed that photographs of extreme unroped
climbing, published out of context with the rest of

the sport, serve only to confirm the public's belief
that climbers are crazy.

I shared Ron's concerns about honestly depicting
the sport. I like my wilderness photography to
appear inner rather than outer directed, so that it
presents the viewpoint of a participant rather than
that of a spectator. To put it another way, a pho-
tographer on the outside looking in records a
spectator sport; on the inside looking out the visual
reality becomes experiential.

The first assignment I landed, however, was for
a magazine that wanted an image of free-soloing.
Together Ron and I made the image that appears
on page vii. Realizing that I was falling into just
the trap Ron was concerned about, I proposed a
story to *Sports Illustrated* that would give its readers
an insider's view of modern rock climbing through
a profile of Ron. In my letter to an editor I had
previously worked with, I explained, "Ron Kauk
is a totally unrecognized world-class athlete who
has put out as much to get where he is as any
Olympic medalist. . . . He works out several hours
a day, running trails, climbing boulders, lifting
weights, walking slack chains for balance, and
doing repetitions on hand-built "machines" that
duplicate overhanging cracks and hanging finger-
tip traverses. . . . He climbs for the joy of it. No
one supports him. He is dedicating the best years
of his life to something that at the present time has
no consistent remuneration."

Sports Illustrated gave me the assignment. In the
image presented here Ron is climbing with a safety
rope that is out of view below him. He is carrying
a sling of hardware with which to attach his rope
to the rock periodically, thus protecting himself
from a fall. His partner is tied to the wall, also out
of view below him.

Because we were climbing in two separate
teams, I was able to photograph Ron from a van-
tage point close enough that I could reach out and
touch him. Ron was the leader of the bottom
team, and I was the second man of the top team.
Thus, when I encountered a visually exciting spot,
I waited, hanging on the rope if necessary (and it
usually was), with a motorized Nikon F3 and
20mm lens, to photograph Ron in the act of lead-
ing the climb he had pioneered a decade earlier, a
route that many climbers call the most classic all-
free wall climb in the world.

TECHNICAL DATA *Nikon F3 with 20mm lens;
Fujichrome Professional 100; small aperture for
extreme depth of field.*

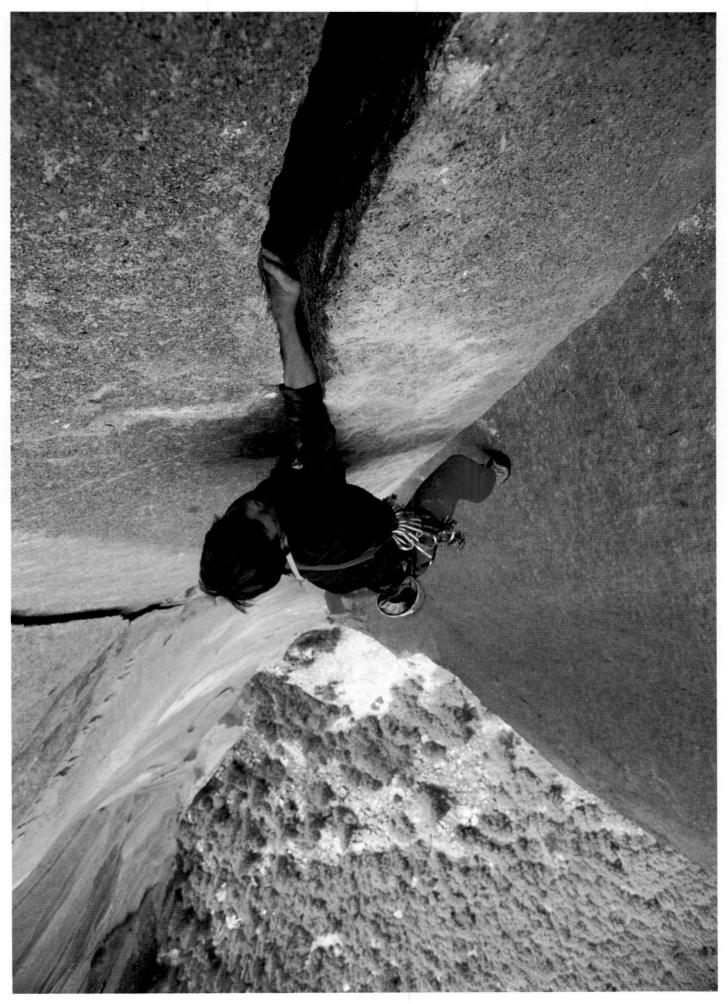

ASTROMAN, EAST FACE OF WASHINGTON COLUMN, YOSEMITE, CALIFORNIA

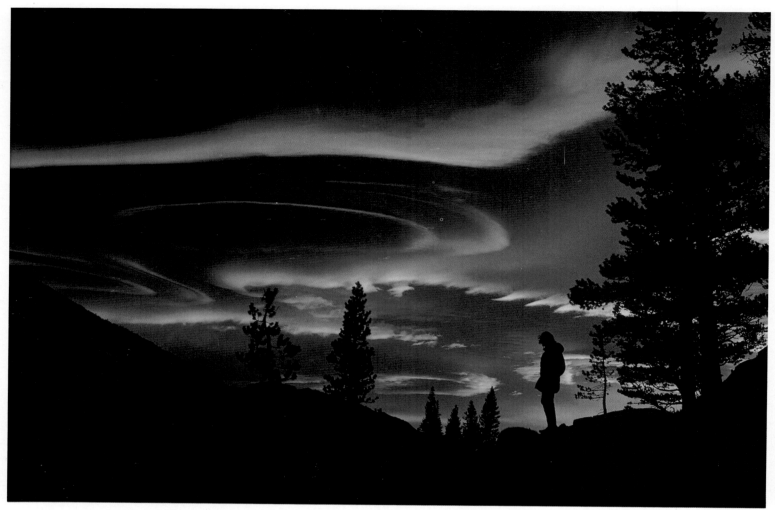

SUNRISE ON TIOGA PASS, HIGH SIERRA, CALIFORNIA

EXHIBIT VI FIGURES IN A LANDSCAPE 159

SUNRISE ON TIOGA PASS, HIGH SIERRA,
CALIFORNIA; 1973

The Tioga Pass road leads into Yosemite from
the edge of the Great Basin over a crest of nearly
ten thousand feet. The road is closed for the winter
when the first major storm hits. On a fall evening
in 1973, I slept in the back of my old station wagon
near the crest of the pass, hedging my bets for
morning photos from a point where I could see
the weather on both sides at once. Depending on
the look of the sky, I planned to head either west
into Yosemite or east toward Mono Lake.

When I awoke before dawn, the sky was filled
with some of the most vivid colors imaginable.
Lenticular wave clouds filled the northern sky, and
their edges had turned crimson in the first rays of
the sun. I jumped up, set my camera on a tripod,
and began photographing reflections of the sky in
a small lake. I quickly realized that the situation
had the potential for a far more powerful image.

With bright light in the sky but no direct light
on the earth, I knew I could get absolutely no de-
tail in the foreground, so I began thinking in terms
of silhouettes. No peaks, hills, or trees had outlines
that looked dramatic enough to carry the image.
I was the only thing left.

Knowing I had at best only two or three minutes
of that fine light, I rushed around looking for a
spot of high ground. A small ridge about five feet
higher than the surrounding terrain gave me a
place to stand profiled against the sky after I set
the self-timer on my camera. I purposefully chose
an exposure that was one stop under my meter in
order to saturate the red hues against as dark a
background as possible. I positioned myself by the
side of the frame in a place where I would be in
balance with the strongest diagonal of light high

in the sky. I tried two different compositions. First
I used a 35mm lens that rendered my profile quite
large in the frame. Then I switched to a 24mm
lens and made this photograph, with a much
smaller profile.

The size of a figure in relation to the landscape
has strong cultural implications. As a general rule,
a larger figure implies human dominance of the
scene, while a smaller one gives the balance of
power to the land. With the environmental move-
ment came a trend toward big landscapes with
little humans. Ansel Adams went to the extreme
of never including people in his most important
landscapes because he felt the power of his en-
vironmental scenes would be weakened. I agree
that a landscape in which all natural elements are
in balance gains nothing aesthetically from the
presence of a human figure. However, such bal-
anced images are extremely rare. One cannot
document an area and hope to find perfect balances
of land and sky, forest and cliff, water and meadow
in every photograph.

In my search for extraordinary light, I often
come up against a situation such as the one at
Tioga Pass: wonderful light on one element of a
scene—in this case the sky—with average or poor
light in other areas. In those cases human figures,
especially unrecognizable silhouettes that allow
each viewer to relate to the scene, often elevate an
otherwise commonplace photograph.

The image with the larger figure was chosen by
National Geographic for a book on national parks,
a very people-oriented subject. In the long run,
however, this version has become far more widely
published and exhibited.

TECHNICAL DATA *Nikon FTN with 24mm lens;
Kodachrome II (ASA 25).*

CALIFORNIA BIGHORN RAMS IN THE HIGH SIERRA,
CALIFORNIA; 1976

I made more than a dozen trips to the High Sierra to photograph this rare subspecies of bighorn sheep before I finally saw it for the first time. On that day in 1972, I found a herd of fifty—one-sixth of the total number of these animals in the entire Sierra range—in one band on open sagebrush slopes above the Owens Valley. They had been forced down from higher ground because of a heavy storm, and they seemed quite wary of my approach. The band was composed of ewes, lambs, and young rams without curled horns.

I thought my chances of ever encountering a band of old rams were poor, but one day a biologist who was studying the animals helped me spot a large herd from a distance of several miles with a powerful scope. He thought there were at least some rams by the way the animals were dispersed, but he wasn't sure.

I spent hours climbing thousands of feet above the valley only to discover, once again, a band of about fifty ewes and youngsters. Worse yet, they spotted me and kept moving upward with every step I took, just out of range of my 500mm lens.

Dejected, I sat down to rest. When I looked up, I saw nine curious rams on a hillside only a few hundred feet away staring intently at me. Concentrating on the main group, I had failed to spot them.

Perhaps because of my unawareness of them, the rams weren't disturbed by my presence. I gradually approached them, walking a few feet, sitting down, moving away a bit, then coming closer again. Their toleration of my presence was well defined; I could get within fifty yards, but one step nearer started them moving away.

I knew from my readings about bighorns that I was in an ideal situation to observe them. I was alone, coming from below, feigning disinterest, and allowing them an escape route onto the kind of cliffy terrain above that made them feel more comfortable with my presence. After waiting years for this moment, I could hardly believe that these rams, the animals I had despaired of ever finding, were so contented in my presence that the telephotos I made were nearly still lifes. Unfortunately, grazing and sleeping bighorns do not look noble.

Over the next two hours I took several rolls of film and bided my time. When I saw afternoon shadows begin to move down the east-facing slope, I knew I had to make my move if I wanted an unusual image of the rams in fine light. I stood up and walked briskly toward them. They, in turn, stood up and bunched tightly together. I stopped again, set up my tripod for the camera with the 500mm lens, and kept another camera with a 200mm lens around my neck. I took what I thought would be my last images as the shadow came within a few feet of the rams. Suddenly, they shifted their gaze from me toward something in the distance—a noise, a sight, or a smell, I'll never know exactly what. At that moment I clicked the shutter, and I never got a chance for a similar frame. The herd seemed to lift into motion like a single animal, plunging down the sagebrush slope as gracefully as a breath of wind passing through a field of grass. They came closer to me than before for just a moment, and I took several shots with my 200mm lens, sure those would be the best of the day. But when I looked at my results, I saw that the action shots lacked the dignity of this alert moment when the animals seemed to be in perfect harmony with their surroundings.

TECHNICAL DATA *Nikon FTN with 500mm lens; Kodachrome 64.*

CALIFORNIA BIGHORN RAMS IN THE HIGH SIERRA, CALIFORNIA

ON THE GREAT TRANGO TOWER, KARAKORAM HIMALAYA, PAKISTAN

ON THE GREAT TRANGO TOWER,
KARAKORAM HIMALAYA, PAKISTAN; 1977

This photograph, more than any other I have made, mirrors my finest memories of alpine rock climbing in the Himalaya. It is neither just an action photo nor a landscape, but rather a blend of both in the same image. On the morning I made it I was very aware of the potential for an image that would say it all. Countless times on a mountain I have been enthralled by both the scenery and the aesthetic nature of the climbing at once but didn't have the right situation to bring it all together on film. Often the scenery is in a different quadrant than the angle of view toward my fellow climbers, and the light rarely favors both subjects at once. Perhaps the most important factor of all is that good landscape photos almost never look straight down from above, and that is the camera angle most often required to include both a climber and the ground below him.

Horizontal distance is the main prerequisite for making a climber appear as a part of the landscape, and that distance can be achieved two ways. Either the climber must be at quite some lateral distance from the camera, or the camera's lens must be wide enough to impart the feeling of such distance to a nearer subject. In this case I had both. Kim Schmitz was making a horizontal traverse, and I used a 24mm lens to include much of the landscape around him. As Kim climbed toward me, I saw that both his figure and his shadow formed a strong diagonal toward Hidden Peak, the white pyramid in the upper left (26,470 feet). This, together with the more obvious diagonals of sun and shadow, made the image come together in my mind. Working in a hurry without a motor-drive, I took just a single frame of this composition. My exposure was for the sunlit rock, directly on the reading of my through-the-lens meter (set at ASA 40 for ASA 25 Kodachrome as described in Chapter 3).

I described that morning's experience in my

EXHIBIT VI FIGURES IN A LANDSCAPE 163

book *Many People Come, Looking, Looking*: "Sunrise caught Kim leading an ice-filled crack in the best alpine granite we had ever seen. He moved with slow grace and confidence, belying the effort he was expending to climb a crack in double boots at 18,000 feet. We were in ecstasy; the weather, the rock, the surroundings, and the companionship were all as fine as we could ever desire. Later, when I reached Kim in the middle of the headwall, we looked at each other and giggled with delight."

Kim and I were leaders for the day of a five-person climb. We had light loads because we were stringing ropes for the others, who then followed us on ascenders, carrying bivouac gear and food. They pulled out the ropes as they came and brought them to us so that we could continue leading. The next day we would be the followers and John Roskelley and Dennis Hennek would take over the lead. Since our cliff caught the sunrise light, I figured that I had but one chance to make the image I wanted in good light. In the evening, light would be off our side: the next day I would not be climbing with the leaders, and the day after that we hoped to be above the exposed rock on the final snow-and-ice slopes leading to the unclimbed summit.

I might never have made the first ascent of the Great Trango Tower had it not been for my own earlier photograph, which appears on pages xiv and xv. Studying a sixteen-by-twenty-inch print on my office wall convinced me that there was a splendid route directly up the face, following a zigzagging series of faces, ramps, and ledges. That earlier photograph was made two years before this one in very different circumstances. On my way to K2 with a very large expedition, I awoke before dawn in a tent with all the comforts of home. As alpenglow lit the peaks through the exceptionally clear air that follows a storm, a Beethoven piano concerto was playing on a stereo tape deck. From my fifty-five-pound porter-carried pack of cameras, I selected a long telephoto lens and attached it to a tripod-mounted camera in the doorway of the tent. Still in my sleeping bag, I shot image after image of snow-fringed towers and buttresses, every one of them unclimbed.

Only by chance did my favorite shot from that take happen to show the route we eventually followed up the tower two years later. I made the image on the opposite page from the sunlit section of face near the lower left corner of that earlier photograph.

TECHNICAL DATA *Nikkormat FTN with 24mm lens; Kodachrome 25.*

WASH DAY, KATHMANDU, NEPAL

WASH DAY, KATHMANDU, NEPAL; 1977

Like all Asian cities, Kathmandu comes alive at dawn. People begin their days out on the streets before sunrise. The romance of being out in the open air, washing clothes within sight of Himalayan peaks, has no American counterpart. If I made a photograph of wash day in my hometown —Berkeley, California—it would show college students crowded around long rows of machines in a laundromat. Such an image might be of interest to the Nepalese, but it wouldn't hold much interest in my own community.

When I first came across this scene, where Nepalese were washing their clothes in a local ditch, my inclination was to make a straight photograph. The contrast of the Asian wash method with our way of doing wash seemed great enough to carry the image. Then I put myself through an exercise I commonly use to "test" my cultural photographs. I tried to think of the approach from my subject's point of view. If I think the photo-

graph would not be meaningful to them, I consider my image less valid than it could be.

All of us have seen this process in reverse. A photographer comes to our hometown or to an area we know and makes what we consider banal images that are then used to illustrate scenes that are dear to us. With a little creativity images can be made to satisfy the tastes of both those familiar with a scene and those who have never seen it before.

As soon as I took out my camera, two men wringing laundry on the hillside stopped what they were doing and stared at me. Two women in the foreground pivoted slightly, turning their backs toward me. I tried to take the overall scene with all four people, but their self-conscious appearance ruined the mood. Then I caught sight of the women's reflections, and I wondered if I could find a position that showed the men's reflections too. Going to the water's edge I found a spot that gave me an even better image: I could juxtapose

EXHIBIT VI FIGURES IN A LANDSCAPE 165

the real forms of the women against the reflections of only the men. I squatted there for several minutes, until the men went back to work, then composed a human landscape with no horizon other than that implied in the reflection. With my elbows braced on my knees, I handheld the camera at 1/30 second to hold as much depth of field as possible.

TECHNICAL DATA *Nikon FTN with 35mm lens; Kodachrome 25; small aperture for depth of field.*

DESCENDING THE RUTH GLACIER,
ALASKA RANGE; 1978

When I first circled Mount McKinley—now Denali Peak—in a small plane in 1972, I was amazed to see a corresponding circle on the ground. The five major glaciers of the mountain flow down its flanks, abruptly turn, and form an interconnected ring of ice ninety miles in diameter. This circle of moving ice is unique among peaks more than 20,000 feet high, and until 1978 no one had followed it completely around the mountain.

Ned Gillette, an Olympic cross-country skier, invited me to join him on a late-winter ski traverse of "The Great Circle." With Alan Bard and Doug Weins we would be a four-man team. I interested *National Geographic* in the story, and we set off for an experience quite unlike normal ski touring.

Because temperatures could drop far below zero degrees, we had to bring heavy clothing. Because the route crossed Denali's three major buttresses at elevations of ten to twelve thousand feet, we had to bring considerable climbing gear. Because of our commitment to *Geographic*, we had far more camera equipment and film than usual.

I used a special camera fanny pack worn in front instead of in back. The ten pounds in front helped counterbalance the eighty on my back. Inside the fanny pack were two Nikon camera bodies and 24mm, 35mm, 55mm, 105mm, and 200mm lenses plus assorted filters, a four-ounce minitripod, and lots of Kodachrome film. Thus, I could set up any lens combination and take a photo within a few seconds without removing the pack from my back.

Because Ned obtained financing from several Norwegian companies, we committed ourselves to using featherweight Epoke 900 skis with narrow fifty-millimeter racing bindings. The light skis made normal turning in deep snow with a heavy pack not only improbable, but also impractical because we couldn't afford to break a ski in the wilds.

One morning as we were descending an icefall on the Ruth Glacier, I looked back to see layers of complementary patterns of snow and light on the slope. First there were the contours of the glacier itself, rugged but rounded under a layer of winter snow. Then there was the interplay of light and shadow, for once within the limits of my film because of the sun's low angle in the Alaskan sky and the bright reflections from surrounding heights that filled the shadows. Finally there were the zigzags of our ski tracks, leading to where Doug and Alan were about to sidestep down a steep section.

Instead of continuing to descend the slope, I skied out in a traverse to find a position for a telephoto shot that would compress the features and enhance the patterns. With a 200mm lens and my camera braced against interlocking ski-pole straps, I made this image when the figures were in just the right position in relation to the other patterns.

TECHNICAL DATA *Nikon FM with 200mm lens; Kodachrome 25.*

DESCENDING THE RUTH GLACIER, ALASKA RANGE

CHAPTER SIX
Operative Vision
HOW EQUIPMENT, ASSIGNMENT, AND ADVENTURE COME TOGETHER IN THE FIELD

Until now I have tried to avoid making equipment recommendations. If I have mentioned a specific item, it has been in the course of a description of a method. These omissions are intentional. Lists and appraisals of equipment are almost meaningless when separated from the full context of their use.

One of the most common questions I'm asked by aspiring photographers is what equipment I would take to a place they are going to visit. I can't answer them because I know my passions, not theirs. If they want to photograph birds nesting, they might want an 800mm lens weighing twenty pounds. For me, that lens would be an anchor.

Perhaps the simplest piece of equipment a photographer uses is a tripod, yet even as honest, diligent, and unbiased a source as *Consumer's Reports* ranked my favorite lightweight model at the bottom of its list. Why? Because it was the least stable in its price class. Why was it so unstable? Because it was one-third the weight of the clunker that won their stability tests. For a wilderness photographer, lightness is a more significant quality than sturdiness at full extension. When I need increased stability, I compromise: I get down on my knees and use my light tripod without its legs extended.

As simple as a tripod is, the way it is used—or not used—can be highly confusing. I've given the same information about my use of tripods in several published interviews and photographic notes, yet when the information has been edited to provide lively reading, some versions have appeared to contradict others. People still come up to me and ask, "Do you use tripods, or don't you? I read in one magazine that instead of taking handheld shots, you always take the time to set up a tripod. In another one you say you have special ways of bracing a camera so you don't have to carry a tripod."

Some of the time I use a tripod for static scenes and long telephotos, while other times —when I need to go very light on wilderness adventures—I make do as best I can without one. This same principle holds true for all my photo equipment. The fact that I own an item—a lens, a filter, or a tripod—doesn't mean that I use it all the time. Sometimes I take it in the field with me and never use it; it may stay in my car or at a base camp.

The ideal way for me to explain my equipment and its application would be to take my readers out in the field with me. The next best way would be to have you join me on a written journey. When I climb a mountain, published accounts usually include a description of how I climbed it, what equipment I used, and what unusual choices confronted me. When I photograph a mountain area, published accounts give plenty of information about the area and virtually none about my photography. To reverse this imbalance, I will describe my most recent Himalayan expedition for the *National Geographic* more from the viewpoint of a photographic journey than as a mountain adventure. Join me and my wife, Barbara, at Kennedy International Airport in New York in May 1984 just before our flight leaves for Pakistan.

We are waiting in the lounge of Pakistan International Airlines for Andrew Embick, our expedition leader. He is four hours overdue. Although this is our first trip with him, we know that being late is unlike him. Embick is thorough to a fault. He graduated from Harvard Medical School and was a Rhodes scholar; his current letterhead reads "Valdez Medical Clinic and Kayak Supply."

Kayaking is Embick's latest passion, and he has become very good at it in just a few years. He is also an accomplished climber. Valdez is a little town in Alaska, and Embick has a long record of first descents of wild Alaskan rivers and first ascents of difficult Alaskan mountain faces. He has just bought a new motordriven Nikon F3 with several lenses, with which he plans to take photos on our trip using film provided by the *Geographic*.

Knowing these facts makes our expedition's goals a bit more understandable. Embick is the leader and trip doctor for a private expedition that hopes to kayak one of the wildest unrun rivers in the Himalaya, climb a virgin rock tower, trek the route of an ancient migration, and bring back a story for the *Geographic*. But where is he now?

My involvement in the expedition came after Embick wrote to me requesting photos of wild granite spires I had described in an article about a 285-mile ski traverse of the Karakoram Himalaya in 1980. I gave him the pictures, with one stipulation: if he got together his expedition, I wanted both Barbara and me to be included. When the expedition was assembled, I proposed a story to the *Geographic*, which Barbara and I will shoot together.

The area where we are heading was once a tiny kingdom called Baltistan, entirely ringed by trans-Himalayan peaks. The cultural variety of Baltistan is unsurpassed, yet I

find it far easier to describe in words than to bring back images of it. How can I explain, in a few photographs, that in this remote Asian backwater the high tides of great civilizations left a blend of religion, language, and race unlike that anywhere else in the world? How do I visually depict the eastward flow of the Balti people's Islamic faith from Persia? What images can depict the way in which their unwritten language rode the most westerly wave of the Tibetan empire, or how their Mongolian features swelled south over high passes from the sands of Chinese Turkestan to blend with European features of uncertain origin?

I have been to this living anthropological museum three times in the last decade, and I know that my task is even greater than bringing home images that single out the old traditions. Such images are no longer journalistically valid unless blended with photographic documentation of the rapid changes that development and tourism have brought in the past ten years. It saddens me to think that I may be witnessing the last days of Shangri-La.

Barbara and I flew out from California yesterday to attend a fundraiser for the expedition at the Explorers Club in Manhattan. This morning we took a shuttle flight to Washington, D.C., where we met with Bill Garrett, the chief editor of the *Geographic*. Garrett is an old Asia hand who shares my concern for the direction of the story. He tells us that our adventures alone will not be good enough for a *Geographic* article in the eighties. He wants complete coverage of the native cultures. He has no doubt that we will bring back splendid scenics, but he questions whether in the normal course of the expedition we can photograph the intimate life of the mountain people.

"Leave the expedition if you have to. Stay on a couple of weeks at our expense if you don't think you have what we need when the adventures are over. The kind of images of native people expeditions typically bring back aren't suitable for us. We need more than cute kids waving and families, lined up in front of their homes, staring into the camera. We want the inside story on how they live, work, and eat, and how they relate to each other. It must be as if your expedition weren't there."

At the *Geographic* we picked up 200 rolls of Kodachrome film: 140 of ASA 64 for low-light and action situations, plus 60 of ASA 25 for scenics. I did not ask for film faster than Kodachrome because for outdoor work the results are too harsh and grainy (although in 1985 I found out that the new Fujichrome Professional 100, when push-processed to ASA 200, gives excellent results; even so I push film speed only when I have no other alternative, because exposure latitude decreases).

Before the flight back to New York from Washington, D.C., we asked that all our film be handchecked through X-ray. I pulled my loaded camera out of my shoulder bag, then let the bag itself with all my basic equipment be X-rayed. That not only speeds up the

process considerably, because security personnel don't have to paw through my equipment, but also it is seen as a gesture of cooperation.

On my return from Pakistan, I will put my exposed film in a clear plastic bag, rather than in a lead-coated, protective one. Personnel rarely stop to open a clear bag that is obviously film, while they often stop the belt of the X-ray machine, crank up the power, and try to see what might be concealed in a lead-lined bag. Once I saw a knife inside a lead film bag displayed on the screen of an X-ray machine; I have also witnessed a depressing slide show of some *National Geographic* images that were ruined by X-rays. Don't be fooled by the assurance that X-rays hurt only films of ASA 1000 or higher. Those ruined images were nearly all on Kodachrome 64. Most problems arise when exposed film is put in checked baggage on international flights inbound to the United States. X-ray spot checks are more frequent and potent than airline personnel are willing to admit.

Just before we go through customs, a harried, sweating Embick arrives. His new Nikon was stolen from his room at the Harvard Club, where he left it while running last-minute errands. The gamma globulin he saved out for innoculating all of us against hepatitis is also missing. Sympathetic paranoia infects me, and I recheck my camera bag and tightly close all its zippers.

I have not yet had a camera or lens stolen while on assignment. My shoulder bag goes virtually everywhere I go in populated areas: to every meal, meeting, and the like. In a high-risk place I even check it at the hotel desk before going for a short morning run. Only in the safety of the high mountains do I sometimes leave it unguarded. In the padded segments of the main compartment are two Nikon F3 camera bodies, one motordrive, and the following lenses: 20mm, 24mm, 35mm, 55mm, 75–150mm zoom, and 180mm. In the side pockets are lens paper, a dust brush, a collapsible four-ounce tripod, an 81A filter, an 80B filter, two polarizers, and a graduated neutral-density filter.

On this trip I am also carrying a padded camera backpack loaded with specialty lenses. Foam padding in both shoulder bag and backpack is an absolute necessity. The greatest risk to my equipment is not that I may drop a camera off the side of a mountain or that it will get plugged with desert dust, but that it may quietly self-destruct because of the steady vibrations of motorized transportation. Unless a camera is packed inside padding, tiny internal screws tend to loosen themselves as the camera jiggles under the seat of an airplane or on the floor of a car, especially if it has been previously opened for repairs. I have had enough experience with loose screws in cameras and lenses that I now sell my cameras and buy new ones every so often rather than have them opened up and cleaned. The cost is not much greater, and the risks are reduced.

The Nikon F3 is a sturdy automatic camera that also has manual settings. I use manual

settings most of the time, but in fast-breaking action and in very low light the automatic mode is quite useful. I have taken half-hour night exposures on automatic with great accuracy, even though the camera manual makes no mention of speeds beyond eight seconds. Another advantage of the F3 is that it gives nearly 100 percent viewfinder accuracy, thus ensuring that when I shade with my hand or crop out telephone wires, the hand and wires won't mysteriously appear in my slides.

A motordrive is most useful to me, not for capturing sequences of action, but for making candid shots of people. When people are self-conscious in front of a camera, they often let their guard down the moment they hear the click of the shutter. When their smile comes, my finger is on the button for a second and third rapid image. The ability to keep my eye at the viewfinder without having to stop to operate the film advance is often crucial to getting the best possible moment during the height of action or emotion.

The most commonly used lens in my collection is a 24mm f/2.8. It is a carefully weighed compromise that gives me just enough interplay of foreground and background while keeping parallax distortion (trees and buildings tipping because the camera angle is not level) within control. I also carry a 20mm lens but find controlling parallax with it just enough harder that I don't use it unless I absolutely need its extra field of view. A 28mm lens is simply not wide enough to give me the feeling I want most of the time. I also rejected a slightly heavier 24mm f/2 model that lets in a stop more light, because it produces more flare when I'm shooting into the sun, something that I can't afford to have in my outdoor work.

The 35mm f/1.4 lens meets my requirements for available-light and night photography. It can be handheld to a lower shutter speed than a normal f/1.4 lens (because the limit for handheld exposures is roughly the reciprocal of the focal length, that is, 1/30 second with this particular lens).

For the normal range I bring a 55mm f/2.8 macro lens. Not only is it useful for extreme close-ups, but also its extremely small, recessed front element reduces flare and makes it ideal for shooting toward the sun. At f/22 it produces an elegant sunstar in a clear sky.

I use the Nikon Series E 75–150 zoom almost as much as the 24mm lens. Its relatively fast f/3.5 aperture and light weight make it a perfect short telephoto for outdoor use. I also carry a 180mm f/2.8 lens in my bag on major assignments. This very fast telephoto has saved the day for me numerous times when I needed a distant shot of a person or animal in low light, or when I needed to use an extremely high shutter speed to stop action. I could not have gotten such photos with a typical 85–210mm f/4.5 zoom that requires a much slower shutter speed, has a darker image in the finder, requires more time to handle and

focus, and actually loses more light than the indicated f-stop because of the sheer number of its elements—usually a dozen or more.

On each lens I have a skylight filter, as much for protection as for its very slight ability to cut haze and reduce scattered blue light in landscapes. When I actually see the need to cut the bluish cast in full shade or cloudy weather, I use the stronger 81A filter, which approximates the effect of two skylight filters. I bring two polarizers; I want to have one in reserve in case one is lost or broken, and sometimes I use two cameras, especially when shooting aerials.

Other special-purpose filters I carry are a deep blue 80B filter to adjust tungsten lighting to daylight film and a gradated neutral-density filter in which one-third of the field is clear, one-third darkened two stops, and one-third gradated between the extremes. When I have a subject in the foreground with a very bright background that exceeds the latitude of my film, as is frequently the case with human activities below sunlit mountains, I simply attach one of these little wonders and cut the contrast range. The meter reading with the filter is actually more accurate than without because the difference between shadows and highlights has been reduced.

Barbara's identical shoulder bag contains less equipment and is easier to carry in towns and airports. She has just one F3 body and motordrive, no heavy 180 f/2.8 (although she wants one), and she takes a 36–72 f/3.5 zoom in place of fixed lenses in that range, which gives her more of a spread in focal lengths, but less flexibility in low light. If the need arises, she adds a 50mm f/1.4 to her selection.

In my wallet is a list of all our equipment and the serial numbers. Also, I keep the same information stored on a word processor, where it is simple to update. The list provides not only information for the police and our insurance company in case of loss, but also proof for U.S. Customs that those items came with me from the United States and were not purchased overseas. I had the list dated and notarized by the realtor up the street from our studio at a cost of one dollar, a faster process by far than taking my equipment into a U.S. Customs office for a signed official form before leaving the country. When returning to the United States with a big bag of flashy cameras, I simply show customs the list (if asked) and walk on through.

On the flight to Pakistan, I begin another list. This one is of photo situations. Since I have been to the Karakoram Himalaya three times before, I have some idea of the kind of situations that will make my coverage complete. I know that if I photograph just on impulse, my results will not pull together into the tight photo essay the *Geographic* wants. I must carefully plan key images and check them off my list only when I feel certain I have them in the can.

For the native culture of the mountains, I list the following: village overview with Braldu River, Balti family in home, external view of Balti home, internal view with god beams coming through windows, evening prayers, headman of the main village, health problems, irrigation, plowing fields with yaks, extended families working together in the fields, herding yaks and goats, cooking tok bread in hot coals. The entire list has forty-four items.

Arriving in Rawalpindi, we step into a scene out of Kipling's old India at Mrs. Davies Private Hotel, a ramshackle nineteenth-century remnant of colonial days, where expeditions on tight budgets traditionally stay en route to the mountains. In 'Pindi in May, the temperature reaches 100 degrees by nine in the morning. Here in Mrs. Davies Hotel, only a single ancient fan takes the edge off the intense heat in our room.

To protect my film from daily temperature extremes, I wrap it inside sleeping bags and stuff them in sacks. The film still gets warm, but far less so than in the open air. By protecting film this way I have yet to see in my processed slides the red color shift caused by heat.

At five the next morning Barbara and I walk through town into the main bazaar. The temperature is comfortable, and the traffic is not yet heavy. As sunrise puts magic into the colors of the town, we both dart about shooting candid street scenes. By seven the light is noticeably flatter and the richness is all but gone. Sweat is already dripping from us as we join the other expedition members back at Mrs. Davies for breakfast.

The ritual of being up at dawn and photographing before breakfast will continue throughout the expedition whenever the weather and the subject matter cooperate. Similarly, I will try to plan dinner so it does not conflict with the evening magic hour of light. In the middle of sunny days, I do virtually no outdoor photography. I may shoot portraits in shadows or an interior shot of a home, but never an important landscape.

A few nights later all of us are up at two in the morning for a long ride in a Ford van. Because of a spell of bad weather, flights have been canceled across four hundred miles of mountains to Skardu, a last outpost of civilization. To avoid the intense heat we ask our hired driver to leave early, but on the way out of town someone notices that we have a very low tire. Six gas stations, two jacks, one fruit market, three hours, and one police citation later we are riding on the spare, which also happens to be low.

The driver imagines, rightly so, that he has lost face with us. He hurries to make up time. Suddenly we hear the squeal of brakes and rubber. A turquoise flash hurtles past my window into the ditch. A small car has spun off the road because our driver passed in a blind dip, but we continue on.

In the quiet town of Abbotabad, we are hustled out of the van by police. Under the

shade of a sprawling tree, a crowd gathers as a ruffled Major Javed of the Pakistan army confronts us. The army controls Pakistan under martial law, and the major was an unfortunate passenger in the little turquoise car. The look on his face makes Clint Eastwood seem kindly.

An intriguing photo situation develops under the tree as the circle of onlookers is pierced by a strong diagonal of emotion. The major is staring down our driver, who in turn is staring at the ground, slumping ever lower under the sheer weight of Urdu phrases that need no translation.

I keep my camera bag closed. The image is attractive but by no means essential to my story. Taking it could jeopardize our tenuous situation. There is a regulation against photographing the military in Pakistan, and now is hardly the time to request an exception or to try to sneak a picture. When tempers cool, our Pakistani liaison officer negotiates a compromise. Our driver is under arrest, but he is released into our custody to get us to Skardu. We guarantee his surrender on the return.

Later in the day we are stopped by a massive rock slide next to the Indus River. Soldiers clear the debris while an officer with a whistle watches for further small slides, which come every few minutes. This image does indeed fit my coverage. It graphically shows that access by the only highway into Baltistan depends on nature's whims. The canyon is so arid that no vegetation stabilizes its walls, and with a chuckle I scrawl a potential *Geographic* caption for an image I have yet to make: "In the depths of the Indus Gorge, rocks fall more often than raindrops."

I take out my camera, walk over to the officer in charge, and motion that I would like to include him in a photograph. My request makes him feel important; he nods approval, bypassing the letter of the law. I make several images of him, then move on to get the crew trying to roll a boulder as big as a Volkswagen.

At intervals along the road, large boulders display a freshly painted sign: "Shangri-La Resort—Where Heaven and Earth Meet." Just before we reach Skardu, we pass the resort. In 1958 an Orient Airlines DC-3 crash-landed near here, much the same as the plane in the fictional Shangri-La of James Hilton's novel. Here, however, four hundred Baltis with yak-hair ropes spent two months dragging the fuselage to its present location, where it became a summer cabin for a Pakistani general. In 1982 the general built Baltistan's first luxury tourist hotel, with the plane as its honeymoon suite.

I open my diary and add an entry to my photo list. On the way out from the mountains, Barbara and I will stay here and photograph this strange new Shangri-La as an ironic twist to our story. When we reach the town of Skardu, I am amazed to see how much it has changed since I was here in 1980. I search out the exact location of my favorite Skardu

photograph from 1975, which showed a horseman on a dirt road passing a field of golden barley. Through my viewfinder I now see pavement, power lines, a wall of buildings, and a traffic cop.

We are bound for an inner sanctum of the Karakoram where the old Shangri-La feeling still survives. Balti villages sprawl against mountainsides in timeless simplicity, looking for all the world like visions out of the European Alps in the Middle Ages. Yet even here Skardu-style changes are coming soon. Although it seems impossible, a road through the wildest river gorge I have ever seen is already under construction.

As the expedition sets off on foot next to the Braldu River, I think about making an image that will show one of these villages as a verdant entity in the middle of a barren expanse. Fed by an irrigation canal at the top and nurtured by countless plowed terraces, each village seems like a single living organism, yet my efforts to frame such an image fail. The planting season has just begun, and the villages lack the vital look I need. For my concept to work, I should wait another month, until green fields are waving in the breeze. I add another entry to my expanding list.

I stored my shoulder bag in Skardu and now have all my lenses and camera bodies in individual padded cases. Some of them are in my backpack; others are in the pack of Ghulam Mahdi, a porter we hired to carry camera equipment for the duration of the trip. Additionally he carries a Nikon SB-11 strobe with filters and accessories, a portable soft box, a small Vivitar tripod, a larger Leitz Tiltall tripod, a Nikon 400mm f/5.6 ED-IF telephoto with matching 2x and 1.4x tele-extenders, and a Nikon 15mm f/3.5 lens with a rectilinear design that does not curve straight lines, making it ideal for use inside homes and other places of close quarters.

When we reach the highest village, Askole, I have the eerie feeling of being in a time warp. As I take portraits of familiar faces, ones I have recorded in previous years, it is apparent that these people have aged far beyond their years. I have a sudden insight into why so many visitors experience the illusion of Shangri-La in these remote Himalayan villages. The Balti people have no written language, and therefore do not record dates of birth or keep track of ages. The faces before me do not represent the fabled young old people who, according to legend, live to be 150 years in perfect health. Instead, these are the faces of old young people. Skin exposed daily to the extreme radiation of high-altitude sun has wizened long before its time. White flashes of tooth and eye that normally signify youth have been muted by the age of 30, the one by grit, the other clouded by innumerable smoky fires.

Here in Askole Barbara and I undertake different sorts of coverage. I prepare to go with Ghulam to photograph the kayakers deep in the Braldu Gorge, and she will stay here

to photograph Balti family life. Because of Moslem belief, women are sequestered from the eyes of unrelated men, and I have never been able to photograph them in the intimacy of home life. Barbara plans to use my strobe inside a special nylon soft box designed by fellow climber-photographer Tom Frost. When the absolutely even light from this featherweight setup is filtered through an amber 85B gel mounted on the strobe, it will resemble the far weaker natural firelight found inside a Balti home.

Following the kayakers is a considerable challenge. Luckily for me the river is a difficult maze that cannot be continuously run. The kayakers have to get out of their boats, memorize a sequence of rapids, run them, and then find a place to stop again. Even so, Ghulam and I must run along the rocky banks at breakneck speed between photographs with about ten pounds of gear apiece. My 400mm is the ticket here. By prefocusing on a rapid from the bank, I am able to get action as if I were right in the middle of the river.

Our overnight gear is carried by porters to a campsite where we join the kayakers in the evening. The following day I continue photographing until we reach the narrowest gorge of all, where the entire river funnels between polished walls of vertical and overhanging rock barely more than a boat's length apart. For a quarter of a mile the walls rise at least one hundred feet on both sides toward a slit in the sky that lets in so little light that my meter reading is three f-stops darker than normal. I rappel into this cauldron on a climbing rope and hang above the water as the kayakers fly past, one by one. With my 24mm lens and a motordrive I can take photos easily with one hand because I don't have to focus or rewind.

After this climax of our kayak photography, Ghulam and I walk fifteen miles of gorge back to Askole. Barbara tells us that everything went even better with her photography than she had hoped. By befriending her subjects before trying to photograph them, she dissolved their resistance. Instead of an intruder with a black box that steals parts of people's souls, Barbara became an honored house guest. Because she is a woman, she had complete access to the half of Balti life I have never seen except in distant glimpses. Even after she set up the high-tech strobe and soft box inside tiny rooms of mud and stone, mothers and children soon relaxed and went about their business as if the camera weren't there.

Barbara is not a climber, but she plans to trek up the glacier with us to our base camp below an unclimbed spire called Lukpilla Brakk. Thirty miles above Askole, Lukpilla rises directly from the huge Biafo Glacier in a granitic wall higher than that of Yosemite's El Capitan. Of all the rock towers I saw on my traverse of the range, it is the finest. My inspiration to climb it has been bolstered over the years by a photo I made from the glacier showing a perfect snow-capped, free-standing obelisk reaching into a clear blue sky—the same photo I sent to Andy Embick.

Four of us plan to climb Lukpilla alpine style, meaning that instead of fixing ropes and camps on the mountain like those of a classic Himalayan expedition, we will take what we can carry, head up the face, and not come down until the climb is finished. It means not using porters or other helpers to carry loads to camps on the cliff, and it also means going alpine style in terms of camera gear. I can afford to bring only the bare essentials to record the climb for the *Geographic*.

I will take one F3 camera without a motordrive, plus 24mm, 35mm, and 75–150 zoom lenses. The weight of that equipment is less than five pounds, including a polarizer and a small cold-weather battery pack that fits in my warm pocket with a wire that goes into the camera's battery socket. I'll use Kodachrome 25 film because I'll have plenty of light most of the time and because I need the slight bit of extra latitude to hold detail in snow and shadows. Kodachrome 25 also has very low ultraviolet response that prevents a bluish cast at high altitudes.

On our way to the climb, we follow a trailless alpine paradise alongside the glacier. Wildflowers are beginning to bloom in well-watered moats left by recent retreats of the ice. Here, too, are tracks of ibex, brown bear, and snow leopard. In Askole I photographed the pelt of a freshly killed leopard, and my 400mm lens is already mounted on a camera body just inside my pack in case we have unusual animal sightings.

The Biafo Glacier is one of the last strongholds of the Himalayan ibex, a scimitar-horned wild goat that weighs up to 275 pounds and lives at altitudes as great as eighteen thousand feet. I usually try to be in the lead to spot wild animals before our party scares them off, but on the second morning Barbara and I walk well behind our Balti porters. From half a mile away we hear a yell and watch sixty ibex flush up a hillside directly in front of the porters. I hurry ahead and catch the group resting in a spot of meadow where they came across the animals less than a stone's throw away.

I decide to pursue the ibex. With my Nikon 400mm f/5.6 lens (which weighs only three pounds) and a pair of matched extenders to convert it to 560mm or 800mm, I scramble up a gully where the animals can't see me from above. They have moved to a high ledge on a steep cliff fifteen hundred feet above the meadow. After climbing almost to their height, I stop just below the crest of the gully and set up my 800mm lens. Lying on my belly, I poke the lens over the top and prop both ends on small rocks to make a cradle as secure as any tripod. Within ten seconds of showing my face, the ibex spot me from a thousand yards. I take a roll of pictures of the animals standing tall on the horizon, then try to follow them as they disappear around a corner on a high ledge. Twenty minutes later I peek around this same corner and see four big males profiled against the snow nearby. My heart pounds with excitement as I try to time photos between beats. The photos are very

satisfying, but most of the ecstasy I feel is from entering, if only for a few minutes, the rarefied world of these mountain creatures.

The next days are uneventful. At fourteen thousand feet we establish base camp in a snowstorm that lasts for five days. When the storm finally breaks one evening, I position myself by a pond to catch reflections of the sunset on the peaks and clouds. We wait a day for avalanches to fall from the surrounding cliffs before heading up onto the spire.

The terrain on our first day of climbing reminds me very much of a major face in the California Sierra in winter. Flesh tones of steep granitic rock are specked with white spots of snow and ice clinging to ledges. Because the climb is bigger than anything in the Sierra, we have heavier packs laden with food and fuel as well as climbing and bivouac gear. Climbing with such loads at this altitude is laborious, and I catch myself thinking how much I enjoy the freedom of movement in my home mountains. But there is also a feeling here I never experience to the same degree in the Sierra, and the enchantment of it goes through my whole being.

Interplays of light and form are shifting minute by minute, foot by foot, as I move up the face of Lukpilla. Of course these things happen in the Sierra, and in every mountain range where I climb, but there is a major difference here. There I have the feeling that aspects of the landscape are known and repeatable. On some other day I could come back and see the same light on the same scene (even if that isn't true in a strict sense). My photographs in such places seem to be limited to variations of the known, to new ways of seeing what has been photographed many times before.

Here on Lukpilla no one has gone before us. The summit is untrodden, as is each spot we stand on or cling to along the way. We are the first to see the landscape open up before our eyes. With each step peaks rise above ridges and new features appear in the distance. At every belay ledge I marvel at the changes in perspective that have come from merely climbing a hundred-odd feet above the last one.

In the evening the air is clear and still. As twilight phenomena appear in their purest forms, I photograph each in its turn with my camera braced on rocks. First the sun drops behind spires on the opposite side of the glacier and god beams radiate across the sky. Minutes later the spires on our side of the glacier turn crimson in alpenglow, while the light below us grows ever bluer. When this junction of light leaves the last peak, it continues in the sky in the rising twilight wedge to the east, red on top, blue on the bottom. Finally the first stars appear, and a crescent moon becomes visible above the horizon.

With my camera set on automatic, I begin making night photographs in a very simple fashion. All I do is turn the exposure-compensation dial to *plus one*, open the lens fully, focus on infinity, set the self-timer, and let the camera do the rest. The procedure is simple;

the reason behind it is far more complex. If color film performed according to basic theory, an automatic camera would render perfect daylight exposures at night. Compensation is needed because of reciprocity failure, which means the film does not respond as well to low-light levels. Exposures begin to darken noticeably at speeds below about 1/15 second. Kodachrome 25, my choice for night exposures, loses about two full stops of exposure and shifts strongly to favor magenta at speeds longer than 1 second. This failure is actually in my favor, because it darkens the exposure to really look like night (so much so that I need to compensate the other way one stop) and cuts the radically blue cast with a hint of magenta. Very fast films give me muddy results with far less exposure latitude, so I leave my regular film in the camera and shoot away tonight with long automatic exposures. If I have to set up to make a 30-second exposure on 400 ASA film, I might as well be making an 8-minute exposure on more suitable Kodachrome 25.

On our third afternoon of climbing, we start up an overhanging granite corner that leads to the final snowfield, perched on top of the spire like vanilla ice cream atop a cone. For the first time we are forced to resort to direct-aid climbing, in which we engineer our way with pitons and nylon ladders instead of climbing with just our hands and feet, using ropes for safety only. The mountain fights back when Jack Tackle, who is leading at this point, hammers in the first direct-aid piton. The vibration knocks loose a nearby chunk of ice, which narrowly misses him. My camera is aimed and ready at the time, and I catch the moment with the falling ice in midair.

On the summit we have camera wars as everyone shoots at each other and the 360-degree panorama of high peaks. Near the beginning of the descent, I spot a situation that captures the top better than the summit itself. With my 24mm lens I take in the top of the spire, the glacier below, and a climber rappelling down the vertical wall. Time and again my best climbing images are made with the widest-angle lens because I am able to increase the apparent horizontal distance between myself and my subject, then turn my camera sideways to put the cliff in profile. With a normal lens I couldn't get such an image except on a rare horizontal traverse.

Two nights later we arrive back at base camp, celebrate our victory with a party, and plan the remaining weeks of the trip. Four members will trek over a glacier pass to Hunza, a route I traveled on my winter traverse. Embick will hike out through Askole to solo some virgin rivers. Two other kayakers are already on their way home. Barbara and I plan to follow *National Geographic*'s advice and strike off on our own to visit villages, investigate history, and record the environmental problems that are coming hand in hand with progress.

Had we come only to climb and kayak, we would not have thought to look so deeply

into the culture of the land. Our cameras lead us by the eye toward scenes we might otherwise not observe. As we pass back through the mountain cultures on the way to the civilized world, we try to conceive images that give the feel of each place along the way. In doing so we gain a painful sense of what the coming road will bring to the people of Askole and the Braldu Valley.

Our first scene is a group of Balti men—our porters—huddled by a fire under the stars, passing a mountain night in the style of their ancestors. While we sleep soundly in high-tech sleeping bags inside tents, the Baltis laugh away the chill mountain air in tight-knit circles around campfires. Back in the villages, however, these same people tell us how new jobs and roads are going to give them better control of their destiny. History is not in their favor. For three-hundred-odd years since their ancestors migrated here over the ice from the kingdoms of Nagar and Hunza, they have managed to stay at arm's length from the harsh rule of Moslems, Sikhs, and Hindus in Baltistan's lower valleys precisely because of their remoteness and their cashless self-sufficiency. The Shangri-La society we are photographing is already beginning to give way to a scramble for visitors' rupees. The native people's destiny is slipping into the hands of those at the other end of this new commerce.

It is true, of course, that the odds are working against every population of mountain dwellers suddenly exposed to the twentieth century. Some, however, fare far better than others. The Sherpas of Nepal's Mount Everest region have fully accepted tourism, but their homeland remains roadless to this day.

The first Western explorer to travel along the Biafo Glacier past Lukpilla Spire, Lord Martin Conway, had a clear vision of what the future might bring to the Braldu Valley. He had spent years in the Alps and the Andes before coming to Baltistan in 1892, where he was most impressed by the cluster of peaks and spires surrounding the Biafo Glacier, even though the focus of his mountaineering was in the K2 region up the Baltoro Glacier. "In years to come," he wrote, "if this mountain group, supremely magnificent in the world, is made accessible to the traveling public, Askoley will be its Zermatt. I, for one, hope that it may long be spared that fate."

Zermatt is now better off than most Alpine villages because it indeed has banned motor vehicles. In Baltistan a careful balance needs to be struck: on the one side, providing access for villagers to some life-enhancing elements of our modern world, such as health care, without destroying their rare ability to live in balance with the rugged surroundings. I have often been told that the best example I could set would be to stay home and not publicize these remote areas, but I believe that in this case history is definitely on my side. The great national parks of the world, from Yosemite to East Africa to Everest, were created after concerned photographers and writers created public pressure for preservation.

A taste of the future is with us when we arrive at the new Shangri-La Tourist Resort. At first Barbara and I feel as if we have found paradise. We take hot showers, eat gourmet meals, relax in the sun, and are waited on by servants. Then I hear a noise that seems extremely out of place in Baltistan: the drone of a power mower.

It is clear to me that we have left the real Shangri-La behind in the mountains and that it is not so much a place as a state of mind. We felt as we did in Askole because we walked into our own past, entering an era when the human race lived closer to the land with little effect on its wildness. Even the modern sports we brought with us—climbing, skiing, kayaking—lost much of their modern recreational character and came closer to their roots: means of transportation over mountain, snow, and water.

We avail ourselves of the road to drive to Hunza and join the expedition for a final few days. There we pass through villages that were as remote as Askole until the sixties. Now they have cars, power, and nonresident-owned businesses. Iftikhar Hussain, an English-speaking Hunza driver, gives us a running commentary of historic events. When I ask about photographing scenes I saw in a 1953 *National Geographic* article, "At World's End in Hunza," he says, "It is not possible today. We do not use our old costumes or rituals for ourselves anymore. We just bring them out for tourists at special festivals."

I ask Iftikhar when that happened. "It began," he says wistfully, slowly gathering his thoughts, "the day they opened the road."

By a series of ever-faster conveyances, we return home to the United States. A jeep takes us to Gilgit, from where a twin-engined prop plane takes a mere hour to cross a section of the western Himalaya that would have taken months to traverse a century ago. Then a jumbo jet delivers us to New York and finally to San Francisco. The precious bag of exposed film, handcarried in my backpack throughout the journey home, is boxed and whisked yet again across the United States, this time by air courier to the *National Geographic*.

An illustrations editor spends weeks paring down seven thousand images to a selection to fit twenty-six pages of text and photos. The story is approved for publication, photographs are sized and arranged on dummy pages, a text is written, and it is scheduled for the May 1985 issue. Shortly before the presses roll, a more timely story from Afghanistan bounces this one to September. In the end it is never published. All photographs are returned to me, and I am invited to propose another story, one more closely tied to Baltistan's culture than to a group of diverse adventures.

The process begins all over again as I write a proposal letter for Barbara and me to work on assignment in Baltistan next year.

EXHIBIT VII
Light Against Light

The images in this section are perhaps the best examples of this book's title. They represent mountain light rather than mountain scenes, and they have one main element in common: different colors and intensities of light have been used to emphasize natural forms. Important features appear to jump out of the scene because they coincide with contours of colored light and shadow. Such situations most often occur during the "magic hours" of dawn and dusk, when light changes so quickly that it is hard to resist the temptation to photograph the glow of the sun just for its intrinsic beauty. To do so, however, is to overlook far greater possibilities.

As I have already mentioned, light during the magic hours mixes in endless combinations, as if someone in the sky were shaking a kaleidoscope. The colors actually have a great deal in common with those seen in a kaleidoscope. Instead of reflections and refractions from loose bits of colored glass floating around in a tube, we are seeing similar effects caused by ice crystals, vapor, dust particles, and air molecules floating around in the sky. The effects are heightened during the early and late hours of the day because the sun's rays skim long miles of horizon where the air is most disturbed. Transmitted light becomes ever redder, reflected light ever bluer, especially where clouds, mist, or objects on the horizon form discrete boundaries at different distances from our eyes to let us observe the color of the light.

The possibilities of integrating light with landscapes are infinite, and it is the photographer's task to choose moments that best express the meaning of the subject. The search for rare situations where light underscores meaning is a major part of why photography continues to hold my interest over the years. I almost never set out to photograph a landscape, nor do I think of my camera as a means of recording a mountain or an animal unless I absolutely need a "record" shot. My first thought is always of light.

It is easy to forget that light to photographers, like language to writers, is their only means of artistic expression. Without an understanding of language, combined with imagination and intuition, occasional strings of lyrical words are little more than intermittent accidents. So are photographs made without understanding the language of light.

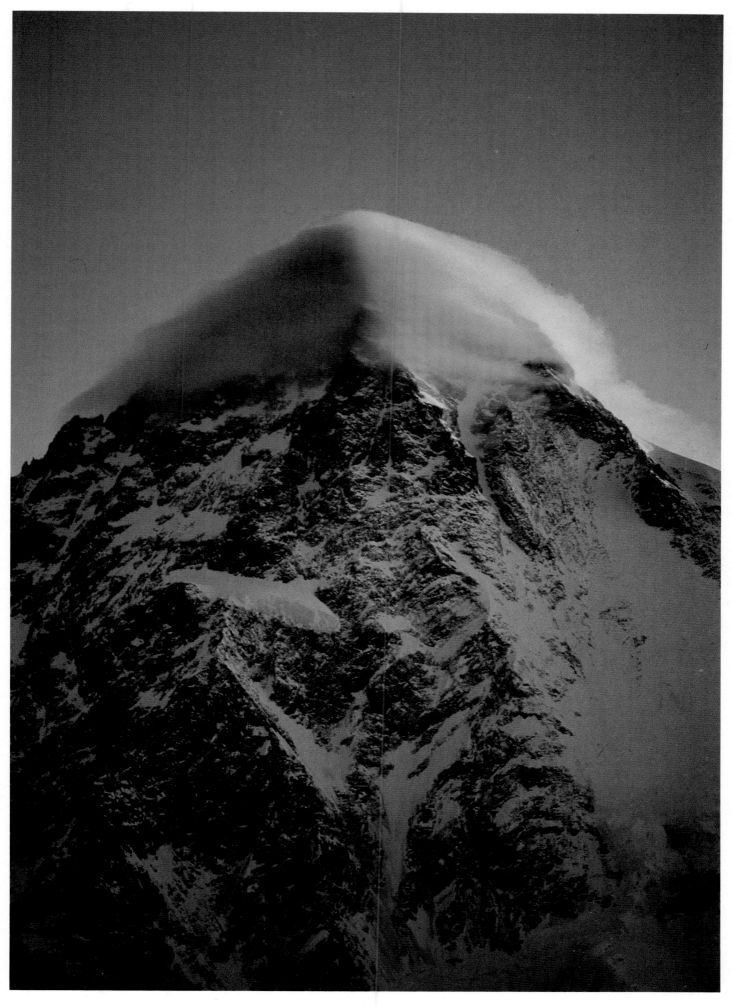

CLOUD CAP ON K2, KARAKORAM HIMALAYA, PAKISTAN

CLOUD CAP ON K2, KARAKORAM HIMALAYA, PAKISTAN; 1975

A minute before I took this photo I was hoping that the cloud blocking the summit would disperse. I was so intent on getting a clear telephoto of the upper mountain at sunrise that I didn't anticipate the beauty of the first rays of sunrise on this lenticular cloud against the shadowy blue snow beneath. Nothing similar had happened on the other sixty-odd mornings I had gotten up before five beneath K2. Usually my reward for being an early riser was seeing white cloud and white snow merging into white sky.

Since my camera with 500mm lens was already mounted on a tripod, I took my first photos that way, concentrating on the intense color in the cloud. Almost too late I realized that the magical light of the cloud needed something earthbound to match it. The significance of the scene was how colored light was separating cloud from mountain, snow, and sky. I changed to a 200mm lens and barely had time to click off two exposures before the magic light was gone. Somewhere to the east a cloud had blocked the sun.

The lens-shaped, lenticular, cloud formed spontaneously out of a clear sky. Mountains with a great amount of vertical relief literally make their own weather. Air masses are generally warmer than land masses, so when a peak thrusts into the sky and the air has a fair amount of water vapor in it, clouds form around the peak. A similar process creates valley fogs on clear mornings, especially in the cool of winter in temperate parts of the world.

The mountain, the lenticular cloud, and the alpenglow that came together to create this scene represent three phenomena approaching natural perfection. To see these in one spot was an unusual experience, and I was definitely in the right place at the right time. Getting there had been a different matter. I had been in the mountains of Pakistan for three months as a member of the 1975 American K2 Expedition, which had just failed in its attempt to make a new route up the second highest mountain in the world. My persistence for photos was supported by both an assignment from *National Geographic* and a book contract with my publisher.

Over the years I have found photographing Himalayan peaks to be fraught with many of the same difficulties as climbing them. In both instances a person must wait out storms in the cold at high altitudes and try to anticipate just the right time to set out with specialized equipment and techniques. First light catches both working furiously against time—hours and days for the mountaineer, often just minutes and seconds for the photographer.

It was actually harder for me to think about photography on that cold morning when the cloud cap glowed with the flush of dawn than it would have been to simply tie into the rope, put one foot in front of the other, and climb.

TECHNICAL DATA *Nikon FTN with 200mm lens; Kodachrome 64.*

SUNRISE ON THE PAMIRS ACROSS THE KASHGAR PLAINS, CHINA; 1980

As I rumbled across the edge of the Taklamakan Desert in an ancient Chinese bus, I thought about the great Himalayan explorer, Eric Shipton, who had been the British Consul of Kashgar before the Communist takeover. His consulate was on a high bluff on the edge of town, and just before I had left on my trip I had read his description of how on a clear morning he could "look back across the purple-shadowed plain to the Pamirs, sparkling in the early sunlight. In those two hours before breakfast I held daily communion with this antique land, its outward appearance unaltered since the days of Marco Polo."

As I looked at the same scene, I realized how perfectly Shipton had described the way light at completely opposite ends of the spectrum merges at dawn in mountain ranges fronted by desert. Because of the endless miles of haze through which low light rays travel, transmitted light is especially red at dawn. Because of the same great distances, reflected light goes beyond usual blueness into shades of purple.

I, too, had gotten up hours before breakfast in Kashgar. My expedition was beginning a long drive to the Pamirs at twilight. As first light touched the crest of the Pamirs across the same purple-shadowed plain, our driver was hell-bent on beating the heat of the day and in no mood to stop. I was in no mood to let such a splendid scene go by, so I decided to gamble on photographing out the bus window on the rough gravel road.

To do that, I needed to hedge every bet. The peaks were too far away for my fast 50mm and

SUNRISE ON THE PAMIRS ACROSS THE KASHGAR PLAINS, CHINA

35mm lenses, so I chose an 85mm f/2 lens, which I find invaluable for low-light telephoto portraits, aerials, and images from moving vehicles. I put it on a Nikon F3 set for automatic exposure and opened the window, being careful to brace my forearms against my chest rather than against any part of the vehicle, which would transmit vibrations to the camera. I made several images at about 1/500 second, and this one with poplar trees and a commune wall had by far the best sharpness and composition. It appeared as the frontispiece of my book *Mountains of the Middle Kingdom: Exploring the High Peaks of China and Tibet*.

TECHNICAL DATA *Nikon F3 with 85mm lens; Kodachrome 64; maximum shutter speed for sharpness from moving vehicle.*

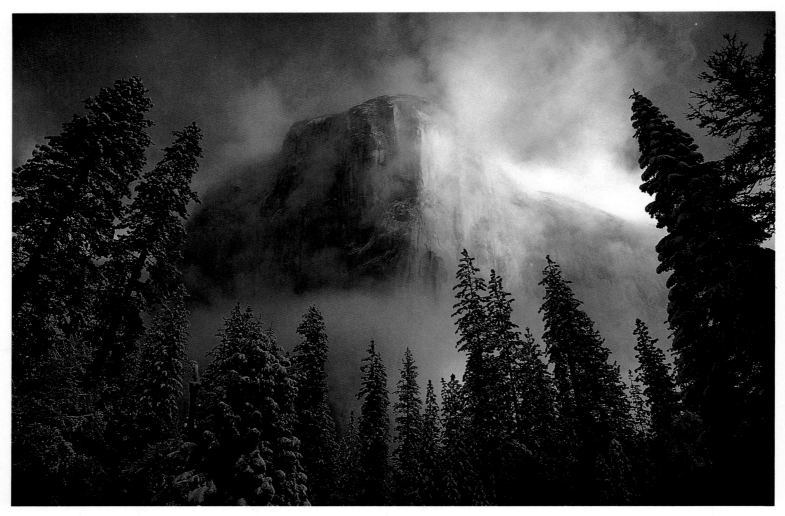

CLEARING STORM OVER EL CAPITAN, YOSEMITE, CALIFORNIA

CLEARING STORM OVER EL CAPITAN, YOSEMITE, CALIFORNIA; 1973

At the end of a long winter storm in Yosemite Valley, I began to drive toward a high vantage point for photographs while clouds still filled the valley. I stopped near El Capitan for a quick photo of the Cathedral Spires emerging from the mist, but when I tried to move on, I discovered my car was stuck in the deep snow alongside the road. As I sat in the front seat cursing my bad luck, I looked out to see clouds parting around El Capitan. Mist rose from cliff and forest as I have never seen it before or since.

Mist and vapor hold the colors and intensity of light far better than any firm object. Landscape artists have traditionally used mist as a vehicle to show off their wildest colors, and the more visionary their approach, the greater the quantity of mist they include.

The vision of golden mist modeling the contours of El Capitan was splendid, but I had difficulty figuring out how to match it with the blue shadow light coming from the snowy trees in the foreground. If I tipped my 24mm wide-angle lens up to take in El Capitan with sky overhead, the trees tilted wildly from parallax distortion. If I used a normal lens, stood back, and made the trees straight in the image, I lost the powerful outline of El Capitan's form. I decided to compromise by choosing a position where distant trees in the center of my frame appeared straight, but closer ones on the sides converged inward. This technique would not work on an ordinary forest scene because the viewer's eyes would be drawn to the large, tilted trees. In this case the vivid light in the center of the image draws attention to that part of the frame, and, thus, "visual sea level" is determined by the small, straight trees backlit by the mist.

With my camera on a tripod, I moved back and forth in the clearing until nothing in the pattern of trees seemed disturbing to my eye. I had the most

EXHIBIT VII LIGHT AGAINST LIGHT 187

trouble with the medium-size trees that I finally placed just right of center of the nose of El Capitan. When I could run my eye, undistracted, around the edges of my image and also feel pleased by the composition in the center, I shot both horizontal and vertical formats in the few minutes that the light lasted.

TECHNICAL DATA *Nikkormat FTN with 24mm lens; Kodachrome II (ASA 25).*

BUTTERMILK ROAD, EASTERN SIERRA,
CALIFORNIA; 1971

This is one of my favorite examples of how unusual light can emphasize truths in landscapes that other light obscures. On an ordinary morning on the east side of the Sierra, the color of first light belies reality. Warm sunrise hits cold mountaintops, while cold, blue light fills warm sagebrush valleys below. An hour after sunrise on a clear morning, the light evens out, and the potential for matching light and form disappears. For the rest of the day, there is little visual difference in lighting anywhere in the scene.

In preparation for this photograph, I drove up Buttermilk Road near Bishop, California, on a spring evening and slept by my car in a clearing. When I awoke to clouds over the mountains, I was at first disappointed. I had hoped to photograph the pink flush of dawn on the peaks. I drove off without taking a single photograph, but before I had gone a mile, a beam of sunlight broke through a slot in the clouds, illuminating only the desert floor with warm, golden light.

Realizing that the light might disappear at any moment, I stopped my car in the middle of the dirt road and braced my camera on the roof. I resisted my initial urge to use a long telephoto to pull in detail in the foreground rocks and instead composed a broader landscape that clearly showed the intersection of warm and cold light. I used my through-the-lens meter to check both the sunlit and shadow areas before setting my exposure. The meter showed a surprisingly small two-stop difference, thanks to snow on the shady peaks and the lack of it in the sunlit valley. I knew that this was within the limits of Kodachrome, but barely so.

Details in the highlights were essential, so I exposed for them and hoped that enough of the peaks could be seen in the shadows to create the mood I envisioned.

Here in exactly the place where tens of thousands of miles of Great Basin desert lapped the edge of the High Sierra, I was able to use the unusual light to underscore the junction of those major climatic realms. By thinking in terms of light and in terms of the importance of meetings of different types of light, I saw the opportunity to visually render cold, blue mountains and warm, golden desert in a way that accentuated the natural geography.

When I made this image, I still considered myself an amateur, occasionally selling a photo or two but depending on other income to support my family. Another year would pass before I made the leap and called myself a professional photographer. With hindsight I could kick myself for saving film and making only two exposures of this scene. I wouldn't change a thing in my primary visualization of this image, but if confronted by the same situation today, I would cover myself in many additional ways, shooting at least a full thirty-six-exposure roll. Why settle for one original? What if a flaw in the film or processing is on the best frame? How easy it would have been at the source to make backup originals that would have cost eleven cents apiece at the time.

Since 1971 I have spent more than thirty nights sleeping in the same area, hoping for a repeat performance of light that has never arrived. If I witness it again, I will begin with a composition similar to this image, bracketing four exposures in half-stops. Then I will shoot the same scene in verticals. Switching to a wider lens, I will repeat all eight images, with space in the sky or foreground for copy. Finally, I will repeat the whole business all over again with a gradated neutral-density filter adjusted to hold back light from the foreground in order to bring out the mountains. After I finish all the creative variants I can think of, I'll start all over again and go for insurance shots of my favorites if the light still holds . . . but I have yet to see anything even close to a repeat performance of this remarkable juxtaposition of light and landscape.

TECHNICAL DATA *Nikkormat FTN with 105mm lens; Kodachrome II (ASA 25).*

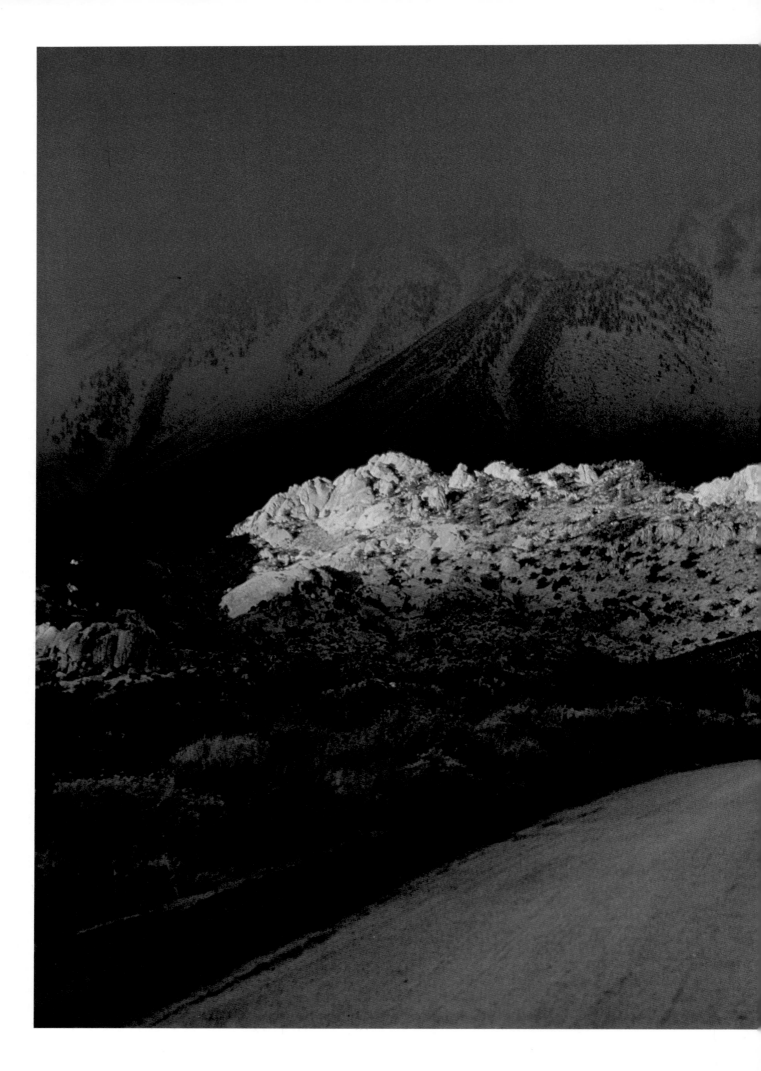

BUTTERMILK ROAD, EASTERN SIERRA, CALIFORNIA

STORMY EVENING ON THE TIBETAN PLATEAU

STORMY EVENING ON THE TIBETAN PLATEAU; 1981

When I was a child, my favorite Renaissance painting was El Greco's *A View of Toledo*, a considerable departure from the artist's usual religious subject matter. It was a landscape with dark clouds and green hillsides and lighting not unlike this photograph. When I first began photography, I was attracted to lighting like that in the El Greco scene, yet I invariably failed to record on film what I saw. Dark clouds are almost always lighter than the land below them, and film fails to single out the glow of the earth the way the human eye or the painter's brush does. An exposure for the clouds renders the ground dark, or an exposure for the ground washes out the clouds.

There are exceptions, however. On those rare evenings when the sun creeps under the leading edge of a storm front, direct light bathes features on the ground while brooding clouds remain in shadow. Because all colors appear more saturated against dark backgrounds, hues in a landscape are at their best in this sort of lighting.

To further preserve the darkness of the sky, I used a split neutral-density filter to hold back the exposure two stops in the upper part of the frame. With my camera and 24mm lens on a tripod, I wandered around the meadow until the arrangement of the flowers and hillocks in the foreground seemed to lead my eye toward the brightly lit cliffs.

The scene has the feeling of remote wilderness, and indeed it is, at fifteen thousand feet, many days' walk from the nearest road. I was camped here while leading a trek along an ancient pilgrimage route that encircles the holy mountain Anye Machin. The land through which we traveled, however, did not fit the definition of wilderness, past or present. It was neither uninhabited by humans or inhabited by its natural complement of wild creatures.

A close look at the foreground grasses shows them to be deplorably overgrazed. In a natural condition they grow in thick tussocks like those in the Alaskan tundra. What happened here is very

EXHIBIT VII LIGHT AGAINST LIGHT 191

much like what would happen to the Brooks Range if a million sheep and goats were allowed to graze the tundra, protected from bears and wolves by armed shepherds who shoot at anything that moves.

In the course of my travels through China's "Wild West," I came to a sad conclusion: wildlife decline in the world's most populous nation is one of the great undisclosed tragedies of the century. I was trekking in the Anye Machin area on assignment for *National Geographic*, looking for the natural treasures promised me by Chinese authorities: "a wealth of rare birds and animals . . . thick virgin forests where deer, leopard, and bear thrive . . . the grasslands and gravel slopes near the snowline are alive with hordes of gazelles, wild asses, and rare musk deer."

Perhaps no one will ever really know what happened in China's wilderness during the three decades after 1949 because of the virtual blackout of records for that period. The last Westerner in the Anye Machin area before Mao's takeover reported that "every few minutes we would spot a bear or a hunting wolf, herds of musk-deer, kyangs, gazelles, bighorn sheep, or foxes. This must be one of the last unspoiled big-game paradises remaining in Asia."

In 1981 I received permission to lead a trek around Anye Machin. Because the Chinese still reported abundant wildlife, I invited some of America's most respected zoologists, geographers, geologists, botanists, ornithologists, and ecologists to join me. Nearly all of them had Asian experience and expertise.

The results of our extensive search for wild mammals around Anye Machin were very disappointing. We saw five wild blue sheep atop a rocky promontory and three MacNeill's deer, a rare relative of the elk, on a distant hillside. In addition, two musk deer were flushed out of the brush. Certainly what we saw could hardly be called "abundant" wildlife, a reference made by almost every earlier explorer.

After returning to America, Rod Jackson, win-

ner of a Rolex award for his ongoing study of snow leopards, wrote the Chinese Mountaineering Association, the World Wildlife Fund, and the Chinese Ministry of Forests about the wildlife situation he had witnessed:

"A professional biologist in my homeland, I was attracted by the CMA's information. . . . In reality, the wildlife of this region has been decimated. . . . Despite a determined search, I found very little wildlife sign. . . . There are many places in Nepal and India where more Tibetan species can be readily seen.

"Trekking in China could become very popular and could further enhance China's friendship to other nations. However, inaccurate information and attitudes that endorse irresponsible wildlife depletion will adversely affect this friendship."

Jackson did not receive an answer from the Chinese, nor did I to a similar letter I wrote. He did, however, get a reply from America. He was told that criticism of Chinese policies might jeopardize his obtaining grants to do research in other countries. Even the Peking Bureau of the Associated Press, which interviewed us about the wildlife situation, promised a story, then killed it.

The rest of the world deserves to know what is happening to a major segment of its wild heritage, but the Chinese are adroit manipulators of the world press. When I wanted to return to Tibet in 1983, word was passed to me from Peking that I would be denied permission unless I wrote a letter of self-criticism to the proper agency. I did so, but I admitted only that it had not been wise for me to try to publicize environmental problems if I expected to return. Perhaps it gained something in translation, because I was allowed to revisit Tibet and see once more the decimation of wildlife that is occurring during my lifetime. Had I made this photograph fifty years ago, it might have included a herd of wild rams standing in the spot of light beneath the cliff.

TECHNICAL DATA *Nikon F3 with 24mm lens; Kodachrome 64; split neutral-density filter.*

DAWN ON SENTINEL PASS TRAIL,
CANADIAN ROCKIES; 1982

Banff Park in the Canadian Rockies is one of the most photographed regions of North America. Book after book displays vivid images made from the same old perspectives. Indeed, I have my own set of classic images, made in the tripod holes of my predecessors during my first visits to Banff in the mid-sixties.

In 1982 I wanted to break out of the old mold and as a result, I made images of Lake Louise quite unlike any I had ever seen (see page 212). To get the image on the page opposite, I broke conventions in a different way, by using a special technique that I have developed over the years—long-distance running with a single-lens-reflex camera. Thus, I was able to arrive with my camera at a place at dawn where I could put together a unique combination of lighting and perspective.

Until the last few years I didn't run with a full-size 35mm camera. I sometimes used a tiny 6.6-ounce Minox 35 on runs or ski tours, but it didn't give me quite the images I wanted. Without interchangeable lenses or through-the-lens viewing, I was able to make record shots, but not the special kind of image that comes from perfectly blended involvement with the subject at hand.

The problem with using a full-size 35mm is figuring out how to carry it comfortably. Camera manufacturers supply what they call "ever-ready" cases made of leather with a name brand embossed on the front. Professional photographers avoid them, calling them "never-ready" cases because they require too much time to use and offer little protection for the camera. When a person runs with one of those cases around his neck, the camera bounces so much that the rigid strap will begin to cause abrasions in the first few miles.

My breakthrough occurred when I discovered a broad neck band with built-in elastic. It had just enough stretch to take the bounce off my neck, but not enough to let the camera yo-yo up and down. That neck band, combined with a very light padded camera case that has a chest strap, enables me to run freely and to get my camera out in less than two seconds. The top flap of the case has a Velcro closure that allows me to tighten the case around the camera to keep it from rattling around with whatever lens I am using. Sometimes I add a padded lens pouch on the chest strap to carry an extra lens or two and filters.

On the morning I made this image I left the 6,000-foot roadhead at Moraine Lake for a mountain run up the highest peak in the region, 11,636-foot Mount Temple. I started when it was just barely light and a few stars were still visible in the sky. Unfortunately I saw some heavy storm clouds, and my goal of making images from the summit in fine morning light didn't seem realistic. Since I was already up and moving, I decided to go anyway, even if I had to turn back later because of weather. Being on the summit of a major peak in the Rockies in running clothes during a storm isn't recommended for either one's health or landscape photography.

As I ran through Larch Valley below Sentinel Pass, alpenglow came underneath the storm clouds and hit the surrounding peaks. At first I didn't stop because I didn't see a situation that fulfilled my requirements. I needed a clearing with a fine view of the peaks, a high place to brace my camera in the dim light, and a scene with a dark area at the horizon to allow me to use a split neutral-density filter. The filter would enable me to hold back the exposure of the sky by two stops, thus bringing out detail in the foreground. The one I was carrying is split 40/60 between its shaded and clear zones.

I ran off the trail looking for a good location and when I didn't find one, I veered back again, ready to give up the idea if need be. Rounding a corner, I came to a stream crossing in the trail with a large boulder nearby. There was everything I needed. With my 35mm lens I was able to compose an image that matched the 40/60 split. The boulder was a perfect spot to prop my camera for very slow shutter speeds. Because I needed to stop down to get depth of field in the foreground, my exposures were around f/8 at 1/8 second.

After taking less than a minute to make photos, I popped my camera back into its case and continued on. Beyond that spot I didn't find any vantage point as good, and the alpenglow quickly faded into the more normal yellow light of dawn. An hour and fifty-five minutes after I started, I reached the summit of Mount Temple, breaking into ankle-deep snow for the last hundred yards. Swirling clouds closed off my view, and I made only a couple of record shots before heading down again.

TECHNICAL DATA *Nikon FM2 with 35mm lens; Kodachrome 64; small aperture for depth of field; split neutral-density filter to open up exposure in foreground.*

DAWN ON SENTINEL PASS TRAIL, CANADIAN ROCKIES

SUNSET AFTER A STORM, YOSEMITE VALLEY, CALIFORNIA

SUNSET AFTER A STORM, YOSEMITE VALLEY CALIFORNIA; 1970

In November 1970 I got a call from the National Park Service and was told that my friend and climbing partner Warren Harding was in immediate need of rescue from the face of El Capitan. A storm had pinned him and his companion, Dean Caldwell, in the middle of a new route they were attempting up a very blank section of cliff. They had been on the climb for fifteen days—longer than anyone had ever spent on a vertical wall.

Jim Bridwell had also been called by the rangers, and we drove together from the Bay Area to Yosemite. As we descended into the valley from Crane Flat, El Capitan and Half Dome were emerging from the clouds in remarkably crystalline light. Even though I was still an amateur photographer at the time, I was always on the lookout for those special situations where natural optical phenomena reveal truths in nature that are hidden in normal illumination. And what I saw was the best example I had seen yet. Even though

we were in a hurry, possibly to be sent by helicopter to the top of El Capitan that very evening, I stopped and set up my camera on a tripod. Using a 200mm lens with no filters, I made two exposures, then rushed off toward the valley, losing no more than three minutes en route.

What struck me as unique about the scene were two elements. First, the two most striking granite forms of the valley, Half Dome and El Capitan, appeared side by side, although they are actually at opposite ends of the valley. Second, each was lit with splendid, but very different, light. Together, the two factors gave the formations the separate character they have in real life, an effect that doesn't usually come across in photos. Usually, images show the great rocks lit in similar light as part of a two-dimensional scene, thereby failing to convey the power of the landscape, which I saw coming alive. With El Capitan in red sunset light and Half Dome in blue shadow under a cloud, this image is a kind of visual archetype of the Yosemite experience.

EXHIBIT VII LIGHT AGAINST LIGHT 195

I am glad that Warren Harding's route was out of sight on the other side of El Capitan. Had I been able to see the unusual activities taking place on the afternoon that this image was made, I might have rushed on without taking a photograph. Twenty-one rescuers and a massive pile of the latest climbing and rescue equipment were being airlifted by helicopter to the rim of El Capitan. When I checked in, less than four hours after receiving an emergency call at my home two hundred miles away, I was told that my services were no longer needed. Another climber, who had also been called away from his job and was told he was not needed, became suspicious when he could not get a clear answer to the simple question: When did Harding ask for a rescue?

He went to the base of the climb, yelled to Harding that the Park Service was about to rescue him, and heard in response, "Like hell they are!" The rescue was called off, and the Park Service tried to cover itself for its expenditure of public funds by wrongly telling the media that Harding had asked for a rescue. Climbers appeared on national TV news programs saying otherwise, and the fiasco provoked the media into creating the single most publicized event in the history of American mountaineering as Harding and his companion hung on day after day, through other storms, before emerging on the twenty-seventh morning. Harding was "totally unprepared for what I saw as I floundered up the last overhang onto the ledge of the rim . . . a veritable army of newsmen [with] batteries of camera snouts trained on us."

TECHNICAL DATA *Nikon FTN with 200mm lens; Kodachrome II (ASA 25).*

LATE SUMMER SNOW UNDER MOUNT WILLIAMSON, SOUTHERN SIERRA, CALIFORNIA; 1983

This is not a found image. I imagined it before seeing the place, spotted the location as I walked over a snowfield on my way to an unclimbed route on the east face of Mount Tyndall, and returned when I knew the light would be optimum. The spot was not photogenic when I passed it at midday, and I didn't take a single photograph. I was aware of its special potential only because I had been thinking about two different photographs during the hike, and my ideas converged here.

On the one hand, I had wanted to make a fine landscape of alpenglow on Mount Williamson. Because of a quirk in geography it is the only one of the dozen fourteen-thousand-foot peaks in the Sierra range that does not sit directly on the crest. Alpenglow on its west face would be in clear view from our evening camp even though we would be deep in the eastern shadow of Mount Tyndall.

On the other hand, I was fascinated by the sun cups caused by differential melting of the snow. I loved their patterns, but I had always been frustrated in my attempts to make a fine photograph of them. I did have some "artsy" photographs that focused in on their form and repetition, but none where they were well integrated into a landscape. In shadowy light they lacked power, and in direct light their whiteness and jagged patterns tended to overpower other aspects of a scene.

As I crossed the snowfield, I thought about putting my two ideas together. I began looking for a place where I could compose an image with orange light on Mount Williamson in the background and ice blue sun cups in shadow in the foreground. To mix the different colors of light, I also wanted some sort of reflection. Because the direct light on the peak would be far more intense than the weak shadow light, I also needed a scene with a dark area on the horizon so that I could use a split neutral-density filter and not have its graduated area show up in my image. This spot had all the right elements, including that all-important one: we would be coming back past it at sunset. Our plan was to climb the overhanging first few hundred feet of the face, then descend for the night and leave ropes in place to give us a head start in the morning.

That evening we began descending our ropes as the glow of last light started to creep up Mount Williamson. I made a beeline for my chosen spot and found everything as I had hoped it would be. I put a 24mm lens with the split filter on my camera, lay down to line up the reflection, braced my elbows in the snow, and shot several frames at 1/15 second, bracketing apertures above and below my meter reading of f/11. I used the slow shutter speed because I needed all the depth of field I could get, knowing from past experience that I could make pin-sharp images at 1/15 with a 24mm lens without a tripod if I held my breath with my elbows steadily braced against something solid.

TECHNICAL DATA *Nikon FM with 24mm lens; Kodachrome 25; small aperture for depth of field; split neutral-density filter to hold back exposure on mountain.*

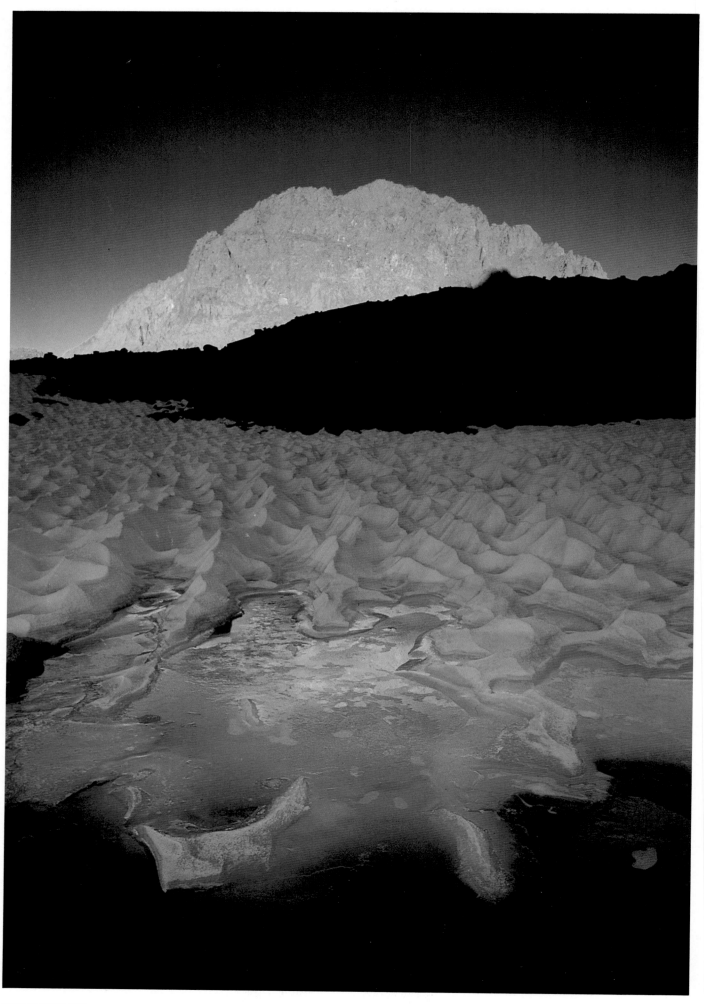

LATE SUMMER SNOW UNDER MOUNT WILLIAMSON, SOUTHERN SIERRA, CALIFORNIA

CHAPTER SEVEN
Dynamic Vision
IN PURSUIT OF THE DYNAMIC LANDSCAPE

Owen Edwards, a critic for *American Photographer*, once wrote: "Great photographers are a combination of wizard and idiot savant. They do what they do without truly understanding how, then make up a lot of convoluted theory to cover up their own ignorance of who and what they really are. Because of the self-doubt that nags photographers, photography's power as an art goes on being misperceived."

The element that I have not yet discussed is luck, and many photographers are afraid to confront its importance. Luck plays a role in all great photographs, especially those of the natural world; yet it is not to be found in the indexes of photography manuals or on the agendas of photography classes and workshops. Luck is what makes photography an entirely different medium from art forms based only on planned creative acts.

As I write this last chapter, I feel a special sense of freedom, because at last I have an audience to whom I can explain how luck is interwoven into my style. The preceding chapters have prepared us to consider this final component as a real part of the creative process instead of as something that makes art by accident. Critics are often quick to demean the luck factor in photography, overemphasizing the randomness of the act of pushing a button to make a photograph. Susan Sontag wrote in her highly acclaimed book *On Photography* that the creation of a photograph is "the sole activity resulting in accredited works of art in which a single movement, a touch of a finger, produces the complete work."

The statement of a philosophy that puts luck in a very different context is concisely

expressed on page one of the *National Geographic Photographer's Field Guide*: "An image doesn't start with a camera–it ends there."

Like the photographers Owen Edwards describes who appear ignorant about their art, I, too, have failed to give concise answers when interviewed about my work. The public is not likely to hear the full story about how any photographer creates pictures when the setting is the "Today Show" or a personality profile published in a magazine or newspaper. I know this both through direct experience with the media and, more important, from the fact that I cannot duplicate my best images, let alone come up with a pat formula for others to do so.

During my first years of photography, I felt too insecure about my work to directly confront the role of luck until it stared me in the face. I knew that sometimes I was luckier than I was other times, but I held dearly to the belief that my best work was based on technique and vision rather than on chance.

I was forced to reconsider that belief after all my attempts to repeat some of my favorite images failed. Even though I had returned to the same places with the same equipment and same personal style, I was unable to duplicate the success of those earlier images. Before I came to understand the role of luck, I began to wonder if I was losing my touch.

After twenty years of such attempts, I have yet to come close to repeating any of my favorite images. Occasionally I make a distinctly different fine image in the locale of one of my old favorites, but my success ratio in such situations is about the same as it would be if I were working in a new location.

I have gradually come to see these attempts as proof of success rather than of failure. Instead of proving my inability to repeat past deeds, these subsequent attempts confirm the uniqueness of my favorite dynamic landscape images. Now I know that the combinations of light and form I seek in nature are virtually infinite and that I will always have new and inspiring subject matter to pursue.

In the preface of this book, I mentioned three components that need to merge at the instant the shutter is released in order to make a truly fine photograph of the natural world: technical proficiency, personal vision, and light. Regardless of being in the right place at the right time with the right equipment, a photographer will fail to make a remarkable image if any one of these elements is deficient. In wild places my ability to control these three factors is never absolute. Luck has a hand in each one of them, but the kind of luck I am talking about differs from the random kind that wins jackpots at casinos.

Webster's defines luck as "the *seemingly* chance happening of events which affect one [emphasis added]." The images I call dynamic landscapes depend on precisely this "seemingly chance happening of events" for their subject matter.

Photographers who are consistently lucky are like those "lucky" people who make great scientific discoveries or great amounts of money: a tremendous amount of work has gone into acquiring knowledge of their fields before they ventured out to become "lucky." Luck is with them because they have made themselves open and receptive to it, and their style allows it to be part of their plan.

Before explaining some of the ways I work with luck to make it come my way, let's take a look at what can happen when luck is totally removed from the equation of wilderness photography. On the opening day of a week-long outdoor workshop, a student proudly showed me a portfolio with some of the most stunning wildflower photos I have ever seen. I was not only very impressed, I was also humbled by the fact that his wildflowers looked so much richer than my own. I wondered if I was qualified to be this person's teacher. Each of the student's flower images was sharply focused, vividly colored, perfectly lit, and set against a royal blue sky. When I turned the pages, however, the landscapes I saw in the back of his portfolio looked to be the uninspired work of an amateur. I told him, "Your wildflowers are really wonderful, but your landscapes need a lot of work. Tell me why they are so different."

"I'm a naturalist, and I'm really into wildflowers, so I devised my own rig to photograph them in the shade. I use a small flash with a wire attached to it to always keep the distance from the flower the same. I put a piece of blue art paper in the background to simulate a well-exposed sky, stop down to f/11, and every slide turns out like these."

This photographer was successful within the confines of a very narrow set of circumstances. He knew his wildflowers, and he knew how to make images of them worthy of publication, but photography of flowers was no longer enough to keep him stimulated. He had come to my workshop to broaden his outlook and to learn to make landscapes.

Any one or two of the flower images were striking in appearance, but in larger numbers it was apparent that something was missing. His predictable blue skies were of a single shade, devoid of clouds and horizon. Although he said he loved the natural world, no hint of it was able to enter his flower images because his approach prohibited it.

Although the student wanted very much to learn how to make spontaneous nature photographs, he had a harder time than less advanced students who didn't have his addiction to total control. Even after classroom presentations of much of the material in this book, the student's best results from our field sessions were little improved over the weak landscapes in his portfolio. They appeared to lack a point of interest, and the eye wandered through them uncomfortably without finding a meaning. He did not understand how to incorporate diverse subject matter and spontaneous events into his photographs; in other words he had not allowed luck to be a part of his style.

The first priority of a nature photographer is to match his camera's way of seeing the world with his own, and that can be done both actively and passively. One way favors inspired luck, while the other is far more random.

When a photographer walks up to a scene and makes a passive translation of what his eyes see into the language of his film, he is generating only a one-way flow of information toward discovery of an image. A photographer who operates in that way wastes much time randomly scanning his surroundings. Each possible photo situation must be looked at, translated into the way the camera will see it, then accepted or rejected. Many go/no-go decisions are necessary. There is also apt to be an accompanying sense of frustration and confusion, not unlike what a person might experience trying to find a name in an un-alphabetized phone book. Meanwhile, clouds move, light changes, and if a fine natural event does occur, the photographer is apt to be found ruminating in the wrong place.

"Lucky" photographers quickly arrive at the right place at the right time as if they were carrying a secret map. In a sense they are. Because the language of film in which they are thinking leads their eyes, instead of being an afterthought, they read clues that others pass by.

Consider the following example of how a photographer can make the language of film active instead of passive. It is late afternoon in a sunlit mountain meadow and two photographers arrive, each with one lens, color film, and a polarizer. The "unlucky" photographer uses polarization passively. Only after selecting a possible scene does he see if the colors will intensify; consequently he takes a great deal of time to appraise the meadow's photo potential and very likely misses the best situation. The "lucky" photographer, actively thinking from the start in the language of film, sees in advance that his polarizer will intensify colors only in directions close to perpendicular to the axis of the sun. He walks through the meadow, keeping his eyes in the direction in which light will polarize, frequently checking a possible scene through his camera. In a fraction of the time the first photographer required to make a rather average photo, the lucky photographer has narrowed his choice to the prime location in the meadow.

Just as such active thought can influence a photographer's luck, so can physical action. In the first chapter I described how a photographer's actions behind the camera have a way of becoming part of his image even though he may not be aware of it. The majority of my dynamic landscapes have involved dynamic actions during their creation. The existence of my own action behind the lens has added a creative fourth dimension to my work. It is by no means one of the required ingredients for a fine photograph of the natural world, but rather it is a catalyst for the other three components; a force that helps me "get lucky" more often.

Landscape photography of every era reflects both the state of its technology and how photographers transport their cameras. Consider, for example, stylistic differences between photographs of Yosemite that Eadweard Muybridge made by carrying mammoth plates on muleback in 1860 and those that I make during ascents of rock climbs a century later. My photographic style reflects lighter cameras, shorter exposure times, and a culture in which individual sports that push the limits of human ability on rock, snow, sky, and water are familiar to everyone through mass media. Muybridge's images have a feeling of stillness; mine have a sense of action, even when they do not include a human subject.

I never take for granted what appears before my eyes. When a full moon rises before sunset, many photographers are content to photograph it without the best light on the horizon, then photograph it again, too high in the sky to make the image dynamic, when the light on the landscape is the most vivid. If I see a full moon poke up too early, I think of how to use my own action to change things. I drive, hike, or run to a place where the horizon is higher or my camera position lower, then compose an image knowing just where it will appear. Rather than happenstance, such an image of a moon just touching a vivid horizon fits Webster's definition of luck: "the seemingly chance happening of events."

I treat sunrises and sunsets similarly. Those who travel with me on photo trips often hear my battlecry, "Let's unset the sunset," just before I drive, hike, or run to higher ground, racing the shadow of last light. A photographer who deals with two or three sunsets a day has more chances to be lucky than a person who settles for just one.

For me, photography is a game, much like mountaineering, in which I push the limits of my mind and body to accomplish my goals. Over the years I have used a number of mental crutches to simplify the complex scenes before my eyes and to aid me in translating those scenes into the language of my film. *Additive* and *subtractive* are my code words for intensified or diminished appearances of subjects on film. I know, for example, that a bright color in direct sun is always additive when polarized, whereas any color in underexposed shadows is subtractive. Although in general I see more subtractive situations in nature than additive ones, possibilities for powerful enhancements of a photograph through additive phenomena abound. When the sun is shining near an edge, there is a potential diffraction star. Any shaft of light in murky air is a potential god beam. People standing in shadows are potentially powerful silhouettes. Even after the sun goes down, additive effects continue around the edges of colored light, such as places where the encroaching blueness of evening touches the yellow glow of artificial light or the pinkness of the rising twilight wedge in the sky.

The next step is accomplished only after much practice. Almost any complex activity,

such as driving a car or operating a computer, eventually becomes ingrained into a person's nervous system to the extent that conscious thought is no longer necessary. When that finally happened to me with photography, I no longer had to translate what my eyes were seeing into the foreign language of film. By actively using the new language in the field, I had become fluent and could visualize either a single scene or a whole panorama without conscious translations back and forth into the "mother tongue" of normal vision.

I cannot overemphasize the importance of this shift in perspective and how much "luckier" it makes me in the field. I can automatically deal with situations where film differs from human vision, and, as with any second language, I can switch back and forth at any time and compare the difference (there is *always* a difference) between film's way of seeing the world and my own.

Sometimes I see additive effects that I know will not appear believable on film because they will be much more spectacular in a photograph than what I am seeing with my eyes. In those cases I take great care to maintain visual sea level by introducing some sort of normal subject matter as a point of reference. Take, for example, a telephoto of a person silhouetted against an underexposed mountain face at dawn. The intense red colors may appear as if they have been heavily filtered, and the black silhouette may look like a montage of two images or a cutout introduced in a copy camera. By including other neutral, or even subtractive, effects in the image, it becomes much more believable. Blue sky above the peak or blue shadows in the foreground show that the scene is not filtered. Shadows that connect with the silhouette make it appear more real.

I apply the principle of visual sea level to compositions as well as to lighting. If I show a climber on an overhanging wall, I try to show also part of the horizon or a tree to make the angle credible. In a photo of a jumbled forest, I will pick one tree to render absolutely straight as a visual point of reference. A great deal of what passes for luck comes from paying close attention to details like these.

The greatest source of my luck in nature photography centers around the discovery of fine light. Unless I consciously think in the language of film, I find my eyes adjusting to color changes of light so automatically and imperceptibly that I am liable to miss the onset of unusual light. By training myself to detect the coming of fine light as early as possible, I am able to put myself into a position where I can carefully combine it with other light and natural forms. When I see a fully developed photo situation from a distance, it is often too late.

Proper use of natural light does not have to be understood in technical terms. As mentioned in Chapter 5, the most important thing to keep in mind is that almost all the variations of light anywhere on earth can be attributed to two factors: the warming of

direct light as it is transmitted through the atmosphere, and the cooling of indirect light by scattering and reflection. By searching for situations where the color of either direct or indirect light is maximized by unusual conditions, a photographer can then use the corresponding normal light of the remaining type somewhere in his image to maintain visual sea level. Thus, the blue haze in shadowy valley looks both more striking and believable with the inclusion of a touch of sunlight on a distant hillside, and the vivid red of alpenglow on a mountain gains impact and credibility if some blue sky is allowed to show.

Any unusual lighting phenomenon needs to be treated in a similar way. When something normally lit is included, the scene gains interest, credibility, and relevance. A good example is a well-known "Rainbow Calendar," published for many years with a different image for each month. Not one photograph of an isolated rainbow has ever appeared in the calendar. Each image includes a contrasting subject that gives it a unique look.

One method I use to increase my luck in capturing the special mood of a wild area was inspired by an insight revealed by a friend who has a theory about the way people perceive geographical extremes. Doug Powell, a geographer at the University of California, has spent much of his life studying climate. He began to notice that in nearly everyone's memory, the extreme becomes the norm. When a Wyoming farmer is asked how cold the winters are, he answers "fifty below," even though that extreme may have occurred only once. Even the daily temperatures reported by the news media are the hottest and the coldest.

Powell's idea that people turn extremes into norms has relevance to how they perceive the mood of a place, and, more important, to how that mood can be captured in a photograph. By searching for geographical extremes and combining them in an image, I re-create those memories of the extreme. For example, if I go to the Rocky Mountains, spend several days searching out the most vivid patch of wildflowers I can find, and juxtapose it against the sheerest mountain wall in the region in fine evening light, locals who see the image will nod knowingly and say, "That's exactly how it looks here."

I try to make luck a consistent part of my work, combining it with the three components needed to make a creative photograph: technical proficiency, personal vision, and light. A major part of the knack of being lucky in photography is in understanding why these three factors must merge at a single moment. Our culture usually considers science and art to be very separate endeavors, but the technical and the creative go hand in hand in both of those fields. A fine description of the creative act in the seemingly disparate fields of science and art is part of Jacob Bronowski's memorable essay "Science and Human Values":

"All science is the search for unity in hidden likenesses. . . . The scientist looks for

order in the appearances of nature by exploring such likenesses. For order does not display itself of itself; if it can be said to be there at all, it is not there for the mere looking. There is no way of pointing a finger or a camera at it; order must be discovered and, in a deep sense, it must be created. What we see, as we see it, is mere disorder....

"The discoveries of science, the works of art are explorations—more, are explosions, of a hidden likeness. The discoverer or the artist presents them in two aspects of nature and fuses them into one. This is the act of creation, in which an original thought is born, and it is the same act in original science and original art. But it is not therefore the monopoly of the man who wrote the poem or made the discovery. On the contrary, I believe this view of the creative act to be right because it alone gives a meaning to the act of appreciation. The poem or the discovery exists in two moments of vision: the moment of appreciation as much as that of creation; for the appreciator must see the movement, wake to the echo which was started in the creation of the work. In the moment of appreciation we live again the moment when the creator saw and held the hidden likeness."

In the making of dynamic landscape images, I recognize that my images must register with three different audiences: myself, my film, and my viewers. What is happening here is clear in terms of Bronowski's "unity of hidden likenesses." Myself, my film, and my viewers are really nothing more than manifestations of the three basic components that must merge at the instant an image is made. Personal vision is how I see my subject. Technical proficiency is how I put that vision onto film. Lighting is what translates my vision to my viewers.

The pursuit of dynamic landscapes is what keeps me interested in photography as my life's work. My personal action not only adds a creative fourth dimension to my results, it also fuels me with a passion that goes beyond anything that can be explained in photographic terms. I believe that a strong kinship exists between all human endeavors that search out the geography of the earth in pursuit of a definite goal. As I hope for a lucky moment while I am carrying a camera on an outdoor adventure, I often have the feeling that there is nothing in the world I would rather be doing and no other place I would rather be. The impression is especially strong when I am photographing wildlife (probably because of the genes I carry from my hunting ancestors). There is something unfathomably satisfying about moving under one's own power through the landscape toward an objective, and the same kind of elation pulses through me when I climb a mountain, stalk a wild creature, run a trail, or zero in on a natural subject with my camera. Making a fine image in such a situation gives me the power to relive something of the original experience as well as impart it to others.

The power of my original feeling helps explain why I have often tried to go back to

duplicate an especially meaningful photograph, always without success. This book is the closest I have come to re-creating those special moments when my favorite photographs were made.

Photographs are like gems: the real and the synthetic are often physically indistinguishable, but there is no question as to ultimate value. A photograph that depicts a moment of real life, whether that of a human activity or of the natural world, is of a higher order than the most perfect replication created by or for the camera with luck removed from the formula.

EXHIBIT VIII
Unexpected Convergence

The photographs in this section have many of the elements found in the other exhibit sections of this book–magic hour, soft light, backlight, light against light. Beyond those is a selective emphasis that sets them apart. Natural forms lose much of their significance when taken out of context, yet many photographers isolate single subjects in what I believe is a misguided quest for simplicity. Of far more importance is harmony, that is, combining the parts into a whole to create a clear message.

Natural forms strike a sympathetic chord within us when harmoniously combined with their surroundings, and sometimes an opportunity arises where the photographer can take this situation one step further. When certain natural forms and phenomena converge unexpectedly in a photograph, the result is synergistic, and the scene becomes supercharged with emotional content.

The painter James Whistler once explained why he didn't accept nature as it is. Although his solution was radically different from mine, his analysis strikes a familiar chord:

"Nature contains all the elements, in color and form, of all the pictures, as the keyboard contains notes of all the music. But the artist is born to pick and choose and group with knowledge. . . . It might almost be said that Nature is usually wrong; that is to say the condition of things that shall bring out the perfection of harmony worthy of a picture is rare and not common at all."

Most of the images in this exhibit appear as if I happened to be in the right place at the right time and had simply to lift my camera and make an image. That is how I want them to look. But like the tricks of a magician, there is more than meets the eye. When I'm hoping to create the appearance of an unexpected convergence, I usually work backward. Instead of trying to discover that perfect harmony fully assembled, I begin with one unusual condition, then use thought and action to turn it into an unexpected convergence. My success rate is not very high, but when I do orchestrate a coincidence of light and form by combining my own efforts with the luck of the draw, I feel incredibly well rewarded. Because I pursue this kind of photography, I have been able to witness many extraordinary moments that I would not otherwise have seen.

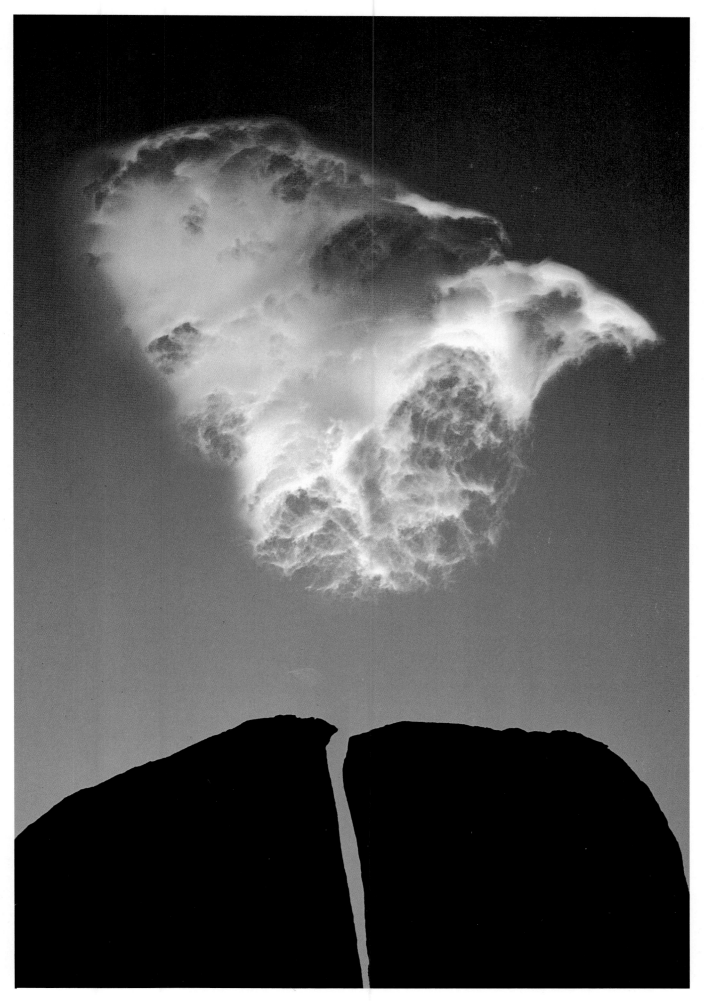

SPLIT ROCK AND CLOUD, EASTERN SIERRA, CALIFORNIA

SPLIT ROCK AND CLOUD, EASTERN SIERRA, CALIFORNIA; 1976

I saw this splendid cirrus cloud moving quickly, as if it had a mind of its own, while I was practice climbing in the Buttermilk region above Bishop, California. I went back to my car to get my camera. What I saw through my viewfinder with a telephoto lens instantly disappointed me. The cloud was there, of course, in perfect detail against the evening sky. Missing, however, were all the feelings of place that were making me appreciate the cloud from where I stood. A photograph of just the cloud could have been made from anywhere—a freeway, a backyard, or a mountaintop.

At first I didn't have any idea what I was looking for, but I did know I had to have some sort of contrasting, earthbound subject to match with the cloud. I hopped in my old station wagon and began driving furiously up and down dirt roads, looking for something to give me the sense of combined order and disorder I desired. My mind was bouncing around at least as much as my vehicle.

The surrounding landscape was striking. I had photographed it many times before, and I knew all too well that the feeling in my heart could not be put on film in a direct way. My eyes could scan the land and mentally pull in the cloud at the same time, as if the one were being viewed with a wide-angle lens and the other with a telephoto. To attempt this with a camera would lose the cloud in a sky cluttered with other, less-perfect cirrus phenomena. I knew that even if the rest of the sky was perfectly clear, the image would not have power unless the cloud was rendered large in the frame.

After thinking things through this far, I concluded that I had to use a 200mm lens. I knew also that I had to expose for detail in the sunlit cloud. Since the sun had long since left the eastern slopes of the Sierra, such an exposure would render any earth subject black. A single strong silhouette was my only hope.

I began looking at the profiles of boulders, but none of them worked because I needed a long, open area below and in front of my foreground subject in order to use a 200mm telephoto to profile it with the cloud high in the sky. Then I remembered a place near the road on the other side of the Buttermilk region that had larger rocks with more space around them. At that point only a few minutes had passed since I had first seen the cloud, and at the speed it was moving, I had at best only a couple of minutes left to make a photograph. I drove half a mile until I saw this tall split boulder, about eighty feet high. I knew it was exactly what I wanted and that all perspective of size would be lost in silhouette. I set up my camera on a tripod, put on a polarizer to accentuate the cloud, and waited less than thirty seconds for it to pass directly behind the rock, thus creating an unlikely but purposeful marriage between two disparate forms.

TECHNICAL DATA *Nikkormat FTN with 200mm lens; Kodachrome 25; polarizing filter.*

STAR STREAKS BEHIND BRISTLECONE PINE, WHITE MOUNTAINS, CALIFORNIA; 1976

On an exceptionally clear winter evening I photographed the image of bristlecone pines at twilight that appears on page 118. While I was driving back along the crest of the White Mountains, the stars came out as I neared Schulman Grove, home of the earth's oldest known living tree, forty-six-hundred-year-old Methuselah. Also on the crest of the range was an observatory built by the University of California to take advantage of the exceptionally clear high-altitude air for astronomical observations.

I wondered if there was any connection between these two superlatives—one of age, the other of astronomy—coinciding in the same stretch of barren mountains. Even if no tangible one existed, I felt that the implied cosmic sense of the antiquity of the trees would be a perfect match for the night sky if I could put them together in one photograph. I stopped at an isolated tree, walked around it, and chose an angle looking south to pose it against the most vivid display in the night sky.

I tried two different techniques. First I bracketed long exposures with my 50mm f/1.4 lens wide open. Then I tried stopping down to f/4, opening the lens for five minutes, and using several flashes of a strobe to light the tree. The first images had a flat, grainy look with a bluish sky. The tree was reddish black and barely visible. With the second technique, which yielded this photograph, the tree was finely lit against an otherworldly black sky. The colors of the stars are far more vivid than what I saw with my eyes, partly because of the way film records stars, but mainly because the rods of the retina that take over in dim light see shades of gray rather than color.

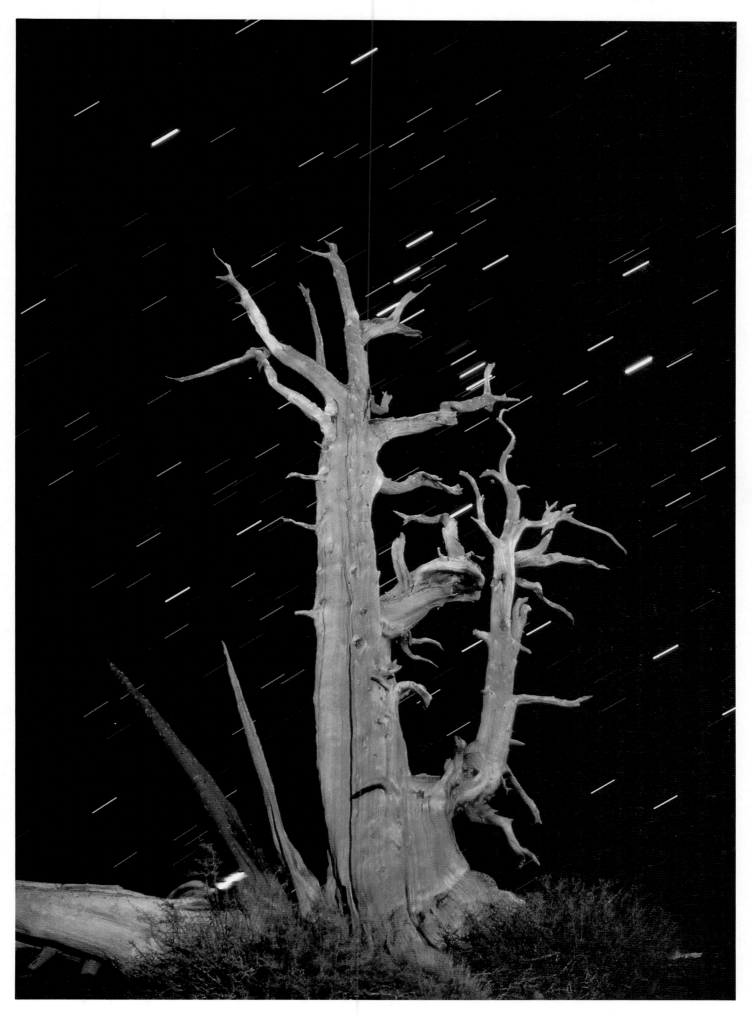

STAR STREAKS BEHIND BRISTLECONE PINE, WHITE MOUNTAINS, CALIFORNIA

The difference in the color of stars relates to their temperatures. Those pictured here are hardly a random selection, but rather some of the most classic astronomical phenomena that can be captured on an ordinary night with a normal lens. The image is focused on the constellation Orion, and the three stars of Orion's belt are just right of the top of the tree. They point at lower left to the brightest star in the heavens, Sirius, the Dog Star. The orange star in the upper left is one of the largest known stars, Betelgeuse, a red supergiant. The red mark below Orion's belt is the Great Nebula, the most conspicuous one visible from the United States. Photos of this nebula made by Ainslee Common a century ago marked the beginning of astrophotography.

TECHNICAL DATA *Nikkormat FTN with 50mm lens; Kodachrome 64; five-minute exposure with flash fill.*

RAINBOW OVER THE POTALA PALACE,
LHASA, TIBET; 1981

The convergence of a rainbow with the golden roofs of the Dalai Lama's palace was not the accident it may seem. In the making of this completely straight image, two old proverbs about rainbows took on literal meaning. There was a chase and a pot of gold, though I didn't have a spare moment to consider either as I raced against time.

The potential was less than obvious when fifteen of us got out of a bus in the rain at the Lhasa Guest House, tired after a long day of sightseeing at the end of a month's journey. We could see a dim rainbow hovering over a field miles from the fabulous Potala Palace, which was in deep shadow under the storm clouds. Many members of the group took photographs of it, but no one joined me to chase rainbows in the rain just as dinner was being served.

I hopped a fence with a bag of cameras and walked diagonally away from the rainbow. It followed. I knew that with each step I took I was actually seeing a different rainbow refracting from inside a different set of water droplets. The primary arc of a rainbow always forms at a radius of forty-two degrees around the antisolar point, directly away from the sun. If I chased the rainbow directly, it would disappear as soon as I went beyond a position where that radius intersected sunlit raindrops. My hope was to chase it sideways and use my motion to aim a rainbow at the palace roofs in a manner similar to lining up the sights of a rifle.

Soon the rainbow grew more intense, and so did my pursuit of it. I ditched my heavy camera bag in a bush and took off running with a Nikon F3, a 75–150 zoom with a polarizing filter, and two rolls of Kodachrome 64. I stopped a couple of times to take "insurance shots" of the rainbow near the palace, and after nearly a mile of running, panting hard at twelve thousand feet in the thin air, I reached the spot where the rainbow was directly behind the palace. The convergence was nowhere near as dramatic as I had hoped it would be because the palace was dark. I took more insurance shots and weighed staying a while longer against the prospect of a cold dinner. Had Lhasa cuisine been better, I might well have decided not to wait in the rain.

The Potala was the traditional home of the Dalai Lama, the spiritual and political leader of Tibet. Past incarnations of the "living god" were entombed inside the eleven-hundred-room building. From every direction the Potala is as resplendent as the Acropolis, and much bigger. It dominates the Lhasa Valley and appears to be part of the seven-hundred-foot hill on which it sits.

More than 100,000 ounces of gold were used in the construction of just the inner tomb of the thirteenth Dalai Lama; thus, the Potala is as close as the real world can come to that pot of gold at the end of a rainbow. Where did the gold come from? According to legend, Padmasambhava, the saint who introduced Tantric Buddhism to Tibet in the ninth century, made the land fertile by sowing the soil with gold. And it was believed that if mortals removed the gold, the land would be ruined.

According to another legend recorded by the Greek historian Herodotus in the fifth century B.C., great ants dug up gold in a desert north of India and fierce tribesmen rushed in to gather it. The most logical explanation for this tale is that the ants were part of a cover-up story meant to keep would-be miners from going where other Tibetans really were digging gold. Viewed from a distance out on the plains, bent figures scratching the ground with antelope horns could be passed off as dangerous killer ants, and the necessary gold could be collected for building the Potala and other holy edifices.

What happened to me next was no less miraculous than the story of the gold. As if by magic, a hole opened in the sky, beaming a spot of evening light directly onto the palace. The background

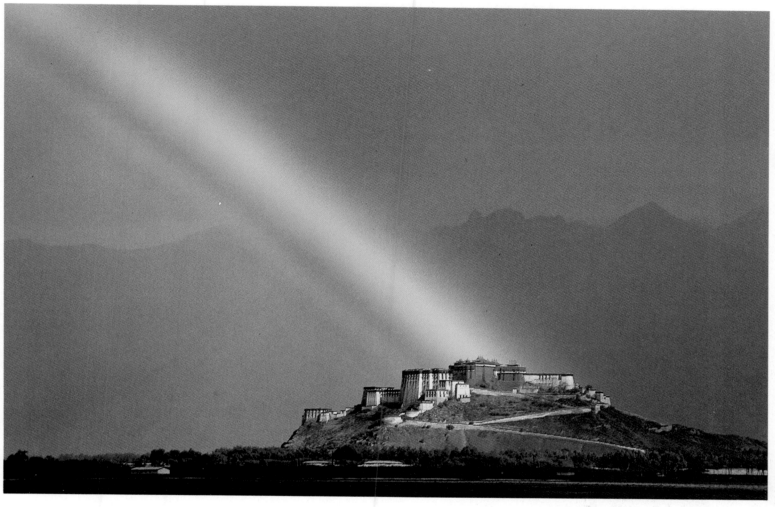

RAINBOW OVER THE POTALA PALACE, LHASA, TIBET

remained dark, and as vivid a rainbow as I have ever seen rose from the golden rooftops of the summit of Buddhism, as if some power in the palace were its source. I increased the rainbow's apparent intensity by further darkening the area around it. I used just enough polarization to cut some of the specular highlights from the water droplets, but not so much that I would weaken or erase the rainbow itself. With my camera braced on a wooden post, I finished off both rolls of film, regretting that I hadn't brought a third, because only during the last few shots was the light at its best.

Another reason for shooting many originals became apparent when I saw my results. I had tried to focus on what seemed to be the most powerful image, the rainbow and palace in the sky, without a foreground. Those images somehow lacked credibility and were far less satisfactory than the more restrained composition presented here, which includes some rather mundane trees and buildings along a narrow strip of ground in front

of the palace. Although I prefer this horizontal shot taken at 150mm, I also made verticals and experimented with both other focal lengths and compositions.

The figurative pot of gold I had chased became a literal one after I returned home. I had been on assignment for *National Geographic* and had sent my unprocessed film to Washington, D.C. An editor soon called to tell me, "You got your rainbow." I received a surprise bonus check. They published an image very similar to this one across two pages of a book on China. The outtakes were returned to me with rights to sell them, and this image quickly became my best-seller of all time. Within months rights were sold for posters, calendars, national ads, limited-edition prints, photography magazines, and travel articles. It has appeared in foreign countries as well as on the cover of my own book on China.

TECHNICAL DATA *Nikon F3 with 75–150mm zoom lens; Kodachrome 64; polarizing filter to darken background.*

REFLECTION IN LAKE LOUISE, CANADIAN ROCKIES

EXHIBIT VIII UNEXPECTED CONVERGENCE 213

REFLECTION IN LAKE LOUISE,
CANADIAN ROCKIES; 1983

This photograph is a result of the same trip and the same photographic outlook as the image on page 193. Because I was in one of the most photographed areas in the world, I was determined to visualize the scenery in a new way. Nowhere was my determination stronger than at Lake Louise, where every photographer makes an image from within a few feet of this one.

Rather than seeing the potential for this photograph immediately, I searched for it with a sense of trying to get as close to my subject as possible. I began walking around with my eye to my viewfinder, with a 20mm lens on my camera. I stalked the shoreline, often dropping to my knees, and found myself coming back several times to this set of boulders. I was attracted to their form, color, and separateness, as well as to the potential for a reflection in the extremely still waters of the lake.

Only after I visualized exactly what I wanted did I go back for my tripod. Because the extreme wide-angle lens needed to be aimed almost straight down only a couple of feet above the rocks, I found it very difficult to set up my tripod so that I could compose this scene without including a tripod leg. It was important that my camera be quite steady because I was shooting a one-second exposure at f/22. The extreme aperture was necessary to hold focus on rocks two feet from my lens and on mountains at infinity. Just as the sun's rays were about to strike the surface of the lake and destroy the reflection, I made my last adjustment and bracketed several exposures in automatic mode, using my self-timer so as not to jar the camera.

TECHNICAL DATA *Nikon F3 with 20mm lens; Kodachrome 25; f/22 for maximum depth of field.*

MOONSET AT SUNRISE, WHEELER CREST,
EASTERN SIERRA, CALIFORNIA; 1972

This extreme telephoto was made from an elevation of four thousand feet on the Owens Valley floor as the moon set behind a distant twelve-thousand-foot ridge. I had spent the night sleeping under the stars on what turned out to be the coldest night of the year—zero degrees Fahrenheit in the low valley and minus twenty-two degrees in the community nearest the ridge in this photograph. I awoke to see three factors immediately converging into a situation with tremendous photographic potential. The full moon was about to touch the horizon, the air was extremely clear, and sunrise alpenglow was on the snowfields.

The full moon has the same exposure value as daylight, thus, it can be photographed only with proper detail against a strongly sunlit scene. Most sunrise light is so filtered by haze that it is several stops darker than the moon, especially when the moon, as in this case, is not setting over the true horizon, where it encounters the same degree of haze, but rather over an apparent horizon of foreground ridge, while it is actually higher in the sky in clearer air. In this case the haze was minimal and the reflectivity of the surface—snow—was maximal. Even so, the original Kodachrome had a somewhat flat look because of magnification through so many miles of air combined with the inherent low contrast of a 500mm mirror-reflex lens.

Noting that the sharpness of the image was impeccable, I decided to try something a little like what a black-and-white photographer does with a flat negative: increase the contrast during another photographic step. I made a duplicate slide on standard Kodachrome instead of on the normal low-contrast duplicating film. That process brought back the snap that I had seen with my eye, and lost virtually no resolution because the film used for duplication was as fine grained as the original emulsion.

The contrast increase did cause the dark blue sky to turn almost black, but the image retained visual sea level by having the correct color in the moon. The technique of duplicating onto Kodachrome works only on very low-contrast images, perhaps only 2 or 3 percent of the outdoor situations I encounter. A Kodachrome duplicate of a normal outdoor scene becomes unacceptably harsh. I continue to make my normal slide duplicates on low-contrast Ektachrome or Fujichrome duplicating films that give me much the same tonal range as the original. Once in a while, however, I encounter a rare situation such as this, where I would have loved to have a very high contrast color film for my original.

With more than a decade of hindsight, I am intrigued by how I came to visualize this image. It has the feeling of a photo from an Apollo mission. I wonder if I would have made it if I had not seen the images of earthrise from the moon, so fresh in everyone's mind in the early seventies.

TECHNICAL DATA *Nikon FTN with 500mm lens; Kodachrome II (ASA 25).*

MOONSET AT SUNRISE, WHEELER CREST, EASTERN SIERRA, CALIFORNIA

YOSEMITE VALLEY IN WINTER, CALIFORNIA

EXHIBIT VIII UNEXPECTED CONVERGENCE 217

YOSEMITE VALLEY IN WINTER, CALIFORNIA; 1979

The traditional viewpoint for photographs of Yosemite Valley is the parking lot by the Wawona Tunnel on the Fresno Road. Whenever unusual light occurs, photographers line up along a wall like militiamen defending a fort. During the sixties and seventies I joined the crowd many times, but the location always frustrated me. It was a single clearing no more than a hundred feet wide where I could not change the perspective of the scene by moving around.

In the wilderness I compose landscape images by moving back and forth or up and down until I get the relationships just right. From the tunnel the arrangement of forms is very nice for a broad scenic with a normal or slightly wide angle lens, but I noticed right away that I couldn't make decent telephoto shots except of individual formations. To me the essence of Yosemite Valley is sheer walls with distinctive shapes rising next to one another. I wanted to emphasize that sheerness with a telephoto, and do it in a way that included several features at once. The perspective isn't right from the tunnel parking lot.

I tried many spots above and below the road, but to no avail. Eventually I realized that I needed two elements to come together in order to create the image I wanted: first, a location where the walls converged in a pleasing manner; second, some sort of unusual light to separate the foreground ridges one from the other. At sunset they normally blended into one another and became quite two dimensional in a telephoto view.

In the winter of 1979, I was driving back from Badger Pass after a stormy day of skiing when I suddenly came out of the clouds. The storm was clearing, and mist was rising from every side canyon. I stopped a mile or so above the tunnel at a place I had noticed previously. I set up my camera with a 200mm lens and polarizer, then began to walk around and experiment.

The game was on. Instead of a static situation, I was working with several fleeting variables. Clouds of vapor were shifting so quickly that my image changed markedly every few seconds. Sometimes El Capitan was totally obscured for a minute or two; at those times I wondered if it would ever come out again. Evening light was warming the scene, but I could see that the sun would drop behind a cloudbank long before it set. While all this was going on, I was trying to change my composition and location to balance the shifting features in my viewfinder. I wanted Half Dome to be the dominant feature, balanced by the other ridges coming out of the same cloud.

I shot an uninspired roll of film before I suddenly saw it all come together. Three ridges on the left emerged from the mist at the same time, balanced perfectly with Half Dome and a closer forested ridge on the right. A piece of El Capitan was floating in the clouds, nearly touching Half Dome. Below the walls and ridges was a rapidly darkening pool of vapor. The sun was beginning to drop behind the clouds.

Realizing I had a remarkable image, I bracketed exposures, verticals and horizontals, and also made several photographs with a shorter lens that put additional space in the sky. Within the year this image appeared on the cover of my book *High and Wild: A Mountaineer's World* and also on a poster for the Yosemite Institute.

TECHNICAL DATA *Nikon FM with 200mm lens; Kodachrome 25; polarizing filter.*

CRESCENT MOON AND UNNAMED PEAK, SAVOIA GLACIER, KARAKORAM HIMALAYA, PAKISTAN; 1975

The seeming simplicity of this scene of a crescent moon disappearing behind a mountain ridge at night belies the major technical and aesthetic complications I encountered making it. As I have said several times, images that show a detailed moon in an evening sky without direct sunlight are invariably composites or double exposures. The moon is as bright as daylight, and thus cannot be properly exposed in an image made after sunset that shows detail in the landscape.

Look closely at this moon. Even though my eight-second exposure with a 500mm f/8 mirror-reflex lens overexposed the moon by more than ten stops, its burned-out crescent is pleasing to the eye. We tend to look for detail in the moon itself to validate our impression of a full moon, but we look only at the outline of a crescent moon. This aesthetic process is similar to that which leads us to reject a dark exposure of a person who is standing close to our lens, while accepting a similar exposure as a silhouette when the figure is at a greater distance. In this case the edge of the moon falling behind the ridge of the peak verifies that the photograph is not a composite.

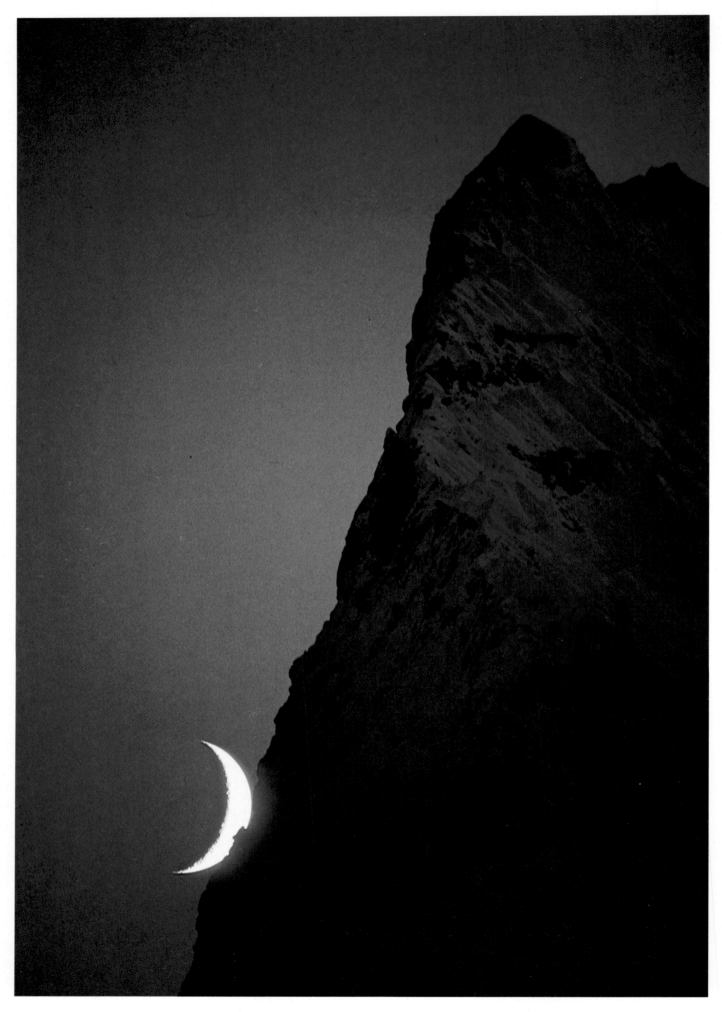

CRESCENT MOON AND UNNAMED PEAK, SAVOIA GLACIER, KARAKORAM HIMALAYA, PAKISTAN

EXHIBIT VIII UNEXPECTED CONVERGENCE 219

The technical complication of making an image of this sort is dealing with the apparent motion of the moon (with apologies to Copernicus). When I had previously experimented, using long exposures of crescent moons with earthbound subjects, my images failed because the moon blurred sideways. I calculated the angular movement across the field of my 500mm lens according to two basic pieces of information. First, the moon and stars shift one degree across the sky every four minutes. Second, the horizontal field of view of a 500mm lens is four degrees. In sixteen minutes the moon moves completely across my frame. Knowing that, I was able to approximate how much motion I could tolerate and still retain the proper outline of the crescent. Experiments confirmed eight seconds as my maximum exposure.

When I used my 35mm f/1.4 lens to get a reading on this mountain within the range of my through-the-lens meter, it converted to a thirty-second exposure with my f/8 500mm lens. I went ahead and shot this image at eight seconds, knowing it would be two stops underexposed, then I brought it back two stops by duplicating it, using the technique I call my "secret ASA 400 Kodachrome," which is explained in Chapter 4.

TECHNICAL DATA *Nikon FTN with 500mm lens; Kodachrome 64; eight-second exposure.*

Acknowledgments

This book would not exist had it not been for the sound advice, incisive editing, and constant encouragement I received from Jim Robertson of The Yolla Bolly Press. Over the course of three years, Jim's endurance and enthusiasm for the project often outstripped my own. Through his guidance, my first idea—a little book of favorite photographs and the stories behind them—grew into this more ambitious work.

Jon Beckmann of Sierra Club Books saw enough promise in the project to increase my proposal for sixty-four images to eighty, and to insist on a comprehensive text that would go far beyond normal how-to prose. I began writing well before my 1983 photographic exhibition, "Mountain Light," which included most of the images described in these pages. Barbara, my wife, was instrumental in booking and creating the show, as well as in extending my horizons beyond the mere pleasure of producing images to become more in tune with the ways in which landscape photography is appreciated as art. Together, Barbara and Kevin O'Farrell, then director of exhibits for the California Academy of Sciences, coined the name "Mountain Light." Kevin's superb installation was viewed by half a million visitors in San Francisco, and his counsel and guidance have kept the show traveling to major cities in the United States and Canada ever since.

The book title *Mountain Light* aptly describes my subject matter but gives no hint of my technique. Barbara underscored the need for a book that would explain the standard methods used for my most unusual images after she overheard viewers' speculations at the gallery. One man checked out the wall to see if the prints were somehow lit from behind. Another knowingly told his companions that the prints had obviously been made on special photographic paper not available to the public. Still another informed his children that I had used a giant strobe to light seagulls against an evening sky (he was correct; most people, however, call it the sun).

While I found these anecdotes highly amusing, Barbara saw them as a mandate to address my text not only to aspiring photographers, but also to novices and nonphotographers. Thanks to her input, I scrapped an early outline that tightly adhered to subjects covered in my photo workshops and began, instead, with descriptions of my early experiences, when I knew next to nothing about photography.

After I completed the manuscript, Jim Robertson worked personally with me to make minor revisions that greatly improved the text's clarity. Then the manuscript passed the able pens of Diana Landau and Linda Gunnarson of Sierra Club Books. Steve Hammond of Color Trend in San Francisco (who also made the fine, enlarged duplicate transparencies used by Dai Nippon of Tokyo for this printing) read the text for technical accuracy. Barbara Youngblood of The Yolla Bolly Press made the final copyedit, preserving my original intentions and style with great sensitivity.

The images themselves would not exist without the technology upon which my career depends or the travels that have put me in so many exotic locations. For the former I owe a great debt to Eastman Kodak, Fuji Photo Film, and Nikon. For the latter my deep appreciation goes to the National Geographic Society for allowing me to pursue open-ended assignments that have not restricted the personal passion which is always at the heart of meaningful photography.

Index

No. of Advts. 4 Years Ago, 802

Two Years Ago, 3,946

SUNDAY - - 5,285

3 STEPS !

The **EVENING**

PRICE ONE CENT.

NEW YORK, TUI

EXTRA

2 P. M.

SNOWED UP.

New York Still Held in the Blizzard's Grip.

Isolated by Snow From the Rest of the World.

Travel on Railroad and Horse Cars Stopped and Wires Down.

Extraordinary Experiences of the Past Twenty-four Hours.

The Worst Now Believed to Be Over—Hundreds Cross the East River on the Ice—New York Digging Itself Out and Walking Downtown—A Show of Operating the Elevated Roads—Downtown Hotels Crowded—Camping Out in Office—Very Few Trips Made by the Ferry-boats.

Having proved to its own satisfaction how it could paralyze New York—if it tried real hard, the weather has consented to a cessation of hostilities and to give the city a chance to recover from the shock.

The snow stopped falling at 5.50 this morning, and at that time also the wind had subsided into something gentler and more to be sought for, though much less searching. The coldest part of the blizzard came last night and so did the darkest; for electric wires suffered with others of their ink, and gas mains were frosted out of all usefulness.

Reports from the South and from the At-

... e office this morning, but reports from Chicago and the West came as usual. It was ... town that Mackinaw, Marquette and the

... ing a... ls of little I... half an

The c... at the Br... end was and tra... re filled... inkling, the line... ple who... 't get on ... hed far... nto the... The au-... ies pre... the same... tions as ... esterday... allowed... certain ... numb... assengers t... the sta-

... was closed... were all ... rries s... f it. Cath... erry was ... rthest... of those... g on the River.

WALKI... THE E... R. ... m Fulto... southw... eemingly ... ding to... r's Isla... s a sheet ... so thic... olid tha... de a per- ... bridge t... York.... t people ... cross... ce struc... e looked ... rly dari... ... with some a... safe passage, however, induced others to follow, and soon there was a black string of ... umanity stretching over the white field ... from... ne to... ore. Persons who... dn't ... need t... oss... all walked over the ice ... with the throng just that they... ight be able to tell of their experience.

The North River ferries were running under extreme difficulties.

SCENE ON THE RIVER.

An EVENING WORLD reporter, holding tightly to himself and his hat while walking in the stiff breeze over the roof of the Equitable Building this morning, saw in place of the river what looked like a ribbon of ice between New York and the Jersey shore. That it was not solid, though, was shown by the ferry-boats, tugs and craft which ploughed successfully, though laboriously, through it.

ON STATEN ISLAND.

Patrons of the Staten Island ferries, leaving New York hopefully last night, got to the St. George's landing, and most of them have been there ever since. The snow is as deep ... th... fi... es are high and ... no trains are running.

Two boats made the trip from the island to New York yesterday morning, one in the af... noon and another this morning. Amid

three unsu... attempt... passage Ca... ham orde... er to put back to... City.

The same... y was the... perience in making a... s, and the... that be done was... up alongside an ... ing wharf an... he boat fr... e in night. The... board did not m... for they h... in a supply... y liquor suffici... eep up the inn... th for an unli... period. The... no ladies amo... assengers, an... as it became e... hat there wa... tting av... for the... the youn... ttled de... to ma... est of the...

THE BRIDGE OF AN OCEAN STEAMER.

One of them produced a harmonicon, and for a time the crowd amused itself with music, the instrumentalist finally being drowned out by the voices of his companions, who became more and more noisy in proportion to the amount of liquid refreshment absorbed.

Several groups passed away the time playing cards, and at least two lively games of 25-cent limit were going on about midnight, at the same time that the wild carousing was going on in various other parts of the saloon.

There was very little sleeping done by any of the company, the principal reason being that the seats were not built that way. A few of the more weary made their beds on the floor of the cabin. The officers on board the vessel turned in early, and let the passengers do as they pleased.

The unhappy looking men that were landed from the Hudson City at Cortlandt street ferry about 7 o'clock this morning didn't spend much time waiting around. They had disappeared within five minutes after the gates were opened.

The ferryboats Chicago and New Jersey, also of the Pennsylvania road, were running at irregular intervals this morning. A great many people who got over to the other side of the river yesterday could not reach their homes in New Jersey, and were obliged to spend the night in the cars and the waiting rooms in Jersey City.

A large number of those people came back to New York early this morning for their breakfasts, for after 8 o'clock last evening it

SUPP

Great Sc

Something

... ring S ... supply ... heir ... ded ... e

To add to th... by the blizzard ... b... ies ... now ... p... able ... ey at ... ing upon thei... from hand to p... coal or provisio... hours.

These people... retail dealers ... much valuabl... estimated th... dollars wa... ... yesterday thro... their places of ... shops were not ... pearance of e... worth while to ...

And those wh... to learn that th... sources of sup...

This is felt i... in the neighb... Washington M... but vegetables ... At Fulton M... are plenty. B... avail in thir w... ing them.

Longshorem... for delivering ... nearby consu... scenes in the c...

Early this m... Italians passed ... carrying a qua... livering an or... to the Hotel B... hotels in Park...

The Astor H... this way and ... taurant in Pa...

But affairs ... downtown res... suspend their ...

At Mouquin... Open... ste... enough ann... mark...

Opposite ... his announc...

BLIZZARD!

THE STORM THAT CHANGED AMERICA

JIM MURPHY

SCHOLASTIC INC.

New York Toronto London Auckland Sydney
Mexico City New Delhi Hong Kong

ACKNOWLEDGMENTS

I want to acknowledge and thank the many individuals who helped me locate information and photographs for this book: Rebecca Streeter, New Jersey Historical Society; Nancy Finlay, Connecticut Historical Society; Barbara A. Brierley, Barnes Museum; Randy Goss, Delaware Public Archives; Roxanne M. Roy, Historical Society of Cheshire County, New Hampshire; B. Austen, Fairfield Historical Society, Connecticut; Anne Easterling and the staff of the Museum of the City of New York; Nicole Wells, the New-York Historical Society; and especially Arthur Cohen for his expert camera work and good cheer.

ISBN 0-590-67310-6

Text copyright © 2000 by Jim Murphy.
All rights reserved.
Published by Scholastic Inc.
SCHOLASTIC and associated logos are trademarks and/or registered
trademarks of Scholastic Inc.

14 13/0

Printed in the U.S.A. 40

First Scholastic paperback printing, January 2001

Cover art copyright © 2000 by Leonid Gore.

The text is set in 13-point Berkeley and the display type in CG Latin Elongated.
Book design by Marijka Kostiw

We gratefully acknowledge Joan Giurdanella for her meticulous fact-checking of the manuscript.

FOR CAROL AND JIM GORDON

GREAT NEIGHBORS AND FRIENDS WHO

APPRECIATE A GOOD SNOW JOB

WHEN THEY HEAR ONE.

TABLE OF CONTENTS

*People out for a stroll in the city
in early spring* (AUTHOR'S COLLECTION)

ONE

THE UNHOLY ONE

On Saturday, March 10, 1888, the weather from Maine on down to Maryland was clear and unusually warm. A few scattered clouds scuttled across the blue sky, but little else marred what was a perfect day. Families went for picnics, took carriage rides, or strolled through their neighborhoods to see the purple and yellow crocuses bursting into bloom. The day was so nice that President Grover Cleveland and his wife left Washington, D.C., for a vacation weekend at their country home.

It had been one of the warmest winters on record in the East. This was especially true of the New York City area, which saw few frosts and little snow. Walt Whitman, the unofficial poet laureate of the *New York Herald*, was so taken by the endless string of balmy days that he penned "The First Dandelion" for Monday's early edition:

> *Simple and fresh and fair from winter's close emerging.*
> *As if no artifice of fashion, business, politics had ever been.*
> *Forth from its sunny nook of shelter'd grace —*
> *innocent, golden, calm as the dawn,*
> *The spring's first dandelion shows its trustful face.*

1

One of the few people unimpressed by the pleasant weather was John J. Meisinger, hardware buyer for the Manhattan department store of E. Ridley and Sons. On Friday, Meisinger had bought approximately 3,000 wooden snow shovels for $1,200. He had planned to keep them in the store's basement until the following winter. Unfortunately, a newspaper reporter heard about the purchase and wrote a satirical article entitled "Meisinger's Folly" that labeled him "Snow Shovel John." As he took delivery of his shovels that March Saturday, Meisinger discovered not only that he was the joke of New York City, but that his job was on the line as well.

Very few of the 15 million people living in the northeastern United States suspected that not one but two massive storm systems were heading their way. Reporter William Inglis certainly didn't as he boarded a pilot boat headed into the Atlantic; nor did seventeen-year-old Sara Wilson as she packed for her trip from Buffalo to New York City. Another seventeen-year-old, James Marshall, had no idea what lay in store for him; neither did former senator Roscoe Conkling, eighteen-year-old May Morrow, Long Island potato farmer Sam Randall, or cub reporter Richard C. Reilly of Brooklyn. Nine-year-old Gurdon Chapell and his four-year-old brother Legrand played happily on their Connecticut farm and never thought about the weather, while down in a small Delaware Bay town, divinity school student John H. Marshall (no relation to James Marshall) worked on the wording of his first sermon.

While all of these people went about their activities, one storm system was sweeping across Minnesota, Wisconsin, and Michigan, and dumping tons of snow along the way. If it held to its course, it would travel over most of New York and Pennsylvania before reaching the Atlantic. In the South, the second system moved over the warm waters of the Gulf of Mexico dragging along moisture-laden air. On that

Saturday, over four inches of rain deluged Pensacola, Florida, while cyclone-force winds tore up Tennessee, Alabama, and Mississippi.

All of this storm activity was being monitored closely at the U.S. Army Signal Corps in Washington, D.C. The Signal Corps was the precursor of our present-day United States National Weather Service and the agency charged with making weather "indications" (as forecasts were called at the time).

Three times a day, all 154 local weather stations telegraphed data about their regions to Washington, D.C., where it was carefully marked on maps and analyzed. The information included readings of the barometric pressure, temperature, humidity, wind velocity and direction, cloudiness, and precipitation. So complete was the information that the Signal Corps boasted it was correct 82 percent of the time.

After examining that day's data, the staff at the Signal Corps concluded there would be no real problem from either storm. The northern storm was losing strength, while the one to the south was on a path

On Saturday, March 10, the center of the northern snowstorm had nearly reached Lake Michigan, while the southern storm and its cyclone-force winds had crossed Arkansas and was about to enter Tennessee.

that would take it safely out to sea. The final indications for the following day were issued at 10 P.M. Saturday night: "Fresh to brisk winds, with rain, will prevail, followed on Monday by colder brisk westerly winds and fair weather throughout the Atlantic states. . . ."

At the New York City Weather Station, these indications and the accompanying data were read by staff member Sergeant Francis Long. Long was a big man, possessed of unlimited energy and an outgoing, friendly personality. He was also a minor celebrity at the weather sta-

tion for having survived three years of subzero temperatures and food shortages on an Arctic expedition.

Long glanced out his window at a clear, moonlit sky dotted with bright stars. The weather station was located at the top of the nine-story Equitable Building, then one of the tallest structures in the world.

Below him, the nighttime city sparkled and teemed with life — gas and electric lights, horse-drawn vehicles, steam-powered elevated trains, and scores of pedestrians on their way home from dinner, concerts, and

This view looking west across New York City was taken in 1894 from the World *newspaper building. Many of the buildings were designed to be massive and impressive, such as the Municipal Courthouse (LOWER RIGHT), while others seem to be reaching up to touch the sky. (NEW-YORK HISTORICAL SOCIETY)*

the theater. Many of these people were coming from a three-mile-long torchlight parade staged by the Barnum and Bailey Circus. Others headed up Fifth Avenue, where some of the country's wealthiest individuals had grand residences.

To the east, Long could see the wooden masts and rigging of forty or fifty sailing ships nestled around the five-year-old Brooklyn Bridge. The Great Bridge, as it was called, was not just the longest suspension bridge in the world; it was proof that science could overcome any earthly obsta-

This sumptuous living room shows how the very wealthy lived at the time. They often had recently refurbished rooms photographed, though usually without appearing in the scene themselves. (NEW-YORK HISTORICAL SOCIETY)

At the first sign of foul weather, many homeless individuals sought shelter in cheap flophouses. One rule of this establishment is PAYMENT IN ADVANCE. (AUTHOR'S COLLECTION)

cle. One commentator referred to it as a bridge to the future, calling it "a source of joy and inspiration to the artist, perhaps the most completely satisfying structure of any kind that [has] appeared in America."

In truth, New York City itself was considered a modern-day wonder. It was the financial and commercial hub of the United States, an emerging world center for art and architecture, the landing point of thousands of immigrants every day, and the place where the latest inventions — such as the telephone — were introduced to the public. French journalist Paul Bourget went to the top of the Equitable Building and was astonished by the city he beheld: "Seen from here it is so colossal, it encloses so formidable an accumulation of human effort, as to overpass the bounds of imagination."

On that Saturday night, of course, Sergeant Long's thoughts were much more practical. He scanned the sky for signs of trouble, then turned his attention to the work at hand.

Based on the Signal Corps's information, and supplemented by their own last-minute readings, the New York City Weather Station telegraphed its indication for the following day to area newspapers: "For Maine, New Hampshire, Vermont, Massachusetts, Rhode Island, Connecticut, eastern New York, eastern Pennsylvania, and New Jersey, fresh to brisk southerly winds, slightly warmer, fair weather, followed by rain. For the District of Columbia, Maryland, Delaware, and Virginia, fresh to brisk southeasterly winds, slightly warmer, threatening weather and rain."

That done, Long and the rest of the station's staff got ready to go home to observe the Sabbath. More data would be gathered before the official closing time of midnight, but essentially, their work was finished.

The same was happening at every other regional weather station and at the Signal Corps's headquarters in Washington, D.C. At midnight, the lights would be extinguished and the doors locked tight until 5 P.M. on Sunday afternoon. That meant that for seventeen hours there would be no one monitoring the changing weather patterns of the nation.

Long took the slow ride down to the street in the steam elevator, said good night to his supervisor, Chief Elias Dunn, and set off on foot for his home in rural Brooklyn. He was now just another citizen looking forward to his day off — and as unaware of the approaching monster as everyone he passed on the street.

For during the long hours while the nation's weather stations were idle, the weather underwent rapid and dramatic changes. The northern storm picked up energy over the Great Lakes region and continued its

march east, bringing bitter cold and snow with it. The southern storm did, as predicted, wander out over the ocean. But instead of staying there, it turned during the night and headed north. As it moved along the coast, it gathered up more and more moisture and its winds gained velocity.

The two systems would eventually join into one massive storm. When people woke on Sunday morning, they were confronted by an ominously dark sky filled with fast-moving clouds and gusting winds. Many people had an unpleasant sense that some sort of living, and not very friendly, creature had arrived to menace them. Such feelings would color the way they thought and wrote about the storm for the rest of their lives.

A minister in a small New Jersey village looked up at the sky, then hurried indoors. "I had the strangest of feelings," he would tell his parishioners that day. "It was as if the unholy one himself was riding in those clouds."

JUST A BABY

On Sunday, March 11, young John Marshall took a stroll around the Delaware town of Lewes (pronounced *loo*-iss) with the pastor of the local Presbyterian church. Marshall's sermon had gone well that morning and he was happy about that. Still, the weather had changed drastically during the night, bringing cold rain and sharp winds.

At the beach, the water was choppy and restless, and the masts of anchored ships whipped back and forth, back and forth. Marshall's friend shrugged off the wind and rain as "just a bit of weather." Even so, Marshall thought he saw apprehension in the faces of the sailors as they peered up at the brooding, gray clouds.

And then there were the steamships, schooners, and tugs in the bay. Not one of them was headed out to sea; they were all hurrying into the safety of the Lewes breakwater. What did they know? Marshall wondered.

To the north and almost 20 miles from shore, twenty-six-year-old reporter William Inglis was seasick, groaning in his forecastle bunk and silently cursing himself. It had been his idea to write about the men who piloted ships into busy New York Harbor.

His editor at the New York *World* hadn't been enthusiastic about the idea at first, but Inglis had argued his case. The currents were treacherous in the lower harbor, he pointed out, and the heavy shipping traffic there required great navigational skill. These pilots did truly heroic work, he told his editor all too convincingly.

Inglis chose to go aboard Pilot Boat No. 13, the *Caldwell F. Colt*. The *Colt* was an 84-foot-long, two-masted schooner and one of the fastest and most aggressive boats in the New York Pilot Fleet. At the time, pilot boats would sail out a day before ships were expected and lay off Sandy Hook. The moment smoke was spotted on the horizon, all sails would be piled on and the pilot boats would race to the incoming vessel. Bigger ships paid higher fees, and the first one there got the job.

Eight other pilot boats were bobbing and rolling in the whitecapped water near the *Colt*, each carrying from four to six pilots. According to the shipping news, at least six large ocean liners were due in port at any

By the afternoon of Sunday, March 11, the center of the northern storm had entered Pennsylvania, bringing along freezing cold air and snow. Meanwhile, the southern storm had swung south toward the Gulf of Mexico, then begun moving north. In addition to extremely strong winds, this storm was also picking up great quantities of moisture from the Atlantic Ocean.

moment, along with from twenty-four to thirty-six freight-carrying vessels.

Despite the wind and a plunging barometer that promised an intense storm, the pilot boats stayed out, waiting and watching. This meant that Inglis had to wait, too, moaning in his bunk.

New York City on that morning was depressingly gloomy. The air felt heavy with moisture, and it was clear that rain would begin falling any minute. After hurrying to and from church, the majority of people settled in for a cozy day at home. Fires were lit, books and newspapers read, popular songs sung, and games were played and argued over.

Conversation was an important way to pass time in an era before the invention of the radio or television. One hot topic was the death of the ninety-year-old ruler of Prussia and Germany, Kaiser Wilhelm I, and the succession of his son, Kronprinz Friedrich, to the throne. The new emperor was himself extremely ill with throat cancer and many wondered how long he would live.

Sporting news from France also drew much comment. American bare-knuckle fighter John L. Sullivan had been held to a thirty-nine-round draw by Englishman Charlie Mitchell. This was surprising enough in itself, but most people were talking about the shocking things Sullivan's estranged wife was saying. "I wish Mitchell had killed him," Mrs. Sullivan told a *New York Herald* reporter. "He is a greatly overrated man. I hope he will die a beggar as he deserves to do for his ill-treatment of me."

Department store buyer John J. Meisenger was a hot topic that day, too, at least in New York City. Word of his snow-shovel purchase had spread, and one of the day's favorite bits of speculation was whether or not he would have a job come Monday morning.

Of course, the Signal Corps and all its local weather stations came in

for verbal abuse as well. "I could have told them it was going to rain," scores of Civil War veterans announced loudly. "My leg hurt like it always does before a storm."

Others pulled out frayed copies of H. H. C. Dunwoody's 1883 best-selling book, *Weather Proverbs*, and proclaimed it the best way to predict the weather. The more pious reached for their family Bibles when the subject of predicting the weather came up, and quoted Job 37:16: "Can any understand the spreadings of the clouds?"

Naturally, some people did venture out. No matter how threatening the weather, there are always those restless, bored, foolish, or curious enough to chance fate. Families went for scheduled visits, and kids played in the courtyards, alleys, and streets near their homes — at least until a hard, cold rain drove them indoors in the afternoon.

Almost all restaurants, theaters, shops, concert halls, and other commercial businesses were shut tight on Sunday, the result of strict Sabbath laws. New York City's reform mayor, Abram Hewitt, had managed to get special licenses for a limited number of cafes, clubs, and music halls, and these places were jammed that night. Also busy were the many illegal beer halls and slop houses, where food and drink were inexpensive and a stove might give off some heat.

A day like this was always hardest on the poor. Those in unheated rooms either put on several layers of clothing to fight off the damp chill, or they stayed in bed. With few people wandering about, beggars had little chance to get the nickels and pennies necessary to buy a meal. Homeless children sought refuge in the hallways and cellars of tenement buildings, while hungry adults lined up at private charity shelters for soup and bread.

As the day progressed, the rain became heavier and the wind more fierce. By 3 P.M. Sunday, the giant storm system stretched from Canada

down to Virginia, with the front cutting right through the middle of Pennsylvania. The front continued to move east until it reached the coast, where it slowed to a near stop, held in position by a mass of freezing Canadian air.

The center of the storm hung off the coast of Virginia at 10 P.M. Around this center, winds moved in a counterclockwise direction, which sent a cold gale out over the Atlantic, where it gathered up moisture. The mix of frigid air and warm water caused the moisture to condense and fall as either an icy rain or snow. At the same time, hurricane-force winds developed.

The change on the ground was sudden and dramatic. Heavy rains deluged Norfolk, Virginia, and Philadelphia. The same intense rain hit New York City, but here the temperatures had dropped to the freezing point. The wind-blown rain quickly covered streets, sidewalks, buildings, elevated railroad tracks, and lampposts with a dangerously slippery coat of ice. In the New England states, temperatures plummeted between 10 and 20 degrees in an hour, and moisture fell as snow whipped about by savage gusts of wind.

It all happened so suddenly that many of those who had ventured out earlier in the day found themselves trapped in a wild storm. James Algeo, his wife, and four-year-old son

When the rains began to fall, these homeless boys had nowhere to go but to this coal cellar under the sidewalk. (AUTHOR'S COLLECTION)

As the storm begins, a wealthy man and his wife try to ignore a poor family warming themselves over a steam grate. (AUTHOR'S COLLECTION)

were in the Bronx visiting friends when the weather changed. Even though a heavy rain was falling at 8 P.M., they left for home anyway.

A thick buildup of ice made the streetcar jump the tracks several times, while slippery rails forced the elevated train to crawl along. The worst part of the Algeos' journey was the two-block walk from the station on 86th Street to their front door. A vicious wind-driven sleet slashed at their faces, numbed their fingers, and caused them to slip and slide all over the icy sidewalk. The trip to the Bronx had taken one hour; the return journey was a hard four-hour trek. When they stumbled inside at midnight, James remembered that a fine snow had just begun to fall.

Despite the severe storm, many people still had work to perform. Train engineers and conductors, the operators of horse-drawn cars, doctors making house calls, telegraph operators, ministers, priests and rabbis, bridge operators, police and firefighters — in short, the thousands of individuals who kept the cities and towns safe and running smoothly — had to brave the storm.

At the time, farmers still made up the single largest group of workers in the United States. Even though factory and office jobs were drawing an increasing number of people to urban areas, over half of the nation's population lived in the country.

Out on Long Island, for instance, seventy-year-old potato farmer Sam Randall had left his plow in the barn that day and stayed indoors whenever possible. But Sam had several cows, plus his plow horses and chickens, to feed and water. Three times that Sunday, he bundled up and hurried through the icy rain to the barn where his animals were sheltered. It was only 150 feet from his back door to the barn, but he was soaked through to the skin by the time he got inside.

The men at the New York City Weather Station had work to do, too. Chief Elias Dunn, Sergeant Francis Long, and the rest of the staff dutifully arrived at the Equitable Building at 5 P.M. sharp on Sunday and began collecting fresh data. The team was instantly aware that something calamitous was in progress: All telegraph contact with Washington was dead. What was going on down there? they wondered.

William Inglis could have given them some idea about what was happening — and what was on the way. Throughout the morning and early afternoon, the pilot-boat captains had watched the storm moving closer. Then, suddenly, the wind shifted to the northwest, wind velocity increased, the temperature dropped, and a blinding snow enveloped them.

The *Colt* now bounced and swung about on the roiling ocean, with captain and crew battling to keep it from rolling over and flooding. To his painful moaning, William Inglis added a new activity — praying.

It wasn't just ships far out at sea that were getting pounded. Down in Lewes, John Marshall was woken from a deep and peaceful sleep by shouting on the road below his window. "To the pier," voices were calling out in the dark. "Hurry! To the pier!"

Marshall glanced out his window. Through a thick, wet snow he could make out the shapes of men running frantically along Kings Highway toward the beach. He dressed quickly and dashed after the slicker-clad figures, barely able to keep his footing on the icy road.

Once at the pier, he saw immediately what had happened. The sudden, violent shift of wind had caught thirty-five ships in the breakwater by complete surprise. Tall masts had snapped like matchsticks and heavy anchor chains strained under the pressure of the thrashing ships, then broke. Before the crews could respond, steamships, schooners, and tugs were bobbing freely and smashing into one another like toys in a child's bath.

As Marshall and 200 others on shore watched, a tug hit the pier and sliced right through the massive timbers. The heavy surf then picked up the boat and tossed it onto the beach. A second tug hit the pier in another spot. This tug's captain managed to get his engines going, but as he backed away, he struck the steamship *Tamesei* and both vessels began to sink.

Some *Tamesei* crewmen leaped to a small portion of the pier nearby. This was the outermost part of the pier, 1,500 feet from land, and on the verge of collapse. But to the men of the *Tamesei*, it was better than being on a sinking piece of metal.

Meanwhile, the tug *Protector* saw what had happened and valiantly

The beach at Lewes is littered with debris from ships, while a two-masted schooner wallows in shallow water. The Lewes Lifesaving Station is in the center left of the photo. (DELAWARE PUBLIC ARCHIVES)

chugged in to rescue those on the sinking tug. Most of the tug's crew (and this included the captain's wife) were able to leap to the safety of the *Protector*'s deck. Then, as the tug went under, a wave swept the mate and one crewman into the water. Luck was with them. The churning waves carried them along until they were close enough to the pier to be pulled to safety by those already there. Another vessel would ram the pier later in the night, and some of its crew would also find refuge on the shaky pier pilings, bringing the number of outcasts there to eleven.

From the distant shore, this drama was nothing but a series of murky silhouettes, accented by the thudding boom of ships crashing into one another and the distant, plaintive cries of the men for help. Rescuers could do nothing for them. A boat would have to be sent to save them, but with the waves running 15 feet high, this was a job for

the professional lifesavers and their self-bailing surfboat. Unfortunately, the crew from Lewes was miles away, rescuing survivors from the seventeen schooners and freighters that had already gone aground.

John Marshall and everyone else did what they could, hauling scores of seamen from the frothing water and aiding the injured. Eventually, the men from the Lewes Lifesaving Station arrived and commenced their work. In all, the lifesavers rescued forty people at the Lewes breakwater, including all eleven men frozen to the pilings. Twenty-two men fell into the churning waters and were lost.

John Marshall wasn't able to witness the final rescues. His clothes soaked through, his face raw and cut from the flying sand, the young man made his way back to his host's home to change and pack. He had witnessed the awesome power of nature firsthand and seen how helpless humans were in the face of the storm's wrath. He'd also observed courage and bravery beyond description, and, yes, miracles. There was no doubt that God's hand had played a part in the rescues, but he had to wonder to what purpose God had sent the awful storm in the first place.

With these thoughts in mind, John Marshall boarded a train bound for Princeton, along with four other passengers. The train chugged ahead for a few miles, then came to a bone-jarring halt. The winds had pushed a giant wall of snow over the tracks, and the train had rammed it so hard that every car was completely covered. Marshall found himself trapped, much like the helpless seamen had been trapped on the pier, in a snowbound prison.

Over 400 miles away from Lewes, another drama was unfolding. The New York *Flyer* carrying seventeen-year-old Sara Wilson left Buffalo at precisely 5 P.M. On time, of course. The sky to the south was dark and threatening, but the conductor was confident that they would reach

New York's Grand Central Depot at the scheduled time of 7:30 A.M. Monday. Sara settled back into the big, comfortable passenger chair and opened her book.

She may have appeared calm and relaxed to others in the car, but Sara was really a bundle of emotions — nervous and excited, eager and apprehensive. This was her first trip on a train and her first time away from home on her own.

Less than an hour after leaving Buffalo, rain began splattering against the windows. The cars were buffeted by strong winds, and passengers could see the passing trees being whipped back and forth in a wild dance. When the rain increased to a downpour, talk in the parlor car took on an uneasy edge. Still, the conductor was able to announce with confidence that the train was running on schedule.

Sara tried to read, but the swaying of the car and fatigue won out, and she was soon asleep. Hours later, she woke to find the world outside her window changed. The rain was gone. In its place was a thick snow that had turned the landscape white. The engineer had also reduced the speed of the train to a crawl, afraid that he might hit an unseen stalled train. By morning, Sara's train was five hours behind schedule and had not even reached Albany.

Sara and the other passengers watched with growing alarm as the train plowed ahead cautiously. The wind was whirling the already fallen snow into tornadolike snow devils or pushing it into bigger and bigger wavelike drifts. Two miles outside of Albany, the engineer spotted a monstrous snowdrift ahead and made an instantaneous decision. He pushed the throttle forward, hoping to smash his train through.

There was no warning for the passengers to brace themselves. When the train hit the snow, Sara was looking out the window, while other people were reading, chatting, snoozing, or strolling about the car. The

engine sliced into the bank of snow easily, but then it seemed as if a giant hand had clamped its fingers around it. The train stopped so abruptly that the parlor car leaped from the tracks and passengers went flying. The engine was almost entirely covered with snow and stuck fast.

None of the passengers was seriously hurt, but that didn't mean they were out of danger. The crash had toppled over the iron stoves used to heat the cars, spewing red-hot coals in every direction. Several men tried to stamp out the flames, but the fire spread quickly, jumping from the carpet to the drapes to the ceiling. In a matter of seconds, one end of the beautiful parlor car was engulfed in flames, and passengers were scrambling to get out the door at the opposite end.

Sara was dragged to her feet by a gentleman passenger and led to the exit. Before leaving, she grabbed her fashionable Empress Eugénie hat with its long red feather. All passengers and crew — forty-seven men and five women — escaped and now found themselves in a driving snowstorm, watching the train being consumed by flames.

It was obvious that they couldn't stand out there very long. But in which direction should they go? The conductor pointed up the tracks and said Albany was only two miles away. It was so close, he told them, that on a clear day they would be able to see the church spires from where they stood. So they divided up into groups of four and set off, with the train crew breaking a trail for the others.

At first, the journey went smoothly because the snow was only a few feet deep beyond the big drift and the trail easy to follow. Within minutes, however, the spirit of adventure vanished. Most of the travelers weren't dressed for the bitter cold, and their leather-bottomed shoes made walking difficult. As the snow became deeper, walking grew more and more fatiguing.

Sara floundered along, trying to keep up with her group. At one

Many trains derailed while attempting to plow through giant snowdrifts.
Workers in Naugatuck, Connecticut, have dug out this particular wreck,
and now must haul it back onto the tracks before passenger service can
resume. (FAIRFIELD HISTORICAL SOCIETY)

point, she stumbled and found herself stuck in snow that was waist-deep. A man came back to pull her out and she went on, exhausted. Later, the men helped her as best as they could and each took a turn carrying her. Soon, however, they found their own strength failing and their thoughts completely taken up with their own survival. They set her on her feet and urged her to keep walking. Then they disappeared into the blinding snow ahead.

Sara was alone now, with nobody to call on for help. The wind slapped at her face and roughly shoved her around. Her long blond hair froze, and she lost feeling in her toes and fingertips. Her mouth was open, gasping for air, and she probably closed her eyes during her final few steps.

The body closes down as hypothermia sets in, and it seems a little like going to sleep. The senses grow numb, pain begins to recede, and the thought process becomes cloudy and unfocused. If Sara called out for help, it was a feeble call. If she tried to walk, her legs did not respond.

At some point, Sara ran out of strength entirely and stopped moving. Snow and ice clung to her clothes, hair, and face as if she were a statue in a park. Then the icy figure toppled over backward. Her will to struggle, to push herself up and keep moving, was gone. She lay there as if she were on the softest of featherbeds.

Immediately, snow began to cover her face and body as well as the hat she had clung to throughout her ordeal. Soon, only the red feather poked through the snow, and then it, too, disappeared. The storm was only a few hours old, really, just a baby, and yet it had already claimed dozens of victims.

THREE
THE LAND IS AN OCEAN OF SNOW

On Monday, March 12, people from Delaware on up to Maine, and inland as far as the Mississippi River, woke to discover a white and hostile visitor lurking outside. A blizzard was rattling their windowpanes and piling up snow against their doors.

A blizzard is defined as any storm where snow is accompanied by temperatures of 20 degrees Fahrenheit or lower, plus winds of at least 35 miles per hour. During the Blizzard of 1888, temperatures often went below zero, and winds were clocked at 75 to 85 miles per hour. Many newspapers nicknamed the storm the Great White Hurricane.

The exact origin of the word *blizzard* is disputed and debated. The English claim it came from the common Midland expression "may I be blizzarded," which, roughly translated, means "I'll be damned." The notion is that the astonished speaker has been knocked over by an icy blast. Others say the word is derived from the German *blitzartig*, which means "lightning-like."

In the United States, some insist the word came from an old western phrase "to be blizzarded," or struck many times by violent punches.

A few curious individuals experience a snowy scene on Joralemon Street, Brooklyn. (NEW-YORK HISTORICAL SOCIETY)

And we do know that in Tennessee and Kentucky, the word is used to refer to a period of intense cold, even without wind or snow.

Whatever its origin, the word *blizzard* certainly fit what was happening to the northeastern coast that morning. As temperatures plummeted, the wet snow changed into tiny, sharp particles of ice that ripped at any exposed skin. A Philadelphia resident remembered how "the snow would follow breath into his lungs and fill them with water, nearly choking him."

An Albany *Journal* reporter struggled through the howling wind and snow to his paper's offices where he wrote: "In truth the land is an ocean of snow. . . . The city looked dead and was literally buried."

His city may have appeared lifeless, but in fact there was a great deal of activity going on. Monday was the beginning of the week, which meant work and school for hundreds of thousands of people. Bank presidents, chambermaids, store owners, factory workers, telegraph operators, students, schoolteachers and principals, Western Union messengers, blacksmiths, and newspaper deliverers alike set out that morning just as they did on any other workday. This was true in big cities such as Albany, Boston, Buffalo, and New York, and in the many smaller towns and villages in between.

Milkman William Brubacker was one such person. When he awoke at 1:30 A.M. Monday morning, a hard, vicious snow was pelting his house in downtown New York City. But Brubacker never hesitated. His customers expected to find their bottles of milk and cream waiting as always, and he had no intention of disappointing them.

After hitching up his horse and wagon, Brubacker went to the Hudson River, where he crossed to Jersey City on a ferry. There he met the milk train, loaded his wagon, and returned to New York City to begin his deliveries. By this time, it was 5 A.M. and Brubacker was already two hours behind schedule.

Dutifully, he followed his usual route, going up one slick cobblestone street and down another, making every stop just as he would on a normal morning. Often, the milk boxes were hidden by drifts of snow and sealed tight by ice, so William had to dig them out and chip away till the lids opened.

At 10 A.M. that morning, he had only covered about half his normal route when painfully cold ears and exhaustion forced him to stop at a

saloon to warm up. He gulped down a glass of whiskey and was preparing to leave when the bartender told him he looked awful. "He made me walk the floor for ten minutes and I had another drink. I began to realize myself that I did not stop any too soon."

At the time, a glass or two (or more) of whiskey was considered the best medicine to fight off cold and frostbite, and was liberally administered to men, women, and children. Never mind that it often left the patient intoxicated, or that the illusion of warmth the liquor provided often prompted a drunk to stagger back out into the storm.

Reluctantly, but wisely, Brubacker turned his horse and wagon around and went home, where he stayed for the next four days. Later, he would recall that long before he understood the danger of the storm,

A horse and carriage struggles along 14th Street and Fifth Avenue during the early part of the storm. (NEW-YORK HISTORICAL SOCIETY)

his horse had turned toward the stable three times. "He had more sense than I," William concluded.

Another group who made it to work were the men of the New York City Weather Station. Sergeant Francis Long was the first at the station, but soon his boss, Chief Dunn, and all the others arrived.

The day before, they had to deal with no communications from Washington or any of the other local weather stations. Today, they found that the machine to measure wind velocity, the anemometer, had frozen stiff. Fixing the instrument seemed out of the question. It was screwed to the top of a four-inch-wide pole that was affixed to the rooftop tower, nearly 200 feet above the sidewalk. Chief Dunn estimated that the wind gusts were "75 miles an hour in a driving spiculum of snow and ice."

Sergeant Long stepped forward and volunteered to repair the anemometer. At first, Dunn refused to let Long risk his life, saying, "You are too heavy a man. The pole will snap and I will be responsible for a dead man." "Sir," Long replied, "it will be at my own risk."

After a few more minutes of discussion, Chief Dunn relented. "[Long] climbed that slim pole without any support," Dunn would say in a report, "adjusted the instrument and replaced some wiring with one hand. . . . The wind pressure was so great that it was most difficult for one to stand up, even by holding on, and impossible to get one's breath if facing the wind. Long was nearly frozen, but still he kept on until the instrument was in proper working order. It was a most heroic act. . . . The principal record of the storm would have been lost had it not been for Francis Long."

Long never wrote about this incident, and he never spoke very much about it, either. He continued working at the weather station for another twenty-eight years, and eventually became chief forecaster. For

The railroad cuts into New York City trapped many trains and their passengers. Here, a long line of passenger trains sit helpless as snow piles up around them. (AUTHOR'S COLLECTION)

Sergeant Long, climbing a wobbling pole in the face of a blizzard was simply a part of his job.

Habit and duty were some of the reasons so many people risked death to show up for work. Everyone at the weather station, for instance, was a member of the U.S. Army; it was their sworn duty to be there. Add to this the fact that a true blizzard rarely visited the East Coast area. People simply did not understand the dangers it posed. Many "hardy individualists" — almost all of them men — looked at the storm as an inconvenience that sheer determination could overcome. Former senator Roscoe Conkling certainly did.

Conkling was a tall, powerfully built man who was an imposing figure even at age fifty-eight. He'd been through some nasty political battles during his career, so a little snow and wind wasn't going to stop

him from walking the twenty-five blocks from his home to the court-house.

Only no one else showed up in court — not the judge, nor the plaintiffs, nor the defendants; not even the other lawyers. Disgusted, Conkling left the courthouse and trudged off to his law office to write letters.

If a few — like Long and Conkling — defied the storm without much trouble, many more felt its bite. A. C. Chadbourne had left Boston the night before on the New Haven Railroad with his business partner, headed to New York City. "I awoke at 7 a.m. . . . and found the train stalled in deep snow at about 127th Street. I got out the car door and saw a line of cars and trains stalled ahead of me as far as one could see."

Chadbourne and his partner decided to abandon the train. "There were some stone steps thoroughly snow covered leading . . . to the

sidewalk. Down these steps we slid, landing in a snowbank at the bottom which buried us alive. Great drifts were piled six to eight feet high in many places and the air was so full of snow it was difficult to see where one was going."

At this point, they should have sought a local hotel to wait out the storm. They were eighty-nine blocks away from the hotel where they usually stayed, a distance of over four miles. But they were focused on the important business deal they hoped to make that afternoon and had no intention of being late. So they pressed on.

They hadn't gone very far when they came upon one of the few clothing stores open that morning. There they bought six pairs of socks and two large handkerchiefs. "We put on the thin woolen socks," Chadbourne remembered. "[Then] we pulled the coarse woolen socks over our shoes, tucked our trousers in them and tied the socks around our ankles with a cord to keep the snow from working down into our feet. We tied the handkerchiefs over our heads and under our chins and then pulled our silk hats as far down our heads as possible. The two other pairs of socks we pulled on over our gloves in place of mittens. . . ."

Their outfits looked ridiculous, but they did protect the covered areas from the numbing cold. The wind was another matter altogether. As they set off again, Chadbourne recalled, "There was a heavy gale blowing. I remember seeing my partner blown helplessly almost a block, his travel ended by falling into a snow drift which completely covered him."

After rescuing him, the two continued their stumbling, sometimes tumbling journey down Third Avenue. Strong gusts of wind tore wooden gates from their posts and store signs from buildings. At one point, Chadbourne and his friend turned a corner and "narrowly es-

caped death . . . [when] a wooden fence was blown on us while wallowing in a deep drift."

Many other things were being blown about as well. Like most cities back then, New York had no antilitter laws, so newspapers, household trash, bits and pieces of debris, broken glass, and ashes were routinely tossed into the gutter without thought. Add to this a daily deposit of two and one-half million pounds of manure and 60,000 gallons of urine from the city's 60,000 horses! All of this garbage hardened into chunks that were picked up by the wind and slapped into travelers' faces.

Whenever possible, Chadbourne and his partner would duck around the corner of a building to find a bit of shelter from the wind. Despite such energy-saving measures, the men were barely able to stay upright as they neared their destination, the Gedney House on 38th Street. "I distinctly remember being blown down twice while crossing Broadway and crawling through the snow on my hands and knees [to the opposite] sidewalk."

Once safe inside the hotel, Chadbourne saw for the first time how the storm had transformed them. "My partner looked terribly, his mustache was a wabbly cake of ice which had pounded on his chin as he walked until [it] was bleeding. My face was scratched, red as a lobster, my eyebrows were frozen and my chin was resting on a cake of snowy ice packed between the top of my overcoat and my bandanna handkerchief."

While Chadbourne and his partner had chosen to brave the storm, most people who attempted to get to their workplaces on Blizzard Monday did so out of fear. There were few laws in place that spelled out a worker's rights or protected him or her in any way. Business owners and their managers assumed that if they could get to work, all of their

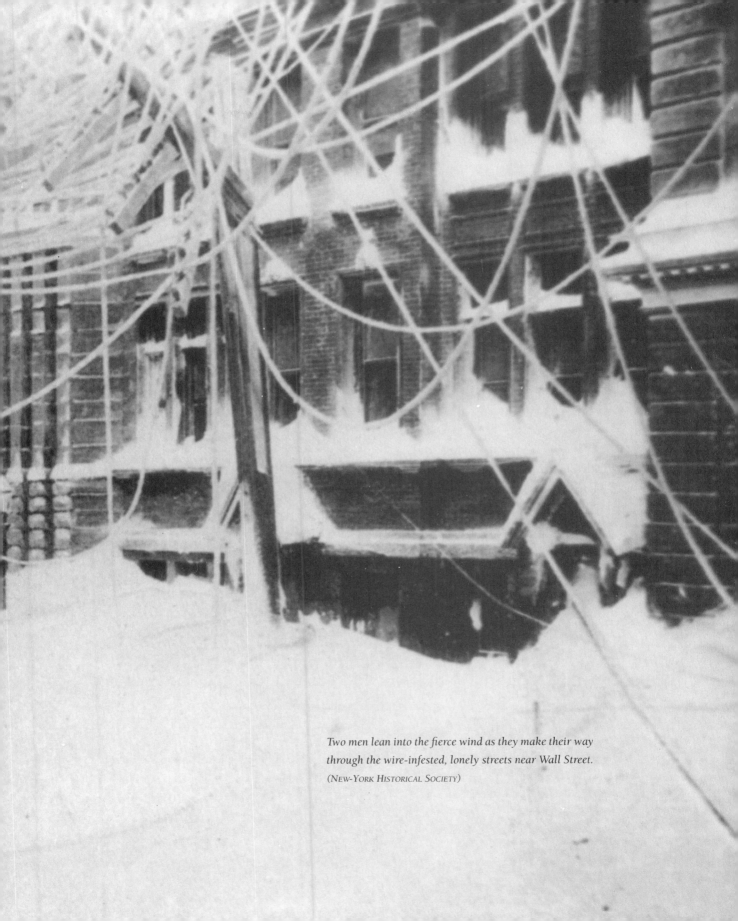

Two men lean into the fierce wind as they make their way through the wire-infested, lonely streets near Wall Street.
(NEW-YORK HISTORICAL SOCIETY)

employees should show up as well. Workers were routinely fined for being late or absent.

Job security had become even more fragile in 1888, when a severe economic depression resulted in the nationwide layoff of more than 100,000 workers. Those lucky enough to have jobs knew they could be replaced very easily. Fourteen-year-old L. B. Aspen walked over sixty blocks to his job. "I did not want to take a chance of losing it," he would explain. "Jobs those days were hard to get — even office-boy jobs."

Eighteen-year-old May Morrow would have preferred to stay inside her warm boardinghouse room on West 47th Street, but she was fairly new at her job and insecure. Besides, she was the telegraph operator for a small wholesale chemical company and vital in the day-to-day operation of that business.

So May left home extra early that morning and managed to catch a slow-moving elevated train — one of the last still running — at Ninth Avenue. The ride seemed to take forever, but May managed to arrive just a few minutes late. No one else showed up for work that day except the head of the firm, Mr. Garrigues. May wasn't upset by the inconvenience; by showing up, she had proved to her boss that she was a dedicated worker.

James Algeo had felt the power of the storm the night before, but he still made sure he got to his job at the American Bank Note Company on time. Only forty other workers of the 1,200 employees braved the weather that day. Over at the Customs House, one-third of the workers arrived, almost all of them women. The employment of female customs inspectors was still in the experimental phase at the time and many of the women felt their jobs were vulnerable.

At the Singer Sewing Machine factory in Elizabeth, New Jersey, 1,800 of the 3,200 workers arrived before the late whistle sounded.

Among those at work that day were seventeen-year-old James Marshall and two of his friends, Alexander Bennett and Charles Lee. All three lived on Staten Island and traveled from there to Elizabeth in a jointly owned rowboat.

On Blizzard Monday, they met as always at the boat landing and set off across Newark Bay, a journey of about one-half mile. They had made the crossing in all sorts of weather, so the hardy young men were not about to let the snow stop them. They were 150 feet from shore when it became clear that this was no ordinary storm. The wind batted their little boat around and the choppy waters splashed them until their faces began to ice up. They were about to turn back when the wind shifted and actually helped push them across the Bay. They arrived at the factory on time.

Even young children wouldn't let the obvious power of the storm get in their way. In Brooklyn, ten-year-old Rufus Billings announced at breakfast that he intended to go to school. His parents tried to talk him out of this reckless adventure, and even hid his boots, but young Rufus was determined. He found his boots and plunged out into the storm before his worried parents could stop him.

A dozen other students were already at the school when Rufus arrived. The only problem was that the door was locked. No adults had made it — not the principal, teachers, or the janitor. Still, these children had no intention of giving up. They huddled at the front door for an hour and only went home when the principal finally appeared and officially proclaimed school closed for the day.

Another very determined child was ten-year-old Sam Strong, who lived in Harlem with his aunt and uncle, Mr. and Mrs. Charles Green. Sam didn't have to fight and argue to go outside. His aunt actually gave him a list of items she wanted him to buy at Brady's notion store before

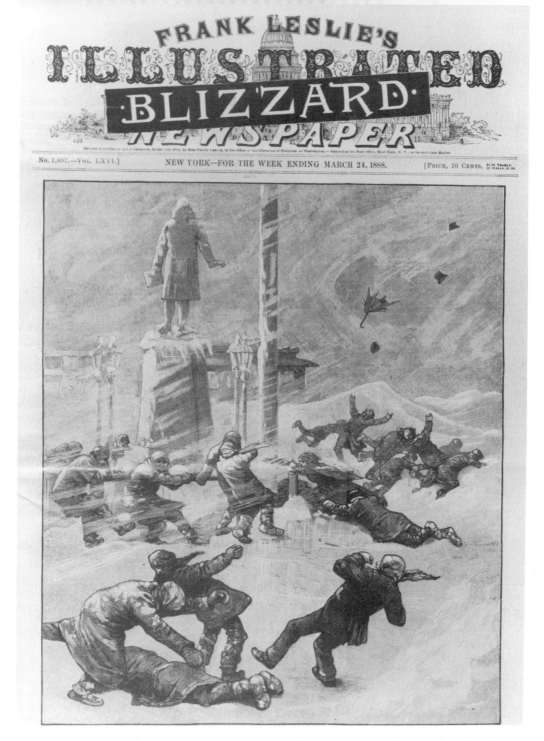

FRANK LESLIE'S
ILLUSTRATED
·BLIZZARD·
NEWSPAPER

No. 1,697.—Vol. LXVI.] NEW YORK—FOR THE WEEK ENDING MARCH 24, 1888. [Price, 10 Cents.

Hats and umbrellas go flying and pedestrians twist and fall in the hurricane-force winds produced by the Great Blizzard. The only thing standing tall and straight is a statue in the background. (Museum of the City of New York)

going on to school. Among the things he was to get were whalebones, dressmaker's chalk, and a large needle, so his aunt could sew herself a new corset.

Sam glanced out the front window and saw a man get blown over by the wind. He also noticed that the front gate was completely covered by a five-foot-tall snowdrift. When he said something about this to his aunt, she made him wear his high rubber boots, a heavy overcoat, woolen cap, gloves, and a muffler. "There," she said as she buttoned up his coat, "you could go to the North Pole in that outfit. Hurry up now, so you won't be late for school."

At first, Sam liked the experience of being outside in a wild storm, fighting his way through belt-high snow and fending off the wind. His aunt and uncle had instilled in him a strong sense of self-reliance and duty. He had been told to go to the store and then to school, so he was going to do both, no matter what the consequences.

Several blocks later, Sam came face-to-face with the violence of the blizzard. As he was crossing an intersection, the wind was on him like a wild animal. It picked him up and tossed him into a deep snowdrift.

Sam struggled and clawed to get free of the snow, but he was in over his head. The more he moved, the more snow fell on top of him. He shrieked for help, but no one heard him above the wind's mighty roar. His boyish romp had turned into a frightening trap in just seconds. Finally, just as his strength was about to give out, a policeman came along and yanked him free. "You hadn't ought to be out in this, Sonny," he recalled the policeman telling him. "You go straight home."

But Sam didn't go home. More determined than ever, he pressed on, going down 125th Street, past abandoned wagons and carriages. A cable car being pulled by four horses struggled along at a feeble pace, while the few other people out that morning were hunkered over

against the icy gusts. "When I could get down out of the cutting wind behind a snowdrift, I was all right," the boy recalled, "but traveling took every ounce of power in my body."

When he finally reached Brady's, he discovered it closed, the front door and window covered completely by a giant snowdrift. Instead of giving up, Sam continued along the street for several blocks, hoping to discover a store — any store — open. There were none.

At this point, he stopped a fellow traveler to see if the man knew where he could purchase a corset needle. The man had no idea where to get the needle, but he did teach Sam something else. "[I] learned a few new and attractive profane expressions to add to my already fair vocabulary of cuss words, and with his help I about-faced and started the homeward trek."

If anything, his return journey proved more treacherous. The drifts seemed to have grown enormously in height; the snow seemed sharper, the wind more cutting. Sam, like thousands of others, would later come to realize that as fatigue set in, obstacles he had handled fairly easily before were now much harder to deal with. Six times Sam got stuck in the snow and six times he had to be pulled to safety. Finally, at around noon, he clawed his way up his front stairs and tumbled into the vestibule.

Neither his aunt nor his uncle — who had stayed home from work — said anything harsh to the boy. It was Sam who was upset. "Although I had fought the snow for more than four hours, I had failed in my mission. There were many tears. . . . I [went to] bed with glass bottles filled with hot water, a big slug of raw whiskey, and some food, and I was asleep, not waking until night and then only for more food and drink. I was exhausted."

F O U R

THIS IS ALL SO OVERWHELMING

Chauncey Depew arrived at the Grand Central Depot on Monday with one goal in mind. As president of the New York Central Railroad, he was determined to keep his trains running. What he found that morning did not make him happy.

Normally, Grand Central was the busiest terminal in North America, with hundreds of trains scheduled to arrive and depart every day. On Blizzard Monday, the immense building was uncomfortably quiet. A New York *Sun* reporter noted that "The interior of the station and the yard immediately outside . . . were as silent as the grave. . . . No sound was audible in the great structure save that of the moaning wind."

Upstairs in his office another sort of silence greeted Depew. The telegraph lines — which usually clicked away with reports on the weather and other related railroad information — were all dead quiet. Depew had no idea where his trains were or of the extent of the problem the storm was causing.

Depew was not the sort of man to lounge in his office fretting. He had succeeded the late William H. Vanderbilt as president of the

railroad, and Vanderbilt was a man who did not let anyone — or any-thing — stand in his way. Those were big shoes to fill, but Depew was determined to battle the snow head-on.

It was obvious that somewhere up the tracks a train or trains were stuck and blocking all other inbound trains. Workers were sent out on foot to find out where those trains were. Next, Depew began consider-ing the best way to clear the track.

Obviously, the snow was too deep for an engine to simply push its way through. Otherwise, some of the early-morning trains would have made it to the station. Depew also assumed that the plows the railroad had were too small to do the job. That left Depew only one option — moving the snow by hand.

In the railyards just behind Grand Central Depot, a crew of Italian laborers shovel snow into coal cars for disposal. (NEW-YORK HISTORICAL SOCIETY)

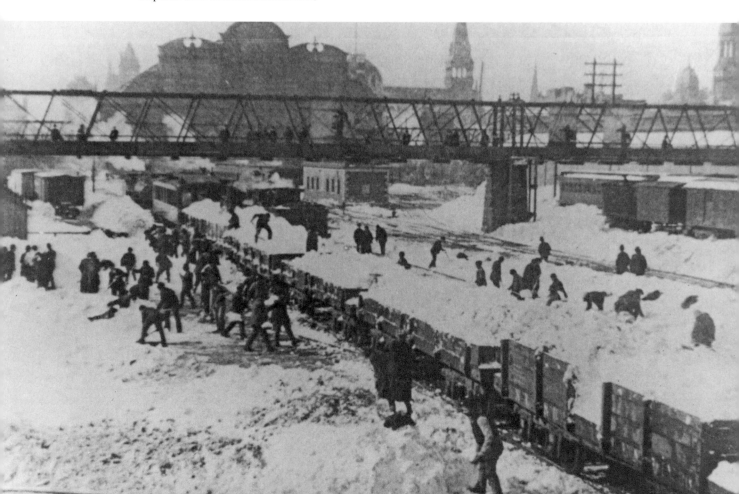

After consulting his assistants and several experienced trainmen, it was decided to hire day laborers to do the job. Despite the fact that shoveling snow in a raging blizzard was hard, dangerous work that paid very little — just $1.20 for a ten-hour day — finding men was easy.

At the time, between 5,000 and 10,000 immigrants were pouring into the United States every day, almost all of them poor and desperate for any sort of work. In the past, the Irish would have answered Depew's call. But in 1888, the largest number of immigrants came from Italy.

Messengers went into the Italian neighborhoods, stopping at church parish houses, charity missions, saloons, and other gathering places to spread the word. Within a few hours, an army of 1,000 Italian workers had been assembled, most of them wearing the thin coats and gloves they had brought from Italy.

The train closest to Grand Central was the Boston *Express*, now imprisoned in a mountain of snow at the 59th Street cut, some fifteen blocks away. A cut is any section of exposed track that runs below the level of the surrounding ground, for example, where the track slices through a hill. Blowing snow fell into these long, narrow slits and piled up, sometimes filling the entire cut.

Six hundred Italian workers descended on the 59th Street cut and began hacking away at the frozen mound of snow. Some removed snow from around the engine, which was almost completely buried, while the rest began clearing the tracks ahead.

Meanwhile, up the tracks at the very top of New York City, 400 other workers faced an even greater challenge — freeing trains at the Spuyten Duyvil cut. This particular cut was 500 feet long and 150 feet deep and had a sharp curve in the middle of it. A commuter train had hit a wall of white at 6:30 A.M. and been buried ever since. The Peekskill local with eight cars stopped behind this first train, then came two long

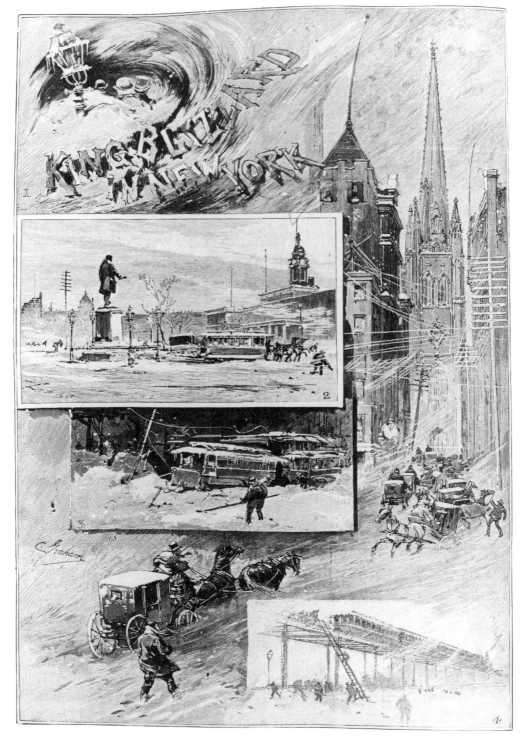

This page from a special "Blizzard Edition" shows how the storm tied up all forms of transportation.
(AUTHOR'S COLLECTION)

trains carrying passengers from the West. In no time at all, eight trains were stuck fast one behind the other in a line over a mile long.

The rock walls were tall and close together at the Spuyten cut, which made digging a difficult chore. In addition, with so little space on the sides, snow and ice had to be carried outside the cut before it could be thrown clear of the tracks.

The Italian laborers went at the snow with great energy, chipping and hacking at it as best they could. The wind shrieked and roared between the walls of the cut and was so strong that at times it tore the wide shovels from the workers' hands.

After clearing eight feet of track, they hit icy snow so solid that the shovels bounced off harmlessly. Picks and axes were brought in, but another hour of assaulting the iced snow produced only 15 feet more of cleared track. No matter how quickly the men worked, snow cascading over the edge of the cut continually covered up the track.

Word about the losing battle was sent back to an increasingly frustrated Depew. Besides the ghost of Vanderbilt to nag him about his failure to keep the trains running, another force was being heard from as well. At around noon, Frederick Van Wyck, a wealthy friend of Depew's, sent a note saying he was trapped just outside the city, and asking if Depew could get his train unstuck. In addition, Harrison Twombly (the son-in-law of Mr. Vanderbilt) was sending frantic messages that the 4 A.M. milk train had failed to appear and that his children needed milk urgently.

Depew knew that this was just the beginning of the complaints. As the New York *Sun* reporter would write, "Most of the unfortunates who were caught in the local trains were wealthy brokers and businessmen, and [Mr. Depew] smiled sadly as he thought of the wrath that would come down upon him from these patrons of his road."

As the snow piles up on the street in front of the Scientific American Building, horsecars, wagons, and pedestrians struggle to keep moving. (AUTHOR'S COLLECTION)

Depew fretted and fumed throughout the day, but it did little good. One of the greatest railroads in the world had come to a complete halt. Of the forty regular mail trains, only one came into New York City that day. No milk nor meat nor coal shipments arrived at all.

When a reporter asked about the condition of the tracks, Depew finally exploded: "There isn't any road — it has disappeared. There are eighteen trains between here and Yonkers and there is no way of getting them down as yet. . . . The engines are absolutely snowed under." Depew sat back in his chair and finally admitted, "There is no way of telling when trains will move again. This is all so overwhelming. . . ."

Depew might have taken some comfort in knowing that he wasn't the only one stopped by the storm. All forms of transportation in New York City were grinding to a snowy halt. The four elevated trains were shut down during the morning out of fear that ice and wind would eventually send a train over the edge. Fifteen thousand commuters, plus the train crews, were marooned high above the streets in unheated wooden coaches.

The horse-drawn streetcars did their very best to keep moving during the early hours. But fighting the deepening snow and slippery paving stones proved too much, even when four and six horses were used. Most drivers realized they were beaten before noon. Once this decision was made, they unhitched their horses and led them back to the barn, abandoning cars — and passengers — on the empty streets.

By late afternoon, the only form of ground transportation available came from private individuals with wagons, coaches, or sleighs. These men drove their exhausted animals hard to keep them plowing through the chest-high snow. Dozens of horses died that day as a result of the abuse. The possibility of a dead horse did not stop drivers from whipping their animals on. It might cost one hundred dollars to replace a horse, a sizable amount in those days. But by noon, the charge for a trip of two or three blocks had gone up to fifty dollars. Drivers pocketed the money and put their animals at risk.

Many New Yorkers knew that this breakdown in the transportation system shouldn't have happened. One such person was the editor of *Scientific American*, Alfred Ely Beach.

Thirty-nine years before, Beach had grown frustrated by the traffic congestion he encountered every day on his way to work. One study by the *New York Tribune* revealed that over 1,000 vehicles passed by the corner of Chambers Street and Broadway *every hour, for thirteen straight hours*. Traveling on a sunny day was so slow that the *Tribune* complained: "We can travel from New York half-way to Philadelphia in less time than the length of Broadway." Whenever it rained or snowed, travel came to a virtual halt.

Beach's idea was simple and logical: If the streets aboveground were jammed, why not travel underground? Beach's subway train was to run the entire length of Broadway. "The cars," Beach promised, "will stop

ten seconds at every corner — thus performing the trip up and down, including stops, in about an hour."

The idea was revolutionary and many people and newspapers championed it. Unfortunately, New York City was controlled politically by William Marcy ("Boss") Tweed and his allies, and they crushed every piece of legislation for Beach's subway. Why? Because Tweed as the city's commissioner of public works had grown rich and powerful by extorting money from the horsecar and street railroad companies. He had no intention of undermining his chief source of income.

Beach spent two decades trying to win approval for his subway. He even built a 300-foot-long test tunnel and car that attracted 400,000 paying customers in 1870. Even with this obvious success, Beach could not overcome his opponents. As he stared out his window on Blizzard Monday at the abandoned coaches and streetcars, Alfred Ely Beach wondered how things might have been different if his subway system were in operation.

If traveling aboveground in New York City was nearly impossible, just getting onto the island was becoming more and more difficult by the minute. The thirty-five ferry lines linking New York City with New Jersey, Long Island, Staten Island, and Brooklyn struggled valiantly to maintain commuter service. The falling snow cut visibility to a few hundred feet, and large chunks of ice clogged the rivers and landing slips. Still, the sturdy side-wheel ferryboats chugged back and forth all morning, even though whitecaps in the Hudson made for a rough ride. "The river rose like an ocean," one commuter mumbled after a wave-tossed ride.

During normal rush hours, ferries came and went at five-minute intervals. On Blizzard Monday, it was not uncommon to wait an hour or longer. As the day wore on, many ferry captains found they could not

force their vessels through the thickening ice, and were forced to give up. One ferry lost power and was swept down the Hudson to the bay where it nearly capsized, while another collided with a schooner, killing one woman passenger.

The larger, more powerful ferries continued their crossings throughout the day, though with increasing danger. At one point, passengers on a Staten Island ferry looked up to see the schooner *Mary Heitman* bouncing wildly along the water toward them. The five crewmen of the schooner clung to the railings helplessly. After barely missing the ferry, the *Mary Heitman* continued her mad journey to the open ocean and neither boat nor crew were ever seen again. As evening approached, only a few of the largest ferries were still running.

With railroad service suspended and most ferries docked, only one sure route into New York City remained open — the Brooklyn Bridge. In the morning, police barred carriages and wagons from the bridge, fearing the high winds might send a vehicle over the edge and into the river below. The cable car that ran up the middle of the bridge labored to make trips across the structure, as did hundreds and hundreds of walking commuters.

Early in the afternoon, ice caused the cable car to jump the tracks as it approached the New York City side. Workmen struggled to get the cable car back on track, but it took them so long that a winch froze, putting a stop to the cable service.

The station and outside platform were jammed with commuters impatient to pay their five-cent fare to get across to Brooklyn. When they learned that the cable car would not be running anymore, they began to push forward and a riot nearly took place.

At around the same time, police were growing more concerned about the effect the storm might have on the bridge itself. While the bridge

With the bridge trains stalled and the ferryboats
blocked, the only way for these rugged Brooklynites
to get home was to hike across the Brooklyn Bridge.
(NEW-YORK HISTORICAL SOCIETY)

The northern storm hadn't really moved much in twenty-four hours, which meant it was still pumping frigid air into the northern Atlantic states. The southern storm with its strong winds and moisture had already rushed north and collided with the cold air from Canada, producing a mighty blizzard.

had withstood many storms in its five years of existence, the concept of suspension bridges was relatively new and untested. Just ten years before, a suspension bridge in Dundee, Scotland, had collapsed during a winter storm, killing seventy-five people. Worried that the weight of ice and snow and thousands of people might cause a similar disaster here, the police officially closed the Brooklyn Bridge to all travel. Not only was the island of New York City isolated from the rest of the world, but everyone on it was trapped.

In general, people living on farms and in small rural towns fared much better than city folk during the blizzard. Those in the countryside were used to being isolated, especially during snowstorms. Winters of the past — and the wisdom and training of the parents and grandparents of these country people — had taught them to be prepared.

Most farm families had an ample wood supply piled just outside the back door. Root cellars contained potatoes, turnips, carrots, and apples, while smoked meats hung from the walls. There would be shelves lined with jars of preserved fruits and vegetables, sacks of wheat and

corn flour, plus casks of homemade wine and apple cider. Even if they were completely cut off, a farm family could survive for days and weeks with little trouble. Yet the blizzard managed to test many of these people as well.

In Tidewater, Virginia, a farm couple watched with growing alarm as a nearby river overflowed its banks and water began seeping under their front door. As the ground floor filled up, the husband and wife retreated upstairs, bringing along their ten pigs and twenty chickens. This oinking, clucking group would live together on the crowded second floor until the water receded four days later.

A young teacher in southern Vermont wasn't surprised in the least to begin classes that morning with every seat occupied. Deep snow was fairly common in the area and the local people weren't about to let a little bad weather stand in the way of their children's education. So this teacher taught lessons through the morning and into the early afternoon.

He grew worried when the storm increased in ferocity at noon, and then alarmed when he saw that a snowdrift was almost up to the windowsill on one side of the building. He decided to dismiss classes early, though he hesitated to send his pupils out on their own. Some of the children were so young and small that the snow on the ground was already over their heads.

His solution to the problem was as straightforward and practical as the people in the area were: He tied a rope to all fourteen of his students, with him and several of the larger students in front to break a trail. Then he led them out into the storm, going from one child's home to the next until each had been delivered safely. His school day finally over, he went home to milk and feed his cows. It would be three weeks before the roads were clear enough to resume classes.

This schoolmaster and his charges were fortunate. They were young

and healthy, so their bodies could withstand the battering of the storm. Others weren't so lucky. Sunday's rain and Monday's snow had kept Sam Randall away from his fields, but it didn't free him of all farm chores. Late Monday afternoon, as the light dimmed, the elderly man got ready to make yet another trip from his house to the barn. Blizzard or not, the cows needed milking and the other animals had to be cared for.

He put on his heavy coat and hat, took a hurricane lamp for light, and began plowing through the waist-high snow to the barn. He was a hearty man for his age, used to the rigors of farm life and manual labor. Yet the force of the wind combined with the effort of moving his legs forward soon wore him down.

The wind swirled the snow up and around and into Randall's face. He was leaning into the wind, trying to pull his legs along, when he slipped and floundered ahead a step or two. The lantern dropped from his hand and then he fell face first into the snow. He struggled to get to his feet, but the wind and snow pushed and pounded at him and kept him from getting up. He died just 30 feet from the warmth of his own house, surrounded by darkness and waves of snow.

Across the Long Island Sound, in the village of Montville, Connecticut, another drama was unfolding. The Chapell family sensed immediately on Monday morning that the storm raging outside was dangerous, but they had provisions to last many days and weren't much alarmed. It didn't even bother them that Mr. Chapell had spent the night at his ailing mother's farm a half mile away. Mrs. Chapell knew how to run a farm — and keep her four sons busy — in any kind of weather.

Everything went along smoothly until word arrived that Father was himself ill with some sort of fever and asking that his wife come at once. Since her oldest son, Alfred, was doing chores in the barn, Mrs. Chapell put her second oldest son, George, in charge of his two little

brothers, Gurdon, nine, and Legrand, four. Then she set off for Grandma's house.

The three boys in the house did their best to stay occupied, popping corn, playing with toys, and chasing the cat from room to room. By midafternoon, boredom had set in and George announced that he was going to Grandma's. Gurdon and Legrand begged to go along, but George had had enough baby-sitting to last him awhile and told them no. George was in such a hurry to get away that he didn't even bother going to the barn to tell Alfred what he planned to do.

The two little boys watched at the window as George disappeared into a wall of swirling white, then they turned back to their play. Almost immediately, the stillness of the house began to make them uneasy. The ticking of the clock seemed loud and sinister, and the snow hitting the windows sounded as if someone were trying to break in. When Legrand asked what they should do next, Gurdon answered, "I know, we'll go and surprise Mother and Father."

They bundled up snugly, then stepped outside. The force of the storm made them hesitate on the front porch. On a clear day, they could see their grandmother's house from there, even though it was two fields and a pasture away. Today, they couldn't even see the front gate.

Gurdon wasn't about to give up. He had been to Grandma's house many times and knew that only a couple of low stone walls stood between them. So he took firm hold of his little brother's hand and waded into the snow.

Later, Alfred would finish up his chores in the barn and return to find the house empty and dark. No alarm bells went off in his head. He assumed that everyone had gone to Grandma's together and would stay there that night. He might have checked with his parents, but, of course, there was no telephone service as yet in their rural area. It

would not be until the next morning that anyone realized Gurdon and Legrand were missing.

By nightfall on Monday, the center of the storm had barely moved, and icy winds of hurricane force swept across an area from Virginia up to Nova Scotia, Canada. The wind was so powerful that in Liberty, New York, the local train station had its roof entirely ripped off. Down in Baltimore, the gale blew the water completely out of the harbor, while the Delaware River seemed to part in two near Philadelphia.

The heavy snowfall continued and temperatures began dropping. At 6 P.M. that night, thermometers in Northfield, Vermont, dipped to 4 degrees Fahrenheit, while farther south in Central Park, the temperature recorded was 12 degrees Fahrenheit — and falling.

Hundreds of cows stranded in distant pastures froze to death that night, while thousands of birds nesting in the decorative trim of buildings succumbed to the freezing cold and fell to the streets below. A guest of the New York City Hotel at 23rd Street looked out his window and saw "a veritable rain of sparrows falling dead from the eaves of nearby buildings." At the Old London Building, 500 dead birds would be swept up when the storm was over.

The astonishing thing to remember is, that even as night came on and the storm worsened, tens of thousands of workers faced another adventure. They still had to make their way home.

I WENT MAGNIFICENTLY ALONG

As darkness closed in, the majority of people chose safety over comfort and stayed inside wherever possible. In New York City, train stations, ferry landings, churches, police stations, firehouses, and mission houses were packed tight. Every hotel was stuffed full, with five or more people sharing a room and others sleeping in the lobby, hallways, and even closets. One elderly woman had her bed made up in a bathtub and was grateful for her accommodations.

In the countryside, people sought shelter in isolated churches, barns, or chicken houses. Most lucky travelers would stumble up to the first house he or she came to and be welcomed inside without hesitation.

Sometimes a gracious home owner found himself or herself in an awkward situation. One Connecticut farmwife opened her door to six wayward travelers, but discovered she didn't have enough food for a decent meal. Instead of disappointing her guests, she went outside and gathered up a heaping basket of frozen sparrows. Dinner was a bit gamy, but no one complained.

Divinity student John Marshall would have traded places willingly with any of the Connecticut sparrow eaters. The train he had taken out

of Lewes had been packed tight in snow all day, and he and the other four passengers had spent the time talking, playing cards, and writing letters. Reading his Bible had helped John pass a number of hours.

Luckily for John, his train had a large supply of coal for its stove. Many other stranded train travelers found themselves shivering and miserable as coal ran out. The most daring individuals would abandon the shelter of their cars to seek out the nearest village. By and large, train travelers stayed put and found creative ways to keep their stove fires burning — which usually meant burning the wooden seats, car paneling, and wall ornaments. When wood grew scarce, passengers often raided the baggage cars and burned crates, suitcases, and, in one case, the U.S. Mail.

Food was another matter. Like many travelers, John Marshall had

In general, no one bothered to remove snow until a storm ended. One exception was the horsecar companies that battled unsuccessfully to keep their most important routes open. Here, a plow pulled by ten horses clears a busy intersection. (AUTHOR'S COLLECTION)

brought along a small satchel of food to snack on during the trip. When these scant supplies were gone, hunger pangs took over.

Gnawing on ice might fill the stomach for a while, but eventually that stomach would demand real food. Long-distance trains often carried supplies of food and milk, and these would be broken into and consumed. A few railroad companies sent out rescue parties with supplies for their stranded passengers. Trains stuck in the more remote areas often did not see help for two or three days. This lack of concern prompted the Providence (Rhode Island) *Journal* to complain, "It seems that the [train] company intends to . . . let the travelling public work out its own salvation."

John Marshall knew firsthand that the storm outside his train cars was a killing force one person couldn't long endure. He stayed put and endured his growling stomach. He would probably have agreed with the sentiments of a conductor, identified only as Mr. DeWolfe, who was at that same moment trapped in rural Connecticut. "The car was warm and tight," Mr. DeWolfe noted, "but the air began to be very heavy and oppressive. It was like a tomb."

While the majority of people chose to stay out of the storm, the need to get home drove thousands of people right into its sharp teeth. May Morrow had spent the day copying letters, filing, and straightening up the office. Every so often, she would stop what she was doing to watch the storm.

Up and down the street, the poles carrying telegraph, telephone, and electric wires had snapped in two and several had crashed through windows. Once, a strange noise drew her to the window, and she and her boss saw a horse tangled in live high-voltage wires with sparks dancing along its head and neck.

New York City was littered with hundreds of fallen poles and

thousands of miles of dangerous wires. At the time, every electric, telephone, and telegraph company put up its own poles and wires, as did the police and fire departments and private burglar-alarm companies. A law passed two years before required that all poles be taken down and the wires placed underground, but absolutely no one had complied with the order. As a result, poles stretched 50 to 150 feet in the air and carried from 100 to 200 wires each.

After seeing the horse die, Mr. Garrigues decided to close the office and head home. He told May that it was too dangerous for her to go out in the storm, and urged her to stay the night at the office. The stove gave off good heat and there was plenty of wood, he pointed out. Remembering the dead horse in the street below, this seemed like sound advice to May.

Everything went well for several hours, but as the light outside began to dim, the solitary nature of May's situation began to bother her. Deepening the gloom was the fact that the gas and electric streetlights were all out. The lines carrying gas to the lamps ran above the ground and had frozen solid. Eventually, the pull of being with her boarding-house friends won out and May prepared to go home.

Going out into the blizzard required careful planning. People who were able to wore two of everything to fight off the cold. Some fashioned homemade snowshoes to help them walk across the snowy terrain, or wore bags over their heads as protection from the stinging blasts of wind and ice. May removed her bustle, pinned up her long skirt so it was above her boot tops, and used a string to tie her hat in place. For added protection, she tied newspapers around her ankles and chest.

A group of Wall Street stockbrokers surveys the tangled mess of telegraph and telephone wires near their offices. (NEW-YORK HISTORICAL SOCIETY)

Outside, May paused a moment before beginning her journey. She was seventy-seven blocks from home and the wind would be in her face most of the way. Then the thought of staying alone in the office came to her again and she stepped out into the storm.

Instantly, her cape whipped up in her face and she was spun around several times. She had just steadied herself when a stout man in a fur coat came up to her and warned, "Your ears are freezing."

Social customs were very conservative in 1888. A woman was not supposed to talk with a man unless she had been properly introduced to him, and not even the blizzard changed this for May. "Let me pass, sir," she demanded as she pushed him aside and hurried along.

Several blocks later, another man grabbed her and steered her into a doorway. She was about to scream for help when he began rubbing her ears. "People don't realize when their ears are being frosted," he said. May touched one of her ears but did not feel anything at all, which frightened her more than the man did.

The man took hold of her cape and arranged it over May's head so that it would cover her ears but still allow her to see. Then he wished her a safe journey and left.

She proceeded, staying on Broadway for as long as possible, mainly because other pedestrians were trudging along that street. If the company gave her a sense of well-being, there were other sights that made her shudder. At one corner, she saw a man clutching the base of a lamppost and overheard a policeman say that he was dead.

Stunned, May forced herself to keep moving. She probably didn't even notice when she entered what was then the city's theater district. Tonight, the usually gaudily lit theaters were dark and the surrounding streets deserted. Only two plays went on that night and neither drew more than a handful of patrons.

Of course, not even a blizzard could stop the great showman, P. T. Barnum. As scheduled, all eighty-six acts of his circus went on at Madison Square Garden, even though the crowd numbered less than 100. As Barnum himself told his audience, "The storm may be a great show, but I still have the greatest show on earth!"

It was at Union Square that May understood just how savage the storm was. Here, the wind was so fierce it bowled over many pedestrians, especially women in their long dresses. To get across the square, walkers held on to one another's shoulders and went single file.

Onward May plodded, past closed-up and darkened department stores such as Arnold Constable and Lord & Taylor. For most stores, Blizzard Monday had been a complete bust. B. Altman rang up one sale, and that was for a single spool of thread. In fact, the only store that did any business to speak of was E. Ridley and Sons. John J. Meisinger had battled his way to the store that morning and set up a crude, handmade

Bars and saloons were packed on Blizzard Monday. Here, an argument has broken out as one customer insists the Blizzard of 1854 was far worse than the one raging outside at that minute. In the background, two men try to stop a drunk patron from foolishly venturing out into the storm. (NEW-YORK HISTORICAL SOCIETY)

sign that announced: WE HAVE SNOW SHOVELS. John sold all 3,000 of his shovels at one dollar a piece, reaping a handsome profit of $1,800. He not only kept his job, but he received a raise as well.

Shopping was the farthest thing from May's mind at that moment. Warmth and shelter were what she craved. New York City had over 10,000 saloons in 1888, and every one of them did a roaring business on Monday. Homeward-bound businessmen stopped in to warm themselves with a glass or two of whiskey, then struggled up the street until they came to another saloon. Naturally, May never even considered stepping into any of these places. Even if she could get over the reek of whiskey, beer, and cigar smoke, a proper young woman never set foot in such an establishment.

There were numerous coffee shops along her route, too, and May thought about stopping for a cup of hot tea. But every coffee shop she approached was jammed with men. Rubbing shoulders with strange men was not something May could do, so she turned into the wind and pushed on.

At Madison Square, the wind again became furious, and May had to walk backward in order to cross it. May continued up Broadway, away from the wealthy homes and shops and into an area of modest brick apartment buildings.

Eighteen blocks later, at 42nd Street, May headed west to Ninth Avenue where she turned and followed the path of the elevated tracks for the remaining five blocks. Exhaustion was beginning to slow her steps and only the thought of her warm room and soft, comfortable bed kept her moving.

When she reached her street another obstacle confronted her. The wind had swept the snow into a giant 10-foot-tall drift on her side of the street so that all of the front steps were completely covered. May

paused a few moments, then summoned up one last burst of energy. She hurried across the street and plunged into the drift, slipping, sliding, and virtually swimming up the steps to the boardinghouse door. Fellow boarders had spotted May by this time and rushed to pull her into the house, where her landlady got her to bed and administered the standard cure for chills and exhaustion — a glass of whiskey. May slept for the next sixteen straight hours, but she would return to work on Wednesday. She was right on time, of course.

May had literally walked into the teeth of the storm and survived because of her youthful energy, iron determination, and intelligence. Others weren't so fortunate.

At about the same time that May Morrow set out for home, the Singer Sewing Machine Company in Elizabeth, New Jersey, dismissed its workers for the day. Three young women exited the front gate,

There were restaurants, coffee shops, and saloons for every economic class. In poor neighborhoods and along the waterfront, tiny coffee booths served up hot coffee, cakes, and light meals for just a few pennies. (AUTHOR'S COLLECTION)

joined arms, and set off for the nearby train station. They were instantly assaulted by the wind, battered, and turned around until they lost their way in the whirling white. Their bodies were discovered the next day still within sight of the factory gates.

Meanwhile, James Marshall and his two friends left the same factory by a rear door and hiked to their rowboat. James took the oars and the trio pushed off.

If possible, the wind seemed stronger and the snow heavier than during their morning journey. They couldn't even see the shore of Staten Island, so James aimed the boat as best he could and then struggled to stay on course. Rough waves slapped against the boat, and before long the trio's clothes were soaked through and icing up. James rowed on with the same fierce determination that had gotten May home safely.

At first, his friends encouraged him and bailed water from the boat. But as time crept by, they grew quiet and less animated in the numbing cold. Two hours later, the boat scraped bottom and James leaped out to see where they were. His friends were barely conscious.

He had no way of knowing it at the time, but the boat had come ashore two miles below their normal landing place. What James found when he looked around was a frozen landscape and absolutely no sign of life.

The wind let up for a few seconds, just enough time for James to make out a haystack in a field 600 feet away. One at a time, James dragged his friends to the stack and covered them up with hay to keep them warm. His own clothes were heavy with ice, and fatigue was setting in as well. To keep himself warm, he began trotting around the haystack. Darkness fell and still James kept on racing around and around. To stop, he knew, would almost certainly mean death.

While James was running, another man stepped out into the storm

also determined to get home. Roscoe Conkling had spent the day at his law office, so consumed with work that he barely noticed the storm outside his window. When he emerged from the building at 5 P.M. even the usually unflappable former senator was taken aback by the increased power of the blizzard.

As Conkling stood there, a young man named William Sulzer approached him and asked if he wanted to share a cab uptown. Sulzer was a lawyer and thinking about going into politics (he would eventually be elected governor of New York State). He was also a shrewd fellow and knew that a friendship with Conkling might be helpful politically.

Conkling asked Sulzer what such a ride might cost and was shocked by the fifty-dollar fee. "I don't know about you, young man," Conkling grumped, "but I'm strong enough to walk." And without another word, the older man stalked off.

Sulzer tagged after Conkling, still hoping to strike up a conversation. This proved extremely difficult. Conkling was walking very quickly. Besides, both men had to walk with heads bowed to keep snow and bits of street debris out of their eyes. Finally, when they came to a hotel, the younger man gave up and went inside to rent a room.

Conkling did not even break stride to say good-bye, but continued barreling through the snow. "I went magnificently along," Conkling would boast the next day, "shouldering through drifts and headed for the north."

Block after block, Conkling battled wind and snow. Ice collected on his clothes, weighing him down and making each step a chore. It took him two hours to make the two-mile journey from his office to Union Square Park. "I was pretty well exhausted when I got [there], and wiping the snow from my eyes, tried to make out the [path]. But it was im-

Artist Otto Stark has captured the raw power of the storm in this view of pedestrians attempting to cross Union Square. (AUTHOR'S COLLECTION)

Otto Stark.
.88

possible. There was no light, and I plunged right on in as straight a line as I could."

Halfway across the square, Conkling stopped to rest, holding on to the base of a gaslight for support. It wasn't long before another traveler recognized Conkling and tried to engage him in conversation. The former senator found the man's chatter annoying, so he pushed off from the gaslight and continued plowing ahead. It would take him another hour to go nine blocks to Madison Square. By this time, every step was a struggle and his eyesight was severely limited by the ice caked on his eyebrows and lashes. The next thing Conkling knew, he had stumbled and fallen into a snowdrift up to his neck.

"For nearly twenty minutes I was stuck there and I came as near giving up and sinking down to die as a man can and not do it." Conkling squirmed and flailed until he freed himself. "When I reached the New York Club at 25th Street, I was covered all over with ice and packed snow. . . ."

Conkling collapsed at the door, but attendants at the club saw him and carried him to the hotel where he lived. It was 10 P.M. when Conkling finally pulled the covers up for a much-needed sleep.

The storm, however, did not rest. Its center had only moved a few miles since 3 P.M., and wind speeds of 50, 60, and 70 miles per hour were being recorded in Boston, Provincetown, New Haven, New York City, Eastport, and elsewhere. Temperatures dropped with the disappearance of the sun. Roscoe Conkling did not realize it, but when he left his office at 5 P.M. the temperature stood at 14 degrees Fahrenheit. By the time he collapsed in front of the New York Club, the temperature was at a frigid 8 degrees. For those exposed to the blizzard during the long night, this would be the cruelest time of all.

RULED BY WIND AND SNOW AND RUIN

Throughout the afternoon and early evening, people made their way home, stumbling through front doors, exhausted and caked in a white glaze. The luckiest were greeted with a warm fire, dry clothes, and a hot meal.

Many others also made it home, but their greetings weren't always so cozy. This was the army of people who made up the working poor — men, women, and children who labored all day but barely earned enough money to survive. Bellhops, bootblacks, sewing machine operators, street sweeps, lamplighters, newspaper boys, messengers, and a host of other unskilled workers were a part of this group, as were the Italians who had spent the day trying to clear the railroad tracks.

The fortunate ones returned to tiny apartments that might house two or three families. Ordinarily, these cramped, airless rooms were intolerable. On Blizzard Monday, the closed-in spaces actually helped the small stoves heat the space more efficiently.

Despite these wretched conditions, there were tens of thousands of people who would have viewed such an apartment as luxurious. Many

For "three cents a spot" a person could get out of the blizzard and maybe even find a dry place on the floor to sleep. (AUTHOR'S COLLECTION)

poor people were living in buildings put up when George Washington was president that were in such bad shape, they were more like unheated sheds.

Writer Charles Edward Russell visited a number of these tenement houses and was appalled by what he found. "The front walls are of brick; the rear and side walls are wooden. On the wooden walls the clapboards sag and sway and are falling off, the ancient laths and plaster are exposed beneath. . . . An icy wind blew through these apertures."

Russell then went through a narrow, gloomy passageway to the backyard, where he found another tenement with seven families inside. After describing the many broken windows and the dank decay of the

structure, Russell concluded, "When the building was new and clean, it might have been a tolerable place to house horses. It was never, at any time, a tolerable place in which to house human beings. For fifty or sixty years it has been unfit for anything except burning."

George Steidler was seven and living in such a tenement on Houston Street during the blizzard. "The tenements were malodorous and overrun with rats and vermin," Steidler would write many years later. "At night, one feeble gas jet illuminated the hall off the street and one lit every other floor. They were turned off at 10 P.M., and one had to grope about on the rickety stairs in absolute blackness."

His building had running water "with only one sink in the hall for every four families. Our toilets were 'backhouses' in the yard. . . . During the storm, these were buried in mountains of snow and were inaccessible. With water freezing and pipes bursting, the families dumped garbage or worse in those sinks. Slops ran over when the drains became stuffed and flowed into hallways and down the steps. . . ."

Because there was no refrigeration, perishable items such as meat, poultry, fish, and butter were usually bought on the day they were to be used. Most households had laid in food to last the weekend on the previous Friday. By the end of Blizzard Monday, food supplies were just about exhausted. Steidler's family had only some dry bread, a little cheese, and a plate of cooked cabbage.

Even something as basic as milk was in short supply. "People hung tin pails on their doorknobs and every morning the milkman filled them with a dipper from his bucket. . . . We never knew what we would find floating in our milk." Of course, they found no milk in the pail on Monday morning.

"Coal was purchased from the grocer in five- and ten-cent quantities," Steidler recalled. "During the blizzard we suffered terribly from

lack of coal. . . ." The boy and his family wandered around their apartment in three layers of clothes, and resorted to burning what little furniture they had for warmth.

As hard as it is to believe, there were still thousands of people who were in even worse shape than those in the most horrible tenements. A noted charity worker of the time, Helen Campbell, estimated that every day approximately "sixty thousand women and men [spent] the night in the streets of New York City." As for homeless children, Campbell believed around 15,000 of them were without shelter during the blizzard.

Where did they stay on Monday night? Hundreds were able to find a bed or chair at one of the twenty-five privately run charity shelters scattered around the city. Still others spent the night in one of the city's

The mission on Water Street gave each homeless man a sandwich and a cup of hot, black coffee. In return, they had to listen to an hour-long sermon on the wickedness of drinking alcohol. (AUTHOR'S COLLECTION)

thirty-five police precincts, or in soup kitchens or church basements. The all-night restaurants were jammed with people seeking warmth and five-cent platters of pig snouts and cabbage, as were the stale-beer joints and underground lodging cellars where a weary person could purchase a spot on the bench or floor for just three cents.

Many could not even afford the three cents to find shelter. Helen Campbell observed sadly: "It is not till one sees them curled up on doorsteps, tucked away in old barrels and empty packing-boxes, sleeping in coal cellars under the sidewalk, lying in any and every sheltered spot, that one begins to realize that there is no softer pillow for them."

New York City wasn't the only place with a homeless population. Every city, big and small, had its share. In Hoboken, New Jersey, a village of squatters' shacks near the Hudson River was so completely covered over with snow that only a few feeble pinpoints of light could be seen from a nearby road. No one — not the police, not the well-meaning charity workers, and not the reporters searching for a good story — ever bothered to visit these sites during the storm.

One of the saddest things about the storm was that for every horrible story one heard, there was always another even more dreadful. William Inglis spent all of Monday bouncing around the interior of the pilot boat *Colt*. The hurricane winds had whipped the ocean into an endless series of towering waves, some of them 50 to 70 feet high.

As long as the captain kept the boat heading into the waves, everything was fine. The boat would ride up, and up, and up the front face of the wave, until it plowed through the crest. It would then speed down the backside of the wave until it reached the bottom or trough, where the next wave would begin lifting it up again. Hundreds of times this happened, over and over again. Up and up, then down and down,

with the captain ever on the alert for a shift in the direction of the waves. As night came, the storm's fury never slackened for a moment.

All of the pilots had come below, as had most of the crew, and everyone sat around the cabin riding out the storm. Few words were spoken, and time passed slowly in this tense way. Then, just as Inglis felt himself giving in to sleep, "a big sea hit the poor schooner solidly . . . and lifted her upward and backward as a hard punch in the jaw will lift a man. . . . A second great wave hit her in the side, and over she went on her beam ends. Everything not tied in place came banging down. Down lay the poor schooner like a horse shot in battle."

A great green torrent of water burst through the main hatch, while another poured into the aft companionway. "The twin floods met and frothed as they chafed at each other. [The] hard-coal fire in the cabin stove . . . sent up a cloud of steam and gas when the water struck it so that it was impossible to see in the cabin."

Men were tossed from bunks and chairs, landing on top of one another or slamming into beams and floating furniture. Inglis had grabbed hold of a railing and hung "pendulum fashion, out of my berth to windward, or rather skyward, my elbows on either side keeping me from tumbling down and my legs waving to and fro helplessly."

The next moment, the schooner began to move. "She rose like a human being, fighting with the awful waves and righted herself as nimbly as a boxer jumps away from a blow. The whole crew was on deck by this time. . . . They began to work the pumps fore and aft and lightened her all they could."

Even hanging upside down, Inglis was impressed with how quickly the men recovered from the tremendous shock and how coolly they were working to save the boat.

"I would like to say a word here, too, for Manuel Gomez, our stew-

A stern-to-bow view of a large sailing vessel encased in ice (DELAWARE PUBLIC ARCHIVES)

ard. He had just finished cooking dinner when the schooner, falling down, sent everything flying. . . . With almost certain death at his heels, that man calmly stood in the galley and fished around for his flying and floating pots and saucepans. He swore at the wave . . . and called it bad names in good Portuguese swear-words. Then, seeing me hanging disconsolate by the elbows in the cabin, with woe written all

over my sea-sick face, he came in and tried to cheer me up by calling the wave more choice names. . . ."

With the steward's help, Inglis got his feet planted on the floor of the cabin. "Outside it was dark . . . and in the cabin the single swinging lamp showed destruction written everywhere. All the berths . . . were flooded. The fair white and gold ceiling was blackened and dented where flying hot coals and cinders had struck it. The carpets and rugs were all washing around. . . .

"The hurricane was still howling, and vast waves thumped and shook our boat again and again as they tried to throw her. Four times in ten minutes it seemed to me she was on her beam ends once more, but she righted herself each time. . . . I had often heard about vessels being on their beam ends but I had never comprehended it. It means death. . . ."

Later, one of the pilots came into the cabin and a shaken Inglis tried to find out how bad their situation really was. "Said I to [him], 'Will you bet 5 to 8 that we come out of this all right?' Said he, 'My lad, we must put our trust in Providence. . . .'"

Over on the mainland, the bitter cold, icy winds, and stinging snow swept across a darkened and abandoned landscape. Those in rural areas had long ago secured any doors or gates that might be swept away by a powerful gust, and gotten animals fed and attended to for the night. Emergency journeys outdoors were accomplished at the end of a strong rope tied to a stair rail.

Cities big and small seemed empty of life as well. Historian Irving

Newspapers rushed out special editions on the blizzard. This "Icicle Edition" by the New York Morning Journal *featured stranded commuters, a newsboy hero who continued selling papers throughout the storm, and a feature on "Panic in Mid-Air" ("mid-air" being on the elevated railroad tracks).* (NEW-YORK HISTORICAL SOCIETY)

SPECIAL SNOW SHEET.

Morning Journal.

ICICLE EDITION.

. 1,926.

NEW YORK, TUESDAY, MARCH 13, 1888.

PRICE ONE CENT.

BLIZZARD EXTRA

SNOW TERROR.

rk Tied Up and Cut Off by Storm.

LYZED CITIES.

rains, Business, Theatres Stopped.

ENTS, MISHAPS.

Pictures of the Worst Day ifty Years by the Journal's Hardy Staff.

which struck New York a few midnight yesterday and has raged rpulsion until the hour of going to everet than that visited the city in the rain of Sunday night turned to ind rose to a tremendous fury and ure fell to 10 above zero.

ight inches of snow had fallen.

eighteen inches had covered the

e there were three feet of snow on

extended over all Long Island, New Jersey, Pennsylvania, nearly as Pittsburg and over the State of

as from the northwest and aver-les as hour...

ature fell to 5 degrees above Zero.

New York by 9 in the morning in he horse-car travel.

at all waved on the Elevated roads on the four lines in New York, econd Avenue line resumed for a The Third Avenue re-vals near midnight. All expert to

on people were kept from their ens.

anges, all the courts but two, most ttle houses, all the shipping house e did no business.

of the theatres were closed.

who reached their business town sought hotels or lodging hese were packed last night.

principal avenues little was done idewalks, home walking was most

were received yesterday: neos of the city. No ships or steamers ded.

ilroad lines out of the city were ll graph wires were broken every-communication almost completely wire out of the city goes out at

beleaguerment of New York this ons.

d was isolated and Coney Island d by the storm.

erdiest occurred on the Elevated stokings or hundreds are reported. had during the night many people their lives in the snowdrifted

exported to last another twenty-if midnight the wind was howling

RESIDENTS AMAZED.

That Surpassed Anything in Their ence.

awoke yesterday under unusual

nat it seemed. It was not that the ting a thousand miles a minute, or the first time since February ashed down New York awoke to et

.t not-unlooked paper was not at the door. t or was not at the corner. on head from the time the aver-down to breakfast at the corner, half blinded

with the snow and wind, he was disconcerted at not finding his usual carriage or mug along.

All the street cars were stopped.

When all the horse-cars stop, few York is very near a revolution. But the citizen spoke of was a step further and found not only a revolu tion, but an earthquake.

He walked along—as means of riding being at hand—to an Elevated Railroad station and boarded a train to go "downtown."

Then he learned what a blizzard is.

The Elevated trains wouldn't run.

New York had been struck by the most terri ble, the most unreasonable storm it has had for more than half a century, perhaps the most violent storm that ever cast a bare, but the Sig nal-service clerk isn't old enough to remember, and nobody else has authority to speak.

Then the average citizen tried to get a cab.

There were cabs running up and down town. People who were unable to brave the storm and walk to business were unable to get to their stores and offices.

A Good Day for Cabbies.

But it cost them a good bit. A Hanson cab from Forty-second street to the Sub-Treasury building cost $10 before 10 o'clock, noon. By the middle of the afternoon it was $25.

A Journal reporter offered a hackman $20 to take him from Chatham square to the scene of the accident, seventy-sixth street, and was laughed to scorn.

Newspaper Row Beats the Deck

Nowhere else in New York did the blizzard speed itself as it did around Newspaper Row. The cluster of tall buildings that raise the towers from the upper parts of the atmosphere and send it swirling down through the streets made techni fusions first a difficulty and then an impossibil ity around the lower end of Printing House

To spots the earth was blown bare. The ex-traordinary eddies here of the high wind and the high buildings had scooped the earth bare—but only in spots. In these spots the wind was enough to catch the unwary pedestrian by his heels and send him sprawling on the snail of his

All the Streets Impassable

All over town the streets were choked up. Commissioner Coleman's promise of clean streets for the rest of the year was among the things of the past.

All the boxes, dangling things, such as awnings and signs, were fluttering and while a solid-sheet of snow stood piled up in front of the mansions of capitalists men. They could not get to the nearest avenue.

On Wall street the venerable George Washington standing in bronze in front of the Sub-Treasury, was warped into fantastic shapes.

No was Benjamin Franklin. In Printing House square he was a filter of twenty and fantastic shape, but when the wind began blowing the bas-reliefs of that surrounded him with a number of fact fiss glory. So was left shorn as completely as if he had struck a modern barber instead of a blizzard.

ELEVATED TRAVEL STOPPED.

Angry Crowds at the Sad two—Passengers in Double Peril.

The New Yorkers who first realized that a wild Western blizzard, with the snort of the prairie and the howl of the mountain wolf, had struck this town were those who got up about 6 o'clock in the morning and ploughed their way to the Elevated stations. They found the stairs leading to the station platform a toboggan slide, the snow so completely covering item that the steps were indistinguishable.

Those who managed to get upstairs, however, were a little surprised to find the station crowded with men, women and children, some fuming and fretting, others talking and joking and not a few men letting off some bad language which were quite in keeping with their misfortune. The poor frozen series had a hard time of it. When he told people that the chances for getting downtown that morning by the Elevated were very slim, they turned on him and wanted to know what kind of a road it was, any way.

It isn't my fault, the blizzard is to blame."

Never had travel on the Elevated been as com-pletely blocked as yesterday. At the opening of the day's business the trains ran at intervals of about twenty-five minutes, and as fast as the arrived they grew fewer and further between, and at times they were hours apart.

This station was the cause of frequent boisterous altercations with the ticket-sellers. But these were inexcusable. The ticket-seller simply feared back in his chair and could, at the angry people, coming out of their street, rage and swear.

From a crowd onward it was almost impossible to board a train when it did arrive. It was the same on all the lines. When the train reached its destination the passengers clambered out and tried to board the down and others standing in the vestibule and others standing on the stairs and few got tickets, and wedging their way safely to the street, where they stood like a mingled on to a fixed course to passion. There were no carriages and no cabs in waiting for those depositing a small rise of bellows fire the reliable man of Mr. Shanks.

Tickets Taken all the Same.

There was considerable grumbling among the waiters and the action of the Elevated people in taking their money and keeping it after it was found that no return could be given.

This station was the cause of frequent boisterous altercations with the ticket-sellers. But these were inexcusable. The ticket-seller simply leaned back in his chair and could at the angry people, coming out of their cold, rage and swear.

From a crowd onward it was almost impossible to board a train when it did arrive. It was the same on all the lines. When the train reached its destination the passengers clambered out and tried to board the down and others standing in the vestibule and others standing on the stairs and few got tickets.

A New Grand Central Depot

By 5 o'clock the blocks in the vicinity of Grand and Allen the streets were jammed with people. Everybody who thought it was possible to ride uptown had gone to that point. As a conse quence it was soon apparent to all that at the rate the trains were running the immense multi tude could not be carried to their destinations in two weeks.

Thousands, therefore, were obliged to ap-proach in this wretched and walk home. This was an undertaking which appalled even the most robust and even impossible for the women and young girls.

Deliver Where None Deep in Snow.

Even in fair Winter weather the walk from Grand street to Harlem is a task which few would care to embrace. But though the blind ing drift of yesterday and the violent hur ricane through many of the violent banks fast nearly unfailing wales New Yorkers had never before been called upon to experience a wretchedly arduous game.

They would guarantee to land passengers almost anywhere they liked for $5, and on vary ing their money in advance and after travelling a few miles declare that the snow was too much for them, or that their horses were exhausted and refuse to drive a foot further. Parties of working girls who had subscribed $5 or $0 for a fare were frequently turned out by a half drunken hackman in some deserted street and left them shivering in frost feet of snow.

A man with a common open freight sled got $60

preferred it to remaining for they knew not how long in the crowded train.

Life and Limb Endangered.

Several times when the track ahead was full of pedestrians trains started, causing a panic among the imperilled people. But so far as learned no fatalities resulted from these occur rences.

As the noon hour approached and the severity of the storm rather increased than diminished the trains ran more slowly and were dispatched less frequently.

The Great Danger.

The snow packed so hard in between the two guard rails that run beside the inch rails that the engineers feared to run their trains.

Passengers on the edge, perhaps of the cars, would run up on the edge of the cars and clamber down into the street. This is the only accident most dreaded by the Manhattan Company.

On Ladders from the Train.

A three-car train on Sixth avenue going down town was stopped at 8:30 a. m. in Third street, between Sixth avenue and South Fifth avenue, and not only did it come to a stop, but it stayed stationary so long that there was scant hope among the passengers of any release till the storm should blow over.

Presently the Fire Department was called up on, and the nearest hook and ladder company coming to the rescue placed ladders against the Elevated road structure.

Ladders that some of the younger passengers had managed to make it to the Eighth street station. By some miracle they were not blown off the track and returned to the train, glad enough to get away from the cutting wind.

When the ladders were put in position the younger and more adventurous of the passengers excuse it escape from the train to the street.

Two of the ladies in the trains were venture-some enough to trust themselves on the ladders at first, but as the hours went by they became

their large teams, ultimately proved powerless to tug through the drifts.

Hundreds except in the immediate vicinity of the surface street car stables send the trucks lie soon. Two, three and at certain points four feet of snow covered them.

Always Room for Ascents.

The stoppage of the Elevated roads caused every car to be absolutely packed as many as a hundred passengers for each car, and it was no uncommon sight for each. Half a dozen men usually helped to keep the driver warm, twice as many hung on at the

click" for innumerable repetitions, and even then the message was generally disconnected and sometimes intelligible.

The great operating room on the ninth floor of the Western Union building, which usually re sounds with the merry click of the instruments, was shrouded with an oppressive silence, only broken occasionally. Three-fourths of the instruments were rendered useless by their operators.

Communication Cut Off.

Chief Operator Brainard when questioned about the condition of the wires said :

"We are completely out of from Philadelphia, Baltimore, Washington, Norfolk and Richmond, Trenton, Paterson, and in fact every place along the seaboard. Our wires are all down, and com munication with the south is out of the ques tion.

"We have three wires to Buffalo and Cleve land and are able to connect with Chicago, Chi cago, St. Louis and the West and southwest in this way. Our offices all over the country have been instructed to send messages for transmis sion on the understanding that they will be sent, subject to delays at all points.

"The storm so far as we can learn does not ex

Continued on Second Page.

A HORSE-CAR WATERLOO.

Double and Triple Teams Unable to Move the Cars.

For the first time in sixteen years New York experienced a universal suspension of street traffic. On every surface car line there was a tie-up, while cars, wagons, hacks and all manner of vehicles were sooner or later stranded in the snow.

Before daylight every line was running its cars and every car started on time. Few, however, reached City Hall. Most of them were aban doned en route, and even the snow-ploughs, with

A Swell's Blizzard Ride—Bound to Get There.

der $25. Two dollars to ride down town was a common hack fare.

Suffering Among the Drivers.

The Third Avenue drivers had a very hard time of it. Turning up one by one at the depot they walked into the main office with chunks of ice as big as eggs hanging in their beards. Every man had a tale of suffering.

"I thought I had a team of horses that could pull anything," muttered a sturdy driver, "but I don't think so any more."

At 8:15 a. m. Superintendent Robinson issued general orders to withdraw all the cars from the tracks. By noon the order was complied with from the Battery to Harlem, but half a dozen cars between City Hall and the depot were along the line.

Snarled in Telegraph Wires on Broadway.

holder, and, at last, rendered desperate by the cold, threw fear to the winds and wrapping their shirts tightly about them, surrendered them selves to the tender mercies of the ladder monop-olist's axe-rescued term firms in sight.

The wind and the snow, however, so confused them that half a dozen, one after the other, of them, went tumbling to the street, and the fire-men, fearing disaster, promptly took away their ladders.

There a bridge was built from the train as it stood, blocked on the road, to the windows of the repair shop of the Elevated Department. It was made of planks with a ladder on either side for a guard rail.

Over this bridge the passengers clambered out, making their escape to the street safety of the streets," west homeward or toward their business as they knew their destination.

" For the first two hours that we were impris-oned there," said a passenger, " we were unable to spend a civil word. Then after that every-body seemed to grow reconciled and began to win fun to the situation and grow jocular. After that there was no rift—"

It was an ass on the Elevated Road on the East Side. The reporter, in company with more than a hundred other unfortunates, stood on a Second avenue station after it was known that the Third, South and Ninth Avenue Roads were all blocked, and the people were jocular in spite of the series that prided them.

An excite ran along and was cheered. Then it was seen that there was no train behind the engine.

Had ones is that engineer," said one busy-looking fellow, "that he would be come wild and cast a team?"

On the Sixth Avenue Road the last train down reached I—third street at 10:30. On the other lines traffic ceased entirely at about 12:15. It was rumored an hour afterward, however, on the Second Avenue line, that the drifts there only ran down as far as Grand and Allen streets. From that time on, the store, Grand and Allen street was the only point at which trains could be taken for uptown. It was, in fact, the grand central station for travel in the city.

When the vast crowds of people on their way below in the evening had climbed up the far stair-ways they were met with the startling announce-ment, printed in big, black letters :

Manhattan Railway Co.
Road Blocked.
No Trains Running.

Upon inquiry at the ticket office the people were informed that a few trains were running on the Second Avenue line from the Grand street station. To those who lived in the upper part of the city this was welcome information, and there was a grand rush from all parts of the town for the prayer of Grand and Allen streets.

A Windy Corner Near the Brooklyn Bridge.

rail with the conductor and an occasional small boy was to be seen perched on the roof.

As 9 o'clock the Broadway line had to be abandoned. The great unembarrassment took place in Union square. All along the line of route disabled cars were standing in drifts. The drivers invariably took their horses to the near-est stables.

The first car on the Third Avenue line left One Hundred and Twenty-ninth street at 6:35 a. m. It reached the Post Office at 9 o'clock. The last to arrive downtown left the One Hundred and Twenty-ninth street stables at 6:30. It was crowded with workingmen and working women and got as far as Park place by 9 o'clock. Speak-ing of the journey to a Journal reporter, One doctor George H. Post said it was the jolliest he ever piloted.

On leaving Harlem all the passengers climbed out and down as far as Fifty-seventh street everyone was able and had contracted such friend-ship that the parting was indeed sweet sorrow. Only three other cars succeeded in covering the entire route.

Several were cast adrift between One Hundred and sixth and Eighty-ninth streets. More than managed to get down as far as Fifty-seventh street after six o'clock were stalled in the com-pany's station.

The Fourth Avenue line was almost as unfor-tunate as the Eighth, which did not get a single car to its destination downtown. At the terminus of a mile along Fourth and Madison avenues up to Eighty-fourth street snowed-up cars were to be seen. One driver did haul passengers oppo-site the Astor House, but he had the assistance of six horses. The heaviest snow-drift of the line was started out at half-past 6, and the timing pile circled his route a foot deep on the tracks as quickly as the plough cleared the way. After half an hour's work the task was given up for the day.

Littleannone rewarded indefatigable efforts on the part of the management of the Sixth Avenue line. In spite of a magnificent snow-plough and six horses to every car only three drivers reach-ed Vesey street.

The first line ran fairly well between 5 and 7 o'clock, but the force wind that swept in from the rivers piled the drifts so high as to make progress after 7:15 an impossibility. The Uni versity plate cars stopped running at 8:30, and those on the Seventh avenue shortly the hour later.

The Avenue B bobtails were uncommonly for-tunate. Six of them ran the gale loaded snow before them. One of the Avenue C lines managed to solve the Bridge.

High Prices for a Ride.

For the hackmen the blizzard proved a ver-itable bonanza. Carriages, cars, hacks, wagons, everything that could be put on runners in de mand every-where. The hackmen made their own bargains, and in many cases refused to abide by them. Blank eyes and broken ribs narrowly escaped a systematic tumor game.

Hundreds of women who understood the jour ney were overcome before it was half accom-plished and made exhausted in the snow, where they would have died had not kind hands carried them to places of safety. Strong men also were prostrated, as the stationhouse records to-day

Cares around the Railroad doubtfully because he had do, Robin Conch Grays

will tell. It was a journey fraught with fatal peril, but thousands had no alternative.

"Those who managed to reach their homes in safety yesterday. It is safe to say, will not for the danger of a similar experience.

for driving a party of four two miles down town. The same driver charged a man $1 for the privi-lege of driving across Forty-second street from Third to Sixth avenue, the passenger sitting on top of a trunk and glad of the chance. A stable-man had refused to turn out a hack for him up anything toward setting them right until the blizzard passes away.

ALL WIRES ARE DOWN.

At 12 O'Clock a Complete Telegraphic Inter ruption is Announced.

As 12 o'clock last night the United Press sent out the following :

Since 7 p. m. we have had for part of the time communication with points in New York State and West to Chicago, and Chicago could reach Southern points; but we are now again cut off from all points. The wire we had was the only one working West out of New York. It was one of the old Baltimore & Ohio wires. It is now broken between Washawken and Harverstraw, as well as all others by that route. The Western Union have no wires, nor the Postal. We have not had any Eastern point, nor Philadelphia, Baltimore nor Washington, at any time to-night.

FLAMES FANNED BY WIND.

Firemen Struggle Amid Snowdrifts Short of Feet—A Mounted Night Patrol.

The boldest firemen felt a chill of fear when a second alarm rang out from the box at Canal and Varick streets at 7:15 last night. It had been preceded twenty minutes before by a first alarm from the box at Canal and West Broad way.

As the engine turned out the snow-clouds were already glowing with the ruddy reflection of the flames. So close doubled that a disastrous conflagration was at hand. When after a terri-ble battle with 7 drifts the first two engines reached the scene the top four-story brick fac-tory No. 9 and 11 Laight street was found to be blazing from cellar to roof.

Fanned by the breath of the northwest the snow-swept wings in the air, scattering huge

From the " L" on Ladders.

brands down the wind and threatening destruc tion to the whole block. In the year 1865 the second call was sent from box No. 259, at Varick street, followed instantly by special call for Engine No. 33. In Grand Jones street, in an unu-moving eight engines and four tricks.

At the expiration of half an hour but four en gines had answered to reaching the scene, and teams began to rook desperate. Engines Nos. 33 and 31 had stood fast to drifts in Canal street. Engine No. 30 in passing the Grand Central Hotel broke a whiffle-tree and came to a dead halt in a drift. One man was set back to the house and started out the second engine of the company. Engines Nos. 13 and 27 stuck fast in drifts and only managed to pro-ceed after additional horses had been pressed into the service.

Lines were run through the Hygienic Hotel, separated from the burning building by a narrow alleyway, and the firemen strove to project streams from the side windows. They accomplished little for the furious blast that swept through the alley swept the solid stream as well and scat tered them in driving mist. In tick-street, im-mediately in the rear of the fire, the hundreds of tenants huddled in a row of tenement house fled in dismay.

In an hour all was over : the fire had burned itself out, all that remained of the big factory were four tottering walls filled with snow. Afterward there was the fire. The building were occupied by Stazawnid-A-Popre, paper box makers, and W. McQuade novelties. Their loss will amount to about $45,000. The adjoining building, No. 7 Laight street, occupied by Pope & Co. printers, and Gunther Station, stationer, on the upper floors, and J. Reed, carpet cleaner, on the ground floor, was com pletely gutted at an additional loss of about $40,000.

After the fire was over Messrs. Paterson & Silver possessed a draft of twenty engines from Dahlman and organized mounted brigade of twenty-five men who patrolled the dry goods district during the rest of this night.

THE BLIZZARD'S VICTIMS.

Accidents By the Storm in Every Section at This City.

At Police Headquarters the gravest anxiety was depicted on the faces of all the officials. With the failure of almost the entire telegraph sys tem of the department the Central Office was com pletely isolated, leaving the commanding officers in total ignorance of what was occurring.

After sounding an alarm officers were ordered to proceed with all speed to the nearest fire and get news. The officers who were sent out to try to protect the storm, fruitless in the face of the storm and they were soon forced to desist.

Electric Alarm Run.

Renewed anxiety was felt at the central office when early in the afternoon a constant alarm came from the electric light contractors that they were no longer able to operate their lamps and that the consequence all the principal thoroughfare would be in darkness. A squad of polo... stantly sent out to the stations-houses, and after which out of the line to guard against any rush at pro-vided to excite extraordinary mishaps.

Crowds were thronging in to the the ... and

Cold and Stormy To-day.

The temperature at Sergeant Dunn's bureau day was 30 degrees above zero at 8 a. m. During the day it fell rapidly to 5 degrees above at 2 p. ... at 11 o'clock thermometer fell to 3 degrees above zero at 9 p. m. degree at 9 o'clock.

The weather for to-day will be cold and no further premises ...

The snow storm will of well expected to be today and the wind is well abated ...

PANIC IN MID-AIR

A Fatal Collision on the Th Avenue Elevated

SNOW BLINDS THE ENGINEER

One Man Killed and Several Sust Serious Injuries

A heavily-loaded train pulled by two eng was slowly pulling southward over the ... packed tracks of the Third Avenue " L" Ro 7 o'clock yesterday morning.

As the train neared the Seventy-sixth s station the waiting crowds on the platform jostled each other in an ... mad struggle to ob foothold on the car platform, large ... incre

The Instant of the Crash.

the danger of an accident. For twenty min the engineers were undecided whether to send further south, but finally the train steam out the engine No. 30 in the rear.

A second crash, drawn by Engine No. 1, ... along the icy tracks of the Car engine 3 of Eighty-fourth ... to Seventy-sixth street ... speed. Samuel Towle was the engineer at throttle, and beside him stood his fireman, ... tin Byrne. The whirling snow almost blin the engineer, and before he could put on the ... brakes the train had sped past the Seventy-... street station. It was now impossible for ... to avert a calamity, though he reversed his e ... The fireman, seeing the collision with ... front train was inevitable, jumped to save life and called to Engineer Towle:

"Sam! Jump, for God's sake, jump!"

But the engineer remained at his post ... ing his life. In a moment engine No. ... dashed into engine No. 30. The steam gr ... resounded from the mighty set-in engine ... crested into the first passenger car, wh ... was soon up filings, wounding windows fra ... frightening men and women alike, until the had thought the train would roll off the t ... the pavement below.

The hissing steam from the disabled engine well as the blinding snow made it impossible those on the wounded street station platform ... to see exactly what had happened. Someo ... bad, however, suffered pretence of mind and ... shatter to send out an ambulance call from ... nearby Presbyterian Hospital, an ... injury this slowest, fortunately, that the acc ... and resulted in as great a loss to life and limb was at first feared.

The engineer was caught between the bro ... fire and the tender. He breathed still as his limb-engines carried him tenderly to the the ... No one who carried the train injured ... but after a careful of the company's Engineer ... and Engineer Towle.

A great number of the passengers were se ... cited at first but it proved hard to convince ... there was no more danger. Rumors that were as fifty people were killed passed from mout ... mouth, and the panicking that the story of ... station vis-a-de and fully:

Samuel Towle, engineer, Ninth sixth street ... ious gashes on the legs...

William Clancy, No. 244 East One Hundred ... Eighteenth street, legs bruised and ...

Beulah Barrnett, No. 244 East Seventy-sev ... street...

Edna Stewart, No. 142 East Eighty-fourth ... jaw bruised. His injuries were more seriou ...

Henry Kahn, No. 524 East Eighty-third street injured internally. His bruise was much ...

A large force of men were put to work to ... the wreckage, and late in the afternoon the ... was cleared up. When the traffic was resum ... last evening.

Werstein described Manhattan as "practically a ghost town, its streets and avenues ruled by wind and snow and ruin; vehicles of all sorts lay overturned in the roadways. Some teamsters had unhitched their horses and led them to safety in nearby livery stables, but others had simply left both vehicles and animals where they stood, bogged down in the snow. The corpses of frozen horses poked stiff-legged out of snow-drifts; abandoned horsecars stood in long rows on cross streets; shattered store signs hung askew; uprooted trees lay in parks and squares."

There was still some activity, of course. Policemen plunged out into the cold to walk their beats, not to deter crime, but to pull hapless drunks from snowdrifts. Firemen remained on duty, though virtually every alarm box in New York City was useless because of downed wires. Fortunately, only two large blazes broke out during the entire blizzard, and these were brought under control before they were able to spread.

Indoors, Sergeant Francis Long and the rest of the weather station crew stayed past quitting time to monitor the storm. And at least one other business was fighting to stay open as well — the newspapers.

Newspaper editors and reporters had woken on Monday to find themselves surrounded by the biggest story of the year. Those who made it to their offices that morning were immediately sent out to interview politicians and prominent businessmen. Artists rushed to draw some of the scenes they had witnessed on the streets.

Now, as Monday evening was drawing to a close, texts were being hastily edited and set in type for Tuesday's early editions. In truth, the newspapers had very little information about the extent of the storm or what was happening in other areas. Just about every telegraph line was down, and even the most energetic reporter couldn't travel very far to see what was really going on. A reporter might talk with the mayor or

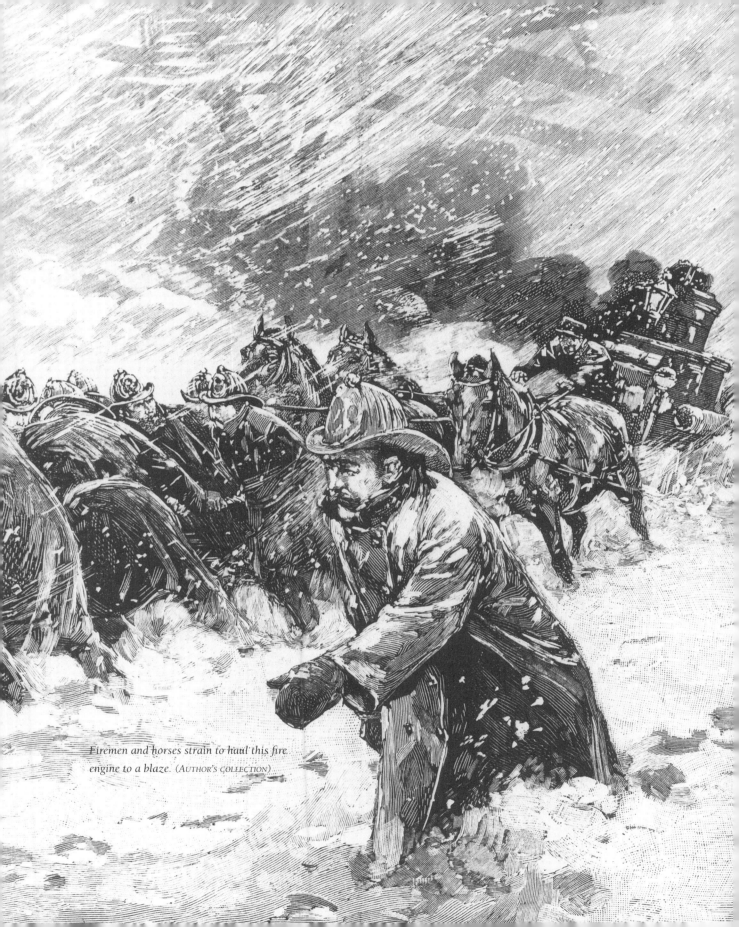

Firemen and horses strain to haul this fire engine to a blaze. (AUTHOR'S COLLECTION)

some other town official, but these people really didn't have many additional facts, either. Everyone everywhere was cut off.

To make up for the lack of real information, newspapers used oversized headlines to fill up space. One Philadelphia paper opened with a headline anyone near a window could see for themselves: STORM STILL RAGING.

In New York, the *Sun* covered just about its entire front page with a series of bold headlines:

THE BURIED CITY
New York's Dreadful Sepulture
Under Masses of Snow.

A NIGHT OF DEVASTATION
How the Tempest Howled and Raged
Through the Dark Wilderness of Streets.

PERISHING MEN AND WOMEN
Wanderers Found Dead in Snowdrifts.

AND THE TEMPERATURES BELOW ZERO.

The stories that followed were all very melodramatic in tone and contained few solid details.

Newspapers were so desperate for stories that they often took any rumor that came their way and reported it as fact. The Albany *Times* had one headline scream: STAMFORD DESTROYED, TERRIBLE DISASTER TO A THRIVING CONNECTICUT TOWN. The very brief story that followed pointed out how isolated all towns and cities had become: "The village of Stam-

ford, Connecticut, as reported by a special dispatch, was totally de-stroyed by fire early this morning. Wires are down and particulars are not obtainable." The report proved to be false; the fire in Stamford had actually been confined to the telegraph office of the local train station.

A few papers tried to maintain a calm tone and report on the storm without resorting to rumors or overly dramatic writing. A Vermont pa-per, the Bellows Falls *Times*, probably produced the most succinct and yet accurate blizzard story of all: "No paths, no streets, no sidewalks, no light, no roads, no guests, no calls, no teams, no hacks, no trains, no moon, no meat, no milk, no paper, no mails, no news, no thing — but snow."

As Monday drew to a close, the most important event was taking place without anyone being aware of it. Throughout the day, the center of the blizzard had traveled north just off the coast. It was an especially slow-moving storm, which meant it became an incredible blizzard ma-chine — picking up moisture from the ocean, freezing it into snow, and then dumping it onto land.

At 10 P.M. Monday night, the storm center finally touched Massachu-setts and then did something that would surprise everyone and add fuel to the notion that the blizzard had an evil mind of its own. The storm turned west and then south, in effect turning around and head-ing down the coast. It was coming back for a second shot at the already buried eastern states.

SEVEN

WHAT WILL MY POOR CHILDREN DO?

Most people went to bed Monday night assuming the storm would be gone by morning. But when they woke on Tuesday, March 13, they found the white hurricane ruling the outdoors as savagely as ever.

If nothing else, Monday had taught everyone at least one valuable lesson: If you did not absolutely have to go outside you should stay snug and safe indoors. Yet tens of thousands still braved the freezing temperatures and driving snow on Tuesday morning.

Farmers still had to tend to livestock and make hasty repairs to barns and other structures damaged by the wind. Those with essential jobs — such as police and firemen and telegraph wire repairmen — fought their way through snow and around abandoned carriages to do their jobs. And many fearful workers — especially those who had stayed home on Monday — once again donned layers of clothes and set out for work.

Tuesday was also another day of work for the nation's newest immigrants. Railroads had hired the largest number of laborers on Blizzard Monday. On Tuesday, telephone and telegraph offices decided to begin uncovering downed poles and wires, while ferryboat operators hoped

On March 13, the center of the southern storm had turned and was battering Long Island for a second time.

to clear their stations and landing docks. Police and fire departments as well as hospitals sought access to their buildings.

Attitudes concerning snow removal were very different in the nineteenth century. In general, city governments either did not see the removal of snow from the streets as a priority or they did not consider it their responsibility at all. Those cities that did remove snow usually waited until the storm had completely stopped to begin shoveling. Because they did not have large, permanent work crews, they would then have to assemble teams of shovelers and rent the necessary equipment. The most important business areas and the streets where the wealthiest people lived were cleared first. It usually took so long to move snow that most secondary streets melted clean long before the shovelers got around to them.

Other cities felt that it was up to the owners of homes, apartment buildings, and businesses to remove snow from the sidewalks and streets directly in front of their property. These cities passed statutes

Snow removal was a hard and time-consuming job. Here, day laborers shovel snow into wagons, after which it will be taken to the river and dumped. (AUTHOR'S COLLECTION)

requiring such snow removal. A sizable number of citizens felt these laws were unfair and continually challenged them in court from 1833 through the 1920s.

Almost all such laws were eventually upheld in state supreme courts, but this did not mean that citizens fell in line immediately. A substantial number of people simply refused to shovel snow, preferring to let nature take its course.

But the Great Blizzard did change the way a lot of people viewed snow removal. New York City's Superintendent of Streets and Roads, Jacob Coleman, was one of the first to appreciate the change.

Since noon the previous day, Coleman had been receiving frantic

messages from Mayor Hewitt and various department heads telling him that a citywide crisis was at hand. Fire equipment couldn't get through; the police were having a hard time patrolling the neighborhoods; food and coal were running low, but delivery wagons couldn't get through. The city was paralyzed and Coleman could sense that his job was on the line unless he could reopen the streets.

Coleman began assembling and sending out his workers long before dawn on Tuesday. By 7 A.M. he had several thousand Italian laborers clearing snow from the Battery north to Union Square. The word *clear* had many meanings that day. In some places, they really did clear the streets of snow — patiently loading it into wagons and hauling it to the river to be dumped.

A boy has conquered this massive pile of snow and now has an unusual view of his town's main street in West Southington, Connecticut. (BARNES MUSEUM)

A resident of Northampton, Massachusetts, surveys the town's main street from the entrance to a snow tunnel. (NEW-YORK HISTORICAL SOCIETY)

Coleman, however, ran into problems immediately. He only had a few dozen wagons at his disposal; to do the job correctly, he estimated that he would need at least 1,000 wagons, and he knew it would take him days to assemble this large a number. Since he wanted to show quick results, Coleman did the only thing he could. He had his shovelers simply toss snow to the side of the street. When they came to hard-packed snow or ice, they merely leveled off the top and pressed on with their work.

This approach saved time, and his crews were able to clear an 11-block stretch of Bowery Street in three hours. The street remained little used at first, because the shovelers had tossed up a solid 10-foot-high

wall of snow on both sides of the avenue with no entrances! This didn't bother Coleman in the least. As far as the superintendent was concerned, he had cleared the streets and now it was up to citizens to get to it.

Eventually, people would dig snow tunnels through the mounds and begin to wander along the street. By afternoon, the tunnels were enlarged and horse-drawn sleighs were moving briskly up and down the Bowery with bells tinkling merrily. One resident described the scene as reminiscent of St. Petersburg, Russia. "Of course," she added, "it was most strange to see sleighs at the level of second-floor windows."

During the day, Coleman did some hasty calculations that told him exactly how daunting a job lay ahead. He estimated that over 24 million cubic yards of snow would have to be moved in order to get traffic flowing again. With this information in hand, the city government authorized the hiring of 17,000 laborers at twenty-five cents an hour. Despite the huge number of men, it would be many days before even the most important business and residential streets were passable.

The services of shovelers came under even sharper demand at midmorning when the snow suddenly lessened. The wind was blowing as hard as before, but people took the lighter snowfall as a sign that the storm was ending and began emerging from their homes. Stores, markets, apartment buildings, hotels, and front stoops all needed clearing and people were happy to pay someone else to do the backbreaking job.

By late morning, the going rate for a shoveler had risen to three dollars a day, and by afternoon, many were commanding and getting four dollars. It wasn't unusual for a worker to quit a job in the middle to take on a higher paying one just down the block.

This produced grumbling about the "unreliable, greedy Italians." Of

course, none of the shovelers had contracts to bind them to a job or to guarantee their employment or wages once the emergency was over. In truth, they were doing what any good American businessman would do — watching the market carefully and trying to maximize profits whenever possible.

A second group of shoveling entrepreneurs also appeared, especially in big cities — gangs of boys armed with shovels, brooms, and ice choppers. The charge for clearing a stoop and short stretch of sidewalk ranged from five dollars all the way up to an astronomical twenty-five dollars. Residents were often more than willing to pay the fee to avoid battling the tons of ice and snow at their doorsteps.

People were often astonished by the strange shapes in their yards and neighborhoods that the drifting snow had created. A Massachusetts farmer was amazed to see a drift rising up over the roof of his barn like some giant ocean wave.

An endless line of day laborers struggles to open this road in South Norwalk, Connecticut. (New-York Historical Society)

In New York City and Brooklyn, the early-morning commuters were shocked when they saw the East River. It looked like a solid sheet of ice.

People immediately rushed to the riverbanks and began to speculate on how thick the ice might be and whether it was safe to walk on. Up close, the distance across looked immense and the ice was clearly not a single sheet, but many big and small ice floes jammed together. No one rushed to be first on the ice.

It was then that a Brooklyn boy of eighteen lowered a ladder onto the ice. Cautiously, he climbed down, then proceeded to jump up and down several times. As he came back toward his ladder, he announced that "She's safe as the United States Mint!"

Instantly, many onlookers announced that they wanted to cross the ice bridge. On the Brooklyn side, the boy gladly held his ladder as one hardy soul after another came down, though he made it clear that the fee to use his ladder would be five cents.

"His pockets bulged with coins," one observer noted. "Soon a long file of pedestrians surely numbering at least two hundred were slowly edging toward the Manhattan shore." Similar business operations were set up on the Manhattan side, and in no time at all, the ice swarmed with people.

Another group of ice-crossers also appeared. The unnamed observer recalled that "all the dogs in Brooklyn . . . came barking and bounding onto the [ice] field as well. The pooches were of all sizes, shapes and varieties. . . . Perhaps they, too, had sensed the drama and historic import of the occasion."

More than just men and dogs crossed the ice bridge. Several women were spotted making the journey, while hordes of boys slid down the icy

The first brave individuals venture onto the ice bridge that linked Brooklyn and New York City. (AUTHOR'S COLLECTION)

pilings and raced across the expanse. And at least one horse was hoisted over the side in a sling-harness and ridden to Brooklyn by its owner.

Police on both sides of the river tried to halt the stream of adventurers, but with little success. Other ladder entrepreneurs had appeared, and now there were more spots where a person could get onto the ice than policemen to block them.

Not everyone had an easy crossing. Many slipped on the treacherous ice or were blown over by the still-fierce wind. A few of the elderly adventurers had to be carried to shore. For over an hour and a half, people and animals paraded from one shore to the other. While no one kept an official count, the policemen on duty that day estimated that between 1,500 and 3,000 walked across the river.

The cheerful mood of the crowd began to subside just after 9 A.M. That was when a deep, ominous grumbling began coming from the ice. The tide was beginning to shift, pushing at the ice to shove it downriver. Meanwhile, three powerful tugs had been ordered out to batter

These tugboats are ramming their way through the ice to get river traffic moving once again. One man is being hauled on board the nearest tug, while a nattily dressed businessman stranded on a nearby chunk of ice waits anxiously to be rescued. (AUTHOR'S COLLECTION)

and break the floe in order to free up the river for navigation. When those operating the ladder-climbing concessions noticed this, they raised their prices to twenty-five cents.

Those on the ice realized the danger they were in and hurried to the closest shore. All of the dogs must have sensed something also, because they fled the ice as well. A large squad of police arrived and began ordering the ladders pulled up and watchers away from the ice. "Very many refused to obey," a reporter for the *Sun* noted. "When the ladders were taken away, they let themselves down from the piers. . . . They thirsted for glory."

Just then, the tide turned and began exerting immense pressure downriver. The giant cake of ice began to move very slowly. "There were over a hundred persons on the ice at this moment," the *Sun* reporter went on. "Most of them broke into a run. Loud were the cries [by those on the riverbank] to get to the shore."

When the ice broke free and began moving seaward, there were between forty and fifty people still on it. The ice came close to the Fulton Ferry pier and some of the stranded tried to grab hold, but the pilings were too slippery. They were close enough that the *Sun* reporter could see that "some exchanged cool jokes with those on the docks. One quietly asked to have a tug sent down for him; another requested a stove; still another shouted that he'd cable from Europe. . . . One man sank down on his knees and prayed."

The ice inched along and collided with a collection of piers on the New York City side. There was a horrible crunching sound as ice met wood, and then the floe came to a shivering stop. In the few minutes it was lodged there, men on the docks lowered down ladders and ropes and managed to pull almost everyone up to safety. Then the floe broke free and continued downriver.

There were still a number of men trapped on smaller chunks of ice heading toward New York Bay and the open sea. Three bobbed about near the Brooklyn shore, while five were close to Manhattan.

The *Sun* reporter took up the story of the three Brooklyn men. "The ice cracked merrily. Then it bulged up, separated and each young man was launched upon a separate cake of ice. The men shouted frantically and waved their arms. . . . Two of the men were on neighboring ice cakes. One finally made a dangerous jump to the cake nearer the shore on which the other stood. The crowd shouted approval, [and] told them to keep their hearts."

A rope with a rock attached to it was eventually tossed to these men and they were hauled to shore and rescued.

"The other young man, who was irreproachably dressed and carried a satchel, was on a cake scarcely twenty-five feet in diameter. He ran from edge to edge, till each time he nearly slipped in the water, and showed such terror that terror was communicated to those on shore."

Farther and farther out the desperate man drifted, and many watchers felt he would be lost. Then the tugboat *S. E. Babcock* managed to plow through a large chunk of ice and swing in close enough for the man to be brought on board.

Meanwhile, the five men near Manhattan were floating out rapidly. Three were on a rather large slab of ice, while two were each on cakes that the *Sun* reporter said were "the size of door mats."

First, a tug nudged the large floe into shore until it hit a wharf and the three men leaped off. Then the tug went after the two last floaters. When they were finally hauled up and safe "the thousands of men on the riverside and the Bridge yelled their applause in rounds of cheers and screams."

In addition to the cheers, Tuesday morning was a time of tears and

much worry in all areas hit by the blizzard. It was when family and friends began searching for those who were missing or who hadn't been heard from since Monday. When concerned relatives of Long Island potato farmer Sam Randall found his house empty that morning, they immediately set out for the barn, assuming he had decided to stay there for the night. While plowing through the deep snow, they stumbled across his frozen body.

This map shows the complete route of the two storms that produced the Great Blizzard of 1888. The southern storm eventually headed across the Atlantic and dumped great quantities of snow on northern England and other parts of Europe, where it became known as the American Storm.

Outside of Albany, railroad officials were compiling a list of the passengers aboard the burned-out train from Buffalo when someone remembered the attractive young woman. Since no one knew where she was, crews were immediately dispatched to search along the tracks. Several hours later, Sara Wilson's body was uncovered, still clutching her Empress Eugénie hat with its pretty red feather.

James Marshall's parents weren't particularly worried when he failed to return home on Monday night. They assumed he had stayed at the Singer factory in Elizabeth. They were concerned on Tuesday morning, but without telephone or telegraph service in their area, there wasn't

In areas where snow was a frequent visitor, towns often didn't bother to dig their streets clean. This snow roller was used in Brattleboro, Vermont, to flatten snow so sleighs could travel easily. (BRATTLEBORO P.H.O.T.O.)

much they could do but wait. They would have been shocked to know that James had kept up his dogged race against death all night and was even then still plodding along, desperately hoping to be discovered.

In Connecticut, the older brother of Legrand and Gurdon Chapell woke up that Tuesday and set out by sleigh to join the rest of the family at Grandma's. When he arrived, he was asked where his little brothers were, and it became instantly clear that they were lost somewhere in the snow.

An hour later, every nearby neighbor had been asked to join in a search for the boys. Falling snow and wind had obliterated their tracks, but it was assumed they had attempted to cross the fields between their

house and their grandmother's. At around noon, Legrand's mittens and cap were found near a very large snowdrift and the worst was assumed.

The searchers were discouraged, but decided that they had to at least find the boys' bodies. But how were they going to do that in such a vast area of snow?

An elderly man who had been in several winter searches suggested that they use bean poles to poke through the crusted snow. He had brought one with him and began demonstrating how to jab it into the snow and poke around with it. When they hit a body, he told those assembled, it would feel softer than the hard ground nearby. He jabbed a few more times, when, from deep within the snow, they heard a very faint cry of "Ouch!"

Frantic digging followed and within minutes both boys were uncovered from the snow cave Gurdon had hollowed out for them twenty-two hours before. The boys were whisked to a warm kitchen where their stiff clothes were cut from their bodies. Next, they were plopped into a tub of tepid water, and then each was given a large dose of whiskey. Even though the boys were beginning to come around, a concerned neighbor insisted that they be wrapped in a sheet smeared with molasses to completely ward off frostbite.

The boys survived and lived long lives, during which they often told of how they had survived the Great Blizzard of 1888. Legrand vividly recalled how he and Gurdon had clung to each other in their cave and how Gurdon had said, "We'll never get out of here. We will die, but I can't carry you out and I can't go and leave you alone."

By the time Legrand and Gurdon were found, the snow had finally stopped falling everywhere. The northern storm was now over Greenland and no longer exerting much influence on weather in the United States. The southern storm, the one that had circled around, was over

the outer tip of Long Island by 3 P.M. The storm would continue turning, then head across the Atlantic toward Europe, picking up moisture as it made its journey. When it hit Europe with its high winds and snow, it was dubbed the "American Storm."

As the storm lessened, then stopped in the United States, efforts to clear roads, sidewalks, and railroad tracks intensified, as did the search for the missing. But most people in cities were far from out of danger. Mothers with buckets trudged from store to store in search of milk for their children, but found none available. In New York, the tiny supply of milk available was reserved for the better restaurants, where the price of a glass quickly went up to seventy-five cents.

Other food prices also zoomed up. On the previous Friday, the cost of a chicken had been seven cents; on Tuesday they went for twenty-five cents. Eggs jumped from twenty-five cents to forty cents a dozen, while butter more than doubled in price to thirty cents a pound. A steak

One way to cope with unshoveled streets was to poke fun at the politicians responsible for snow removal. This particular cartoon appeared in a New York City paper, but people in other cities held the same view of their politicians. (AUTHOR'S COLLECTION)

At a recent meeting of the Board of Aldermen, it was Resolved to let the streets take care of themselves, as heretofore.

that cost sixteen cents a pound was now blizzard-priced at twenty-two cents; spring lamb went from twenty-eight cents to thirty cents a pound. These prices may seem extremely low to us, but back in 1888, someone with an unskilled job might be making between three and twenty dollars per week. Even an increase of a few pennies per pound could mean the difference between eating and not eating to a poor family.

The same leap in price happened with coal. Before the blizzard, it cost one cent a pound. By Tuesday, the price stood at two and a half cents and was rising. The poor might be able to purchase five or ten pounds of coal, but such a meager supply wouldn't last very long in a stove going throughout the day and night.

There was little the poorest in the city could do but suffer. Church and private shelters were already full and struggling to care for those presently in their charge. Police stations were likewise jammed and had no real food supplies to hand out. The city itself provided very little in the way of direct help to those in need.

In fact, the only known attempt at widespread relief came from a wealthy realtor, P. M. Wilson. Wilson owned a number of buildings on Broadway as well as large tracts of land on the West Side of the city. He knew from his visits to the West Side that the poor there must be suffering terribly, and before noon, placards began appearing which read:

ATTENTION!

FREE COAL TO POOR FAMILIES IN THE NEIGHBORHOOD WILL BE SUPPLIED AFTER 12:00 NOON, MARCH 13, 1888, AT THE ENGINE ROOM OF THE ROSS BUILDING, HUDSON STREET, CORNER BANK STREET.

BY ORDER OF,

P. M. WILSON

During the coal shortage, a man in Brooklyn uses a boat to haul coal. (MUSEUM OF THE CITY OF NEW YORK)

A long line of needy people soon formed outside the door to the engine room — mothers cradling infants, little children, men out of work, and even elderly men and women came. Each brought a pail, bucket, or sack to haul away a few pounds of the precious fuel.

Wilson's kindness helped several hundred families have coal enough for a warm home and a hot meal. But by Tuesday night, countless individuals and families throughout the area hit by the blizzard had much to endure. Food was so scarce in New Haven, Connecticut, that a man wrote in his diary: "We are desperate. No milk. Only condensed milk and that is going fast. All fresh meat gone. Groceries shut. Restaurants dark. Nothing to eat. Nothing. What will my poor children do?"

IT IS ONLY A SNOWSTORM

The Great Blizzard officially ended on Wednesday, March 14. An additional two inches of snow fell on upstate New York and New England, but it was a gentle fall with little accompanying wind. Skies throughout the storm region cleared, and temperatures from Delaware all the way up to Canada rose. Both Philadelphia and Boston recorded a balmy 40 degrees. As quickly as it had disappeared, the warm weather returned.

Down in Lewes, Delaware, the nice weather brought out crowds who gawked at the devastation in the harbor. The long steel pier had a 200-foot-long chunk ripped out of it, and boats and ships were strewn about everywhere, some on land, some wallowing in shallow water. Despite the dangers, the captains and crews of these vessels hurried to get aboard them. Salvage laws stated that both the craft and its contents belonged to the first person to take possession of it.

Just outside of Lewes, a very hungry John Marshall breathed a sigh of relief — and said a prayer of thanks — when a rescue crew finally located and dug out his train. While the vast majority of trains would be moving on Wednesday, a small number — estimated at between

Breakthrough! A line of engines coupled together finally forces its way through a snowdrift so it can get to a stranded train. (AUTHOR'S COLLECTION)

twenty and thirty trains — would remain snowbound until Friday. Most of these missing trains were either in very remote areas, or they belonged to railroad companies that did not want to spend money to rescue them.

On Wednesday in New York City, a plow pulled by a team of twenty-eight horses and assisted by over 100 Italian shovelers finally opened up the 59th Street and Spuyten Duyvil cuts. Within minutes, one train after another began limping in, and Grand Central Depot gradually came back to life. Chauncey Depew expressed satisfaction that his railroad was running once again, and then, after issuing a few orders, he left the office. He would have to face many disgruntled patrons in the days ahead, but for the moment, all he wanted was to be at home and asleep in his own bed.

In addition to passenger trains, others carrying the mail and desper-

ately needed supplies of beef, chicken, and dairy products began pulling into stations everywhere on Wednesday. The widespread famine some had feared never materialized, though many grocers kept prices very high until the end of the following week.

While the predicted famine was averted, another sort of disaster began to unfold in isolated rural areas. Train service to Poughkeepsie, New York, did not return to normal for three weeks. During that time, local dairy farmers were forced to destroy tens of thousands of gallons of milk and thousands of pounds of butter. Over in Pennsylvania, the lack of transportation led to the layoff of over 10,000 coal and iron miners. In addition, many rural factories were also forced to shut down temporarily as well. Either they couldn't get the necessary materials to make their products or the fuel to run their machines, or else they had no way to get what they made to market. It would take weeks, and in some cases months, for the dairy farmers, miners, and workers to recover from the financial setbacks caused by the blizzard.

The hardships suffered by these people, as well as by the poor, were largely ignored by most citizens, politicians, and the newspapers. It seemed that everyone wanted to put the storm behind them and get back to normal as quickly as possible. The New York *Sun* crowed: WE ARE ON TOP NOW. THE TOWN HAS GOT THE BLIZZARD DOWN. NO LONGER ISOLATED. Another New York City paper proudly announced: DIGGING OUT OF IT. THE BIG CITY GETS UP AND SHAKES ITSELF. YOU CAN GET AROUND NOW.

Such boasts were made everywhere hit by the blizzard. A Connecticut paper said firmly: FLAKES HAVE LOST THEIR GRIP, while in Vermont the claim was, THE BLOCKADE BROKEN. RAILROAD TRAFFIC AT LEAST PARTIALLY RESUMED IN VERMONT. Gone was the sense that the storm was invincible and that humans were helpless. The Waterbury, Connecticut, paper

Shortly after the snow stopped falling, these two men attempted to clear a path across a street. The wind took most of their work and tossed it back into their faces. (AUTHOR'S COLLECTION)

made it clear who was now boss: PUSHED THROUGH! WATERBURY HEAD AND SHOULDERS ABOVE THE DRIFTS. MEN WHO CANNOT BE DOWNED IN THIS WAY. THE SNOW BEATING A VERY HASTY RETREAT.

While the newspapers trumpeted the storm's demise, people used humor to show they had not been defeated by the blizzard. A prankster placed a placard on a particularly huge drift near New York City's Madison Square that read: THIS SNOW IS ABSOLUTELY FREE! PLEASE TAKE A SAMPLE!

Several blocks away, a shopkeeper, frustrated that he could not find anyone to shovel his snow, left this sign outside his place of business: IMPORTANT! EXPENSIVE DIAMOND RING LOST UNDER THIS SNOW DRIFT! FINDERS KEEPERS! START DIGGING! YOU MAY BE THE LUCKY WINNER!

Up in Albany, a florist took his unsold flowers and stuck them in a snowdrift to resemble a hill of beautiful springtime flowers. A sign on the drift warned pedestrians: DON'T PICK THE FLOWERS.

It seemed as if every city and most towns had some youthful pranksters as well. In Albany, a group of boys with excess energy dug a 100-foot-long path up the sidewalk and around the corner. Unsuspecting adults wouldn't realize that the path came to a dead end until they came face-to-face with an 80-foot-tall drift. A slight variation on the "path to nowhere" was found in New York City. On turning the corner, adults discovered the path narrowing until it was just wide enough for a child's thin body to squeeze through.

The brave words and humor helped people unwind from the tension and terror of the storm's assault. It also distracted them from the massive chore of digging out. It was all posturing, of course, and all one had to do to know this was to look around.

William Inglis was in a cheerful mood as his pilot schooner *Colt*

This resident of Danbury, Connecticut, pauses for a moment before digging his way through a daunting pile of snow outside his home. (CONNECTICUT HISTORICAL SOCIETY)

neared shore. "We all thanked God that we were alive," he would write. Besides, he had a great adventure story to tell his readers.

As the schooner neared land, Inglis realized for the first time the true extent of the storm's devastation. Numerous damaged ships were being towed in by tugs, while broken and battered boats could be seen in all directions. "We saw three wrecked pilot-boats ashore [near] Sandy Hook, another in Gravesend, and poor No. 2, with nothing but her masts showing below the Bay Ridge pier. . . ."

Just then, the steward called them below for lunch, the first hot meal they had had since Sunday. "As we fell to sharply, a tug passed by one quarter to windward. The man at the wheel hailed her for news."

The answer was shouted in a loud voice that everyone below heard clearly. "Nine pilot boats wrecked." They had all been fierce competitors of the *Colt* for business, but they were also friends and neighbors. "Big Fairgreaves pushed his plate away and went on deck. There were tears coming out of the corners of his eyes. None of the rest of us ate any more."

In truth, the cruelty of the storm had not really ended. On that Wednesday morning, a Staten Island farmer was out looking for stray cattle when he discovered a young man stumbling around and around one of his haystacks. It was James Marshall. Amazingly, he had managed to keep moving, sometimes running, sometimes walking, sometimes crawling on his hands and knees, since Monday evening. He was mumbling incoherently by the time the farmer got him to a doctor.

Despite Marshall's attempt to shelter them, both his friends had died from exposure. As for Marshall, an article in the New York *World* told about his own terrible fate: "Dr. E. D. Conley, who is attending Marshall, says he will be taken to the infirmary this morning where his hands and feet will be amputated."

Nor was the blizzard's danger really over, even with the sky brighten-

Hundreds of small boats were caught in the storm and capsized by the gigantic waves. This drawing shows one of the few people who managed to drag himself ashore. (MUSEUM OF THE CITY OF NEW YORK)

ing and temperatures going up. Responding to a rumor that a tidal wave had destroyed a hotel at Coney Island, the New York *Eagle* sent out twenty-one-year-old cub reporter Richard C. Reilly that Wednesday.

Reilly managed to get aboard a train clearing the tracks to Brighton Beach, and from there he struggled through one mile of deep snow to Coney Island. The storm had severely damaged the town, but there was no evidence that a tidal wave had struck. After thoroughly exploring the area and talking with numerous residents, Reilly decided to head back with his story.

Even though the train had already left and darkness was approaching, Reilly refused to give up. He wanted his story to appear before any other paper could beat him out. He found a stable and rented a horse and sleigh (for a whopping thirty-five dollars!), then set off.

All day, Reilly had taken detailed notes, and he did so on his way back to the office, too. His last entry was made near Patrick Maher's

Many bodies were pulled from the snow and transported to the morgue. Relatives had to identify the body before it could be released for burial. (AUTHOR'S COLLECTION)

farm. Reilly's unconscious body was found the next day lying in a snowbank. No one really knows what happened to him, but detectives hired by the *Eagle* suggested that the day's strenuous physical effort had brought on a heart attack. Despite efforts to revive him — which included placing hot bricks at his feet and thirteen hot-water bottles around his body — Reilly died without regaining consciousness. The blizzard had claimed another victim.

There were many other victims. Most historians place the number of those killed at around 400, but this number must certainly be too low. On average, 400 people were buried every week in New York City. When burials began again on the Friday after the storm, over 800 bodies were brought to the area's cemeteries. This additional number does not include the hundreds killed at sea on foreign ships (who were never counted on official lists in the United States) or those who perished in

cities and towns in other states. Nor does this number include the many individuals who died from heart attacks or other illnesses brought on by exposure to cold or from shoveling wet, heavy snow.

One such victim was the unstoppable Roscoe Conkling. The day after collapsing at the door of the New York Club, Conkling went downtown to be interviewed by the press. He talked at length about his adventure, but then went home with a terrible headache. His condition worsened, but the ever stubborn Conkling refused to follow his doctor's orders to rest. He died on April 18. His death certificate stated that he died from mastoiditis and pneumonia, but everyone who read Conkling's obituary knew it was the Great Blizzard that had done him in.

There have been numerous winter storms to rival and even surpass the Blizzard of 1888 in snowfall and wind velocity. The American Midwest had seen many savage blizzards that whipped down from northwest Canada with blinding speed and awful intensity. One struck on December 21, 1836, that plunged temperatures by 50 degrees in a matter of minutes. An Illinois settler named John Moses wrote about the instant cold that hit his area: "The water in the little ponds in the road froze in waves, sharp-edged and pointed, as the gale had blown it. . . . Men caught out on horseback were frozen to their saddles, and had to be lifted off and carried to the fire to be thawed apart. Two young men were frozen to death near Rushville. One of them was found with his back against a tree, with his horse's bridle over his arm, and his horse frozen in front of him."

During the winter of 1880–1881, the Plains were hit by a series of particularly fierce blizzards — one a week, each lasting three or more days, from January through April. These storms stopped railroad service for seventy-nine straight days and dumped 11 feet of snow in the Dakota Territory. In January of 1888, a blizzard earned the nickname the "schoolchildren's storm" because it struck the Nebraska and

Dakota Territory with such speed that children were caught on their way home from school.

Even in our own times, we have seen killer blizzards more powerful than the Blizzard of 1888. The Superstorm of 1993 roared across the eastern United States from March 12 to 14, dumping record-breaking amounts of snow in all areas. The *National Disaster Survey Report* called the 1993 storm "among the greatest nontropical weather events to affect the Nation in modern times." The report went on to note that the storm inconvenienced over 100 million people and that, even with ample warning of its approach, over 200 people died in it.

Despite these and other historic storms, the Blizzard of 1888 is still the one most written about in our nation's history. Why is this?

First, the sudden onslaught of the storm and the way it completely shut down every big and small city from Virginia on up into Canada traumatized millions of people. The fear they felt during the storm, and the relief at having survived it, lingered in their memories for many years afterward.

In itself, this is not unusual, since every natural disaster leaves survivors with similar feelings and vivid impressions. The Blizzard of 1888 differed because it was recorded in great detail by the many newspapers then in existence. Adding to this abundance of information were the more than 1,200 personal accounts collected over the years by an organization known as the Society of Blizzard Men and Blizzard Ladies of 1888, and now housed at the New-York Historical Society.

A massive written record plays an important role in sustaining the memory and myths of any storm. But the Blizzard of 1888 is recalled today primarily because of the long-term impact it had on the way we live in the United States.

New York City had been completely paralyzed — and embarrassed —

by the storm. As a consequence, *The New York Times* pointed out, "people vexed at the collapse of all the principal means of intercommunication and transportation became reflective, and the result was a general expression of opinion that an immediate and radical improvement was imperative."

This was easier said than done because changes in the way New York or other cities operated required legislation. And getting any law passed was a complicated and tricky process. Because of this, Mayor Hewitt began by going after a fairly easy target.

Moments after the snow stopped falling on Wednesday, he ordered companies to put their wires underground and to take down their poles. He was able to act so quickly in this instance because the necessary legislation was already in place. Even so, most companies simply ignored Hewitt and began putting up their overladen poles again. One company even sued the city, claiming the law was a violation of its constitutional guarantee of freedom of speech.

But the blizzard had fostered in the public a mood for change. People remembered a prestorm city encircled and bound up by thousands of wires, and they remembered writhing live wires dancing on their streets and sidewalks during the storm. It didn't take a genius to see that underground wires made sense. Public opinion was further aroused when a Western Union lineman was electrocuted and, as one historian tells it, "thousands watched as the body dangled from overhead lines for nearly an hour, its mouth spitting blue flame." By 1894, all wires in New York City had been banished underground, and other cities — including Washington, D.C.; Boston; Albany; and Buffalo, to name a few — followed its example.

Snapped poles and high-voltage wires weren't the only thing to anger citizens in New York and other cities or to cause a change in the way things were done. Flying debris — from store signs, household

garbage, and broken glass to newspapers, coal, and horse manure —
had all endangered pedestrians during the storm.

It would take months and years of public debate and squabbling, but
eventually a series of tough new ordinances emerged. Containers hold-
ing coal, garbage, and other items were banned from sidewalks, while
store and home owners were required to clean up the streets and side-
walks in front of their property. The size and types of signs were regu-
lated as well, and some of the first antilittering laws were drawn up. In
short, many activities once considered the private affairs of a citizen
became matters for public concern and legislation.

The blizzard also caused Alfred Ely Beach's 1849 dream of an under-
ground railway system to be set in motion at long last. The powerful
aboveground transportation companies and their political cronies
would continue to call a subway system a costly and unnecessary ex-
pense. But the hundreds of thousands of voting commuters who had
been trapped during the storm felt otherwise.

The first subway line in New York City, opened in 1904 by August
Belmont's Interborough Rapid Transit Company (the IRT), initially
covered 22 miles and was an immediate success. Soon, it was carrying
over 600,000 people a year, in rain, summer heat, and, as Alfred Ely Beach
had said all along, even during snowstorms. Other cities, including
Newark, New Jersey, Chicago, Boston, and Philadelphia, would also in-
stall underground rail systems in the years following the blizzard.

Another profound change was in the way people and their govern-
ments viewed snow. In New York City alone, the cost to businesses for the
three-day blizzard was estimated at between $2,500,000 and $3,000,000.
Even with 17,000 shovelers, snow removal was slow and businesses
couldn't bring in needed supplies or send out what they produced. Com-
plaints about the slow clearing of streets persisted long after the snow

The storm is over and hundreds of impatient passengers are lined up and waiting, but these horse carriages still aren't moving at this station on Bowery Street. (AUTHOR'S COLLECTION)

had melted, and were one important reason why Mayor Hewitt was voted out of office the following November.

It didn't take city politicians long to realize that their jobs depended on a quick and efficient response to future snowstorms and other disasters. Plans were drawn up to meet future emergencies, no matter how unusual they might be. These plans included details on what might happen, how the city should respond, the costs involved, and the necessary workforce.

Giant icicles dangle from the surrounding roofs as this Italian work gang in Newark shovels snow to the side of the street and begins spreading dirt so horses have better footing. (NEW JERSEY HISTORICAL SOCIETY)

The notion that the work of the city could be done by temporary help was also rejected, and more permanent workers were hired by the city to clean streets, pick up garbage, and remove snow. One interesting result of this change was that thousands of recently arrived Italian immigrants found secure jobs with the city.

New York City wasn't the only place to change as a result of the blizzard. Following the storm, no city would be built or managed that did not have detailed emergency plans and the workers available to carry them out. These changes did not happen overnight. The increased obligations all cost money, and many people objected to the resulting rise in taxes. Numerous efforts were made to stall the necessary legislation, especially when it came to helping the poor. Change did come, however. In fact, only one major city — Detroit — still does not plow snow from its residential streets. But the notion that a city has no responsibility for its people and businesses in an emergency died with the blizzard.

The upset that followed the storm seemed unusually strong in Washington, D.C. The nation's capital had been completely cut off from the rest of the country from Sunday through Wednesday. During that time, President Grover Cleveland and his wife had been stranded at their country home outside of Washington, without any way to contact his cabinet or the Congress.

One senator's highly emotional speech about the danger posed by the Blizzard of 1888 ended with this declaration: "We cannot control the elements. We cannot prevent another blizzard. We can protect our communications. All wires now running overhead must be placed underground in the urban areas and thus shielded from the caprices of nature. Not only are the overhead wires unsafe and unsightly — they are a damned menace to the security of the United States of America."

What if the country had been invaded while the storm was raging?

Brattleboro postman Spencer W. Knight tried to deliver mail during the blizzard but was forced to give up early on. Here he is after the sidewalk had been shoveled through wave after wave of snow. (BRATTLEBORO P.H.O.T.O.)

senators wanted to know. What if assassins had killed the president while communications were down?

Like all other cities, Washington, D.C., responded by passing laws and regulations designed to keep streets open and telephone and telegraph wires safe. Congress, however, wasn't finished. It heaped particular scorn on the Signal Corps's failure to predict the storm and demanded to know why.

When the head of the Washington Weather Station, General Adolphus Greely, tried to shrug off the storm as "a somewhat unusual class of storm," he was severely criticized.

The first chief forecaster for the fledgling National Weather Service,

Snowdrifts dwarf a line of pedestrians in Hartford, Connecticut. (CONNECTICUT HISTORICAL SOCIETY)

Professor Cleveland Abbe, was more direct in assessing why his people had failed to predict the storm's intensity. "The element that fooled us was the ocean winds, about which we never have any warning," he said. "You see, we know so little anyway, and there is so much more of which we are and must be ignorant. . . . We are utterly ignorant of what is going on to the east of us, and overhead."

Abbe's confession of ignorance had several effects. Control of the Signal Corps was taken away from the army and handed over to the Department of Agriculture in 1891. Its name was changed to the less military one of the United States Weather Bureau.

The second change had to do with the Weather Bureau's mission. The Signal Corps focused on issuing daily weather indications and advance warnings about storms. The Weather Bureau expanded its role of responsibility to learning meteorological laws, hoping that knowledge about how and why weather happens would improve its ability to more accurately predict it. With these changes went an ever-increasing budget.

This change in the way the nation approached the weather was a significant start, and would eventually lead to the use of radar, high-speed electronic computers, and satellites in forecasting weather patterns. The theories about the clash of warm and cold air masses high up in the atmosphere and their effect on the weather (put forward by Norwegian Vilhelm Bjerknes and his son Jacob) also lay in the future. Today, weather forecasting for the following day has an accuracy rate of 95 percent.

Finally, the practice of closing the Bureau for the Sabbath was abolished. In the future, the Weather Bureau would stay open and alert twenty-four hours a day, seven days a week. No longer would the country be open to a surprise change in the weather.

What mattered most at the close of the nineteenth century was that the flaws revealed by the Blizzard of 1888 had been addressed and solved. There would be no chance for future killer storms to catch the nation unprepared. Or so people back then believed.

On September 8, 1900, a hurricane tore apart Galveston, Texas, and killed an estimated 6,000 people. The Weather Bureau correctly predicted the storm, but failed to take into account the effect of the high tide. Thirty-eight years later, the Bureau forecasted a severe windstorm for Long Island and southern New England, but incorrectly judged the storm's speed. Over 600 people perished as a result.

And even as the new millennium dawned, nature flexed its muscles once again. On January 24, 2000, a storm hit the East Coast with

record-breaking snowfalls from North Carolina up into Massachusetts. Many cities were unable to cope with the snow and came to a frozen halt. North Carolina was so completely paralyzed it had to call out the National Guard to help clear its roads, while in Washington, D.C., the federal government was forced to close most of its offices for two days.

The storm had developed in the south and wandered out into the Atlantic where forecasters expected it to die. But, like the Blizzard of 1888, this recent storm shocked everyone when it turned and came back onshore. In a front-page article, *The New York Times* noted that "officials at the National Weather Service acknowledged . . . that their forecasts had failed to predict the size, intensity, or course of the storm."

The lesson is clear: No matter how many pieces of equipment we develop, no matter how many ways we try to predict weather patterns, nature always has the potential to surprise and overwhelm us.

Probably the best summation about the Blizzard of 1888 — and all other killer storms — was made in a Hartford *Courant* editorial while the snow was still fresh on the ground.

"It is the boasting and progressive Nineteenth Century that is paralyzed," the editorial said, "while the slow-going Eighteenth would have taken such an experience without a ruffle. It is our own 'advantages' that have gone back on us.

"But lo . . . there comes a storm [and] there is no railroad, no telegraph, no horse car, no milk, no delivery of food at the door. We starve in the midst of plenty. . . . It warns us to be discreet and temperate in our boasting. It is only a snowstorm, but it has downed us."

NOTES ON SOURCES
AND RELATED READING MATERIAL

When I was five years old, a great, howling snowstorm struck the northeast coast of the United States. The snow piled up so high that our town had to use long-necked steam shovels to clear the streets. But what I remembered most vividly was a walk I took with my mother and older brother shortly after the storm ended.

We were going to a friend's house, which was only two blocks away and a journey we had made many times before. At one point, my mother and brother were 20 feet ahead of me, breaking a trail through waist-high snow. I decided this was the perfect time for a little adventure. So off I scurried — up a neighbor's driveway and across his backyard. My plan was to travel parallel to the sidewalk through all the backyards and beat my mother and brother to the end of the block.

Everything went well for several backyards. Then I climbed up a wire fence and leaped into the next yard — only this time the earth dropped out from under me. I had landed in a deep drift of powdery white snow and found myself in over my head!

I clawed and kicked at the snow to get free, without success. I tried to pull myself up and out of my snowy trap, but each time the walls

caved in around me. I cleared the snow away from my head, but I couldn't escape its grasp or even move my feet an inch. And the more I flailed and screamed for help, the more tired my legs and arms became. Worse, when I quieted down for a second to rest, the only sound I heard was the lonely moan of the wind. No one, I thought, was ever going to rescue me.

I was probably stuck in that drift for only a minute longer, but it felt like an eternity. And you can imagine how happy I was to finally hear

my mother and brother answer one of my feeble calls. My little encounter with snow came flooding back to me in great detail one day as I pored over more than 1,200 letters of reminiscence written by members of the Society of Blizzard Men and Blizzard Ladies.

These can be found in the manuscript collection of the New-York Historical Society and are the source of most of the personal recollections I've quoted. A limited number of these recollections appeared in Hugh Flick's "The Great Blizzard and the Blizzard Men of 1888,"

The Blizzard Men and Blizzard Ladies of 1888 gather at the Hotel Pennsylvania in New York City on March 12, 1938, to celebrate the fiftieth anniversary of the Great Blizzard. (New-York Historical Society)

published in the *New-York Historical Society Quarterly Bulletin*, vol. 19 (1935), 31. Whenever possible, I have credited the author of the quotes by name, but many of these letters are unsigned.

Several individual's stories, as well as their quotes, come from sources other than the New-York Historical Society's archives. Information about Sara Wilson and A. C. Chadbourne comes from *The Great Blizzard of 1888*, by Samuel Meredith Strong (New York: Privately printed, 1938); Chauncey Depew details his own struggle with the blizzard in his autobiography, *My Memories of Eighty Years* (New York: Charles Scribner's Sons, 1922); information about Roscoe Conkling was found in William H. Hoy's article, "Roscoe Conkling Nearly Dead," which appeared in the New York *Sun* on March 14, 1888, as well as Samuel Meredith Strong's history of the blizzard (see above).

A number of histories of the Great Blizzard of 1888 proved to be especially helpful in reconstructing scenes and events. *The Blizzard of '88* by Mary Cable (New York: Atheneum, 1988) has a strong focus on the dangers faced by commuting workers due to the shutdown of public transportation. Irving Werstein's *The Blizzard of '88* (New York: Thomas Y. Crowell, 1960) makes the plight of the urban poor especially clear and dramatic. *Blizzard! The Great Storm of '88* by Judd Caplovich (Vernon, Vermont: VeRo Publishing Company, 1987) does an extremely good job of covering the storm in areas outside of New York City, plus it contains hundreds of photographs and newspaper clippings.

Other sources consulted were: *New York in the Blizzard,* by Napoleon Augustus Jennings (New York: Rogers and Sherwood, 1888); "The Mighty Blizzard of March 1888," by Edward Oxford, *American History Illustrated* 23 (March 1988), 11–19; and "The Great Blizzard of '88," by Nat Brandt, *American Heritage* 108 (1977), 32.

Technical information about the storm and the U.S. Signal Corps comes from a number of valuable sources: *The Great Storm Off the Atlantic Coast of the United States, March 11th–14th 1888,* by Everett Hayden (Washington, D.C.: Government Printing Office, 1888); *Braving the Elements: The Stormy History of American Weather,* by David Laskin (New York: Anchor Books, Doubleday, 1996); *Snow in America,* by Bernard Mergen (Washington and London: Smithsonian Institution Press, 1997); *A Century of Weather Service,* by Patrick Hughes (New York: Gordon and Branch, 1970); *A History of the United States Weather Bureau,* by Donald R. Whitnah (Urbana, Illinois: University of Illinois Press, 1961); "The Great Storm of March 11–14, 1888," by General Adolphus W. Greely, *National Geographic* 1 (May 1888); "The Blizzard of '88," by Patrick Hughes, *Weatherwise* (1981), 250; and "Summary of the Blizzard of '88 Centennial Meeting," by Mark L. Kramer and Gary Solomon, *Bulletin of the American Meteorological Society* 69 (August 1988), 981–83.

Other weather-related material comes from the following sources: *American Weather,* by General Adolphus W. Greely (New York: Dodd, Mead and Company, 1888); *Great Storms,* by L. G. C. Laughton (New York: William F. Payson, 1931); *Early American Winters,* by David Ludlum (Boston: American Meteorological Society, 1966); and *Great Gales and Dire Disasters,* by Edward Rowe Snow (New York: Dodd, Mead and Company, 1952).

Because the Blizzard of 1888 had such a powerful effect on New York City and its citizens, much of this book takes place there. Information and details about the city's history, infrastructure, and day-to-day operation come from the following titles: *Labyrinths of Iron: Subways in History, Myth, Art, Technology, and War,* by Bobrick Benson (New York: Henry Holt and Company, 1986); *Gotham: A History of New York City*

to 1898, by Edwin G. Burrows and Mike Wallace (New York: Oxford University Press, 1999); *Under the Sidewalks of New York,* by Brian J. Cudahy (Brattleboro, Vermont: Stephen Greene Press, 1979); *The Historical Atlas of New York City,* by Eric Homberger (New York: Henry

Shovelers in front of the Hotel Pennsylvania pause a moment to have their picture snapped.

Holt and Company, 1994); *722 Miles: The Building of the Subways and How They Transformed New York,* by Clifton Hood (New York: Simon & Schuster, 1993); *The Way It Was: New York, 1850–1890,* by Clarence P. Hornung (New York: Schocken Books, 1977); *The Encyclopedia of*

New York City, by Kenneth T. Jackson (New York and New Haven: Yale University Press and The New-York Historical Society, 1995); *Under the City Streets,* by Pamela Jones (New York: Holt, Rinehart and Winston, 1978); *The Columbia Historical Portrait of New York,* by John A. Kouwenhoven (New York: Harper and Row, 1953); *The Building of Manhattan: How Manhattan Was Built Over Ground and Underground from the Dutch Settlers to the Skyscraper,* by Donald A. Mackey (New York: Harper and Row, 1987); and *Fares, Please! A Popular History of Trolleys, Horse-Cars, Street-Cars, Buses, Elevateds, and Subways,* by John Anderson Miller (New York: D. Appleton-Century, 1941).

Information about the poor and homeless was obtained from the following sources: *Darkness and Daylight: or Lights and Shadows of New York Life,* by Helen Campbell, Thomas W. Knox, and Thomas Byrnes (Hartford, Connecticut: A. D. Worthington, 1892); *The Tenement House Problem,* by Robert W. DeForest and Lawrence Veiller (New York: Macmillan Co., 1903); *La Storia: Five Centuries of the Italian American Experience,* by Jerre Mangione and Ben Morreale (New York: Harper-Perennial, HarperCollins Publishers, 1992); *How the Other Half Lives,* by Jacob Riis (New York: Charles Scribner's Sons, 1890); and *New York: Sunshine and Shade,* by Roger Whitehouse (New York: Harper and Row, 1974).

Finally, concern about potential food and coal shortages were voiced in a number of newspapers: *The Philadelphia Inquirer*, March 13 and 14, 1888; *The New York Times*, March 14, 1888; the New York *Sun*, March 15, 1888; the Boston *Daily Globe*, March 15, 1888; and the *Torrington (VT) Register*, March 17, 1888.

INDEX

PAGE NUMBERS IN BOLD INDICATE ILLUSTRATIONS